Shaw and the Actresses
Franchise League

ALSO BY ELLEN ECKER DOLGIN

Modernizing Joan of Arc: Conceptions, Costumes, and Canonization (McFarland, 2008)

Shaw and the Actresses Franchise League

Staging Equality

ELLEN ECKER DOLGIN

McFarland & Company, Inc., Publishers
Jefferson, North Carolina

LIBRARY OF CONGRESS CATALOGUING-IN-PUBLICATION DATA

Dolgin, Ellen Ecker, 1951–
　　Shaw and the Actresses Franchise League : staging equality / Ellen Ecker Dolgin.
　　　p.　cm.
　　Includes bibliographical references and index.

　　ISBN 978-0-7864-6947-5 (softcover : acid free paper) ∞
　　ISBN 978-1-4766-1979-8 (ebook)

　　1. Actresses' Franchise League—History.　2. Women in the theater—Great Britain—History—20th century.　3. Women theatrical producers and directors—Great Britain—Biography.　4. Actresses—Great Britain—History—Biography.　5. Feminist theater—England—London—History—20th century.　6. Suffrage—Great Britain—History—20th century.　I. Title.

PN2595.13.W65D85　2015
792.02'80820941—dc23　　　　　　　　　　　　　　　　　2015001208

BRITISH LIBRARY CATALOGUING DATA ARE AVAILABLE

© 2015 Ellen Ecker Dolgin. All rights reserved

No part of this book may be reproduced or transmitted in any form or by any means, electronic or mechanical, including photocopying or recording, or by any information storage and retrieval system, without permission in writing from the publisher.

Front cover: Detail from publicity still for *Androcles and the Lion*, 1913. Lillah McCarthy in starring role as Lavinia appears with playwright Bernard Shaw. Courtesy of Bernard F. Burgunder Collection, Division of Rare and Manuscript Collections, Carl A. Kroch Library, Cornell University and the Society of Authors, on behalf of the Bernard Shaw Estate.

Printed in the United States of America

McFarland & Company, Inc., Publishers
　Box 611, Jefferson, North Carolina 28640
　　www.mcfarlandpub.com

In memory of Kay Fowler, my heart sister, for
the inspiration to pursue this project and
all of our other shared passions.

To Andrew and Trella and Eva and Kim, with love,
gratitude, and anticipation for many more
shared triumphs among us.

Table of Contents

Acknowledgments ix
Preface: Shattering Stasis 1
Introduction: The Spectacular Turned Inward 5

1. Getting Past the Tableaux 19
2. Her Unrecognizable Self: Smashing the Idol of Woman 33
3. Theatre No Stranger Than Ourselves 51
4. Moving Mountains in Small Spaces: New Drama ca. 1900–1914 80
5. Breaking News: Transatlantic Theatrical Activists 113
6. Tandem Stages: Transatlantic Suffrage Drama 131
7. Crossing Aisles & Isles: 1908–World War I 158
8. Splintered Souls: 1914–1924 193

Chapter Notes 217
Bibliography 231
Index 239

Acknowledgments

The impetus to write this book came first from my students at Dominican College of Blauvelt, New York. I shared with them a conference paper I was about to present at the International Shaw Society Conference in Washington, D.C., in October of 2009. My talk was about two of Bernard Shaw's young women, Joan of Arc and Cleopatra, as representatives of what we now term "teen power." One mused, "Maybe another book for you, Dr. Dolgin?" My thanks to that class and the many other classes who routinely prompt my next steps.

Administrators at Dominican College also gave me consistent support, including the academic deans, Drs. Thom Nowak and Ann Vavolizza, and the division director of Arts and Sciences, Dr. Mark Meachem. To my colleagues, Drs. Kate Hickey, Tanya Radford, James Reitter, Rob Stauffer, Kevin Hermberg, and Rosanna Arcieri, just know that your encouragement and conversations are a constant source of energy. As for my office mate, Dr. AnnMarie DiSiena, your strategies for perseverance kept me on track.

Dick Dietrich, the founding president of the ISS, recommended me for sabbatical, and he and the subsequent presidents, Leonard Connolly and Michael O'Hara, have been stalwart supporters. David Staller's Project Shaw concert-style readings of Shaw's plays have delighted and inspired many close readings in this text; I am also thankful to you, David, for our many conversations and differing perspectives on the plays. My gratitude to all the Shavians for these years of shared delights and mutual inspiration at our conferences at Niagara-on-the-Lake, Guelph, Ontario, Chicago,

and, most of all, Ayot-St. Lawrence, England, for the Shaw-at-Home conference in 2013. Many thanks to Lizzie Dunford and Sue Morgan and all the staff at Shaw's home, Shaw's Corner, for bringing the totality of Shaw's world to us. The 100-year anniversary of Shaw's *Pygmalion* brought an amazing opportunity for me: an interview with Jenny Lawlor of WNYC, New York Public Radio, which was broadcast as part of a special edition of *Studio 360* that featured the cultural benchmarks of 1914.

My humble thanks to the many special librarians who have gone well beyond the necessary on my behalf: the Fales Library at New York University, The British Library, and The Victoria & Albert Theatre Museum at Blythe House. I am also very grateful to the librarians at the University of Pennsylvania, Philip H. Ward Collection of Theatrical Images, 1856–1910, Rare Book & Manuscript Library Image Collections, the Cornell University Bernard F. Burgunder collection of George Bernard Shaw, Division of Rare and Manuscript Collections, and Tom Lisanti, manager, Permissions & Reproduction Services at the New York Public Library. The staff at Art Resource, New York, and the Library of Congress Prints & Photographs collections provided shrewd advice and swift attention.

Friends and colleagues at NeMLA (Northeast Modern Language Association) have been critical to my development as a feminist critic across genres. In particular, I am grateful for the sessions devoted to my scholarship on Joan of Arc and the women's drama that developed during the suffrage movement and that is a central focus of this book. The Comparative Drama Conference has also shaped many of the concepts here, both in terms of Shaw's and the Actresses Franchise League's contribution to dramaturgy and performance.

On a more personal note, let me say a word of appreciation to my circle of friends, and my former student and editor extraordinaire, Tara Rose, who has worked on both this book and its predecessor, *Modernizing Joan of Arc* (McFarland, 2008). As for my adult children, our shared pleasure in theater and our own versions of "discussion plays" are among my fondest memories.

Preface: Shattering Stasis

> To move from mind's eye to body's eye was realization, and to add a third dimension to two was realization.... [However,] the tableaux vivant should not be confounded with the dramatic tableau of effect and situation.... Both present a readable, picturesque, frozen arrangement of living figures; but the dramatic tableau arrested motion, while the tableaux vivant brought stillness to life.—Martin Meisel, *Realizations*[1]

> The ease with which she adapted herself to stage pictures was the most useful lesson her artist lovers taught her; in life Ellen Terry failed to become the women they imagined, but on the stage she absorbed herself into these women perfectly. Her eerie ability to become her setting would impress [all].—Nina Auerbach, *Ellen Terry: Player in Her Time*[2]

In 2009, a century after Joan of Arc's beatification by the Catholic Church, I planned a conference paper on Bernard Shaw's *St. Joan* (1923) and the potential connection between Shaw's play and Elizabeth Robins's 1907 play *Votes for Women*. Joan's centrality in the suffrage movement and her prominence in their parades was irrefutable, but needed more probing. I turned to the coverage of Joan's beatification and impending sanctity in the press and came up with a telling article in the *New York Times* from 1912. The article featured the visit of an English archbishop to an event at New York's Waldorf Astoria Hotel. Of her, he said,

> "Many people have asked me if, were she living today, [Joan] would be a suffragette," said Father Vaughn, and there was a ripple in the audience as people leaned forward lest they miss his reply. "How can I tell? Send your

wireless across the great spaces and ask her.... I do not know what Joan of Arc would have thought ... but if she were here, ladies and gentlemen, I think she might break our hearts, but I know she would not break our windows."[3]

As noted by the *New York Times* article, Father Vaughan's use of the word suffragette, in reference to the most radical branch of the women's movement, was the only mention of suffrage in the "evening devoted to the Maid whose name is on the banners of so many enlisted in the suffrage cause."[4] Joan's double iconic roles—of religious devotee and protofeminist—were readily available in the popular imagination and required no further explanation. The reference to the wireless might have raised expectations of a more modern perspective on Joan; if so, the audience experienced a double disappointment. Even as Joan's achievements were valorized rather than condemned in modern times, her image remained "frozen" like a dramatic tableau for many. The women modeling themselves on Joan in the Waldorf Astoria that evening, or working for women's citizenship during the day, had inherited Joan's role of social impropriety.

Suffrage leaders learned much from Joan, and one thing served as a bridge between the 19th and 20th centuries: pageantry. Joan shrewdly used costume and imagery to call attention to her cause, and suffrage used Joan as a visual symbol. The Victorian theatre audience had reveled in the sophistication of the visual effects of dramatic tableau that punctuated the plot of melodramas as much as the psychological depth in Shakespearean acting. The theatre had given women a voice as well as presence by the 1870s. Acting became a respectable profession and young girls could imagine themselves onstage as a career. Tableaux vivants, on the other hand, were women's private, amateur theatricals, made popular after Emma, Lady Hamilton, initiated the practice of striking "attitudes" of strong women in the late 18th century (see Chapter 1). Throughout the 19th century, women used the tableaux vivants as parlor entertainments but also as a means to educate themselves. Striking the poses of exemplary women imprinted their achievements from ancient times onto the present moment and empowered modern women's own choices and rebellions against their repressed social roles. Thus the importance of Meisel's distinction that this form "brings stillness to life."

Social stability had consistently relied on what Martin Meisel describes as a "readable, picturesque, frozen arrangement of living figures" to function. Nina Auerbach's provocative phrase that a woman would "become her setting"—and thereby blend into the background that supports her—could apply to what had been standard practice for women across cultures for millennia and certainly applied to the tableaux vivant style. Ellen

Terry's adoration by the public did not preclude her real-life departure from the roles of dutiful daughters, wives, and mothers she portrayed onstage. Her offstage persona was likewise prominent, which informs Auerbach's pithy note that Terry's pictorial blending onstage was "eerie." Like the women history tried to erase, lives of successful women often revolved largely around those who refused to stay put. In several ways, this paradox for women, and its connection to tableau and tableaux vivant, underlies this project, especially since this work began as an outgrowth of my cultural study of Joan of Arc as a recurring social icon.

In the Preface to *Modernizing Joan of Arc* (2008), I discussed the apparent impossibility of assigning a single interpretation or meaning to Joan even after she was canonized in 1920 and speculated that this phenomenon epitomized resistance to complex women leaders and/or the changes these individuals demand and produce. The era that canonized Joan, from 1869 to 1920, coincided with each of the ideological conundrums this illiterate peasant girl evoked in the 15th century. The same issues surrounding gender, social class, and voices of authority remained headline news internationally in the later era. Years earlier, the Epilogue of *St. Joan*, and Shaw's merging of the Joan's Rehabilitation Trial of 1456 with the news of her canonization onstage, spurred my examination of the process of changing history through iconoclasm. This dream sequence scene may have featured 15th-century characters, but they were shown in the frame of Freud's theories, as well as Shaw's trademark comedy. As he so often did, Shaw turned the audiences into bystanders of a social order that condemned a rebellious individual who believed in something larger for the benefit of many.

In continuing to explore what the suffrage movement took from Joan, I discovered the unexpected. Two other women—literary figures—were linked time and again to Joan in the early 20th century: Euripides's Medea and Ibsen's Hedda Gabler. For 20th-century feminists, the push for women's full citizenship resulted in an unlikely triptych: Medea, Hedda, and Joan of Arc. Glaringly disparate on the surface, these three figures embodied society's response to individuals who dared defy proscribed behavior for wives, daughters, or self-promoting leaders. Startlingly, each of these figures was portrayed onstage or on the streets in the same year, 1907, as Elizabeth Robins's play.

Gilbert Murray's new translation of *Medea* premiered at the Savoy Theatre, directed by Granville Barker. Medea's speech to the Nurse about the plight of women was incorporated into the push for British legislation before the First World War.[5] London's first Hedda Gabler in 1891 had been American-born Elizabeth Robins, who had collaborated with Marion Lea

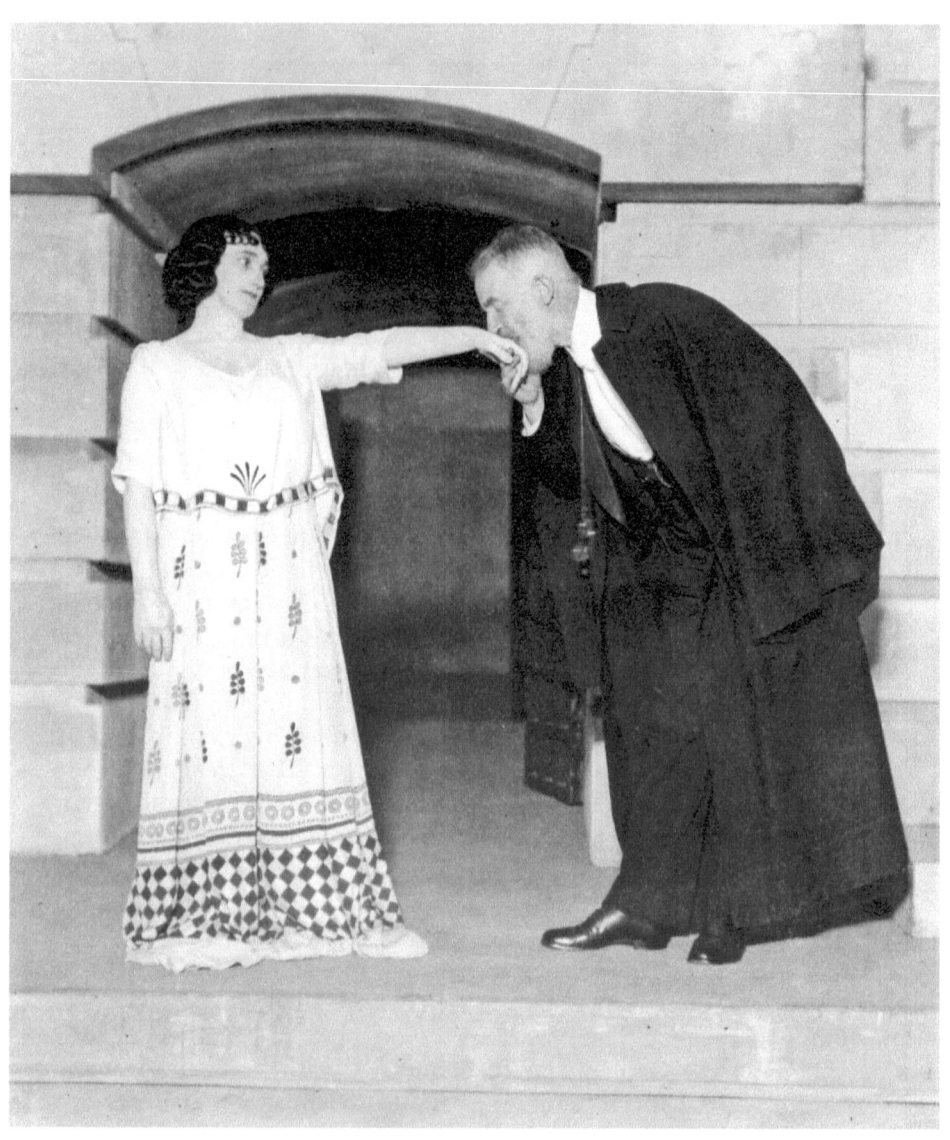

Lillah McCarthy and Bernard Shaw, publicity photograph for *Androcles and the Lion* (1913). Courtesy Bernard F. Burgunder Collection of George Bernard Shaw. Division of Rare and Manuscript Collections, Cornell University Library. Shaw wrote the role of Lavinia in this play specifically for Lillah McCarthy. Her costume shown here is on view at the Victoria and Albert Museum, London.

to produce this and more Ibsen plays. Ibsen's deviant heroine was recognized by women at matinees as emblematic of their own repressed social condition. In the Royal Court revival of 1907, Mrs. Patrick Campbell played Hedda under Granville Barker's direction.

As Chapter 4 will describe in detail, Elizabeth Robins's play was part of the groundbreaking Vedrenne-Barker seasons at the Royal Court Theatre (1904–1907) that had catapulted Bernard Shaw to the forefront of theatre on both sides of the Atlantic. These three years introduced new British dramatists and continued the work of subscription theatre societies in promoting controversial works by Ibsen and Shaw and an earlier work of Robins. People went to the Court theatre to engage with ideas and see performances by actors who cared about the ideas as well as the characters they portrayed.

It was Harley Granville-Barker who changed the name of Robins's play from *The Friend* to *Votes for Women* and used the entirety of the Court's small stage to "realize" a rally in London's Trafalgar Square as Act 2 of the play. This scene became celebrated from the moment of its premiere and was considered the best crowd scene of the era. The other name that changed by the time of the performance was the young socialite who becomes a convert to the cause after the Trafalgar Square scene. Originally named Beatrice, her name became Jean, and the play's protagonist, Vida Levering, remarks that Jean may well be the next Joan of Arc.[6] The action of the play as a whole incorporates timely references to WSPU disruption of Parliament in 1906 and the ongoing work of the women's movement to encourage women of all social classes to strive for suffrage along with labor rights.

Additionally, 1907 was the year that Harriot Blatch, daughter of Elizabeth Cady Stanton, brought open-air suffrage meetings to cities in the U.S. after spending time with the W.S.P.U.[7] Emmeline Pankhurst had brought Robins in as a leader to this most radical of suffrage organizations. Robins was the first but not the only actress to bring theatre and activism into public collaboration in the Edwardian era. As the women's movement became more radical internationally, their efforts were chronicled by the rapidly developing mass culture of the time. By 1908, partial successes notwithstanding, the refusal of Parliament to grant women's suffrage called for broader-based coalitions of activists. Actresses, who had struggled a long time to attain respectability as professionals, decided to combine their theatrical expertise onstage and as managers and formed the Actresses Franchise League. Four hundred women met at the Criterion Hotel and formulated a strategy that combined pamphlet distribution, theatrical performances (known as suffrage dramas), and platform speaking events/marches. By 1911 close to 1000 women were involved.[8]

Each layer I found led me back to one thought: the interconnectedness among the writers, theatre practitioners, and the public at large.

Ibsen's far-reaching critique of social hypocrisy, repression, and class privilege inspired the work of Fabian playwrights Shaw, Barker and Galsworthy; the emergence of New Women in more public roles became a norm, onstage and off; Medea and other Euripidean characters resurrected the strength and complexity that ancient women confronted in their personal relationships, family ties, and in response to war. All of these strands formed a nexus. The stage became the site for representing pressing social issues as well as radical solutions. What people saw onstage and heard in public speeches applied to them directly and invited them to re-shape their own individual identities and goals. The chapters that follow will show the dialogic relationship among playwrights and theatre practitioners, evolving in works they either did together or in response to one another. Considering these plays in tandem is the crux of my analysis.

Introduction: The Spectacular Turned Inward

> It is not possible to put the new woman seriously on the stage in her relation to modern society without stirring up, both on the stage and in the auditorium, the struggle to keep her in her old place.—Bernard Shaw, 1894/5[1]

A striking feature of theatrical innovation ca. 1890–1925 is its paradoxical relation to traditions of its past. The advent of modern social drama that began with Henrik Ibsen reversed 19th-century melodrama and the *pièce-bien-faite* (well-made play) by shifting plays' emphasis from plot to character. Yet it is equally true that these talkier plays continued to infuse earlier approaches to theatre of ideas into the context of new ideological stances.

The transformation of atmosphere—another form of visual spectacle as it were—showed theatre and those who performed there as more respectable. The physical landscape of stages and stage design had also figured significantly in the evolution of public connection to live performance from the late Victorian to the early 20th century. Julie Holledge cites Henry James' 1877 assessment of London theatres and audiences; James had "the impression that the theatre in England is a social luxury and not an artistic necessity." Impeccably dressed and mannered personnel sold the tickets and ushered people to their seats. As for the audience, James continued, they were "well-dressed, tranquil, motionless; it suggests domestic virtue and comfortable homes."[2]

Marie Bancroft's refurbished Prince of Wales Theatre was the site for Tom Robertson's realistic representations of domestic life and the cruelty

of the class system. Viv Gardner asserts that Bancroft, through these productions, "played her part in the gentrification and feminization of the theatre.... Paradoxically, it is the very development of a more respectable, woman-friendly theatrical space that confirms the 'private sphere' as the realm of the female within the public areas, just as the department store [had done]."[3]

For ordinary women, tableaux vivants became a potent remedy for the paucity of women in prominent public roles. This activity fostered awareness of women's achievements of the past. Inspired by the heritage of historical figures so prominent in the era, as well as the increase in women's education and burgeoning workplace opportunity for single women by this time, they could represent the intellectual and social contributions of modern women along with goddesses, queens, especially Cleopatra, and the martyred warrior Joan of Arc. The form would be used and expanded by Edy Craig in her series of tableaux vivants for her mother, Ellen Terry's, Jubilee celebration in 1906.[4] This performance would inspire the perennially popular suffrage drama *The Pageant of Great Women* by Cicely Hamilton and Christopher St. John in 1909, directed by Edy Craig.

Such a turnaround in audience acceptance and identification could not have occurred as quickly or completely had another major change not come first: the legitimization of acting as a profession—particularly for women—around the 1870s and the broadening of audiences that developed as a result. Despite the fact that actresses had been on the stage since the Restoration, the Victorian era had continued to chafe at women in public roles and spaces. The economic as well as artistic success of key actresses in the late 19th century can therefore be seen either as ironic, or an irritant that made status quo norms more vital, or a combination of these two reactions.

An essential corollary for these conflicted attitudes was the advent of the matinee in the 1870s. This shrewd business decision allowed theatre producers to take chances with plays by new and/or unknown playwrights since daytime performances would not interfere with actors/actresses and their evening performances. In London and later in the U.S., producers of the Ibsen plays and those by his followers capitalized on this new trend in theatergoing. Audiences for these matinee performances were predominately matrons and adolescent girls, who quickly learned to seek out the theatre's representation of the dangerous topics of the day: women's sexual and intellectual desire and restlessness. Audiences likewise recognized that Victorian actresses had already embodied what would become the New Woman and the ability of that socially constructed individual to take care of herself.

Grounded in the notion that theatrical works of this time were staged

in tandem, and often performed by a strongly intertwined group of actors, theater managers, and playwrights, this study examines how the apparent contradictions between past traditions and present innovations formed a nexus rather than a schism. As the following chapters will show, Shaw would include portions of the women's activist agenda in his own plays, and women theatre managers produced premieres and revivals of Shaw's plays and crafted their own works that were the true beginnings of women's theatre.

Chapter 1 focuses on the tableau vivant, from the late 18th century to the early 20th century, and also includes a brief snapshot of women's public performance from the 17th century as backdrop. The popularity of women's private theatricals, the tableaux vivants, coincided with the beginnings of the star system in Paris and London, and the women they worshipped, like Rachel Felix, portrayed depths of feelings they had been admonished not to imitate, not even in their own intimate lives. Performances by Felix and later Sarah Bernhardt emphasized great scenes as more than metaphorical for women's complex and vital inner life, framed by the social and cultural limitations women had faced for millennia. And so melodrama as these actresses represented it culminated with the heights of passions, joyful and bereft.

Melodrama's nascent beginnings as resistance to the constriction of "legitimate" houses in the London theatre price wars of the early 1800s evolved into codified dramatic structures that bespoke behavioral guidelines for spectators as well as actors by the end of the 19th century. Elaine Hadley argues that the original hybrid form of melodrama—plays with music—included pointed social commentary aimed at their less than elite audiences. The enormous technological changes also increased excitement and/or anxiety in everyday life. The speed of train travel and the beginnings of mass culture pervades Victorian literature, which, as Nina Auerbach notes, "conveys a covert fear that any activity is destructive of character because all activity smacks of acting."[5] Even more provocative is the notion Auerbach attributes to Terry Castle and other scholars: "this demonic, elusive spirit of performance—with its potentially infinite denials of the ontological fixities that codify culture—is female by definition."[6]

Because people enjoyed quick-paced action, melodrama fused elements of Gothic fiction's heightened visualizations and emotional extremes to invite audiences to feel they were participants in the plot unfolding.[7] As Peter Brooks explains, "Melodrama ... [was] less a genre than an imaginative mode ... a coherent mode of imagining and representing ... [it] is an inescapable dimension of modern consciousness."[8] As the examination of private inner longings and temptations became a prominent part of the *pièce-bien-faite* as it was in the great novels of the period, sexuality came

to the stage, but in melodrama, women who gave into sexual *liaisons* remained "fallen," and thereby doomed to defeat and/or death.

Great actresses continued to explore the exteriorities and boundaries of gender. In the 1860s, Sarah Bernhardt launched her international reputation by playing eighteen breeches parts. The curator notes for the 2005–06 Jewish Museum exhibit about Bernhardt remarks that her "exaggerated femininity gave her male impersonations a special piquancy"; Bernhardt herself felt that male roles were more "stimulating" and an actress is better suited to play parts of young men because "woman more readily looks the part, yet has the maturity of mind to grasp it."[9] Bernhardt's insight was two-fold; women's bodies in young men's roles would more easily carry the illusion of youth next to male actors, and also be able to use their experience as women in a male-dominated society to show young men understanding and assuming the power they would have.

If we consider two pinnacle French works on the 19th-century stage, *Phèdre* (1677), Racine's version of Euripides' *Hippolytus* and influenced by Seneca's version, and Alexandre Dumas fils' *Camille* (*La Dame aux Camélias*, 1852), distinct effects emerge. Racine's neo-classical work shifts the center of the tragedy to Phèdre. While Racine blamed her, the 19th-century *mise-en-scène* focused upon the woman who went beyond silence; she told her story as well as showed her torment, with candor and strength as well as pain. Both Rachel Felix and Sarah Bernhardt won acclaim in this role. In Dumas' play, he infuses the familiar situation of a son's entanglement with a courtesan and a father putting a stop to it by inducing the woman to break off the relationship. Marguerite (the Camille character) also represents another key cultural phenomenon: tuberculosis. Sarah Bernhardt managed to die beautifully and differently every night she performed this role.[10]

Bernhardt's renowned physicality was equally adept at masculine stances/posturing as to a sensual, inward feminine portrayal, something that amazed her audiences. Despite her "unfashionable" androgynous body, Bernhardt was every inch a woman. Sigmund Freud saw her in *Theodora* in Paris in 1884. He dismissed the merits of the play, but permanently adored Sarah Bernhardt and kept her photo in his office. "After the first words uttered in an intimate, endearing voice, I felt I had known her all my life. I have never seen an actress who surprised me so little; I at once believed everything about her."[11]

Lillie Langtry, who would be mentored and befriended by Bernhardt, described Sarah Bernhardt's first London appearance in 1879 in the role of Phèdre, saying the actress was "so striking, so singular that, to everyday people, she seemed eccentric. She filled the imagination as a great poet

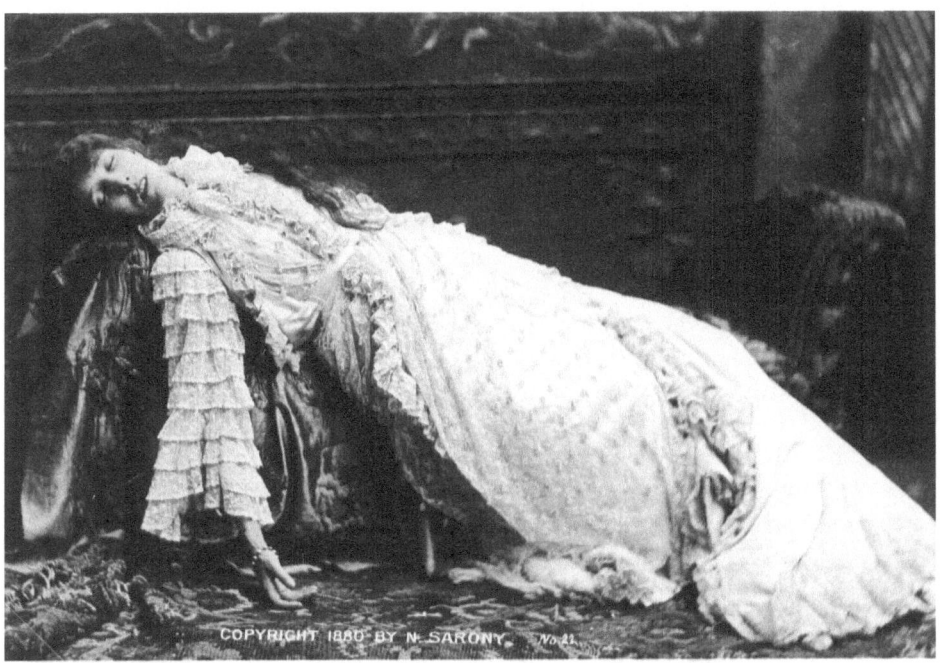

Sarah Bernhardt, death scene in *La Dame aux Camélias* by Alexandre Dumas. Photograph by Sarony. Courtesy of Philip H. Ward Collection of Theatrical Images, Kislak Center for Special Collections, Rare Books and Manuscripts, University of Pennsylvania Libraries. Bernhardt was said to die a little differently with each performance of Marguerite's death.

might do.... This great and overwhelming artist was almost too individual, too exotic, to be completely understood or properly estimated *all at once*."[12] Bernhardt's portrayal of the tragic queen had such verisimilitude that audiences felt every moment of anguish, especially since the actress's stage fright had caused her to begin her key scene at a pitch and tone that was far too high, but Bernhardt gave the audience full access to it all, recognizing even as she performed that it was "real": her own experience and the character's merged, with an immediacy heretofore unknown.[13]

Mentored by Sarah Bernhardt, Lillie Langtry set up international performing tours in the late 19th and early 20th centuries. Ellen Terry, who also befriended Bernhardt, had managed the Lyceum Theatre with Henry Irving from the 1880s until his death in 1902. Ellen Terry's lectures on Shakespeare's women given in England, Australia, and New York from 1911 to 1921 argued eloquently that the Bard gave us many protofeminist characters; she asserted that the women's movement did, in large measure, begin in the 15th century.[14]

Terry was also involved her daughter, Edy Craig's, Pioneer Players.

Edy began a political theatre that grew out of the Actresses Franchise League work. Terry's interpretations of Shakespearean women onstage invited audiences "in" the way her daughter's generation of playwrights and actors would; the lecture/performances she would give about these characters at the end of her career reveal the depth of her intellectual, emotional, and psychological intelligence, which adds another layer to public understanding of the actor's art. Terry's ability to go from the traditional gendered roles Henry Irving assigned her in the Lyceum Theatre to her wholehearted participation in evolving women's theatre of ideas in the Edwardian era would serve as a model as well as mirror for women of multiple generations who came to see their own lives and choices embodied by this actress/activist/mother.

Staging change began with the revolution of Ibsen. Chapter 2 traces immediate reception to Ibsen's plays, by critics and audiences, and plays by Oscar Wilde and Bernard Shaw that echo or respond to *A Doll House* in particular. Bernard Shaw saw the London premiere of Henrik Ibsen's *A Doll House* in 1889 starring Janet Achurch; the actress and future activist Elizabeth Robins was also in the audience.[15] Each of them recognized the immediate and permanent impact of the play on private and public conceptions of domesticity because Ibsen exposed what lay under the surface of conversations. The play galvanized the push for suffrage and full citizenship for women that was ongoing behind the scenes of government into undeniable, international public view. While the powerful chafed at this indubitable challenge to convention and authority, those who needed change were only too happy to see it staged.

Ibsen's multi-pronged challenges to society's norms of gender, social class, and conformity combined a Romantic sensibility and the realistic representation of deviant behavior in response to repression. Ibsen's chosen issues—syphilis, sexual harassment, and the ramifications of psychological as well as moral denial on public as well as personal planes—repelled but engrossed audiences. These themes were not comfortably about "other people"; rather, spectators could not help but find themselves and those they knew in the unfolding living room drama of the realistic theatre's box set. Yet it was not the emotions that shocked the viewers. Nineteenth-century acting had showcased intense private moments, but these belonged to characters of the past—in works by Shakespeare or Racine—and therefore did not impinge on audiences' everyday lives.

Chapter 3 surveys the transition in theatre in the 1890s. Fiction writer and essayist Sarah Grand coined the phrase the New Woman in an 1894 essay: one who was no longer bound by the dependent roles reinforced in melodrama; on the contrary, she became determined to fulfill her own

ambitions. Oscar Wilde's plays sought to undermine the foundations of Victorian smugness and social stasis by representing the surface of their world and then allowing individual characters, especially young women, to undermine or disregard convention and standards.

The mutual influences between Bernard Shaw and the women actresses, writers, and activists who worked with him became multi-layered. Because these actresses had a profession that gave them economic independence, they would be lampooned in periodicals like *Punch* and in Sidney Grundy's play *The New Woman* (1894). Grundy argued ultimately that what women really needed was marriage and stability: the staples of the well-made play formula. This play's strategy for acknowledging the woman question and the anxiety over blurring gender lines and roles was to counter the idea of new women with its inverse: that women's ideas and behavior were as old as Eve, as one woman says to another in Act 3. Grundy's nod to the idea of regenerating men, derived from Sarah Grand's 1894 essay, was merely satiric.[16]

Despite the resistance to the implications of this construct for domestic relations and the workforce, the term spread like wildfire, and the gauntlet had been thrown. New representations of gender onstage needed to influence public and private behavior to break down the barriers that seemed impervious to change. It was all right to retain some of the familiar plot structures to introduce inverted outcomes because this strategy helped reverse the most important melodramatic principle: the succession of events had to give way to the psycho-social examination of individuals struggling to shape an emerging future with no absolute parameters.

The cultural phenomenon that spawned the theatre of ideas in the Edwardian period also sprang directly from an ever-increasing cosmopolitanism and an ever-widening use of the matinee to introduce new playwrights as well as re-interpretations of classic texts. In structure and/or appearance, the spin on form and staging challenged long-established norms. The 19th-century fascination with stage pictures evolved into a multi-sensory journey for audiences. Their love of the visual expanded from the love of the strange to include appreciation of the embodied everyday scene and began to incorporate the language, ideas, and experience of onstage characters into their own future lives. In the intimate theatre venues they were at the edge of their seats to catch every word, rather than merely be dazzled by the spectacle of what they saw as a series of heightened moments. The question to ponder is how could this paradoxical blend of new and old catch the attention of so many?

Chapter 4 zeroes in on the Royal Court Theatre seasons, 1904–07,

that launched the plays of Shaw, Galsworthy, Barker, Robins, and modern interpretations of Euripides. Shaw and his circle wrote plays whose individuals showed real-life choices already available to women. Before he became known as a playwright, Shaw had made an enormous contribution to the evolution of British theatre through his perspicacity and popularity as theatre critic. Shaw's reviews revealed his astonishing ability to capture the experience of a specific performance to signal the change he attempted to instill in audiences.[17]

In his confrontation with gender stereotypes onstage, Shaw gave matronly as well as young women fully developed, complex characters. According to Gay Gibson Cima, Shaw admired the work of the younger actresses onstage because they were "products of the modern movement for the higher education of women, [they were] literate, in touch with advanced thought, [and came] by natural predilection [to] the stage from outside the theatrical class."[18] The Court seasons saw premieres of several works by Shaw, Granville Barker, Elizabeth Robins, John Galsworthy and Gilbert Murray's versions of Euripides, staging *Hippolytus, The Trojan Women, and Electra* in the three seasons. In 1907, Edyth Olive starred as *Medea* in the Savoy. Edith Hall's article about Medea in connection to evolving attitudes regarding women's rights, motherhood, domestic violence, and legal statues traces the interpretations of translators and actresses in Victorian and Edwardian times. Medea is used to enact legislation on key women's issues. Hall notes the timeliness of the 1907 production in connection to the WSPU (Women's Social and Political Union) and its increasingly confrontational strategies that began the years of suffragettes going to prison for their cause. Further, Gilbert Murray believed Euripides to be especially modern.[19]

Edwardian plays of ideas brought the political platform into the private lives that unfolded onstage and across continents. Chapters 5 and 6 are concerned with the political events that led to the establishment of the Actresses Franchise League and the suffrage drama that developed on both sides of the Atlantic before the First World War. The push and pull of Parliament's jostling with the suffrage amendment throughout the late Victorian era fomented the radicalization of women, including actresses. Merging the arts and activism on behalf of full citizenship for women, they first came together on a single afternoon and created a plan of action.

Further, the new theatre confronted social issues in increasingly direct ways. The younger playwrights expanded the social critique that Robertson began by challenging the very basis of domesticity, especially for women. Chapter 6, a survey of suffrage dramas, will show the combination of political and dramatic strategies. Key dramatists for the Actresses Fran-

chise League included Cicely Hamilton, Christopher St. John, Gertrude Jennings, Gertrude Vaughan, and Alice Chapin. Actresses performing for the League suffrage works and other new works by women included Ellen Terry, Gertrude Kingston, Gertrude Elliot, Edyth Olive, Dorothy Minto, Lillah McCarthy, Beatrice Forbes-Robertson, Sybil Thorndike, and Mrs. Patrick Campbell.

Chapter 7 glimpses at the transatlantic little theatres and the development of activist as well as artistic directions for the early 20th century. In tragic and comic plays, actual lived experience was the emphasis. In these, women took action on their own behalf instead of solely reacting to decisions made by the men in their lives. Further, these theatrical representations defied another crucial boundary: the unspoken but dominant distinction between private and public life. Theatre groups on both sides of the Atlantic aimed to make a people's theatre staged in smaller spaces that veered away from grand spectacle and the more clearly demarcated "fourth wall" separation between performers and audience. Coupled with the shift from plays of fixed character types connected to sexual status and social class to portrayals of ordinary working and middle-class women came an ambiguity surrounding the mimetic function of theatre because who and what was on stage was in flux. In addition to works by Shaw, Barker, and Robins, new women playwrights included Elizabeth Baker, Rachel Crothers, and Githa Sowerby.

Chapter 8 completes the study and moves works from the First World War to the mid–1920s: once again in transatlantic fashion. Assessing the network of theatrical and political changes that had been wrought, and the groundwork for those who would follow, draws the study to its conclusion. Two plays that responded to the First World War are at the heart of the chapter: Edna St. Vincent Millay's *Aria da Capo* (1919) and Shaw's *Heartbreak House* (New York world premiere 1920). I return to Shaw's *St. Joan* (1923 in Berlin and New York and 1924 in London) for the study's conclusion. In a sense, this masterpiece by Shaw both answers and sets in motion the paradox of past and present traditions onstage.

If Victorian dramatists and painters worked in a complementary manner, modern dramatists began to work like novelists: depicting the ordinary as something that mattered greatly, and yet blended into the fabric of real time. Virginia Woolf's 1938 essay "A Sketch of the Past," part of her posthumous memoir *Moments of Being*, encapsulates the phenomenon perfectly. Woolf recognizes that most of our daily life seems to float by us without our true attention; she terms this as "non-being ... nondescript cotton wool." She asserts that "a great part of every day is not lived consciously. One walks, eats, sees things, deals with what has to be done."

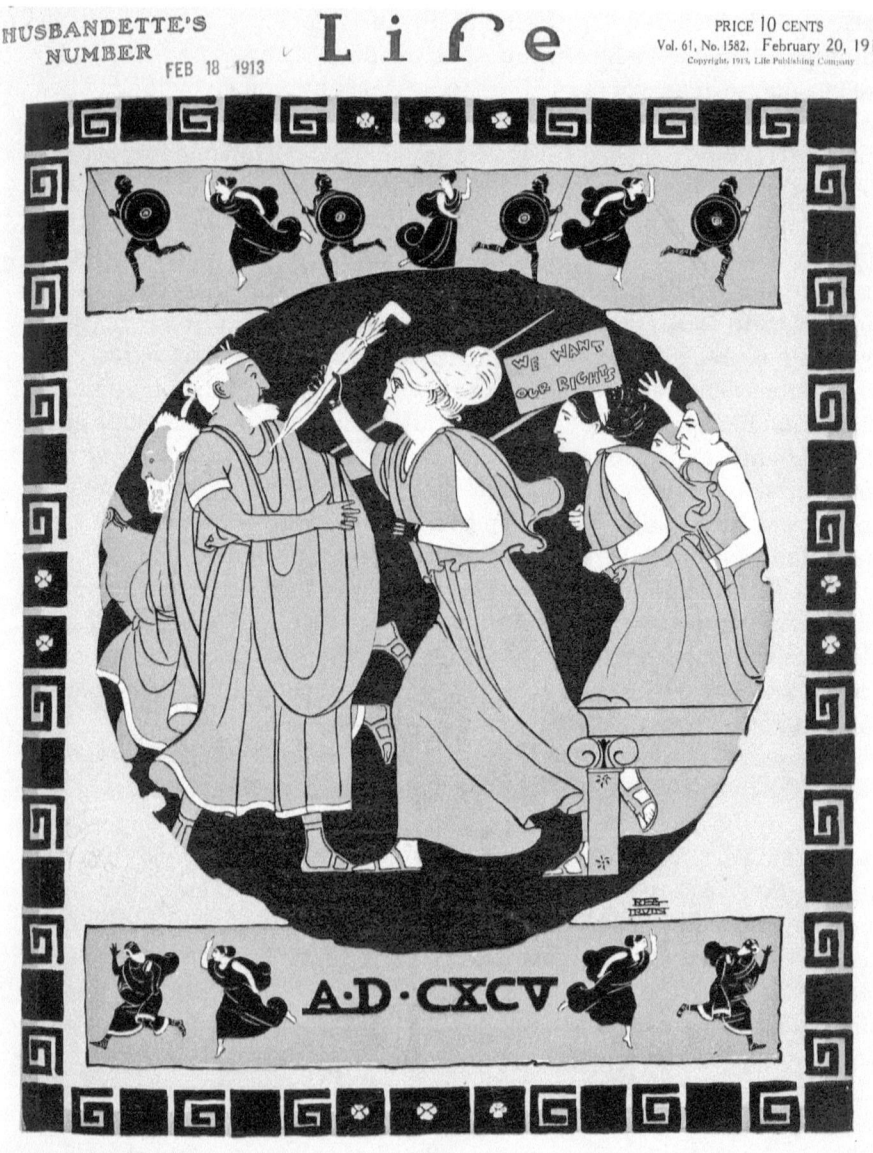

"Ancient History," Husbandette's Number, *Life*, February 1913. Library of Congress. By 1913, the touring productions of Euripides's plays adapted by Gilbert Murray and Aristophanes's *Lysistrata*, the one pictured here, had taken audiences by storm on both sides of the Atlantic. More importantly, the characters from the ancient Greek plays had been inserted into the push for women's rights.

Woolf pinpoints our focus on "what is exceptional"; these are the moments of being that her title names. Yet Woolf understands that what we don't remember matters perhaps even more than what we deem as important, and so to fully tell the story of anyone's life, even our own, we must reconnect to what lies beneath the surface of memory. She offers us a brilliant, concrete metaphor to go about finding traces of strong emotion: "I shall fit a plug into the wall; and listen in on the past."[20] Although Woolf's focus is on the internal mapping of life's meaning, what she describes as moments of being and even non-being are the visible actions taken onstage. Her description illuminates the power of dramatic structure—from exposition to setting, costume, and props—as well as to the speeches characters deliver to bring inner life out into the open, and vice-versa.

As audience members we focus on the big moments when watching a play just as we do in our own lives, but it is also true that we notice the "non-being" onstage because we have yet to determine where and when the "moments of being" in the play will come. Perhaps this explains the pleasure of dramatic irony; as spectators we can perceive more than the individual characters can because we are privy to more information than they are. Therefore, these momentous occasions within realistic drama represent life as it is actually lived, allowing the audience to participate as much as the actors onstage.

Clearly, the increased complexity of characterization in these new directions in drama required audiences to participate more in meaning making than in plot prediction. What will happen next? involved more than playwrights' manipulation of incidents and actors' body language. Without the formality of melodrama's semiotic markers, people began to see characters, rather than larger-than-life performers, work through conflicts. For the audience, this was more like reading a novel than watching a play, without the solitude and privacy. What must have seemed jarring to them was the theatrical outer expression of a novelistic interior monologue.

Spectators were used to eavesdropping as a convention of drama, but the characters in these realistic plays were facing situations the audience had likely encountered themselves. The speed of the well-made plays of intrigue—their tendency toward constantly interrupted conversation—had diverted audiences' attention. Conversely and ironically, the newer plays stretched time in a manner completely opposite to that of the tableau freeze. Problem play texts capture precisely what angst looked like and felt like: not for queens and kings but for people no stranger than ourselves. Theatergoers raised on Shakespearean soliloquy already appreciated the illusion of "one-on-one" time with an actor, but these plays seemed

to include whole scenes of this intensity. Audiences were forced to share their private soul-searching among strangers, something they were learning to do when riding trains or venturing into large department stores. The spectacular moved inward, as characters made decisions that flew in the face of moral and social convention, either disturbing or amazing audience members, but nonetheless serving as spurs for them to examine their own life choices.

1

Getting Past the Tableaux

> Visual amazement is the heart of the scene. Living pictures were the source of Victorian theatrical excitement ... the moment of sight is the moment of revelation.... To be was to be seen.—Nina Auerbach, *Private Theatricals*[1]

In the late 18th century, the French playwright Denis Diderot championed a pictorial theatre, one to, according to Neil Flax, "exploit the artistic effects of painting, that 'would offer to the spectator as many actual pictures [*tableaux reels*] as there are moments in the action favorable to the painter.'"[2] Diderot felt these tableaux should emerge spontaneously from within the text, thereby giving the emotional credibility found in the best visual art to theatrical performance. The enormous impact of Diderot's concepts not only dominated onstage productions, but can be viewed also as a forerunner to narrative storytelling in film. From momentary "living pictures" to melodramatic structures emphasizing heightened emotional moments, the viewer/audience member became attuned to reading visual cues as the basis of understanding the situations characters faced. Needless to say, such emphasis required generalized, universal emotional responses. These in turn would reinforce social class and gender positions.

One form of theatre or popular entertainment that emerged by the 1780s became known as "attitudes," also known tableaux vivants, living pictures. Johann Wolfgang von Goethe saw Emma Hamilton's attitudes, and went on to incorporate tableaux vivants performed in the home in his 1809 novel, *Die Wahlverwandstchafen* (*Elective Affinities*). From the outset, these became the province of women's performance. Goethe's importance as a writer and cultural mediator of his day is obvious here,

as his choice of setting for the performance almost immediately relegated tableaux vivants to the lower art form of domestic entertainment. According to Peter M. McIsaac, these scenes in the novel enabled Goethe to "probe not only a fascinating range of issues having to do with female bodies and emotions, including tableaux vivants' role in socializing young women, but also Goethe's own beliefs about women and their place in society." Goethe's attempt to lessen the status of this art form also stemmed from his own dismissal of the women writers of his time and their use of similar scenes in their fiction. Yet Goethe did appreciate the ability of women to become living pictures from the perspective of the male gaze. What he could not predict was the appropriation of this art form as both private and public affirmation of women's historical achievements as well as limitations by middle- and upper-class women in Europe and in the United States. McIsaac goes on to say that it did not take long for the performers of the genre to create their own scenes in addition to the original conception of imitating existing artwork.[3]

McIsaac contends that this coincided with the high/low cultural divide that emerged around 1800. Goethe and Schiller felt that women writers and readers alike were "dilettantes," "incapable of distinguishing between the work of art and its emotional effects."[4] Such an assessment is in direct contrast to Diderot's precepts, and the continual success of the genre would prove the assumptions hollow. Stéphane Michaud emphasizes the primacy of the designation of "woman" during the French Revolution as "deity of the domestic temple." Michaud perceives representations of "woman" in 19th-century visual art as the continuation of an abstraction. He terms it as a "kind of force that vanquished ideology and removed woman from the realm of fact. Although contemporaries forthrightly insisted that it was Nature, we cannot take them at their word. No, it was the force of the *image*. The women in these representations are *imaginary*. For the nineteenth century, woman was an idol."[5]

In other words, the proliferation of references to sculptural qualities in women reflected the determination of the male gaze to freeze actual women into beautiful stasis, or encourage their live counterparts to regard statues or idols as ideals for themselves.

Nineteenth-century ballet contributed greatly to this. Ironically, Romantic ballet revolved around woman, the prima ballerina, yet often her role involved fanciful spectacle rather than individualized character: "Supernatural female creatures such as sylphs ... water nymphs and later swans, enjoyed great popularity. They appealed to the contemporary taste for idealized, fantasized womanhood and gave an opportunity for abstract choreography for the corps de ballet."[6] The word statuesque came into

English, and the ballerina, graceful, expressive, and demure, was its epitome. The bodies were in motion, and their physical strength unmistakable, and yet they floated by like angels or fairies, so their characters were frozen in gendered norms or mythology.

The supremacy of sculpture and the impact of women as statues was enormous for this era, according to Gail Marshall. The cool (chaste) body and the stasis of the body and, of course, the silenced voice emblematized womanly virtue. Marshall provides an insightful premise about the multilayered semiotics of this cultural moment. It shows us "something of the dimensions and implications both of the use of Victorian statuary's celebration of the female form, and of writers' application of the sculptural metaphor ... sculpture is a way of achieving, rather than simply commemorating, the association of timeless ideals with women."[7]

The common shift, one far more fundamental than particulars of any era, contributed to this evolution: eliminating the prohibition of women on legitimate theatre stages in the 17th century, first in France and then in England. Women's performance in court masques—similar in size and scope to the tradition of private theatricals that continued into the 20th century—had laid the groundwork for this. First, Anne of Denmark, James I's queen, was a patron and participant in masques for ten years. She worked closely with Ben Jonson, as noted by Julie Sanders. Jonson credits the Queen with devising the foil or anti-masque of *The Masque of Queens* (1609), for which the playwright "devised that twelve women in the habit of hags or witches should fill that part."[8] Sanders' argument is that the "contribution of Anne and her court women to the masque, although a potent symbolic act intended to be read and construed by fellow courtiers, was a silent one." Charles I, her son, married a French woman, Henrietta Maria, who was even more daring, especially in light of Puritan condemnation: she "shifted the parameters of female performance in the late 1620s when, importing French courtly conventions to Whitehall, she spoke as well as danced in court drama and when, in several of these dramatic entertainments, her ladies-in waiting performed male as well as female roles."[9]

On the verge of King Charles II's edict to have women play the women's parts in England, Samuel Pepys, a spectator and not a theatrical figure, noted in his diary from 18 August 1660 that he saw "one Kinaston, a boy, acted the Duke's sister, but made the loveliest lady that ever I saw in my life."[10] Jeffrey Hatcher's play, *Compleat Female Stage Beauty*, includes a conversation between him and his female dresser, Maria, who wants to act. Kynaston explains to her that his tutor taught him to concentrate on the inner/outer connection. Then he reveals the real emphasis of Restoration style: outer behaviors and gestures when he muses: "A woman playing

a woman; what's the trick in that?"[11] By the 18th century, Shakespeare's double jokes of boys playing women who got out of women's clothes to travel as men in disguise became, instead, women putting on the guise of a man, with a woman's consciousness underneath.

Kynaston and the first actress, Mrs. Margaret Hughes[12] both play Desdemona until men are no longer allowed to portray women on London stages. Later on, Kynaston plays Othello to her Desdemona; the death scene was so real that the audience almost believed she was dead. Kynaston's wrenching experience of re-learning posturing, gesturing and speaking as a man and not a woman must have astonished as well as captivated the audience when impression of Kynaston as Othello: "To the theater to see the actor Kynaston. He had good fortune to appear in many guises, and by the end was surely the handsomest man in the house."[13]

Desdemona, who begins the play as a confident woman who can handle her "divided duty" between father and husband and make her own decisions, becomes the weak, pleading wife, slapped in public, and then smothered—her voice as well as life snatched away—is one of the key iconographic representations of the danger of women speaking out, no matter in which century the play is staged.

In her lecture on Shakespeare's "Pathetic Women" given in theaters in the U.S., Britain and Australia between 1910 and 1921, Ellen Terry provides a feminist appreciation for Shakespeare's creation. Terry contends that this role is often misunderstood by those who see: "Desdemona [as] a ninny, a pathetic figure" and who think

> an actress of the dolly type, a pretty young thing with a vapid innocent expression, is well suited to the part. I shall perhaps surprise you by telling you that a great tragic actress, with a strong personality and a strong method, is far better suited to it, for Desdemona is strong, not weak ... by nature she is unconventional.... She is not prim or demure ... [but]expressive, the kind of woman who being devoid of coquetry behaves as she feels.... The pertinacity with which she begs Othello to reinstate Cassio does not strike me as evidence that she is a rather foolish woman.... Her purity of heart and her charity ... are sufficient explanation of her being slow to grasp the situation [until]she has been grossly insulted and brutally assaulted.... Her behavior from that dreadful moment should surely convince us that she is not a simpleton, but a saint.[14]

Terry's encapsulization of Desdemona's lack of pretense serves to solidify our awareness of the way we all watch our own behavior. Early in the 19th century, Jane Austen used her knowledge and love of theatrical performance to infuse her novels with the unmistakable impression that people were conscious of creating their own performance of daily routine. Austen embodied the inner lives of her protagonists and the gendered

perceptions of their potential roles in their world. Austen's women are totally conscious of the performative roles these barriers have thrust upon them. The old stereotypes about women's duplicity and manipulation are shown as appearance-saving behaviors and language, used by women to avoid confrontations.

Women's "work" (handiwork) may have kept them seated in appropriate postures in the parlor, but their minds and emotions were elsewhere. Jane Austen's manuscripts lay under her embroidery, an option she knew was not open to others. Characters like Anne Elliot in *Persuasion* (1818) had silenced their own rebellion. Anne's own youthful compliance with authority caused her to refuse the proposal of Frederick Wentworth eight years before the novel opens, on the grounds that he had "only himself to recommend him."[15] This "exposition" comes to the fore in the novel's opening chapters. Anne learns that his sister will be leasing her family's home, Kellynch Hall, due to her father's fiscal irresponsibility, and Frederick will be returning to the area to visit. Anne's visible "start" at hearing this news is understood by her sister but not by her father, who apparently has forgotten all about Wentworth. Austen makes it clear that Anne has faded into the background since this disappointment, but the re-emergence of Frederick Wentworth and his family into her narrow world prompts her to "rising action," as Anne confronts Lady Russell about the persuasion that had created her emotional as well as physical stasis.

When Anne and Wentworth first meet again the atmosphere is tense and his attitude harsh. Yet when her nephew is hurt and Anne carries the child on her back, it is Frederick who removes him, allowing Anne to be free of the statue-like posture. Late in the novel, in conversation with Captain Harville, Anne attributes women's struggle with emotions to lack of vocation and their "living quietly at home, confined." In her argument that women love longer than men, Anne refutes the evidence from books, reminding him that men "had all the advantage of telling their own story" and women love even "after all hope is gone." Wentworth overhears this and dashes off a letter for Anne: one that will release them from the past and give them their chance at lifetime happiness. The letter concludes by saying he will know whether or not to propose again by "one look" she will give him upon his return.[16]

This scene could be from a comedy of intrigue from the 18th century and would be the climax. The wit of the dialogue, the visual cues—Frederick dropping his pen, leaving his gloves—and the reliance on body language make it easy to imagine. The reliance on dialogue and minimal use of description, which is comparable to stage directions for actors, shows Austen's connection to the theater. And yet we cannot ignore Austen's

real subversion of the traditional sexual politics that lead to a somewhat "expected" happy ending for Anne and Wentworth. She had lost him when she gave in to authority at nineteen; he loved her mind, her rational capabilities, and her frankness: none of which belong to a fan-waving coquette of Restoration comedy.

Paula Byrne's *Jane Austen and the Theatre* provides a fully realized construct of the theatre as influence and delight for Jane Austen in her life and works.[17] In her introduction, Byrne cites the opinion of George Henry Lewes, the influential editor and common-law husband of George Eliot, who compared Austen's style and contribution to English literature to Shakespeare's. In his 1859 *Blackwood's Magazine* article about her novels, Lewes designated Austen as "the Prose Shakespeare." He zeroed in on her "*dramatic presentation*: instead of telling us what her characters are, and what they feel, she presents the people and they reveal themselves."[18]

Lewes' criticism reflects Austen's incorporation of dramatic structure into her innovative narrative storytelling. In conjunction with her renowned narrative irony, Austen managed to critique society's snobbery and gender constraints with remarkable subtlety. On the surface, her novels are comedies of manners—like the Restoration comedies—and focused on young women and marriages. While many consider these subjects "conservative," the range of choices for middle and upper class women ca. 1810 revolved around little else. What her domestic scenes accomplished was the inverse of pictorial theatre realizations; the novels' heroines are so individualized that the frame around them—the idealized, subservient, woman—cannot contain them.

Austen's captivation by theatre was hardly unusual, but her attending theatrical productions, in addition to enjoying private theatricals, did set her apart from upper-class society's disdain for theatre. Austen rebuts this attitude in *Persuasion* by illustrating Anne Elliot's character as superior: she believes "good company" has less to do with social position than to the open-mindedness one attains by attending the theatre, concerts, and lectures available to them in Bath. The concert scene that occurs the evening before the resolution of Anne and Wentworth's conflict, discussed above, shows Anne's ability to hear and simultaneously translate Italian lyrics and appreciate the beauty of the music: skills that truly impress us and make us recognize that Anne's actions reflect her words.

Austen already was ahead of her time with the in-depth psychological and social perspective; what brings her further forward—in line with representations of the New Woman in fiction and drama in the modern period—is her inclusion of Wentworth's self reflection on his own inner landscape, and conclusion that he had not come to know himself until he

recognized the stifled anger at her refusal in the past, moved past it, and could see her as a full human being. Because of their self-education, Anne and Frederick can be partners. Neither will be property of the other. Austen's re-envisioning of gender roles through interior monologue would not be examined onstage in a thorough and realistic manner until the new drama hit the boards.[19]

The dynamic inner lives Jane Austen gave to her ordinary heroines would begin to be embodied in the theatre when the great French star, Rachel Felix, came onstage a generation later. One of the first truly international performers, she earned acclaim in Paris, became a favorite of Victoria and Albert in London, and captivated audiences in St. Petersburg, and in the United States. Her fame in the 1840s and 1850s coincided with the 1848 revolutions and the coming of the realistic novel. Rachel enthralled audiences because her waif-like frame conveyed huge emotions in classically controlled style, particularly the depths of suffering. Her acting style inverted declamation to convey a more natural unfolding of experience. Her representation of Corneille's *Camille* (Horace, 1640) revolutionized what had been decorous acting style in conjunction with the stiff formality of the playwright's style. Rachel Brownstein's biography of her, *Tragic Muse* (1995) places Rachel Felix's impoverished upbringing at the center of the actresses' development, as this gave her a way to imprint the lived experience of an outsider into her perfectly-executed delivery of the lines. Brownstein remarks: "If the elevated persons she played were on the one hand palpably discrepant with the very young, pale, and plain-faced girl, on the other they fit her like a second skin, or a life-mask … she played a real aspect of herself now, as Camille, the Roman maiden who bravely defends her high ideal of personal integrity."[20]

When Rachel performed this role in St. Petersburg in 1853–54, the Russian critic, Pavel Vasil'evich Annenkov, witnessed Rachel's innovative interpretation of Camille's reaction to hearing of her lover's death from her brother. The former representation emphasized the madness caused by this loss and made Camille pathetic, according to Brownstein, who characterizes Rachel's as "a threatening, avenging fury…. Camille grows from a wounded, angry young woman to a prophet of disaster and finally a monster of destructive, ambitious egotism." Brownstein quotes Annenkov's critique. He found the whole scene "practically unendurable…. It is impossible to differentiate the couplets, feelings, nuances in her and present their significance out of context; everything originates in and flows with the fiery rush of passions which tears to pieces all moral barriers and pours forth as a hideous phenomenon of the human soul."[21]

Rachel's public *personae* were equally compelling. She became the

living symbol of the "Marianne," the recognizable image in paintings and stamps, and the epitome of loyalty and reserve for French women. Such recognition could have stemmed from her performance style, especially in classical roles, judging from Brownstein's commentary: "everyone compared Rachel to a marble statue—because of her pallor ... because of the confident quiet majesty with which she stalked onto a stage and stood still for a moment before she spoke; because her eloquent rare gestures were restrained, and of course because the trope was current."[22] In 1848 Rachel portrayed *La Marsellaise* onstage and was immortalized in sculpture and on sheet music as the Revolution's icon. Her stance on the political and embodiment on the stage made her, in Brownstein's words, "an idea incarnate, her speech-act not merely affirming but making historical reality, and identifying her with the nation."[23] Despite the pleasure in visual spectacle, audiences became used to witnessing something more. The best actors and actresses of the 19th century brought psychological depths never seen before, inviting audiences to plumb their own emotional landscapes, and displaying what was seldom shared openly, even with family members.

The influence of the great actresses permeated society through the other "dangerous" mode: the novel. Rachel Felix became a model for the actress as character in fiction. Brownstein's analysis of Charlotte Bronte's portrayal of Rachel in *Villette* emphasizes the response of her repressed heroine, Lucy Snowe, to watching Vashti (the Rachel character) represent her innermost passions. Not only does Lucy recognize the genius in the acting, but also its shattering of her own separation of her identity into inner and outer. As Brownstein puts it, "there is a single contradictory one [Lucy], which the actress thrills, transfixes, enthralls, enchains and animates."[24]

Bronte's own reaction to Rachel's performance is infused into Lucy's, but Brownstein includes more from Bronte herself; to Elizabeth Gaskell, she wrote: "I shall *never* forget her—She will come to me in sleepless nights again and yet again." And to a man whose romantic affections she had turned down: "It is scarcely human nature that she shows you; it is something wilder and worse; the feelings and fury of a fiend." A similar impression came from Hans Christian Andersen, commenting on Rachel's performance in *Phèdre*: "'You get ice-cold shivers down your back, as if you were watching a sleepwalker who expressed your hidden, deepest feelings.'"[25]

The recollection of Charlotte Bronte and Hans Christian Andersen to the intimacy both expressed by Rachel as character and re-produced within them is more than intriguing; it shows us how personal the the-

atrical experience had become. Each writer's emphasis on privacy and vulnerability reflects the novelty of the experience and its disruption of the heretofore-undisturbed boundary between private and public in such a setting.

Popularity of updated classical plays corresponded to the museums' placement of ancient sculptures and objects of ordinary life from Greece, Rome, and Asia. The turns to the past were distinct from the Neo-Classical focus on replicating the rules as well as look of classical art. Martin Meisel contends that in the mid–19th century, the focus of painting and drama shared a "narrative language.... In both, emotion became typified character and was subordinated to situation."[26] Such emphasis in drama was clearly classical/neo-Classical, but its overarching achievements were visual, or "realizations." Meisel continues his analysis by noting the truly unusual feature: stasis. The dramaturgy of the era focused on individual, pictorial moments that eclipse viewers' attention: "Each picture, dissolving, leads not into consequent activity, but to a new infusion and distribution of elements from which a new picture will be assembled or resolved. The form is serial discontinuity, like that of the magic lantern."[27]

While theatrical form, especially melodrama, latched onto the pictorial, painters focused on storytelling. The 19th-century uses of the past were aligned more with the relative simplicity of ordinary life they imagined existed before the Industrial Revolution. Britain's Pre-Raphaelite painters, especially Holman and early Millais, "embraced a realism that ostentatiously abjured painterly contrivances for effect ... [instead] inventing story situations ... as if they were novelists and playwrights."[28] These painters returned to medieval style of composition; their dreamy female figures, whether nymph-like or Shakespeare's Ophelia, evoke this leisurely pace at a time when Victorian women were chafing at their confinement. Actresses like Ellen Terry began to dress like the figures in these paintings, both onstage and off. Perhaps it is not ironic, then that these paintings helped rid western women of tight lacing in favor of diaphanous gowns that allowed freer movement.[29]

One of the key trends in late 19th-century London theatre was to have actresses as statues onstage, costumed in the flowing robes of ancient Greece and Rome, and often in a work evoking Ovid's Pygmalion and Galatea myth, or in productions of Shakespeare's *A Winter's Tale,* in which Hermione's second metamorphosis- from statue to woman—happens so she can bless her daughter. Marshall references the pivotal work of Mrs. Jameson in 1832 about Shakespeare's heroines; Jameson lauds Hermione's noble silence and wonders if her return to life spoils the impact of the pathos of her seemingly permanent stasis and suffering. Marshall notes the fre-

quency of this play's production and this particular scene's function as "not only a moment of psychological, but also of spectacular, interest"; it was also a favorite for the tableaux vivants.[30]

The onstage tableau that were an integral part of melodrama were more like paintings in their singular focus on one emotion at a time than the wish fulfillment represented by the women's private theatricals. These would evolve to go beyond enacting figures in painting; they would emphasize individual heroic figures, ranging from mythological deities (Athena) to rulers (Cleopatra) to warrior figures (Joan of Arc). These performances, complicated the perceptions of "woman." Taking their cues from the classical paintings and sculpture that were permeating high and popular culture, the tableaux vivants found the same kind of visual semiotics that theatre used, but for an alternative motive. The tableaux vivants took full advantage of being the performers while the men were the audience, inverting the usual power dynamic in the domestic sphere. These became an integral part of cementing women's communities along with forging individual identities.

Monika Elbert's richly detailed analysis of mid–19th-century American tableaux vivants features the primacy of these in the influential woman's periodical, *Godey's Lady's Book*, and the Conversations of Margaret Fuller. The periodical featured written and visual materials that emphasized women's moral leadership as well as encouraged readers' "project of self-fashioning." Fuller engaged her audience in a dialogue, thereby empowering them to do more than imbibe her doctrine; she truly educated them by giving them the tools to open their own minds. Collectively, then, women were "being invited to envision themselves in idealized roles, [through which] they were learning how to integrate their identities as public and private figures."[31]

Young women whose birth placed them in material comfort were denied pursuit of anything other than marriage and charitable acts. Florence Nightingale, possibly the most famous rebel of the mid–Victorian era, eschewed her obligation to marry and instead created her own work. In her 1860 writing, *Cassandra: or nothing to do*, Nightingale expressed her bitter resentment of women treated as "contingent beings who must fit their lives to the needs of others."[32] The London stages' penchant for statue roles for women (especially Galatea and Hermione) dovetailed with Nightingale's remarks. W. S. Gilbert's *Pygmalion & Galatea* (1871) was one of his greatest successes and frequently revived. An enthusiastic *London Times* review of the premiere night at the Haymarket Theatre, 12 December 1871, pinpoints Gilbert's special contribution to the updating of Ovid's story:

> For Mr. W. S. Gilbert's mythological comedy, "Pygmalion and Galatea" to fill three acts shows much audacity on the part of the author ... the ingenuity with which it is solved is remarkable. Mr. W. S. Gilbert blesses Pygmalion with a jealous wife, who is *not* the statue, but merely sat as a model for it. A spring of action is thus at once provided.... What the gods did for the sculptured figure, Mr. Gilbert has done for the myth.[33]

By 1859, a popular and influential handbook for presenting tableaux by James Head appeared; reissued five times before 1867, *Home Pastimes, Or Tableaux vivants* specified possible themes—ranging from myth to royalty, costume choices, and designated roles for men as observers/admirers, and determined that when one woman performed alone, her eyes should be cast up or have "an averted glance as if aware of herself alone." In the group scenes, women should look at each other." Head claimed that this was the "essence of beauty."[34] Not only was this gaze the opposite of the theatrical tableau freeze, during which actors looked out directly to the audience, but it is likewise curious since it encouraged men's experience of glimpsing surreptitiously at women's private lives. Nowhere does Head or Elbert say that men obviously overlooked the women's focus on themselves and each other rather than on their men.

Victorian men who sympathized with gender equality—William Lloyd Garrison, and John Stuart Mill, co-writing with his wife Harriet Taylor, were more direct in their criticism of men. Garrison spoke at the Women's Rights Convention in Cleveland, 1853, in rebuttal to a man's contention that slights towards women were not deliberate. Garrison maintained that male privilege was "intelligent wickedness," a conscious choice to benefit themselves at the expense of women's dignity and full citizenship.[35] It was Mill who introduced the first Petition for women's suffrage in Parliament in 1866.

Mill went further in *Subjection of Women* (1869) and, in keeping with the tenor of the times, framed women's position in their own homes as economic slavery, and her relation to her sons perverted by the boys' understanding that they had a higher position than their mothers, even if they owed her deference. He examines the seen and unseen aspects of the ideology thus:

> What must be the effect on his character, of this lesson? ... Men of the cultivated classes are often not aware how deeply it sinks into the immense majority of male minds. For, among right-feeling and well-bred people, the inequality is kept as much as possible out of sight; above all, out of sight of the children. As much obedience is required from boys to their mother as to their father: they are not permitted to domineer over their sisters ... the compensations of the chivalrous feeling being made prominent, while the servitude, which requires them is kept in the background.[36]

Mill's representation of this aspect of family life could not be more telling. The schism between how one behaved and why was apparently ignored, and children learned more through observation than instruction; it was as if family life were staged without the possibility of improvisation. No wonder men could claim they never thought about the reasons for women's status. The idol/ideal construct of woman was touted by those intimidated by the unstoppable shift in attitudes towards women's roles. Their denial revealed anxiety towards the issue on the one hand and gave activists a framework for representing the real virtues of women on the other.

Along with the power of these visual (and staged) idealized representations, actual women's voices began to join the cultural conversation as initiators rather than mere receivers. Although *Godey's Lady's Book* did not outwardly support the woman suffrage movement, both the visual and written content complicated the notions of the binary spheres as well as constructs of gender conformity. Just as the tableaux vivants did, *Godey's* materials "offer signs promoting what is acceptable or conventional at the same time as they conjure up feelings that are unacceptable or unconventional."[37] Elizabeth Ellet wrote a series of vignettes for *Godey's* in 1847–48 on "Heroic Women of the Revolution," went on to write a three-volume study on the subject (1848–50) and then biographical sketches *Pioneer Women* (1852).[38]

In Margaret Fuller's 1843 essay, "The Great Lawsuit," she reminded her readers that the question of gender equality and potential cooperation should be at hand: "I believe that, at present, women are the best helpers of one another. Let them think; let them act.... We only ask of men to remove arbitrary barriers." To refute those who found such notions beyond women's abilities or out of synch with religion or Nature, Fuller pointed to ancient women's public religious life, modern Quaker women preachers and the great actresses.[39] In the extended version of her essay, *Woman in the Nineteenth Century* (1845) Fuller outlined the women in mythological and actual history whose virtues and actions had molded civilization and glorified women's roles. Fuller also confronted the verbal and visual misogyny she saw everywhere. She derides the diatribes that insisted that the "beauty of home would be destroyed, the delicacy of the sex be violated, the dignity of halls of legislation degraded by an attempt to introduce them [women] there. ... We have ludicrous pictures of ladies in hysterics at the polls, and senate chambers filled with cradles."

Fuller deconstructs the image of the fragile female who is middle class by discussing the plights of the Indian squaw, washerwoman, Negresses in the field, and sempstresses all together, bluntly reminding her readers

of the travesties of slavery, and working-class women's continual toil for less than adequate wages. Returning to middle-class women's need for activity, she informs men that giving a woman public roles would not take her away from home any more frequently than she already does for "balls, theatres, meetings for promoting missions, revival meetings, and others to which she flies, in hopes of an animation for her existence commensurate with what she sees enjoyed by men."[40]

The editor of *Godey's* from 1837 to 1877, Sarah Josepha Hale, praised Fuller and defended her against the charge that she longed to be masculine. Hale said simply that Fuller was a truth seeker, and intellectual inquiry was a legitimate activity for women. Hale, like Fuller, "does not imagine herself as disempowered but as a central figure in a quiet revolution to elevate the status of women even as she continues to valorize their special role as moral arbiters." Hale also compiled *Woman's Record; or, Sketches of All Distinguished Women, From Creation to A.D. 1854.* James Parton spearheaded *Eminent Women of the Age* in 1869, with contributors that included Fanny Fern, Elizabeth Cady Stanton, and Horace Greely. This collection highlighted the present-day crusaders and others making a true difference.[41]

The literary tradition of compiling sketches of prominent women's lives had begun with Boccaccio's *Famous Women* in the 1360s; while he praises some accomplishments, he also focuses on sexual purity as the chief virtue. Christine de Pizan counters many of Boccaccio's portraits in her 1405 text, *The Book of the City of Ladies*, which is a full medieval allegory, featuring the guidance of Ladies Reason, Rectitude, and Justice to instruct Christine in the virtues of women and instructing her to build a city where only such ladies may dwell. With the exception of Mary, all the figures are pagan: queens, warriors, and ordinary women who rose to occasions and evoked women's ideal virtues: intelligent, practical solutions, fierce loyalty, and moral grounding. de Pizan's work was unread from the 16th century until the late 18th century, when series of feminist histories began to appear.[42]

Similarly, the tableaux "whether staged in the parlor or in print, did not simply celebrate true womanhood or inspired motherhood; rather, they presented a kaleidoscopic vision of woman in the splendid variety of her being—daring, impulsive, rebellious, heroic, introspective."[43] Since these women's private theatricals, tableaux vivants, favored idealized women as well as those of exceptional achievement, it would seem that they, too, thought of woman as an idol. But the reverse is truer; in the stasis of these theatrical moments, women's collective courage to move beyond their stultifying roles grew. Perhaps the most significant example of tableaux vivants

using silence as a foil to empowerment were the series of these Edy Craig produced for her mother's theatre jubilee in 1906.

After generations of women had attempted to work within the political system to gain access and a true say in the world around them, tactics had moved beyond politeness in the early 20th century; younger women would no longer brook confinement. When Ellen Terry's jubilee was planned in 1906 to her honor her fifty years onstage, her daughter, Edy Craig, was on the planning committee. Edy spoke her mind and held firm to her opinions, and apparently was off-putting to the men, so they summarily removed her and all the other women. When the draft of the program arrived, Ellen Terry saw that there were no actresses at all; taken aback, yes, but she called it a joke and wrote to Sir Arthur Pinero, the head of the committee, to say that if no women would be appearing, neither would she. They relented and said there could be tableaux so the actresses could be seen. This private theatrical form worked for women's empowerment even if men enjoyed it for its voyeuristic opportunities. The joke was then on the committee, however, because Edy had scripted heroic, historic tableaux of women's leadership, including Anne Boleyn, Joan of Arc, Cleopatra, Queen Victoria, and the Madonna. As Terry biographer Nina Auerbach observes: "Taken together ... their tableaux were a quiet call to arms, forcing the audience to look at a world drained of men where heroic women were in command ... these powerful young actresses formed a proud counterpoint to [the jubilee's] romping complacency."[44]

Women in the audience, witnessing such an outcome and absorbing the wealth of achievements brought before them as truly living pictures were growing accustomed to envisioning themselves in roles both idealized and realistic. Their private theatricals had opened them up to new possibilities, and the ongoing striving for public roles seemed like a landscape of promise for them to explore.

2

Her Unrecognizable Self: Smashing the Idol of Woman

> Status quo gender relations were "a curious variant" because the man received idolatrous submission from the woman, while chivalrous behavior required him to cater to her as a servant catered to him ... handing her chairs, sitting only after she sat. [Yet] Having thus established a sort of angelic status for her, he has gone on to assume that she can have no property, no rights, no soul, and no other purpose in life except to be the angel on his hearth and the fulfiller of his sexual destiny and her own.—Bernard Shaw lecture, 1914[1]

The tension between motion and stasis that was applied particularly to women, found in theatrical and visual art representations of women, and complicated by women's performance in tableaux vivant can be seen as more than leitmotif. The evolving woman question became truly international in scope. Yet, Nina Auerbach argues persuasively that the desire for static images was a fundamental Victorian attitude. The burgeoning of psychology in addition to the debates over religion and science gave way to a pressing need for stability. Auerbach contends that all the Victorians had "nothing left to believe in but their own lives." The rapid technological innovations in combination with social upheaval led to distrust of anything resembling changeability. Theatricality was distrusted as "the ultimate, deceitful mobility. It connotes not only lies, but a fluidity of character that decomposes the uniform integrity of the self."[2] With Auerbach's cogent cultural context in mind, it is easier for us to conceptualize the impact of Ibsen's characters and situations and the permanent transmogrification of theatre that ensued.

The emergence of Henrik Ibsen's revolutionary drama, translated and performed in England and the United States beginning in 1889, pitted itself against what Emma Goldman deemed "every stone of our social structure," all of which hinge on a lie. Goldman calls Ibsen an "uncompromising demolisher of all false idols and dynamiter of all social shams and hypocrisy."[3] In her discussion of *A Doll's House*, Goldman emphasizes that the tendency to make social roles into idols worked in both directions. Nora's decision to spare her dying father her need for funds to save her husband's life is noble. She looks beyond the convention of asking either of these men permission, and does what is strictly forbidden—borrowing money—the only way she can: forging her father's name. Of course it can be argued that Nora is naïve regarding the law, but that is not Goldman's point; rather, it is Nora's unawareness of "the true character of her idol, Torvald. Goldman continues: "Indeed, so absolutely sure is she of her strong oak, her lord, her god, that she would rather kill herself" by the end of Act II. Helmer's rage over *Nora's* crime in Act III "subsides the moment the danger of publicity is averted—proving that *Helmer*, like many a moralist is not so much incensed at *Nora's* offense as by the fear of being found out. Not so *Nora*. Finding out is her salvation."[4]

Ibsen's depiction of Nora's evolution from seemingly a flighty, shallow, immature woman to one with clear-eyed vision and the ability to act on her own behalf is not so different in its substance from third act back to first; on the contrary, it shows Nora as someone who weighs a situation and comes to decisive action. What probably accounted for the inability of people to comprehend the last half hour of the play was the gender of the protagonist. By exposing the husband as "hysterical" and the wife as the intellectual, philosophical explicator of their situation, Ibsen touched on so many nerves within the social fabric that it is no wonder that the turnaround in the play could be missed entirely. Clear distinctions existed at this time between a lady, with its accompanying gospel of propriety, and the actress, newly regarded as a professional, respectable individual. Nora represents each of these in her transformation from worshipful doll to disillusioned, empowered individual. She has spent her life deferring to patriarchal authority (the lady), but she recognizes the usefulness of her performative powers, manipulating Torvald's inclination to scold through sexual allure and "little girl" helplessness (the actress). When Mrs. Linde advises Nora to tell her husband the truth in Act I, Nora says that would be impossible because it would upset the balance of their relationship if Torvald knew he owed her anything and ruin their happy home. How many millions of women had ensured their husbands knew nothing of their wives' actions on their behalf!

Ibsen's precise meta-theatricality in Nora's actions until the "real drama" at the end of Act III underscores the role-playing that substituted for intimacy in marital relations. When Nora removes her costume and forces Torvald to see the sham of their relations, Ibsen underplays the theatricality of the scene; Nora speaks her true thoughts and reveals her actual feelings. Indeed, this last conversation before the door slam would have been mere denouement in a melodrama; Torvald's reactions to the letter would surely have been the climax. Despite our tendency to think of Ibsen's text as a use and subversion of the *pièce-bien-faite*, we should not fail also to discern the ironic presence of Greek tragedy here: Nora's *anagnorisis* and *perpeteia* apply to both Torvald and herself. Nora knew in advance that full disclosure would ruin their relationship; she could never have predicted Torvald's lack of interest in why she did what she did. As he always does, Ibsen strips away an idealized vision to bring characters and audiences alike to fuller understanding. Torvald's unexamined behaviors throughout the play are Ibsen's illustration of the privilege of power as well as its smugness. Torvald's observation of Krogstad as a moral weakling turns out to be mere foil for his own self-interest. Nora's understanding that his ego needed constant bolstering nonetheless gave her pause when Torvald revealed his own vanity as cause for Krogstad's dismissal. The gift of Krogstad's second letter is not one for Torvald, however; it is Nora who will be assume full agency when she finally recognizes who Torvald is, what she has allowed herself to be, and what she can no longer live with.

Mildred Aldrich's 1889 review of the Boston production zeroes in on essential elements of the play's structure and its impact on men. She noted that the play had "many elements to appeal to the masculine mind, and its treatment of a big subject admits of a deal of difference of opinion." Aldrich had "rarely seen a house more attentive, or—after the first half of the first act-more interested in a play." But the most compelling part of the audience reaction came after the play was over: "More than half ... expected another act. They could not realize that the play was ended and when they did, alas for poor Nora—the abuse she got was something appalling."[5] Aldrich discusses an unnamed critic's claim that Nora deserted a husband with "a man's ordinary faults and selfishness. That may be so, Alrdrich comments, but "it is not pleasant to believe that the average man believes the first accusation brought against his wife, and without once asking her if it be true, treats her as if she were the veriest drab in the world." She reports on the German production's revision of the ending, complete with reconciliation, which she disparages because, "when that is done, Ibsen has had no cause to write this play."[6]

The responses to the London premiere production of *A Doll House* the previous spring had been equally dichotomized. Clement Scott, considered the "dean of London critics and a former progressive," according to Margot Peters, was staunch in his attack on Nora, and the whole feel of the play's closing scene. Nora is no longer a wife, or even a devoted mother: "Her husband appeals to her, but in vain. He reminds her of her duty; she cannot recognize it.... He recalls to her the innocent children; she has *herself* to look after now! It is all self, self, self! This is the ideal woman of the new creed ... a mass of aggregate conceit and self sufficiency." The second review published in the same issue of *Theatre* (1 July 1889), reflects the opposite response. R. H. Hervey reminded readers that an increasing number of women are "dissatisfied with their social position ... more become so every day, [it] is an undoubted fact; and of their dissatisfaction Ibsen has made himself the mouthpiece."[7]

Three years earlier, Bernard Shaw had played the part of Nils Krogstad in the first performance of Ibsen in England at the lodgings of Eleanor Marx and Edward Aveling.[8] When he attended the 1889 performance, "he walked out of the Novelty that night conscious that he had ... taken part in an epoch-making event, the production of a play that, as Shaw described it, 'gave Victorian domestic morality its death-blow.' His mother announced with the conviction possible to one who has slammed her own door: 'That one is a *divil*.'"[9]

Elizabeth Robins' critique captures far more of the excitement of the moment. Peters tell us Robins was with Shaw, his mother and their mutual friend, William Archer, who had translated Ibsen. Robins

> believed that they were "on the threshold of an event that was to change lives and literature.... I never knew before or since anybody strike so surely the note of gaiety and homeliness as Janet Achurch did in that first scene. You saw her biting into one of the forbidden macaroons ... inviting you to share that confidence in life that was so near shipwreck ... the famous lines ... for all time they should be said just as they were first said, and by just that person."[10]

As a fellow actress, Robins is able to convey the totality of Achurch's interpretation of the role and explore the precise combination of voice and gesture—essential criteria for melodramatic performance—but also the power of the technique and the realism in the text's dialogue and the set's intimacy. The shipwreck metaphor and the delivery of the lines alone would not signify the change, as these would be applied to the already-established theatrical practices and melodramatic scripts that Sarah Bernhardt had imprinted onto the popular imagination.

Mildred Aldrich's aforementioned review pinpoints the precise anx-

iety produced by this play, as well as its engendering of masculine audience resistance. Her contemporary, Annie Nathan Meyer, confronts this kind of response from a fellow critic, Mr. Harding, in her piece, "Ibsen's Attitude Toward Woman," in *The Critic*, 1890. Harding complains that Ibsen views the world through a "jaundiced eye" and quotes Hamlet's speech about neither man nor woman delighting him. Meyer takes great offence at this, stating that she finds Ibsen's view full of hope; he is not content "merely to scold the world ... but never ceases to hold up before us a possibility of a society free from all the 'lies and shams.' ... His is not the cry of a wounded animal, but rather ... a wounded soul ... that, although wounded, is yet capable of rising to the ... road to salvation ... [shown by] his strong, sympathetic belief in the future of woman."[11]

Meyer's direct confrontation may well have been read as "acting out," further delighting her supporters and irritating Harding's, but nonetheless reconfirming the significance of the cultural shift. As her argument proceeds, Meyer points to the height of Ibsen's love aka delight in woman as evident by the lessons in "Doll House" and its double, "Ghosts"; namely, "the beautiful truth that Woman is a responsible being, as complete in herself, as capable of exercising self-government as Man. They sound a clarion call[12] to women to throw off the yoke of the Past, to arise, to put aside their worn out ideal and to boldly assume the duties of the Present Age."[13]

A century later, Joan Templeton became the new voice of feminist understanding of these two Ibsen plays; her work was needed because the abovementioned women theater critics had not been included in mainstream Ibsen criticism. Templeton's 1989 article describing the tendency of male critics to stay fixated on the 19th-century patriarchal position created a skirmish, but cemented Ibsen's central place in representation of women.[14] Her study *Ibsen's Women* grew out of the responses of her undergraduate students to Mrs. Alving in *Ghosts*. As her Preface explains it, Templeton recognized that her own immersion in the scholarship of Ibsen was equally "ghost ridden." She had believed that both Nora and Mrs. Alving were "to blame," despite their opposite choices. Further, the conversation within the criticism reflected what she terms "a widespread determination to rescue *A Doll House* and its author from the contamination of feminism." In turn, Templeton reconfirmed her belief that this play was the "quintessential feminist work because it does nothing less than destroy the notion of Woman, the female Other of history."[15]

Ghosts was in some ways more shocking than *A Doll House* in its sweep. In Ibsen's well-known determination to answer Nora's critics through the portrayal of Mrs. Alving, a woman who ran from her impossible marriage but was persuaded to return to it, Ibsen not only showed

society as hypocritical, elitist, and repressive to women, but he also dared to show the full-blown consequences of syphilis and potential euthanasia onstage. A 1903 *New York Times* review of a revival of the play, once again starring Mary Shaw, who had originated the role in the U.S., betrays none of the sexism that would come in the later critical articles that Templeton observes.

In this piece, the sub-heading declares that the "horrors of the play mitigated by intelligent acting," and proceeds to specify the power as well as the chilling horror of a work the reviewer lauds as the "greatest of the modern intellectual dramas." Yet what we would now deem the "rawness" of the play is central to the article. The reviewer cautions: "Those whose nerves vibrate loosely in the living presence of horror, and those to whom beauty and truth are always pink and blue, had better stay away. But all those who wish to look upon life as it is, who think of it sincerely and feel it deeply, will do well to absent themselves from felicity awhile and see this capital performance."[16]

The diverse groups within the audience and its reactions were the article's lead: "Matinee girls were there, and intellectual persons, and theatrical reporters, and tribunes of the mid–Victorian moralities." Interestingly, the centrality of Oswald's idiocy and impending death—whether at his own hand or his mother's—dominated the piece rather than any discussion on the weakness or failure of Mrs. Alving. Mary Shaw's portrayal is praised for her empathy towards the other characters, and her ability to retain the realistic style even when she needed the large voice and gestures to be heard in the large theater. Mary Shaw's portrayal of the horrifying, revelatory moment when Mrs. Alving overhears Oswald and Regina in the dining room—the very spot where their parents once were—is likened to Phédre and Hamlet in its power to evoke tragedy.[17]

If a reviewer in 1903 could connect the disparate members of the audience to the clear stance as well as greatness within Ibsen's work, why is it that later literary critics would fail to recognize the entrapment that Mrs. Alving faced in time present as well as time past? How could they not see that Mrs. Alving represented the reverse choice of Nora Helmer, and that Mrs. Alving's attempt to flee her marriage, had it not been foiled, could have avoided the conception of a syphilitic son and his untimely, cruel end?

The title of Robert Corrigan's 1959 essay, "The Sun Also Rises: Ibsen's 'Ghosts' As Tragedy?" is eerily evocative of Hemingway's 1925 novel about the profligate of the world who are lost in the 1920s, but he shows no similar grasp of the quagmire of society and its rules that has choked Mrs. Alving and cloaked the full reality from her. Rather, Corrigan contends

that Mrs. Alving is Ibsen "imitating an action in which a woman of ability and stature finds her ideals and intellectual attitudes and beliefs in conflict with an inherited emotional life determined by the habitual responses of respectability and convention." So far, so good, but he quickly changes the direction of his argument: "as the play's form evolves," Mrs. Alving's intellectual values are "doomed to defeat because she has no control over her emotional inheritance—an inheritance of ghosts.... Every significant choice that Mrs. Alving has ever made ... is determined by these ghosts of the past rather than by intellectual deliberation." He deems her struggle over the lifetime of her son "flights into intellectual honesty [that] are no use to her when it comes to action."[18] How 19th-century of him, and how much an assessment of its own time: the 1950s flight from feminist strides.

Back in 1894, Annie Nathan Meyer encapsulated Ibsen's point in *Ghosts*, labeling it a real tragedy that "paints the hideous consequences of living that kind of life which meets with the applause and encouragement of Society to the utter crushing of woman's self-respect. I mean the condoning of demoralization in a husband. Ibsen does not shrink from showing this kind of complaisance in its proper light."[19] In a completely contrasting view to that of Corrigan, Meyer contends that it is fitting for woman to adore Ibsen's plays because "no writer of any century has said so much to her that is so vital and stimulating, that never falls into sentimentality of false praise, but always holds up the highest standard of thought and action."[20]

Joan Templeton's *précis* of the play extends and enriches Meyer's point. In her essay, "Of This Time, of This Place" unpacks the sexist reading of the play that takes too seriously Mrs. Alving's remark to Oswald that she did not give his father the joy of life. Templeton sees the tragic action of this play as the complete inverse: "the revelation of the pollution caused by her surrender, not once, but twice, to that man." Pollution here is not only a reference to syphilis but also to the anathema of Greek tragedy. But Templeton makes it clear that Mrs. Alving is no relation to Oedipus; hers is a "different kind of tragedy, whose shape is not a search for self-truth, which the protagonist knows only too intimately, but rather the inexorable bringing to light of the consequences of her ignoring that truth in favor of the world's demands."[21] This last remark reinforces the notion of Nora and Mrs. Alving as doubles, since Nora's self-discovery is the nexus of her play.

In his homage to Ibsen, *The Quintessence of Ibsenism* (1891), Bernard Shaw describes the process of an individual's growth from "fear and fight" to "mere consciousness to knowledge by daring more and more to face facts and tell himself the truth." In effect, Shaw sketches the prototypical search for meaning and identity extant since the time of Gilgamesh. Before

an individual was mature and courageous enough for this, he "masked" what he found threatening; each of these masks needs a "hero to tear it off." Shaw goes one step further, designating the masks' ideals: concepts to cling to until he could look "the specters in the face—dared, that is, to be more and more a realist." This entire frame of reference is applied to the "fancy picture" of the family "as beautiful and holy natural institution."[22] In some of Shaw's plays, these concepts are incorporated into key conflicts between and/or among family members. Other texts apply these to characters who work together. His 1894 play, *Candida*, features both of these and is Shaw's self-proclaimed reversal of Ibsen's *A Doll House*.

Candida is the central figure in the play, and yet she is not onstage continuously. More importantly, it is not Candida who undergoes the kind of transformation typical of a protagonist. She seems more of a catalyst for change in others rather than a woman longing for change for herself. Morell idolizes his wife, but does he really see fully the woman he is married to? As is the case with Torvald and many other male characters in fiction and drama, Morell is so absorbed by his work and pressing speaking engagements that he doesn't really notice how smoothly his life runs because of Candida. His need of her is unquestioned and as normal to him as the devotion of those in his parish or in his audiences. So far this is the portrait of one of those "idealized" Victorian "separate sphere" marriages/masks that Shaw depicts in *The Quintessence of Ibsenism*; what complicates the scenario is the hero worship and/or infatuation each of the partners in this marriage enjoys.

The young poet, Marchbanks, whom Morell rescued from the Park openly adores Candida, and has decided to confront her husband, Rev. Morell, and stake his claim for Candida. Marchbanks may think Candida superior to her husband, but he still has the ownership mentality of the masks of idealism and patriarchy. Morell's secretary, Prosperpine (Prossy), attempts to conceal her "complaint," but Candida and the other young men recognize her infatuation with Candida's husband.

Prossy is no dewy-eyed maiden, however; she is efficient and self-sufficient: a representative of the odd women and the New Women so important to this era. So is Shaw's allusion to the mythological figure ironic, a subtle affirmation of young women's new-found mobility? Alvin Klein's review of the 1997 New York production recognizes her agency when he calls Prossy "a leading feminist in George Bernard Shaw's gallery of outspoken women."[23] Shaw shows this in many ways, but one that is especially apt is Prossy's discussion of Candida with Lexy, confronting him about his slavish imitation of Morell. Prossy admits to Lexy that Morell's fondness for Candida is "enough to drive anyone out of their senses ... to hear

a woman raved about in that absurd manner merely because she has good hair and a tolerable figure." Lexy is surprised that she harbors such negative feelings about Mrs. Morell. Prossy denies this, and acknowledges how "nice" and "good-hearted" Candida is and that she, as a woman, can see this more clearly than the men who revere Candida.

When Lexy is unconvinced, she turns on him "indignantly" (Shaw's stage direction): "Oh, what a profound knowledge of the human heart you have, Mr. Lexy Mill! How well you know the weakness of Woman, don't you? It must be so nice to be a man and have a fine penetrating intellect instead of mere emotions like us." Lexy does manage to have the last word here, though: "Ah, if you women only had the same clue to Man's strength that you have to his weakness, Miss Prossy, there would be no Woman Question."[24]

Here Shaw blatantly thrusts the news of the day into the laps of the audience, particularly the perspective shown in Sarah Grand's essay, "The New Woman," which emerged the same year as this Shaw play, 1894. While continuing his representation of a domestic scene that appears to reflect the anti-feminist ideology Lexy alludes to above, Shaw's play fails to conform to its image of cheerful ease. After all, Candida has been gone for weeks, as Anita Gates' 2011 review emphasizes. Gates asks: "What kind of Victorian housewife is Candida exactly?" The Morells are not wealthy enough to spare Candida from chopping onions for dinner and asking a horrified Marchbanks to help, but she is hardly an invisible drudge either. Gates reminds her readers that this character is "Shaw's tribute to women's strength ... the title character does prevail."[25] So Candida does and does not fit the mold of domestic angel, and her husband does and does not fulfill the requisite authority in the household. The question then becomes whether or not this blending of the roles of Nora and Torvald Helmer is the play's strength or weakness.

In 1904, the *New York Times* report of London theatrical news declared that *Candida* was "not as well received as in America." One of the London papers (unnamed) has labeled Shaw "the most brilliantly perverse writer of his time.... Fundamentally [it is a] ... domestic drama possessing obvious points in common with the conventional *ménage à trois* play so largely favored by the French. But having selected this promising, though simple, theme, Mr. Shaw sets forth to transform and distort, even, it might be said, to burlesque it."[26] These remarks are so completely bizarre and off the mark that it almost seems like this reviewer could be worked into the play as a caricature!

Fortunately, Desmond MacCarthy's review of the same production provides a much more elaborate picture of the play, and what helped make

the Vedrenne-Barker Court Theatre productions of 1904–1907 so memorable. MacCarthy conveys the complexity of the characters individually and in relation to each other, and to the situation Shaw creates around them. Far from the "conventional *ménage à trois*" aforementioned, *Candida* is, in MacCarthy's estimation, a play about people's need for individualized recognition, even if they perform typically gendered roles. Shaw's characters are a mixture. In Morell, MacCarthy finds a "perfectly sincere man" but one who "has avoided probing himself or examining his relations towards others.... He is certainly a good man, and believes himself to be a strong one." Morell does not see until the very end of the play that he is the weaker individual, weaker even than the young poet/would-be lover of Candida, Marchbanks.

In Candida herself, MacCarthy sees her easy manner, and her clear thinking. He calls her the most "matter-of-fact" of the characters and has "a good deal of George Sand in her." He also recognizes that Candida has a "great admiration for intense emotion and poetic sensibility" but really only really believes in "obvious things, which plain people value most, a happy fireside, hard regular work and practical kindness ... she sympathizes with [Marchbanks] in so far as she can mother and comfort him ... and enjoys his adoration without being moved by it."[27]

Reactions to Candida's womanly values and her apparent enjoyment of her domesticity remain mixed among reviewers and audiences; however, her ability to manage people as well as a household betrays her true powers. Shaw's decision to make her grounded and practical rather than a repressed intellectual is one way that the inverted Ibsen play really works. After all, who is more conventional than Torvald? Shaw plays with his audience's expectation to see the two men square off for Candida as prize; of course it is she who must determine the outcome of the play. And here is where Shaw does and does not invert the Ibsen play. No matter that Candida chooses her husband because he is weaker than the poet; she chooses and demands respect and confronts their male privilege handily in her big scene, having Marchbanks and Morell "bid" for her. Her eventual choice reinforces her domestic role, however, even if the lessons of the evening remain Morell's.

The dialogue returns to the Prossy and Lexy scene discussed earlier. Candida asks if she is to choose which one she "must belong to." Morell says she must. Marchbanks understands that "Candida means that she belongs to herself." Despite the fact that each of the bids is straight out of sentimental fiction and/or melodrama, the decision being hers removes the expectation of tableau-like features.[28] Christopher Innes's apt encapsulation of how the play inverts *A Doll House* rests on Shaw's turning away

from the melodramatic twists and turns and, perhaps more importantly, the distinction between the two playwrights' focal point for shaking audiences' social assumptions. Ibsen, says Innes, "denies the audience's moral expectations." Shaw's play "discredits expectations derived from literary norms.... Here is not romantic escapism." Innes concurs that Shaw's play reverses Ibsen's door slam on domesticity.[29] Shaw's elimination of the sham within the domesticity may be the even larger point and inversion.

Oscar Wilde's examination of the dangers of idealization as well as the pitfalls of the fallen, regardless of gender, merge seamlessly with the timely issues of the Woman Question and the duties of *noblesse oblige* in his 1895 comedy, *An Ideal Husband*. Kerry Powell believes this is the play that most shows the influence of Ibsen on Wilde somewhat "detoured through Shaw and his little book *The Quintessence of Ibsenism*, which Wilde found so interesting.... Wilde surely found much that he could turn to his own use later—including at least four instances of the phrase 'ideal husband' which he would resurrect in 1895 as the title of his most Ibsenite play." Shaw summarizes the action of Ibsen's dramas and invokes the phrase "ideal husband" repeatedly in analyzing *A Doll's House* as the idealist's dream. Her sense of duty, Shaw explains, undergoes drastic redefinition once she realizes that she and Torvald have only been "playing at ideal husband and father, wife and mother." Powell also reminds us that Wilde centered his own play's action on this very hazard.[30]

As was his trademark, the frothy tone and sparkle of the dialogue embed the satirical bite of Wilde's observations of the social codes and attitudes that cross theatrical genre boundaries. So often labeled the English Sardou because of his use of melodramatic stock situations and character types, Wilde's serious social critique often was plainly overlooked. Visually, the opening scene (and its meticulous stage directions) of this play conforms to the Victorian taste for "realizations," but no tableau freezes occur. Wilde refers to Boucher's 18th-century tapestry, "The Triumph of Love," as dominant in the ballroom, and describes women at the party as people Watteau would want to paint. Gertrude Chiltern is called "a woman of grave Greek beauty"; Mabel Chiltern is likened to "a Tanagra statuette ... and would be rather annoyed if she were told so."[31] While all of these references to classical or neo-classical art refer to glorifications of love, it is equally true that Wilde chose pieces that show women dancing rather than passively standing around looking beautiful and waiting for men to assert themselves. On the contrary, the women in this play act on their own behalf. Gertrude is active in women's politics, Mabel patronizes the arts, and Mrs. Cheveley enjoys "tedious, practical subjects" like large-scale stock investments.

Even before the play introduces the husband as an "ideal," Robert Chiltern is confronted with his past by the play's villain, Laura Cheveley. Immediately we are reminded of the blackmail plot in Act I of *A Doll House* with both the gender and rationale completely inverted. Nora forged a signature because she could not get a loan under her own name to take Torvald away for his health; Robert Chiltern divulged secret material for financial gain that could ensure the beginnings of his brilliant political career. Krogstad threatens Nora because her husband has fired him for vanity's sake. Mrs. Cheveley wants to add to her own wealth by bribing Robert to back an international scheme he has already exposed as a "swindle." Chiltern is appalled and rejoins: "You seem unable to realize that you are talking to an English gentleman." He asks what sent her to his life. She has all the answers: "circumstances" (she has the letter that proves that the criminal action underneath his success). She reminds him of his inability to escape this inevitability: "Sooner or later we all have to pay for what we do. You have to pay now.... Even you are not rich enough, Sir Robert, to buy back your past. No man is."[32]

Wilde's dramatic structure takes what is best from the theatrical conventions of the past and then improves upon them by adding psychological realism. He uses the comedy of intrigue, sets up a "fallen" creature who can be "ruined," but changes the stereotype by implicating a man rather than a woman, and complicates the connection between Mrs. Cheveley and Robert Chiltern in two ways: first, by having her and Gertrude despise each other from their school days (polar opposite again from Ibsen's Nora and Christine), and second, by Mrs. Cheveley's long-ago abandonment of Lord Goring, Mabel Chiltern's desired love. Goring recognizes the dropped brooch that Mabel has found as a gift he once gave Laura and takes it, making a "strange request" that she let him know who writes to the Chilterns in search of it.

On his way out, Gertrude speaks to Goring about Mrs. Cheveley's conversation with Robert and her anger over it; Lord Goring assumes that Robert can handle himself, but Gertrude believes otherwise, and wants Robert to have nothing to do with Mrs. Cheveley; if only he could oblige his wife's request! In a use of dramatic irony that can only be described as perfect, Gertrude speaks of the past, truth, and abhorrence of compromise, and Robert paraphrases Mrs. Cheveley's remarks in reply. This scene is reminiscent of Torvald's answers to Nora after Krogstad begins the blackmailing plot; he speaks of lies poisoning one's children and the importance of never borrowing money. Both of these characters drive daggers into the hearts of their spouses unawares.

Gertrude goes farther, however, and reminds Robert how he has

always stood above others: "You have never let the world soil you. To the world, as to myself, you have been an ideal always. Oh! Be that ideal still.... Robert, men can love what is beneath them —things unworthy stained, dishonored. We women worship when we love; and when we lose our worship, we lose everything. Oh! don't kill my love for you, don't kill that!"[33] By the end of the first act, Wilde's play reveals the meaning of Nora's disillusionment in *A Doll House*, potentially heightening the audience's foreboding for this couple's future.

And who does Robert turn to for advice when he is on the verge of hysteria but Arthur, Lord Goring, best friend to both Gertrude and himself, and yet another echo of Ibsen's scenario. Lord Goring is someone who tries to avoid all of life's platitudes and enjoys giving the appearance of being an idler with nothing serious to say. Yet he is Wilde's mouthpiece in the play, as well as an embodiment of a truly noble man. He tells Robert to go to his wife and tell her the truth. When Gertrude turns to him later for advice, he is there for her as well; he has told her to come to him when she needs help, just what Rank wanted to do for Nora.

Bernard Shaw's praise of Wilde's play is apt right here. His review speaks of Wilde as "our only thorough playwright. He plays with everything: with wit, with philosophy, with drama, with actors and audience, with the whole theatre."[34] *An Ideal Husband* is even thorough in another way, particularly in regard to Ibsen's *A Doll House*; Wilde goes beyond the shocking ending. Gertrude throws Robert out of the house; Robert gives his speech in Parliament, believing he has lost Gertrude so he stands on his principles, prepared for the worst from Mrs. Cheveley. To this melodramatic plot Wilde adds the mix-up over letters and Lord Goring's re-entanglement with Laura—for the sake of Robert. On the surface, it all seems formulaic, but the psychological depth in the characters goes far beyond pre-scripted *pièce-bien fete*. Robert and Gertrude reunite once Robert reconfirms his self-respect and Gertrude learns not to put Robert or anyone else on too high a pedestal.

Christopher Innes perceives the apparent conservatism of Wilde's comedies, as evidenced by their "reassertion of moral standards" at their endings. However, Innes just uses this as a starting point: "The comic surface disguises [his] iconoclasm; and in failing to recognize that Wilde's plays trivialized the values they so ostentatiously appeared to uphold, the late Victorian audience unconsciously displayed the accuracy of his attack."[35] With Innes in mind, consider the play's ending. Robert and Gertrude have a fresh start and a rekindled romance: totally in keeping with the tradition that a comedy must end in harmonious resolution. After unraveling layers of complexities, internal and external, Lord Goring pro-

poses to Mabel, who wants nothing to do with the ideal husband his father wants him to be for her. She tells them both "It sounds like something in the next world."[36] Her sister-in-law may be the one most active in women's causes, but it is Mabel who truly represents the younger generation's rejection of fixed roles; her remark places these safely beyond reach.

Mabel also emblematizes the freedom of young women coming of age in the 1890s; plenty of audience members could solidly identify with her. The matinee performances that began in the 1870s came about for two reasons, both of which were linked to economic criteria: to extend the run of a popular work and to give untried works a venue. As the Introduction pointed out, this theatrical decision dovetailed with the opening of department stores in the theatre district as well as the Bancrofts' refurbished, "domesticated" Prince of Wales Theatre. Susan Torrey Barstow points out a further purpose, or possibly result of this cultural conflation, especially for women onstage and off. These plays provided a "space for the observation and critique of staged femininity." She further argues that these afternoons fostered the development of "a new feminist self-consciousness" as well as taking theatre in new and innovative directions. Specifically, Barstow points to the Ibsen matinees of the 1890s as an essential contribution to the "creation of turn-of-the-century feminism, a feminism that would later realize itself in the theatricalized struggles of the Edwardian suffrage movement." These performances were at "the heyday of the theatrical matinee, when nearly sixty percent of plays produced in London" featured afternoon shows.[37]

The dominant audiences, dubbed as "matinee girls" by the critics, were a startling or disturbing factor for the critics who began to experience what it was to be a minority figure. The fact that young women came unescorted was the focal point of their attack. As Torrey Barstow puts it, their presence was seen as the downside of increased education, economic self-sufficiency and leisure: "the matinee girl indicated, by her very presence in the pit or gallery, a relaxation of the moral restraints that governed young women's conduct."[38] The other equally important segment of the audience of women were the married, bourgeois women—middle-aged—whose attendance at these plays awakened a shared consciousness of women's experiences. One particular play evoked an extraordinary remark, one overheard by Elizabeth Robins, who produced and starred in the play *Hedda Gabler*. The unidentified married woman who, according to Robins, was "not noticeably unhappy" told her companion (Robins does not identify the gender), "laughingly, 'Hedda is all of us.'"[39] Robins was hardly surprised by the remark, and incorporated it into her own writing, her essay, "Ibsen and the Actress." Julie Holledge's study of Edwardian women and the theatre,

Innocent Flowers (1981) cites this key passage from Robins's work, one that describes the awareness that she and her partner, Marion Lea, had when they secured the English performing rights to *Hedda Gabler*. They assumed that men as critics or audience members would not be likely to perceive the totality of the title character; here is the commentary that leads up to this spectator's remark: "Mr. Clement Scott understand Hedda? Any man except that wizard Ibsen really understand her? Of course not. That was the tremendous part of it. How should men understand Hedda on the stage when they didn't understand her in the persona of their wives, their daughters, their women friends?"[40]

The two actresses recognized that Hedda was a template of sorts for the frustration and repression that had stymied and isolated women for so long. Holledge asserts that to them, Hedda was "an anti-heroine whose energy and intellect have been converted into negativity and destructiveness, yet at no time does she express remorse or guilt for her actions." Robins' assessment is that Hedda is "'a bundle of unused possibilities, educated to fear life; too much opportunity to develop her weaknesses.'"[41] Although Elizabeth Robins would not identify herself as a feminist or activist for more than another decade, her remarks about Hedda Gabler could be squarely placed into the remarks of a protofeminist foremother a century earlier; Mary Wollstonecraft would cite this character's wasted life as a direct result of the enforced decorativeness of women that purported their genteel accomplishments were all they needed. On the contrary, Wollstonecraft speaks of the harm that comes from inadequate education for women: "Women ought to endeavor to purify their heart; but how can they do so when their uncultivated understandings make them entirely dependent on their senses for employment and amusement, when no noble pursuit sets them above the little vanities of the day?"[42] Hedda Gabler was not the likeable Nora or the tragic Mrs. Alving; she was called demonic, or as we would now say, deviant. Why then would she be the one that women saw as their representative?

Although Elizabeth Robins and Marion Lea were already professional, experienced actresses before their work with Ibsen's plays began, their onstage connection, first in *A Doll House* and then in *Hedda Gabler*, became a force in changing women's representations onstage. Robins wrote to Archer in 1890 to discuss *Ghosts*, what Angela John, Robins's biographer, calls "that risqué play" because she wanted to play Mrs. Alving. Archer agreed to meet her because he had been impressed with her acting and supportive, but warned her about remaining identified with Ibsen plays: "Do you know, Miss Robins, you are treading on dangerous ground? Do you know there are many good people who foam at the mouth when Ibsen is

mentioned?" Robins did not act in *Ghosts*, but played the leading role in the new Ibsen play, *Hedda Gabler*, and "proved the truth in Archer's warning." For Robins this was a "watershed not least because it was at this juncture that she ceased to be solely involved in the acting side of the stage. With Marion Lea she now undertook joint management ... and may, as Joanne Gates has argued, "'be credited with changing the course of English drama.'"[43]

Ibsen's play centers on a woman known to be headstrong, proud, and arrogant: a General's daughter adept at shooting pistols, riding a horse, and commanding attention. Yet the character we actually meet is spiraling out of control because she no longer feels any of the strength those around her continue to associate with her. More to the point, she is rude and difficult from the outset, and yet reveals angst and hysteria almost from her first moments onstage. Married but six months, Hedda is already bored and trapped by her decision to marry a man she did not love, the kind but self-absorbed scholar, George Tesman. George's Aunt Julia sees immediately that Hedda is pregnant, something Hedda has not admitted to anyone, including herself. It is this that is sending her over the edge. She will only admit to Judge Brack that marriage is a trap because it means one is "everlastingly" with the same person. Of course Brack assumed that Hedda married for love, but instead it was because she was getting older and had "danced myself tired, my dear Judge. My day was done [with a slight shudder]."[44]

Thea Elvsted is Hedda's alter ego in the play. Thea is delicate, pliant, and yet able to get more of what she wants, until destiny sends her to Hedda's door. Unbeknownst to her, she is involved with Hedda's old flame as well as her husband's friend, Eilert Lovborg, whom Hedda threatened to shoot years ago when he attempted to go beyond conversing about sex. Hedda obviously has regretted that for years. But Hedda never really gets outside of gendered roles or expectations, with the exception of her vengeful acts of destroying Lovborg's manuscript and orchestrating his suicide by supplying the pistol—supposedly because it will eclipse her husband's work. Hedda's actual motive is jealousy of the fulfilling connection between Thea and Lovborg, and this other woman's courage to walk out on her husband despite her apparent fragility and resemblance to the melodramatic heroine. Hedda, like Nora, is very attached to her father and seems to be motherless, but she lacks Nora's character or capacity to love. In a way, Hedda is more easily linked to Gustave Flaubert's Emma Bovary.

Like Emma, Hedda has married impulsively and quickly recognizes her unhappiness; neither husband has a clue. Flaubert's technique of double interior monologues to show the total incompatibility of Charles and

Emma, especially during her pregnancy, would have been a parallel most of the audience would have known, as the novel was so influential in its time. Charles is thrilled to become a father and is more in love with Emma than ever; she, conversely is only anxious for the baby if it will be boy, "a kind of anticipatory revenge for all her past helplessness ... a woman is constantly thwarted. Always there is a desire that impels and a convention that restrains."[45] Emma commits suicide because of debts and adultery, but Hedda does so to avoid giving birth and remaining trapped in her marriage and, most importantly, because Judge Brack would be able to control her because he knows she gave Lovborg the pistol he used in his suicide.

The clearly melodramatic emotions and plot points seem odd for a play that became known as revolutionary. Susan Torrey Barstow recognizes that Ibsen's heroine was "Neither old nor new ... [but] a transitional figure." The play's performance, according to writer Edith Lee's observation, "'heralded not a smooth transition for women but a violent death and rebirth.'"[46] The tightness of the play's structure and the brevity of the dialogue are also indication of both old and new forms. Gay Gibson Cima's commentary on the complexity of portraying Ibsen's characters provides a clear framework for this: "Actors faced a difficult challenge in their attempts to penetrate the seemingly unambiguous, plain, prosaic dialogue, to uncover the characters' psychological motives."[47] As for Robins's preparation of the role of Hedda, she paid particular attention to the Act IV scene with Judge Brack that literally sends her into the upstage left corner to her death. When Brack tells Hedda the truth about Lovborg's death and intimates that her pistol was the weapon, he also makes it clear that he will protect her providing she give in to his unwanted intimacy. Robins enlarged the scene by use of melodramatic pauses and gestures. Cima notes that these choices would be clear to "1890s audiences [who] could see readily that Hedda simultaneously mocks and enacts the role of woman as ideal victim."[48] Hedda could be iconographic for women because she represented their smoldering resentments, and yet their inability to go beyond their masculine authorities.

Between the time of the performance of Hedda, Robins's last role, and the Coronation Suffrage parade of 1911 that was led by a woman dressed as Hedda, Elizabeth Robins had evolved from an actress loving the parts of Ibsen to a feminist who believed these women left a lot to be desired. Penny Farfan explains the paradoxical choice of Hedda for the pageant: "the recognizable figure whom the actresses were to rally behind was not the character that Ibsen depicted ... but, rather, the character that they themselves imagined Hedda would have been had she somehow had existence outside of Ibsen's play."[49] Robins herself would become a key organ-

izer and member of the Women's Social and Political Union and the Actresses Franchise League in the first decade of the 20th century, which Chapter 5 will chronicle. She would also write the first full suffrage play in 1907, which would be produced by the Vedrenne-Barker Court Theatre (see Chapter 4). That same year, she wrote an article for *Collier's Weekly* that describes her own inner journey towards feminism.

Robins describes herself as attending a Trafalgar Square meeting "out of shamefaced curiosity ... head full of masculine criticism about woman's limitations, her well-known inability to stick to the point, her poverty in logic and ... impossibility ... of her coping with the mob." Before this day, Robins had felt women needed more education and discipline, and not the freedom the Movement called for, "not realizing that the higher discipline can come only through liberty." Later she had an interview with a London editor who bemoaned the inevitability of granting women the vote. He was concerned that women would lose more than they gained, especially since men felt the "deteriorating" effect of public life; wouldn't all this "publicity and concentration of attention on themselves be bad for women?"[50]

Robins's reply could not be more telling or a better close for this chapter. Then forty-five, she pointed to her career as her proof: "I had spent a good part of my adult existence under conditions where I could see the effect on character of just these fierce tests, save that in the theatre they operate innocent of political significance." Then she qualifies this answer by distinguishing between the necessary focus on self that acting demands in contrast to the "civilizing, ennobling" service to others that suffrage work was. Her phrase, so familiar as one in reference to what women did for men, must have startled this man, but how it makes us smile now.

3

Theatre No Stranger Than Ourselves

> When she stood up to read the speech ... she was nervous, but courageously stood her ground. She began slowly, and with a most "fetching" voice, to *think* out the words. You saw her think them, heard her speak them. It was so different from the intelligent elocution, the good recitation, but bad impersonation of the others! "A pathetic face, a passionate voice, a *brain*," I thought to myself.—Ellen Terry on Lena Ashwell student recital, 1890[1]

Theatre in the last years of the 19th century was the site of social transformation accompanied by the awakening of modern psychology. Audiences in some venues were learning to attend to a character's individual moments, in lieu of a scene's final tableau freeze, to grasp the meaning of the play. Consequently, spectators began to recognize what seasoned actresses like Ellen Terry already knew: acting required astute intellect. By acknowledging the actors' inner identification with the roles they portrayed, audiences could then reflect more intently on inner and outer conceptions of reality shown onstage.

Because the experience of social change was presented to people sitting among strangers, theatre also became a perfect pairing with *flâneurism* and the spectacle of modern urban life. Despite the designation of *flâneur* as a "masculine, bourgeois" individual who enjoyed observing the urban scene at a distance, Cassell's *Guide to Paris* spoke of the preponderance of women strolling the boulevards, sitting in cafés or hotel lobbies reading the newspaper, visiting department stores, or venturing into the darker

Johnston Forbes-Robertson and Gertrude Elliot in Act I of Bernard Shaw's *Caesar and Cleopatra*. Courtesy Bernard F. Burgunder collection of George Bernard Shaw. Division of Rare and Manuscript Collections, Cornell University Library. Shaw wrote the role of Caesar for Forbes-Robertson and the two co-directed the play twice. For both of these productions, 1906 in New York and 1913 in London, Cleopatra was played by Gertrude Elliot. In this opening act, Caesar believes he is praying to Egypt's great sphinx; Cleopatra, who is hiding from the Romans and does not know who he is, tells the "old gentleman" that this is her pet sphinx. This staging makes the scope of the setting as well as the storyline palpable for an audience.

side of life—the Paris Morgue— to view the bodies "laid out behind a large display window for consideration by, and possible information from, anyone who stopped by. As what Vanessa Schwartz labels a "free theater for the masses, the morgue fit into a modern Parisian landscape in which the banal and everyday were embedded in sensational narratives."[2]

Add to these the sensationalized articles in the press, the popularity of serialized novels, and the potential to rub shoulders with all levels of society, and it is easy to conceive of an awakening consciousness of adventure in everyday life. The birth of the wax museum in 1882 conflated these experiences. Celebrities were brought to life in meticulously realistic ways and, though made of an ephemeral material, served to deepen the significance of mass culture. The Paris Morgue, closed by then to spectators, was re-created in the wax museum. As Schwartz notes, this place combined popular culture and the legitimacy of the museum."[3] Further, the wax museum built upon the already passionate affinity for collecting specimens from nature and putting them under glass in viewing jars as well as capturing images of people and things through photographs. Experiences could be visibly re-lived, adding to the power of memory.

The cosmopolitan consciousness on both sides of the Atlantic drew from international artists in all media who, in turn, reflected the diversity of the promenade, as well as the streetcar. According to Schwartz's depiction of 19th-century Paris, especially at the *fin-de siècle,* the streets had become meeting places as well as sites of spectatorship. The late 19th century is readily identified with the technological advancements that brought photography and graphic arts to people across class lines; these new forms were essential to the emergence of international, mass culture. This was pleasurable activity of "collective participation in a culture in which representations proliferated to such an extent that they became interchangeable with reality."[4] These experiences retained the dominance of Gothic and vampire fiction and connections to the supernatural, reinforcing the emerging concept of how the private could become manifest onstage.

Once Henrik Ibsen's dramaturgy had dispensed with the veneer of status quo plotlines as audience cues by the 1890s, performance became less about an intensified series of individual crises, and more an unfolding of an individual decision with sweeping social ramifications. The major conflicts of the era surrounding gender, sexuality, upward mobility, and "ideal" family life were represented in plays written by widely divergent authors. The rapidity of social change and its counterpart, the desire for stasis, informed the choices playwrights gave their characters and, subsequently, the resolution of their private and public dilemmas. Playwrights as well as audience members struggled to reconcile the removal of clear

cause and effect; what was once the "right" way to live became mercurial, and compromised by the blurring of gender/class lines in the power structure. Ibsen's blend of romanticism and realism showed audiences the damage done by clinging to an idealized past or future, and the angst of recognizing the inevitable contradictions the present moment forced upon them. For people used to formulaic play construction that treated social mores as "givens," plays laying well-established codes of private behavior bare and open to question sparked resistance as well as inspiration.

Because realistic and naturalistic drama from the 1890s onward emphasized the breaches rather than the idealized harmony of 19th-century domestic scenes, negative responses by reviewers and audiences were inevitable. Provocation was precisely what dramatists sought, however, after Ibsen's premiere of *A Doll House* in Copenhagen in December, 1879 catapulted social issues into the public and private lives of people. Joan Templeton emphasizes in *Ibsen's Women* that the premiere audience was not "shocked"; rather, they were "deeply shaken." Templeton notes Gosse's report that all of Scandinavia "rang with Nora's 'declaration of independence.'" The work was not received as theatrical representation but as "real." People left the theatre but not the ideas, which inspired heated arguments night after night.[5]

Templeton traces the revulsion people felt for the ending and the changed versions that appeared in Germany, Britain and the United States before 1889, when William Archer's translation was staged with Janet Achurch. Achurch established Nora as the full evolution of doll-child/wife to self-aware seeker of individual identity and purpose (see Chapter 2 for the responses to this production from Shaw, Elizabeth Robins, and theatre critics).[6] The controversy did not end. Templeton's examination of the controversy over Act III well into the 20th century is clear evidence of the depth of Ibsen's critique of domestic institutions, as well as the many reasons critics can find to ignore the complexity of Nora's character in the earlier acts of the play that set up the awakening she experiences at the end. Over and over again, according to Templeton, people cited the speech Ibsen gave in 1898 to the Norwegian Women's Rights League, which honored him for his fight on behalf of women. Ibsen thanked them but said he "must disclaim the honor of having consciously worked for the women's rights movement." He acknowledged that the woman problem was important to solve, "along with all the others; but that has not been the whole purpose. My task has been the description of humanity."[7]

If we take Ibsen at his word in this speech, it could hardly account for the true distortion of the comment, and the arising trend to dismiss the relevance of Ibsen's women characters' struggles. Conversely, women

activists and fiction writers gravitated to the women in Ibsen's plays even if the characters could not extricate themselves from the circumstances that stifled them. The directness of the Ibsen's plays' confrontation with social hypocrisy that had fostered "unmentionable" topics surrounding sexual mores and syphilis, power relationships, and disgraceful treatment of the poor and women gave readers and viewers permission to do likewise.

London's well-established separation between the fashionable West End and the grimy, impoverished East End began to fray in the late Victorian era, argues Judith Walkowitz. She focuses on the seismic shift in the occupation of public spaces in London in late–Victorian times. The previously unquestioned primacy of male privilege in *flaneurism* underwent "an array of changes within the prevailing imaginary landscape of London." The shift disrupted the literal as well as psycho-social, turning it "from one that was geographically bounded to one whose boundaries were indiscriminately and dangerously transgressed" by women across class lines who were creating a "contested terrain" via new commercial spaces, journalistic practices, expanding networks of female philanthropy, and a range of public spectacles."[8] In her expansion of this argument, Walkowitz provides compelling contextualization:

> In the 1880s, marginalized groups—working men and women of all classes—repeatedly spilled over and out of their ascribed, bounded roles, costumes, and locales into the public streets and the wrong parts of town, engaged on missions of their own.... These new explorers drew on the well-established repertoire of the urban *flaneur*, imaginatively revamping certain features of urban spectatorship to accommodate their own social circumstances ... these encounters rendered the streets of London an enigmatic and contested site.[9]

All of these ruptures in the social fabric were present in the years just prior to the coming of Ibsen. Interestingly, it was the West End's Trafalgar Square that garnered most of the activism of the day, first with the working people's demonstrations for unemployment relief in 1886–87 under the "red flag of revolution" and also the "silken banners of trade unions and socialist societies that proclaimed workingmen's rights to civic participation, as producers of wealth."[10] Within twenty years the suffrage speakers would rally there, and the site would be re-created onstage in 1907 by Harley Granville Barker for the Court Theatre's premiere of Elizabeth Robins' *Votes for Women* (see Chapter 4).

The dialogic and yet dichotomous relationship between stage and public platform seems an inevitable outgrowth of the conventions central to realistic drama. If Ibsen brought private issues onstage to place them into public conversation and consciousness, it is equally true that public issues became embedded into dramatic texts to highlight individualized,

private connections to ongoing social events. Yet, the practitioners of the realistic and naturalistic theatre focused more heavily on creating an ordinary stage place than on audience reception. As Una Chaudhuri reminds us in *Staging Place*, "conventions of the realistic drama made their own contribution to the practice of deriving identity from environment." On the one hand, André Antoine, founder of the Théâtre-Libre in the 1880s designated the playhouse as a private society, with audiences receiving mailed invitations, in order to eradicate the notion of a playhouse as open public space. Chaudhuri points out that spectators were not necessarily ready for so intimate a role and, conversely, that such a blurring put them in a paradoxical position: "an impossible displacement" since they were given the "role of ultimate hermeneutic authority" while, at the same time, being acutely aware of the "authorizing but invisible presence of the omnipotent puppet master playwright, creator of all meaning."[11]

Moreover, since most realistic dramas are set in a home, the idea of home as a space we negotiate could either distance audience members or engage their absorption of the place and space of the stage as well as the situations confronting the characters. Chaudhuri continues: "The fully iconic, single-set, middle-class living room of realism produced so closed and so *complete* a stage world that it supported the new and powerful fantasy of the stage not as a place to pretend in or to perform on but a place to *be*."[12] Chaudhuri's context deepens as she comments on the preponderance of doors in these sets that actually worked, and even slammed, as evidence of the connection between simply coming and going from a room and reaching life-changing decisions that rejected one's home environment.[13]

Young girls as well as matrons were the majority of the audiences for Ibsen and his followers, especially at matinee performances. Through identification with the characters' situations in the plays, connections between observed home life, onstage and off, and the ongoing struggle for women's and workers' rights reported in the press became more "real." More and more young women sought work and lodging outside the home. This enormous shift led to a continual proliferation of lampoons about this "New Woman" in the press. Most prominent were the images of George Egerton, pseudonym for Mary Dunne. According to Margaret Stetz, she was the "most radical and pilloried of the so-called New Women writers of the 1890s ... known for her short hair, her pince-nez, and her solemnly penetrating gaze, all of which appeared in numerous caricatures in *Punch* Magazine, and, most famously, in a theatre poster by Albert Morrow for Sidney Grundy's 1894 anti-suffrage play, *The New Woman*.[14] This visual, with its direct gaze, symbolized the effrontery of the new women, who dared to presume eye contact with the male authority they questioned.

Further complicating the reaction to the "deviant" women portrayed onstage as well as those who embodied their characteristics in public and private life was the fusion of Ibsen's women and the modern interpretations of Shakespeare's characters in these same years. The primacy of Shakespeare in the collective consciousness of Victorian society cannot be overstated. Not only were his plays the most often performed onstage, but they were also studied in schools and discussed among one's peers. Gale Marshall's study, *Shakespeare and Victorian Women*, emphasizes the solid connection between the rise of literacy and formal education across gender and class lines. Shakespeare's works stood as the embodiment of character and behavioral traits, especially for women, including those who might not ever have been to the theatre.

Marshall's assertion that a two-pronged relationship developed between the increase in girls' education and conventional interpretations of Shakespeare elucidates the cultural moment. Firstly, the rise in Shakespeare's renown through greater literacy would benefit from the support of an educated female audience. Secondly and conversely, "to what extent did an educated female readership need the guiding example of Shakespeare and his women in order to use its new opportunities and responsibilities wisely?"[15] Across the Victorian era, prominent actresses used Shakespeare in public lectures on womanhood as well as portray onstage models. Ellen Terry's eponymous comment that Shakespeare was the only man she ever truly loved when she was a girl evolved into her own perspicacious lectures on Shakespeare's women that would be given on both sides of the Atlantic in the early 20th century, and in which Terry would show that Shakespeare favored strong and intelligent women in his plays.[16]

Why was it then that Stella (Mrs. Patrick) Campbell's portrayal of Ophelia as a truly depressed young woman in 1895 caused such discomfort among spectators and critics alike? The most compelling reason is that Campbell came to this Shakespearean role around the same time that her career skyrocketed in two plays that showcased the demise of fallen women: Arthur Wing Pinero's *The Second Mrs. Tanqueray* (1893) and *The Notorious Mrs. Ebbsmith* (1895). Apparently, Pinero's roles were so thoroughly associated with Campbell that her truly feminist and groundbreaking interpretation of Ophelia could not be detached from Paula Tanqueray or Agnes Ebbsmith. The other, more underlying, reason would be the entrenched and revered images of Ophelia as a model of Victorian girlhood and domesticity. Given both of these fixed notions of femininity, propriety, and idealized passivity, new readings of Shakespeare's characters might have seemed like one too many changes for the audiences of that era.

Pinero's plays, dubbed "new woman" plays at the time, nonetheless

stayed the course of constructing plots around women's need to remain constant to orthodox gender roles. In the former play, Paula Tanqueray has married a man well aware of her sexual "past"; when his daughter learns of it and shows up with her step-mother's former consort, the second Mrs. Tanqueray suicides to avoid hurting the girl. Pinero's text demands no change in audience response or attitude. In Pinero's latter play, Mrs. Ebbsmith is a widow, has been a platform speaker, taking over her father's secularist lectures, and has turned to nursing to make ends meet. Through nursing she finds new love. Shaw's review of *The Notorious Mrs. Ebbsmith* gives us a true sense of disappointment in Pinero's plunge into doing something new: "he has had no idea beyond that of doing something daring and bringing down the house by running away from the consequences."[17] Shaw's calls Pinero's assumption that platform speaking would lead to starvation a "want of practical acquaintance with the business of political agitation." Then Shaw points out that Pinero's deeper mistake is one that should not be tolerated from an "intellectually responsible person":

> [Pinero] has fallen into the common error of supposing that the woman who speaks in public and takes an interest in wider concerns than those of her own household is a special variety of the human species; that she "Trafalgar Squares" aristocratic visitors in her drawing room; and that there is something dramatic in her discovery that she has the common passions of humanity.[18]

At the time of the play's action, Mrs. Ebbsmith is living with a man married to a "shrew," and determined to live with Mrs. Ebbsmith without marriage. By the end of the play, she rebukes her lover, tormented by the wrong she has done to his wife. Once again, stasis.

In addition to the Pinero characters "emerging" in her Shakespearean performance, Mrs. Patrick Campbell infused her own psychological sufferings and her professional savvy into her portrayal of Ophelia, thereby blocking audience identification: precisely the inverse of the reception to her Pinero roles. Despite the tradition of Victorian actresses showing audiences the pertinence of Shakespeare's women to their own lives, Campbell's interpretations dared to attach modernity to characters who had become more trope than human individuals to the public. Fiona Gregory explores the *milieu* in which Shakespeare's Ophelia became identified as "a type of ideal femininity built around prettiness and passivity, acquiescence and silence." In Pre-Raphaelite painting, Ophelia's madness and death was a favored subject, along with other dead women, such as the Lady of Shallott. The glorification of dead beauty connects to the idealization of stillness and pliancy for Victorian women that Shakespeare's heroines often refute. Playing Ophelia had allowed an actress a way to

"advertise her inherent respectability."[19] Ellen Terry's approach to Ophelia became iconic; it was the role that initiated her connection to and partnership with Henry Irving at the Lyceum in 1878. Terry's way of evoking Ophelia's instability was through shifting her voice and mannerisms abruptly and often. This technique blended seamlessly with her Pre-Raphaelite appearance: flowing hair and robes.[20]

Michael Holroyd's biography of Terry and her children adds another layer of significance: Terry's costume choices. The norm in Victorian theatre was for actresses to supply their own costumes. Since Irving rehearsed everyone except Terry at first, she chose hers early: pink for the first scenes, light gold/amber for the nunnery scene, and black for the mad scene. Irving was nonplused by the choice, telling Terry only that Ophelia was usually in white. Terry knew that but felt black would be "more interesting." Irving left it to a wardrobe manager to confront the actress: "My God! Madam, there must be only one black figure in this play, and that's Hamlet!" Holroyd notes that Terry acquiesced but later remarked: "I could have gone mad much more comfortably in black."[21]

Terry's position on the appropriateness of funereal costume for Ophelia would have given credence to the character's psychological unraveling over her father's death by Hamlet's hand. Her own self-recrimination that must have followed the nunnery scene and the play-within-the-play exchange between her and Hamlet is something Shakespeare does not include in her speeches. Instead, Ophelia's psychological state becomes a true corollary to Hamlet's; the powerlessness he feels in his first act soliloquy, "It is not nor cannot come to good./But break my heart, for I must hold my tongue" follows his submission to remain at Elsinore. His bolder remarks earlier in the scene about his own "inky cloak" being but the "trappings and the suits of woe"[22] introduces the woe that Ophelia will experience on several occasions in the play: Laertes's admonishment of her for her intimacy with Hamlet, her father's rebuke; her last lines in the nunnery scene, which, by the end of Act IV can double in meaning for Hamlet's nature and her own mind; and her own guilt for betraying the man she loved by submitting to her father's plan in the first place. Allowing Ophelia to mourn in appropriate costume, as Hamlet had done, would have cued audiences to focus on the intelligence and judgment that Ophelia tragically lost.

Campbell and all others portraying Ophelia in the late Victorian era would have been measured against Terry's interpretation. Gregory explains that Campbell was perceived as "miscast" for Ophelia, " a role the late–Victorian audience tended to associate with docility and sexual naivety." Campbell's "personal associations with the aesthetic avant-garde,

and the aura of decadence and sophistication that surrounded her celebrity persona" also stymied positive reception. Campbell "rejected the conventional stage model of ... prettiness and pathos and instead offered a vacant, depressive, "beaten" Ophelia."[23] Campbell's choices not only reflected a feminist bent, but also the actress's own experience with the prevailing treatment for neurasthenia: the "rest cure." She used her performance as Ophelia to communicate the harmful effects of this treatment at around the same time Charlotte Perkins Gilman's short story, "The Yellow Wallpaper," chronicled a nameless first-person narrator into madness as a result of the rest cure. Gilman published the story as a cry of help, and to alert the physician who created the technique to abandon it.[24]

The more perplexing aspect of Campbell's reception as Ophelia, however, is the well-established record of a shift towards seeing Ophelia as weak by 1897. Gregory cites Terry's own commentary in her later lectures on Shakespeare's Women, and a key point from Jessie O'Donnell in 1897. This shift derives from the nunnery scene; Ophelia's willingness to be part of the scheme to spy on Hamlet shows her to be shallow and not truly a woman in love; these actions, or, rather protracted passivity, discredited Ophelia.[25] Shaw's review reveled in Campbell's performance precisely for the reasons that others objected to it: her interpretation brought new meaning to the scenes with the King and Queen as well as Laertes upon his return. The discomfort and pain that she emphasized in Ophelia went directly to the audience. Clement Scott mentioned this, but Shaw celebrated it. Campbell's mad scene was not, in Shaw's words, "a pretty interlude coming in just when a little relief from the blue-black cloak is welcome, touches us with a chill of the blood that gives it its right tragic power ... the pain is good for [the audience], good for the theatre, and good for the play."[26]

Shaw implied that Campbell's portrayal of Ophelia confronts ideological fixity. Placing the negative reception in the specific theatrical context of the mid 1890s, it is also possible to infer that rejection of Campbell's performance choices also illustrates the patriarchal resistance to Nora Helmer's transformation in Ibsen's *A Doll House*.

Both Ophelia and Nora are motherless daughters overly sheltered by fathers. Each of the young women is likewise toyed with by the man she loves. Nora flees to disrupt stagnation and to finally grow up; Ophelia has no such option in Shakespeare's time. Nora contemplates suicide but does not go through with it because her experience of subterfuge to protect her father and husband (and her acceptance of the docility of women's sphere) had been overturned by the "rude awakening" that Torvald Helmer refers to when he reads the letter condemning Nora. Nora's education has

allowed her to become intrinsically stronger than Ophelia possibly could and Ibsen can therefore allow her to pursue her own identity. Since London theatres were filled with Ibsen's plays as well as Shakespeare's in the 1890s, and women schooled on Shakespeare dominated the matinee performances of Ibsen, comparisons and contrasts of women's roles in each would logically have occurred to the spectators.

The complicated structuring of gender in Shakespearean performance that began with women playing women in the 17th century became another thing altogether when women began to play the roles of men. Even the men who worked towards liberating theatre and women's performance chafed at women's behavior that was too far beyond the proscribed boundaries. William Archer, whose translation of Ibsen and support of Elizabeth Robins as actress and director were without question, became bewildered and disturbed by a cross-dressed performance of Shakespeare's *As You Like It* also on the boards in London in 1894. Kerry Powell argues that the women playing the men's parts were too realistically masculine because their costumes included beards and facial hair. Max Beerbolm would be equally upset by Sarah Bernhardt's portrayal of the title role in *Hamlet* in the same decade.[27] Since Bernhardt had first come to the fore in her breeches roles around 1870, this is somewhat surprising. Perhaps the assumption of main [male] roles in Shakespearean performance was perceived as more threatening because of the unspoken— yet almost sacred— regard for the essentially masculine domain of the Bard and his key roles. Assuming equal access by actresses to these roles must have seemed too great a liberty for the women to take.

In a sense these responses complicate the *Punch* lampoons mentioned earlier, and give the cartoons more than satirical semiotic value. At the same time, the irrefutable resistance to gender blurring reaffirms the stasis of the cult of domesticity that designated women's powers as private rather than public in much of the collective consciousness of the time. The unmistakable agency and power that cross-dressed actresses exuded as Shakespeare's heroes strongly suggested the deeper and broader ramifications of what women suffrage would demand within another decade: full citizenship for women.

Ironically, women posing as men to support a family were not a problem onstage in the 1890s, even if the playwright was a woman. Clothilde Graves's comedy, *A Mother of Three* (1896), was a favorite among London audiences. Her play incorporated a staple of the era: a woman raising children alone because her husband and their father abandoned them. It is not a sentimental melodrama, although Graves does incorporate the plot-driven formula rather than truly develop a character study. However, the

play benefits from its quick-paced scenes because these allow Graves to infuse the text with gender reversals that probe more deeply than the dialogue's lightness would predict. The mother of three has also been the father—and the protagonist plays both parts until the end of the third act. At no point is the mother assuming the guise of a man for outspoken feminist reasons; rather, she has done so to provide support for her triplets: three girls of eighteen. Graves's choice to show rather than announce the qualities of the New Woman thereby confirmed what Sarah Grand's 1894 essay, "The New Aspect of the Woman Question," stated, namely: "The man of the future will be better while the women will be stronger and wiser. To bring this about is the whole aim and object of the present struggle, and with the discovery of the means lies the solution of the Woman Question."[28]

Their father had gone abroad on a scientific journey when their mother was pregnant and has never returned, until the action of the play. The visual evidence of one actor portraying both roles was hardly new; the strength shown by the mother of three in both parental roles is the play's social statement. She has managed to keep afloat by having a boarder; at the play's opening the boarder has left and she places an advertisement for a new one; the estranged husband sees the ad and it gives him the resolve to find his wife and become the new boarder.

The daughters all wish to marry and it is the end of the season. Their problem is that they only have one evening gown and one pair of satin slippers, so they must take turns attending the social events that can land them husbands. Such circumstances invoke fairy tales and the kinds of transformation these contain. It is a clever allusion for this farcical text. In the meantime the mother has sold her hair: a practice well-known in Victorian life and noted in Louisa May Alcott's *Little Women* (1868–9) and O. Henry's short story, "The Gift of the Magi" (1905). Her daughters become "hysterical" at the sacrifice, but the mother says that her action was nothing more than her heartfelt role as a parent would dictate. The seamless blending of maternal and paternal feelings and roles by Graves is the cue to her unorthodoxy.

What makes the play transcend sentimentality is Graves's introduction of the absent father, who has sent money for his daughter (he only knows of one) intermittently. Once the father is in the scene, the alternating gender of the mother is more pronounced. Watching the mother of three go easily from one to the other leads to the comic resolution when her husband is shown that he is she and vice-versa. They decide to begin again as a couple, an outcome that reinforces what the suffrage plays of Chapter 6 emphasize: cooperation between men and women. The play

ends with the mother of three confirming that all she did was for her girls, and the girls immediately welcoming their contrite and affectionate father. Because the play is a farce, the almost non-existent *denouement* and the flatness of the characters surrounding the protagonist matter not.[29]

Graves invited her audiences to visualize what they knew already. But it was Oscar Wilde's use of stage convention and the power of satirical comedy that had pushed audiences to view the familiar—in reverse. It appeared that Wilde was content with the formula of Scribe and Sardou, as he used the key elements of the well-made play to perfection. Unlike Ibsen or Shaw, Wilde's critique threw daggers into upper-crust smugness by inverting gendered behaviors and having his characters engage in witty barbs in laissez-faire attitudes. His genius and substance came at the end of speeches, when audiences were already laughing at what they assumed was a conventional joke. Like Congreve and Sheridan, a light mood could turn on a phrase, and moral indignation emerge at just the right time, but in Wilde's plays, they come for reasons quite opposite from snobbish norms.

For the young women in the audiences, the impression of these cross-dressed characters by women actresses were likely highly suggestive. The 1890s was the first generation to come of age with the freedom of movement that bicycles and extended train service provided. Even those who never demonstrated in the streets for women's rights took full advantage of these freedoms, as Oscar Wilde's plays revealed. These carry the tradition of Restoration comedies, but his characters are individualized and down-to-earth. If stereotypes exist in their minds, the dialogue with other characters reveals them for what they truly are.

In Act I of *The Importance of Being Earnest* (1895), Jack Worthing proposes to Gwendolyn. The look of the scene and its gestures show Wilde's appreciation of melodrama's emphasis on expressing emotion. Jack declares how smitten he has been since he met her, etc. Gwendolyn, who has known this all along, only complains that he had not shown his affection more, especially in public: the height of impropriety. The disruption of the formula continues. He is nonplused and she pretends not to notice, clearly signaling who is in control by use of women's indirect power. When Gwendolyn's mother, Lady Bracknell, interviews Jack as a prospective husband for Gwendolyn, all of her motherly attributes can equally be seen as fatherly. Since Lord Bracknell is never onstage, Wilde treats him almost like Algernon's imaginary Mr. Bunburry and Jack's fictional brother, Ernest. The masterstroke behind the farcical form is that men and not women need to bolster their position via manipulation and false personae.

Wilde explodes Victorian standards within five minutes in the hilarious exchange between Jack and Lady Bracknell. At first Wilde delivers

the froth; asked if he smokes, Jack confesses that he does, expecting rebuke. Instead, Lady Bracknell approves because a gentleman "needs an occupation." When Jack confesses that he has lost both of his parents or, rather, they had lost him as an infant, Wilde changes the mood in the opposite direction. Where is there any parental feeling—motherly or fatherly—in Lady Bracknell's remarks that losing one parent may be considered a misfortune but losing two is carelessness? How could Jack's abandonment at Victoria Station in a handbag relegate him to "parcel" status? Lack of family connections had long been a stumbling block in British society, but Wilde's exposure of the raw nerve of impunity in this scene startles. True character of course was in Mr. Cardew, who adopted the baby without thought to pedigree and named him for the destination marked on the railway ticket. "The line is immaterial" says Lady Bracknell.[30] True in more ways than one, winks Wilde here.

One of the lightest and funniest scenes in the play is the diary exchange between Gwendolyn and Cicely in the following act; each mistakenly believes she is engaged to someone named Ernest. To prove their claims each produces her diary: a clear nod to the letters that inevitably showed up in *pièces-bien-faite*.[31] Since Gwendolyn has just arrived from London, Cecily is surprised that her diary is with her. Gwendolyn's response, "I never travel without my diary with me. One should always have something sensational to read on the train" essentially transposes the private into the kind of boundary-blurring narrative of "spectacular reality" that Vanessa Schwartz elucidates.

Cecily had already used her own diary to show her new fiancée that they had become engaged months earlier and she had broken it off once via fictionalized diary entries. The comedy is not solely in her imaginary engagement, but equally in the reaction of her fiancée. He objects to her breaking it off when "the weather continues charming"; on a more serious note he hopes she won't do so again. Cecily's reply is more serious: "I don't think I could break it off now I have actually met you" and goes right on to say it is his name (Ernest) that she had decided she must marry.[32] Cecily's clear implication is that even if he is real and the equivalent of her Prince Charming, it is still the name that has attached him to her.[33] Wilde's subtle incorporation of the thematics and transformations in fairy tales here should not go unnoticed. No matter the gendered constrictions, and the one plausible ending for young women—marriage—Wilde nonetheless reveals his tribute to the resourcefulness and agency that young girls and women create for themselves within the fairy tale realm. For that matter, Gwendolyn and Cecily have internalized mass culture's form, used it to write their own blend of fact and fiction, and shown themselves modern

young women in the bargain. Furthermore, Wilde has illustrated that a name, Ernest, had less to do with a person than an image: another quintessential Wildean use and inversion of cultural phenomena. In terms of theatrical structure, Wilde's play could seem to be a typical comedy of manners or intrigue, but therein lay the genius of it. Nowhere in this play do women serve as objects for men.

Shaw wrote his own answer to *The Importance of Being Earnest* in 1897: *You Never Can Tell*. For Shaw, Wilde's masterpiece was merely amusing because it had no connection to social ideas. According to John Bertolini, Wilde took exception to Shaw's review of Wilde's play because it espoused a theory that *Earnest* "must have been an old play dusted off" by Wilde. As evidence to support his guess, Shaw suggested the "Gilbertian heartlessness" of the play combined with its triple-decker title, which relegated Wilde's latest play to the 1870s.[34] Shaw saw only the form in Wilde's play, and yet apparently missed the social deconstruction behind it. It is true, however, that Lady Bracknell could have been a Gilbertian creation— one of his "dame" roles played by men.

The 2011 Roundabout Theater Company's production of *Earnest* that originated in the Stratford Theatre festival a year and a half earlier featured Brian Bedford as Lady Bracknell. Charles Isherwood's review for *The New York Times* noted that other men have done the role but Bedford stood apart because he is "playing a role, not working a gimmick" (aka the Gilbertian riposte signature style). Bedford's "stiff posture and serene bustling suggest a woman bearing her rectitude like a suit of armor and her trials with the surety of the righteous," Isherwood continued.[35] Actually, such a description is not far off the mark for Mrs. Clandon, the New Woman mother who has raised her children alone in Shaw's *You Never Can Tell*.

Shaw's own comedy is light and almost frothy in tone, but has a serious basis. Mrs. Clandon left her husband when her eldest child was a toddler and she was pregnant with twins because he was abusive to his wife and had also struck his daughter. Mrs. Clandon has lived on Gibraltar for eighteen years, supporting her family by writing a series of 20th-century guides to parenting and other social issues. Wilde's Cecily Cardew can easily be glimpsed by Dolly, one of the twins; like Wilde's character, Dolly is outspoken, well read, and determined to carve her own path. Her brother Phil routinely makes pronouncements on things based on his "study of human nature," and the elder sister, Gloria has been raised to advocate for women. From the outset, this play references Sarah Grand, not only for her articles but her novel, *The Heavenly Twins*. If Wilde's play was too trivial (Wilde's own term), Grand's novel was distressing to Shaw because of the purity and moral superiority Grand claimed for women in the novel.[36]

The point from *Earnest* that Shaw develops in multiple ways in *You Never Can Tell* is the stigma of having no father. In the play's first scene, Dolly goes to a novice dentist to get a tooth pulled, and she promptly invites him to lunch at their hotel when Phil comes to join her. The dentist, Valentine, is delighted but then refuses to go since they don't know who their father is; only when they can talk about their grandfather does Valentine accept with alacrity. Valentine's inquiry, however, engenders conversation among the siblings and they determine to ask their mother the one thing they have been forbidden: question her about their father. It is not for "form," in Shaw's play; it is a real nagging question for them, as it obviously was for Jack Worthing in Wilde's play. Shaw's play then goes on to include as much coincidence as any drawing-room comedy, when the seaside resort Mrs. Clandon chose as their entrance back into England is where their estranged father happens to be, and Mr. Cramden is also Valentine's landlord. The twins also invite the landlord to lunch, despite his very odd remark to Dolly that she resembles his mother. Shaw's enjoyment of the characters is obvious as he creates a complex web around issues of sudden love, parent-child understanding or, in the case of the landlord turned father, strained but honest conversation. The centerpiece of the play is the waiter at the hotel, whom Dolly calls William because he reminds her of Shakespeare. He has the wisdom, warmth, and easy manner to prod them all to the best possible outcome.

Kerry Powell adds the other important layer to Shaw's play: his inclusion of and revision to Clothilde Graves's *Mother of Three*, discussed above. Shaw dismissed the play as a farce, but then rewrote it in *You Never Can Tell*. Powell claims that Shaw was actually "resisting the aspect of the 'philosophy' of the New Woman which made him most uncomfortable—that part which challenged the polarization of male and female and dared to require modification in the behavior of men."[37] And yet *You Never Can Tell* likewise examines the way people need to take emotional risks, weather arguments, and determine their future. When Valentine and Gloria become smitten, Gloria realizes that her mother taught her about everything except passion and emotions. Valentine says what most of us think when love takes us over: dread because we know the feeling is bigger than we are.[38]

In 2013, David Staller of Project Shaw directed a revival of the play at New York's Pearl Theatre Company. In his program notes, Staller acknowledges Shaw's rebuttal to Wilde but adds another layer: He was pushing fifty and, "probably due to his feeling of inferiority and lack of formal education which he brilliantly suppressed by creating the flamboyantly confident persona in the form of G.B.S., he was prone to dark depressions.

Fortified with the decision that the only way to face the future was to embrace its uncertainties, he set to work to prove his point."[39] Shaw's play reveals all of these psychological factors, and then does what Shaw did best: upend Victorian complacency. By the end of *You Never Can Tell* social classes blend, firmly held emotional barriers break, and, as the Pearl's Acting Artistic Director, Kate Farrington, put it: "the bald coincidences of Victorian farce give way to something more impish and more grand—a play in which 'happy accident,' when viewed logically and correctly is, in its own cheerful way, perfectly natural."[40]

In earlier plays, Wilde had given Victorian audiences ways to view unhappy accidents as well. In *Lady Windermere's Fan* (1892), the fan, letters, and well-kept secrets leading to completely false assumptions situate the reversal of fortune that will come from innate character rather than serendipitous circumstances. Mrs. Erlynne did abandon her infant daughter and had run away from her marriage years ago; she has been the fallen woman many times over, and, true to convention, she has paid the price. She regrets her actions, of course, but never felt maternal until her daughter seems destined to repeat her own mistake. Rather than a sentimental story about a mother's epiphany that all she ever really wanted was to be with her child, Wilde gives us a portrait of a woman who inveigles money from her daughter's husband to bankroll her search for a husband and a fresh start in life.

Of course the rumor mill spins a story that the woman is having an affair with Lord Windermere. Lady Windermere, Mrs. Erlynne's daughter, becomes convinced this is true when she looks at her husband's checkbook and sees several large amounts given to Mrs. Erlynne. He is upset that she is "spying" on him, and yet will not share the reason he gave the money: the secret of Mrs. Erlynne's situation or her relation to his wife, Margaret. He insists that Mrs. Erlynne come to their house party, which naturally insults Margaret, who then shows the harshness of society's teachings. Immediately she believes the rumor and disavows her own marriage. She tells him she cares not that money has been given to this woman, but feels "degraded" because: "you who have loved me, you have you have taught me to love you, should pass from the love that is given to the love that is bought." His reply evokes Wilde's critique: "Mrs. Erlynne was once honored, loved, respected. She was well born, she had a position—she lost everything—threw it away, if you like. That makes it all the more bitter. Misfortunes one can endure—they come from outside, they are accidents. But to suffer for one's own faults—ah! there is the sting of life."[41]

While much of the play conforms to the formulaic melodrama, Wilde nonetheless challenges two prevailing social notions: first, that an indi-

vidual, regardless of gender, cannot be selfish and selfless; second, that people need their ideals removed to grow and change. Wilde allows Mrs. Erlynne to be self-serving and get the money she needs to resume respectability and yet put all at risk to prevent her daughter's mistake. When Lady Windermere's fan is in plain sight at Lord Darlington's rooms after Mrs. Erlynne has sent her away to avoid disgrace, Mrs. Erlynne tells the men she had picked it up by mistake and returns the fan to Margaret the next morning.

Just when the audience of the time would have expected the "tell-all" scene and reunion of mother and daughter, Wilde demurs. Margaret's idealization of her presumably dead mother remains intact. Why? Because Mrs. Erlynne will not magically become a real mother, and Margaret need never know she had been abandoned by a mother who is alive and in front of her. This is Wilde's way of admiring the ideas of Henrik Ibsen, but offering these to audiences in an alternative way. Ibsen's consistent need to undo ideals to enable growth becomes something different in Wilde's text. The trope of the all-sacrificing mother is not cast aside; rather, it is shown to be multi-dimensional. The illusions of the audience, rather than the character, are examined instead.

Bernard Shaw would expose a more far-reaching representation of society's relegation of misery as well as shame to poor women, those who had no pretty conventions to hide behind. *Mrs. Warren's Profession*, written in 1894,[42] was one of the clearest Ibsenite challenges to Victorian and Edwardian smugness regarding women's sexuality. Composed in clear opposition to Pinero's *The Second Mrs. Tanqueray*, Shaw's play "deliberately reversed every convention of the fallen-woman drama," according to Sos Eltis.[43] Pinero's play combined a realistic view of upper-class social interaction within the context of the woman with a questionable reputation stereotype.

The center of Shaw's play is the daughter, Vivie, who is a clear representation of the New Woman, from her masculine handshake and penchant for whiskey and cigars to her determination to live on her own. Shaw's play begins and ends with Vivie onstage alone, signaling to the audience that what happens to her during the course of the play affects her more inwardly than outwardly; she will pursue the life she planned before the action of the play occurred. Instead of a stepmother possibly "tainting" her husband's "pure" daughter, Shaw's play centers on the generational as well as moral disparities between a mother and a daughter who have not really lived together, but whose genuine interaction in this play teaches us the boundaries and limitations of societal labels.

The complication of the play surrounds the source of Vivie's financial

security, rather than any untoward behavior in the protagonist herself. Shaw's opening scene stage directions note his intentions. Vivie's initial behaviors mirror the lampoons of the New Woman. Unaware that her mother is coming and has invited other guests to the cottage where she is staying, Vivie is reading actuarial accounting books contentedly. As each man comes into the scene, they wince at the crush of her handshake, as well as her refusal to bow to chivalry of any kind. Vivie hands out the lawn chairs herself, and has brisk, masculine manners. One can't help but believe Shaw was winking at the anti-suffrage sentiment alive and well in his audiences here. This way of opening the play establishes the conflict between parents and children that would become one of Shavian dramaturgy's clear contributions to modern drama.

But what the play did that was insufferable to the Lord Chamberlain and many early critics was to put the issue of prostitution into view within an unrepentant, successful Madam who paralleled her work ethic with those of captains of industry.[44] Shaw's play was censored because such a stark evocation of the horrors of the class system caused the furor among critics, actors, and even supporters of New Drama like J.Grein, director of the Independent Theatre, and William Archer, translator of Ibsen. Shaw's outrage because of this flagrant hypocrisy by the Examiner of Plays[45] emerges plainly and extensively in his Author's Apology to *Mrs. Warren's Profession*. Shaw's consternation aimed at three distinct kinds of naysayers. Firstly, the theatre managers and critics who had lauded the coming of Ibsen and helped stage Shaw's first play *Widower's Houses* (1892)— specifically Grein and Archer, who claimed that this play "'shattered his ideals'" (Grein) and that [Shaw] "'cannot touch pitch without wallowing in it'" (Archer). Shaw then undercuts the critics by remarking: "Anybody can upset the theatre critics, in a turn of the wrist, by substituting the moral commonplaces of the pulpit, the platform, or the library." Instead, he argues, if the judges of the play worked in the Christian Social Union or were women "well experienced in Rescue, Temperance, and Girls' Club work … no moral panic will arise." This is because all of them would know that they would continue to lose their daily battle against prostitution "as long as poverty makes virtue hideous and the spare pocket-money of rich bachelordom makes vice dazzling." Shaw also takes the side of the women's campaign for the repeal of the Contagious Diseases Act that "would compulsorily examine and register Mrs. Warren, whilst leaving Mrs. Warren's patrons, especially her military patrons, free to destroy her health and anybody else's without fear of reprisals."[46]

Clearly Shaw's stern reminders of Victorian mores should have required no explanation. From the early years of Victoria's reign, a con-

siderable portion of women had to earn money to survive, whether single, married, or living in common-law relationships. Those in the working classes lived in crushing poverty, and exposés began to appear in the 1840s that told of women slipping into prostitution. Yet more people in the population were literate and able to afford the "penny weekly" London magazines that fed them stories. According to Sally Mitchell, these magazines had the highest circulation among those on the cusp of the middle class in the mid–Victorian era, "an audience of changing aspirations, expectations, and opportunities ... readership crossed class lines ... [and was] open to individuals whose literacy gave them the necessary qualifications ... the common denominator was the aspiration for respectability."[47]

Shaw may have counted on the lingering influence of these "penny weekly" stories as ready references for his audiences, as he proceeded to chip away at them during the mother and daughter scene at the end of Act II of *Mrs. Warren's Profession*. This truth-telling scene both fulfills Victorian melodrama's penchant for high-intensity act closers, and illustrates the thin veneers that such scenes can pierce. Ignorant of her own origin and the details of her mother's life, Vivie has grown up with tutors and caregivers and graduated from Newnham, one of the first women's colleges in England, and displays all the privilege of that class. Her mother has provided all of this and now expects a mother's reward: an obedient daughter who will take care of her when she is old. Vivie has no inclination to do this; after all, she doesn't know her mother and has been denied family life of any kind.

Vivie begins the scene with the intention of dismissing her mother's demands for affection from her, an attitude fueled by her resentment towards her mother's sudden desire for true connection. Vivie demands to know her origins; Kitty provides no clear answers, but instead falls back on reminding her daughter that she owes her mother respect, as well as gratitude for all she has provided for her. Kitty had protected her child from potential disgrace, but, conversely, chose her own enjoyment of financial success over true attachment between mother and daughter.

As Vivie learns her mother's history, Eltis notes that Mrs. Warren responds "not with shame and repentance, but with vigorous self-justification ... society left her with the immoral choice."[48] Kitty's own childhood and adolescence were Dickensian; a half sister had died from the lead poisoning in a factory, whereas Kitty was given a "great opportunity" to serve in a bar until the wee hours for board and a few shillings. Kitty tells Vivie that Liz, her older sister, came into the bar, beautifully dressed. Liz had left home, and now Kitty realizes she has chosen the oldest woman's profession. Liz barely recognized her overworked sister and

convinces Kitty to join her. Shaw uses the familiarity of the plight of London's underclass to highlight Kitty Warren's recognition that she had to work with what she had: her own attractive body and quick mind.

Vivie's response to her mother's story wins her heart, and of course, arouses the sympathy of the audience. Vivie tells Kitty that she is "stronger than all England."[49]

Pinero's sense of the dramatist's task—"giving back to the multitude their own thoughts and conceptions illuminated, enlarged, and, if needful, purged, perfected, transfigured"[50] was the complete inverse of Shaw's. When Paula Tanqueray's past catches up with her and has impact on her step-daughter as well as her husband, she has the "grace" to commit suicide to avoid further complications for those around her. Sos Eltis explains that Paula recognizes that her future could only bring ruination because her

> repentance and self-inflicted death fulfill traditional expectations, though the conclusion lies ambiguously between tragic waste and the only possible solution to an insuperable problem. Ultimately her demise leaves the audience free to indulge whatever degree of pity she has inspired without being challenged to find a place for her in their social and moral scheme.[51]

Herein lay the key distinction: Pinero showed the social reality without expectation that the audience be moved to correct it. Shaw sets his play up to have mother and daughter understand each other, but then reverses course at the end of the play because Vivie cannot reconcile herself to her mother remaining a Madam well past necessity's justification for her to do so.

According to Richard Dietrich, Shaw used some of Pinero's main concepts and then turned them inside out: "Shaw one-upped Pinero by creating a 'woman with a past' who was allowed to speak for herself rather than having words put into her mouth." More importantly, Dietrich observes that Shaw's plays' attacks on Victorian family ideals, as well as romantic and religious ones, are the frame, rather than the center of the work.

Dietrich contends that Shaw's purpose is psychological: "one character, usually a younger person, a potential Realist, is taught a lesson by another character, usually an older person, who may or may not be aware of what is being taught; and the result is, first, disillusionment, second, enlightenment, and third, a growth in spirit that allows the evolving character to better realize his or her authentic self."[52] In this play, the pattern Dietrich describes works on more than one level. Vivie does learn from her mother and Sir George Crofts, but she also turns the lesson back on her mother by the closing scene of the play.

Vivie's sense of herself as a non-romantic businesswoman is even

stronger by the play's end because of the enlightenment and disillusionment she receives. Shaw's play urges us to understand why Kitty chose her profession and, in so doing, recognize the enormity of insufficient choices for women. Mrs. Warren's claim in Act II that it's "only good manners" to feel shame for her work, falls flat once George Crofts referred to the "business" in present tense, sure that Vivie was aware of where her money came from. Kitty's point to Vivie, that almost all women must persuade men one way or another to support them, then begins to leads us elsewhere. Kitty Warren turns out to be a combination of a shrewd executive and a middle-aged Victorian woman who wants her daughter to turn sentimental, despite the fact that she had spent almost no time with her.

We applaud Vivie for understanding the need that drove her mother to make such a choice, but do not admire her smugness when she dismisses her mother from her life, permanently, because she cannot understand her staying in the profession years longer than was necessary for economic survival. By refusing money from her mother at this point in her life Vivie is taking her stand, but it is nonetheless true that without the advantages her mother provided, she could not claim independence.

Nonetheless, Vivie Warren can begin a partnership in an actuarial firm in London under a more seasoned woman by the end of the play. Shaw clearly signals growth and change on the horizon. Such a choice for Vivie not only acknowledges the first generation of women graduates, but also nods to suffrage leader Millicent Fawcett's daughter, who won the math tripos and went on to become an activist educator.[53] Further, in a possible nod to Ibsen's emphasis on heredity, Shaw has Vivie recognize that she is her mother's daughter in her need to work and her ability to turn off emotional reactions. Kitty learns that her choice to not be with Vivie at least some of the time when her daughter was a child makes her wish to be with her daughter in future old age impossible. Neither of them is a heroine. Ultimately, both mother and daughter represent the masculine domain of preferring work to all else. This combination makes Shaw's work truly new drama.[54]

Dorothy Hadfield, among other scholars, emphasizes the importance of Shaw's writings in the 1890s on the woman question; these earned him "significant notice as an ardent champion of early feminism. Casting himself as Ibsen's dramatic disciple, Shaw wrote the female parts in his own plays with depth and complexity in motivation and thought, placing them squarely center stage to argue their case,"[55] and thereby became renowned as a feminist playwright. Even if Shaw relied on iconic elements of social comedy and had his women marry by the end of the play, his characters allowed actresses to showcase their brains, take charge of the action of

scenes, and move past tableau-like gestures. That is why a number of younger actresses wanted to work with him.

Yet, Hadfield emphasizes, Shaw's "offstage productions"—his relations to actresses and women writers who were aspiring feminist playwrights—present "a slightly different vision of Shaw's commitment to women's emancipation: one that suggests that his efforts to liberate women from the bonds of convention may have largely served a desire to constrain and confine them instead within the ones he himself defined."[56] Put another way, crafting unconventional behavior for the stage gave Shaw a way to engage in social critique; sharing the playwright's role with women he admired onstage could meet his resistance, either as an egotistical artist, a Victorian-era man, or a combination of both of these. Conversely, Shaw maintained close ties with actresses who would be managers. Two examples would be Lena Ashwell and Edy Craig. Both of these women acted in Shaw's plays and produced Shaw's plays in their own theatres.

Lena Ashwell followed the sagacious and kind advice of Edy Craig's mother, Ellen Terry (see chapter epigraph), and changed her path from music to acting in 1890. Terry helped Ashwell secure a minor role in the touring company of *Lady Windermere's Fan* in 1892 and did a variety of small roles in melodrama and comedy. Her first strong praise came in a tour to Ireland in Sidney Grundy's *Sowing the Wind* in 1894. The *Irish Times* critic emphasized how well Ashwell overcame any possible temptation to "'tear passion to tatters [she was] extremely impressive and powerful in her delivery ... of the lines in defense of erring woman, or rather in denunciation of that society which shrinks from the stricken sister.'"[57] Other critics confirmed Ellen Terry's impression that Ashwell went far beyond declamation and showed her passion and intellect.

Shaw then wrote a very favorable review of her performance as Prince Edward in *Richard III* at the Lyceum in 1896, cast by Henry Irving this time. Shaw was struck by how much stronger her voice was, and how much more confidently she held herself onstage. The person Shaw went after in the review was Irving, who he castigates as thinking of Ashwell as she had been earlier, as understudy for Ellen Terry's Elaine in *King Arthur*. Shaw commented that Ashwell in doublet and hose could not disguise the womanly charm and power of Ashwell's presence: "Nothing can be more absurd than the spectacle of Sir Henry elaborately playing the uncle to his little nephew when he is obviously addressing a fine young woman in rational dress, who is very thoroughly her own mistress, and treads the boards with no little authority and assurance as one of the younger generation knocking vigorously at the door."[58]

Another member of that dominant generation of actress/managers,

Elizabeth Robins, encouraged Ashwell to take the parts that would show her powers, and take chances on works from forward-thinking dramatists. She took the advice and landed the role that would make her a star soon afterwards, Mrs. Dane in Henry Arthur Jones's *Mrs. Dane's Defence* (1900).[59] Within a few years, each of these women would exert considerable influence on change in the theatre, and as activist leaders.

Edy Craig was also a member of the Lyceum and, like her mother, was visually as well as dramatically talented. She became a costumier as well as actress in the company and would use these combined skills to great advantage beginning with her mother's Jubilee in 1906 (see Chapter 1). Her first work in a Shaw play was in the first production of *Candida* in 1897, where she was the original Proserpine (Prossy) with Janet Achurch as Candida. Prossy gave Edy a chance to combine her political passion and her comic timing to great advantage as one of Shaw's New Women; she repeated the role in the Stage Society production in 1900.[60] As a theatre manager in various venues, Craig would stage Shaw's *Press Cuttings* along with *How the Vote Was Won* for the Women's Freedom League Fair in 1909, and her subscription theatre, the Pioneer Players, would stage *Mrs. Warren's Profession* in 1912, a production Shaw liked immensely. All in all Craig would stage more than twenty Shaw plays by the end of the 1920s.[61]

His work in the 1890s cements Shaw's work with and on behalf of women in the theatre. Sometimes, however Shaw's personal ambivalence towards women entered the script. A clear example of Shaw's contradictory portraits of women is his representation of Cleopatra in his 1898 *Caesar and Cleopatra*. Shaw's Cleopatra is young, somewhat puerile, and yet brimming with intellect and charisma. While neither Caesar nor Cleopatra is introduced as all-powerful in Act I, it is clear that Caesar is the center of this play. Although the play is labeled a history, their historical sexual liaison and the son Cleopatra hoped would inherit Caesar's rule in Rome is eliminated from Shaw's play. Shaw's decision is in keeping with his indignation over the sanctioning of sexual emphasis in representations of Cleopatra in visual art or onstage. Victorians' popular image was shameful in two directions: Cleopatra's behavior and their fascination with it. In the "Author's Apology" to *Mrs. Warren's Profession* five years earlier, Shaw warned of the danger: "It is not the fault of their authors that the long string of wanton's tragedies, from Antony and Cleopatra to [Pinero's] Iris, are snares to poor girls."[62]

This emerges clearly in Ra's "Prologue" to the audience in *Caesar and Cleopatra*, where the god Ra addresses the audience, chastising the women's "alluring" appearance, which allows them to "conceal your thoughts from your men, leading them to believe that ye deem them wondrous strong

and masterful whilst in truth ye hold them in your hearts as children without judgment."[63] Ra shows them little respect: "Do you crave for a story of an unchaste woman? ... Cleopatra is as yet but a child that is whipped by her nurse. And what I am about to shew you for the good of your souls is how Caesar ... found Cleopatra ... and what things happened between the old Caesar and the child queen."[64]

According to Doris Adler, the stage history/reception of Cleopatra had been fragmentary from the Restoration until the 19th century.[65] Apparently, Shakespeare's Cleopatra became problematic to stage since women did not "boy" her. Cleopatra gained a more womanly appearance, achieved through elaborate costumes, but productions retained the emphasis on the tragic scenes and the character's grand gestures. Cleopatra's centrality in women's tableaux vivants stemmed not from her perceived role as temptress; rather, women viewed her as powerful leader and protector of her son fathered by Julius Caesar, who she hoped would inherit his father's powerful position. The women who would portray her onstage in the late 19th century, albeit in fragmentary tableau scenes rather than Shakespeare's whole play, were women who were simultaneously leaders for women's professional and political empowerment.

By 1889, Adler informs us, three actresses completely reversed Cleopatra's onstage *persona* and played her as a youthful, clinging, sympathetic and complex woman, with gauzy, sensual clothing. An American amateur, Cora Potter started the trend; she was followed by Sarah Bernhardt in Paris, Lillie Langtry in London, and Fanny Davenport in New York. Bernhardt had Sardou extract the key scenes for Cleopatra from Shakespeare's play and she and other actresses performed simply "Cleopatra." In 1897, Shaw saw Janet Auchurch's *Antony and Cleopatra* played in like fashion.[66] Adler suggests the influence of these performances on Shaw's Cleopatra; perhaps this was the case, minus the sexual allure.

In Act I of Shaw's *Caesar and Cleopatra*, Cleopatra is but a frightened child hiding from the Romans who will "eat her," setting up the question of which culture is more civilized. The double dramatic irony here is that Caesar believes he is alone before *the* sphinx, and offers his innermost thoughts: "I am he whose genius you are the symbol: part brute, part woman, and part god—nothing of man in me at all. Have I read your riddle, Sphinx?" When Cleopatra calls out to him as "old gentleman," and offers to share her sanctuary, she also tells him he is really addressing her "pet sphinx." Here Shaw startles the audience as well as the character. Caesar is quite disappointed, but immediately enchanted by this "divine child."[67]

Later in Act I, Caesar takes Cleopatra back to the Palace without revealing his identity, warning her that "this very night you must stand

face to face with Caesar in the palace of your fathers.... Whatever dread may be in your soul—however terrible Caesar may be to you—you must confront him as a brave woman and a great queen; and you must feel no fear."[68] Far younger than her years here, Cleopatra replies that a sorcerer would be needed for that, but with Caesar's schooling, Cleopatra rises to the challenge. Above all else, Caesar wants Cleopatra to rise above her heritage and rule with wisdom and clemency: not with haste and violence. Cleopatra matures throughout the play, but remains insecure, always seeking the approval, attention, and direction of Caesar: a prototypical Victorian dynamic.

Yet Shaw's take on Cleopatra is mercurial, especially to us as postmodern audience. He may have cast his Cleopatra into the "ingénue" mold he so often worked against, but would not let her complete the lessons of the ingénue. Despite Shaw's disgust with actresses like Bernhardt and their stage vehicles, it is curious that his Cleopatra retains their presence and "big scenes": arriving at Caesar's ship rolled in rug; the banquet scene. But his twist was showing her as pouting like a spoiled or scheming child rather than a temptress. In Shaw's text, Cleopatra's charm does not override what Caesar perceives, in clear imperialistic fashion, as the inferiority of her culture and upbringing.

In Act IV we see the fullest growth in Cleopatra's ability to rule, and of her deepening character. In the opening scene of this act with her women, they tease her for her sudden seriousness, and she chides them for their foolish talk and attitudes. In her scene without Caesar, Cleopatra shows that she has learned ruling is far less about doing what she likes than doing what needs to be done for the sake of her people. She recognizes that Caesar loves no one and lives through and for his work. She illustrates leadership moments later, when she learns that Pothinus intends to tell Caesar that Cleopatra is against him. Cleopatra acts swiftly, and commands Ftatateeta to kill him. At the celebratory banquet scene, when Caesar uncharacteristically drinks wine, the news arrives. When she sees Caesar's anger, she tries to cover up, but then does take responsibility: "He was slain by order of the Queen of Egypt. I am not Julius Caesar the dreamer, who allows every slave to insult him."

All but Caesar agree that she was right to have him killed. But Caesar sees that Pothinus' assassination has led to blood in the streets, and makes his role of "superman" clear at this moment in the play: "If one man in all the world can be found, now or forever, to know that you did wrong, that man will have either to conquer the world as I have, or be crucified by it."[69] He later tells Cleopatra that he had never trusted her.

Act V pushes Cleopatra to the background: Caesar has granted the

position of Viceroy to Rufio. Why has Shaw denied Cleopatra her earned historical role here? Cleopatra is far from his thoughts; she has to seek him out to say goodbye. Why no suggestion of the empowered and intelligent Cleopatra Shakespeare gave us? Is Caesar or Cleopatra "part brute, part woman, part god"—sphinxlike by the play's end? Once she's come into the scene, Caesar's mood changes on a dime. Once again he's kissing her on the forehead with a promise to send her Mark Antony, while she waves good-bye with her handkerchief, weeping in ironic but nonetheless melodramatic style, having been put squarely back into her place as a woman. Shaw's choice of Rufio as Viceroy is more than puzzling since it is historically inaccurate. Conversely, however, this choice by Shaw makes sense if we think of *Caesar and Cleopatra* as Shaw's critique of the centuries-old emphasis on Cleopatra's sexuality and quasi *femme fatale* power over Mark Antony in productions of Shakespeare's *Antony and Cleopatra* once women played the role of Cleopatra onstage.

Thus the ambiguity of Cleopatra in the popular imagination during the heightened phases of the woman question exemplified the duality of women's images and roles. On the one hand they were merely enticing bodies; on the other, they were shrewd leaders. Another work from the 1890s that had far-reaching implications for the status quo ideology of the *fin-de-siècle* also concerned a figure from antiquity and came once again from Oscar Wilde: *Salome* (1892). Written in French expressly for his friend Sarah Bernhardt, the play was scheduled as part of the Palace English Opera House season of Bernhardt. At the last minute, the play could not be licensed for performance in London because it "depicted biblical characters onstage." As a result, the Palace became a variety theatre, and became a site of gentlemen's entertainment.[70]

Considering that this text appeared during the build-up of Wilde's own personal crisis and imminent trial for indecency in 1895, it is no wonder that *Salome* was attacked. Nevertheless, the work was not only recognized instantly as a modern masterpiece, but also an inspiration for the drawings of Aubrey Beardsley, a libretto for an opera of the same name by Richard Strauss, and the re-introduction of bawdy tableaux vivants in the Empire, Alhambra and other major sites in London's Soho in 1893.[71] This was the same year that Pinero's *Mrs. Tanqueray* hit the boards. These tableaux featured nudity but also stasis, and "passivity" for women in the tradition of frozen poses. Walkowitz notes: "Despite the sensational exploitation of the genre in the music halls, female posing would also continue to be a respectable form of amateur entertainment, highlighting dramatic effect, emotional tension, and incipient action."[72] These entertainments also reconfirmed Victorian theatrical tableaux, and the tacit acceptance of the

Aubrey Beardsley, illustration for Oscar Wilde's *Salome*. The Art Archive at Art Resource, NY. Beardsley's drawings catapulted the text of Wilde's scandalous representation of Salome and her lust for (and commanded murder of) John the Baptist into wide circulation, and showed the true gender fluidity of Wilde's interpretation of the story. Note especially the illusion of mirror image between the two figures and the sweep of each costume.

danger of women's agency and the reassurance of women's passivity in these visual enactments.

Wilde's *Salome* was most noted for Salome's Dance of the Seven Veils, by which she manipulates her step-father and exacts her revenge: beheading John the Baptist. Oscar Wilde's version of the story drew heavily upon the 19th-century reconfiguration of the history of Salome, particularly versions by Flaubert and Mallarme. Wilde's complication of Salome's character in his play to give her agency through her sexual desire: undoing the Victorian notion that only men experienced desire. According to Udo Kultermann, the dance stretches back to Ishtar in *Gilgamesh* and can be read as either traditionally misogynistic *(femme fatale)* or transgressive: " it unveils the female body for imaginative and creative purposes ... exploiting the male gaze and transformation of earlier female dependencies to a new form of freedom.... Salome can be seen as the fighter for freedom, independence, and equality of the sexes."[73]

Carmen Trammell Scaggs points to Wilde's representation as faithful to the tenets of the Decadent movement: "He enters the chasm of human emotion and reveals both the savage and noble heights to which humanity ascends. He explores the deeply ingrained gender ideologies of modernity and the sexual perversities of modern culture."[74]

Collectively, these cultural threads coalesced into potent statements about women's sexuality and control, whether Salome is coded as *femme fatale*, feminist icon, or a foil for the true beauty Wilde has Salome perceive in the text: Jokanaan. Scaggs notes a number of coded homoerotic references in Wilde's text beyond Salome's consistent refrain of Jokanaan's beauty. The Syrian who chases her is in danger; she promises him to drop a green flower, referring to a green chrysanthemum, a homosexual emblem in 1890s Paris.[75] Any of these levels of transgression alone could have caused the censorship. Collectively, the sexual and public power exercised by Wilde's *Salome* signaled Wilde's recognition of the shift in attitudes towards gender and sexuality across the spectrum, despite the taboos.[76]

As the 1890s came to a close, many of the very large theatre venues would begin to lose their dominance. The New Drama of the Edwardian era was born with the establishment of little theatres. As social stasis continued to shatter, playwrights created new styles and ideas, and continued to reinvent forms from the past to create truly modern drama. These are the subjects of the next chapter.

4

Moving Mountains in Small Spaces: New Drama ca. 1900–1914

> At the Court the acting pleased from the first.... The aim of the management throughout was truth as opposed to effect. The ideas which regulated every detail, decided the importance of each scene and the prominence of each character was a recognition ... that in order to make others feel you must feel yourself, and to feel yourself you must be natural.—Desmond MacCarthy, *The Court Theatre, 1904–1907*[1]

The impetus in the early 1900s to put up shoestring productions of new and controversial plays in London was a necessity: private performance gave innovators a means to escape censors and attract audiences for realistic drama. These alternative theatrical experiences reinforced the impact of theatergoing as a participatory experience. People who attended little theatres no longer expected plays to merely divert them for the afternoon or evening. Rather, they became used to getting to know the characters who peopled these plays and analyzing the onstage conflicts in comparison to their own life experiences. The physical intimacy of the venues enabled the actors, directors, and stage designers to more readily embody what Stanislavsky urged his actors to achieve. That is, the character thinking through a situation, recognizing an emotional or spiritual epiphany, or simply choosing what to serve at dinner had to be given to each audience with the freshness of discovery. In return, audiences experienced these ordinary experiences from the "inside out." Those in the vanguard of the

New Drama wanted to teach audiences how to be fully immersed in a play. It is no accident that the playwrights and actors in this study believed strongly in the necessity of a national theatre: a repertory of varied styles, experiments, and short play runs.

These venues continued what the subscription society of the 1890s had begun. In 1891, J.T. Grein's Independent Theatre Society opened; its mission was to foster European drama in London. Its first production was Ibsen's *Ghosts* in 1891, the same year Elizabeth Robins and Marion Lea mounted the London premiere of *Hedda Gabler* at the Vaudeville Theatre. Robins's biographer, Angela John, emphasizes that the spring of 1891 changed theatre landscape not only because of the new drama presented, but also due to the enormity of Robins's and Lea's contributions to the translation as well as casting for the production. They chose to produce Hedda for several reasons; chief among these were the two strong roles for women and the play's title as a woman's name.[2]

The prompt books of the production for *Hedda Gabler* indicate how new the ground was for actors and actresses working with Ibsen and, even moreso, how challenging the performances were for audiences used to plays beginning with detailed exposition. Angela John explains that the book Robins would write, *Ibsen and the Actress* (1928) would delineate the challenges but also the great rewards of bringing Ibsen's characters to audiences. Robins concentrated on Ibsen's method of having much action beyond what was represented on the stage so he could draw the inner lives of people to the forefront. Angela John's perception that Robins's use of the body to evoke Hedda's character was her way of showing audiences "her understanding of how guilt prompts evasive and euphemistic speech."[3] Robins "took her audiences seriously," says Angela John; a spectator advised her to never take another curtain call following the première of *Hedda Gabler* in an effort to add to the "realism of Hedda's final act."[4] She complied.

A year later, Grein staged Shaw's first play, *Widower's Houses*, exposing slum landlordism and introducing what would become a Shavian trademark: an assertive young woman as the center of the action.[5] Founding members of Grein's society included Arthur Wing Pinero and Henry Arthur Jones, who were ordinarily associated with commercial theatre. Pinero's and Jones's plays featured stereotypes like the "fallen woman" but, as Christopher Innes points out, gave heroines dialogue that pointed out the sexual double standard that condemned them. Further, these two commercial playwrights were fully behind Shaw and Barker in their fight against censorship on the stage.[6] By 1899, the Stage Society emerged with Shaw's fast-paced portrait of an unconventional family, *You Never Can*

Tell,[7] which would be at the Royalty Theatre the following year. James Woodfield explains that The Stage Society was "run by a committee with a wide range of ability and experience ... and it had the cooperation of the acting profession."[8]

Smaller theatre spaces also prompted the rise of the actress manager. Mrs. Patrick Campbell's rose to prominence through Pinero's plays, but Campbell would go on to produce and star in Maurice Maeterlinck's *Pelléas and Mélisande* in 1898 in London and 1902 in New York,[9] followed by Edith Lyttleton's play about the plight of workers, *Warp and Woof*, in 1904.[10] Lena Ashwell's work in Jones's *Mrs. Dane's Defence* in 1900 made her a star. By 1904 she set out as a manager because, like so many other actresses, she knew the prevailing casting system limited her options. By 1907, Ashwell would become the owner/manager of the Kingsway Theatre. Edy Craig, Ellen Terry's daughter, acted and did costumes for the Lyceum Theatre, and would spearhead and direct the Pioneer Players from 1911 to 1925.[11]

The success of the Stage Society "led directly to the launching of the Vedrenne-Barker management at the Royal Court 1904–07 and to the explosion of Shaw onto the theatrical scene."[12] Harley Granville Barker accepted J.H. Leigh's invitation to produce *Two Gentlemen of Verona* in 1904 with the stipulation that Leigh's business manager, John Vedrenne, also stage six matinees of Bernard Shaw's *Candida*.[13] Shaw had already written eleven plays, but until Barker's initiative he had been, in Dennis Kennedy's words "the most important playwright in English and European history to have been snubbed by the regular theatres."[14] Florence Farr's production of Shaw's *Arms and the Man* in 1894 at the Avenue Theatre in London, and Richard Mansfield's New York productions of *Arms and the Man* in 1894 and of *The Devil's Disciple* in 1896 were Shaw's only true exposure to mass audiences before the Vedrenne-Barker seasons began in 1904.[15]

Granville Barker had the vision of a small art theatre already in his mind before his arrangement with John Vedrenne materialized. In 1903, Barker wrote to William Archer with his fresh idea: to have a small London theatre which would extend the Sunday and matinee venues to a fuller stock season, "and change the bill often enough to avoid any suggestion that a play's run must be controlled by the box office." Barker's other crucial stipulation was the opening of tickets for non-subscribers at a reasonable cost. The limited funds were a boon to Barker's vision because emphasis would be on the quality of the plays and performers rather than expensive production costs. The other vital plus of the scheme would be remedy for the performers: "our actors—and worse still our actresses—are becoming demoralized by a lack of intellectual work—the continual demand for nothing but smartness and prettiness." In addition to the wide range of

socially significant themes in a wide range of texts, Granville Barker wanted to produce two other pivotal strands of modern drama: revival of Greek drama, and the continuation of the European symbolist and art theatre. The alternation among the three kinds of plays also benefitted from the trademarks of the Barker-Vedrenne seasons: ensemble-style acting, actors and actresses playing many types of roles, and the minimal effort and expense towards staging.

Archer's great contributions as translator, critic, and co-founder of the New Century Theatre in 1897 with Elizabeth Robins were the work of a quarter century. But Archer was not a "practical man of the stage.... Barker was young, idealistic, and indefatigable; he was now an accomplished actor and a promising playwright." It took a year but Archer made the connection to the Court for Barker to direct *Two Gentlemen of Verona*.[16] The critic, A.B. Walkley was struck by Barker's production, referring to its "vein of airy intellectuality almost Bernard-Shawesque in its modernity."[17] Kennedy emphasizes the mention of Shaw in Walkley's review as "especially appropriate" to cement the agreement with John Vedrenne.[18]

These innovative Vedrenne-Barker productions would include eleven Shaw plays, Gilbert Murray's new translations of Euripides's plays, European works by Ibsen and Maeterlink, Yeats from the Abbey Theatre, and works by St. John Hankin, John Galsworthy, and Elizabeth Robins. As audiences grew in number, the power of plays to spur activism and/or different attitudes towards personal choices came to the fore, and a clear demarcation developed between "commercial" and "little" theatre. The grandeur and pleasing visual aspects belonged to the former; the evolving consciousness of psychosocial performance was the purview of the latter.

Between the turn of the 20th century and the First World War a number of theatre groups and venues arose on both sides of the Atlantic. Shared though disparate visions led them beyond the ideology that informed the melodramas that had been the basis of popular culture for nearly a century. Jane Addams and Ellen Gates Starr co-founded Hull House in Chicago in 1889, inspired in part by their visit to London's Toynbee Hall in London's East End slums. This place was opened by Oxford-educated men in memory of Arnold Toynbee, and to honor his wish to give back to those in need, with more than a handout. Toynbee's founders aimed to "bridge the gulf that industrialism had created between rich and poor.... In addition to reproducing a college atmosphere with lectures, clubs, picture exhibits, and university extension classes, Toynbee residents worked to promote labor issues and other kinds of civic reform."[19]

Shortly upon arrival at Hull House, Addams and Starr witnessed their principles in real time. They were introduced to the primacy of theater in

the lives of the community; they glimpsed a long line of people waiting to attend a Sunday matinee at the Bijou theater two hours ahead of the scheduled performance. When the women spoke to a group of youth after the play, they learned far more about the theatrical experience than about the youths' individual lives: "the young men told us their ambitions in the phrases of stage heroes, and the girls, so far as their romantic dreams could be shyly put into words, possessed no others but those *soiled by long use in the melodrama* [emphasis mine] ... an afternoon a week in the gallery of a Halsted Street theatre [was seen] as their one opportunity to see life."[20]

Addams was struck by the pervasiveness of melodrama's fixed notions of behavior as well as the preponderance of moral dangers these productions fed audiences. The two women quickly decided to incorporate classes in drama as well as dance into the activities at Hull House, and determined that the plays their youth would study and see be more realistic as well as beneficial. This idea dovetailed easily with their belief that every person needed ways to express themselves through the arts. Stuart Hecht notes that Addams believed theatre was singular in its "power to provide models of moral behavior and social conduct otherwise not available to poor urban dwellers."[21] William Dean Howells, in a letter to Jane Addams in 1902, expressed similar concern about the negative impact of melodrama: "'I am not sure ... that anything so false as the old melodrama can be the beginning of good.... I doubt if the delight of the poor, or even the rich, in an impossible picture of life, can be wholesome for them. They can get the same effect from gin or whiskey.'"[22]

The Henry Street Settlement would open in New York four years later than Hull House and have the same mission, but it would not be until 1915 that their theatre, the Neighborhood Playhouse would begin.[23] Both of these settlement houses were located in immigrant slums and the various cultures would bring folk traditions as well as social and political beliefs to the amateur dramatic societies that emerged. The Hull-House Theatre would run for fifteen years in this way, performing Greek tragedy with neighborhood Greeks doing the play in its original language, adaptations of Old Testament stories by Jewish players, and Christmas pantomimes. Addams emphasized the enormous benefit of each immigrant group touting their heritage, but also how much the community was enriched by the diverse audiences that attended the panoply of plays.

Within a few years, Hull House also would be the site of American premieres of plays by Henrik Ibsen, Bernard Shaw, John Galsworthy, and Lady Gregory. Professional actresses like Mary Shaw (doing Ibsen's *Ghosts* and Shaw's *Mrs. Warren's Profession*) appeared at the Hull-House Theatre. What is immediately striking is the parallel sense of identification felt by

the Hull House spectators to the new drama by Ibsen, Shaw and Galsworthy that came to Hull House from the Vedrenne-Barker seasons. Addams remarked: "the latter are surprisingly popular, perhaps because of their sincere attempt to expose the shams and pretenses of contemporary life and to penetrate into some of its perplexing social and domestic situations."[24]

Addams's observations reinforce the impetus that Shaw, Barker, and the other playwrights felt to show people characters like themselves and their wish to circumvent repressive and discriminatory situations. Theatre as a means of combining inner and outer influences on individuals and communities clearly resonated. Further, the connection between British reformers and American Progressives underscored the push for "people's theatre." The evolving dramaturgy took Ibsen's fundamental principles of exposing hypocrisy and revealing the dire consequences of melodrama's fantasies and expanded the 19th-century *thèsis* play into an onstage unfolding of discussion and debate. In moving from what happens next to a focus on the individuals undergoing the incidents of the plot, the transition to modern drama established characters' self-conscious examination of conflicts all through a play. Appreciation of great acting remained; it was the criteria for judging it that shifted.

Rather than the Victorian delight of seeing a scene as a finished work of art, 20th-century spectators came to relish the process of a scene come together through the connections among all characters in it. As Desmond MacCarthy observed in 1907, "good acting can make poor scenery seem real, [but] real scenery cannot do the same for poor acting.... Elaborate scenery, however splendid is, and must remain a portentous matter of fact; while a scene which is suggested takes significance from all that happens, for it is formed out of the spectator's imagination."[25]

Granville Barker's visual and auditory sensibilities worked simultaneously. The musical director, Theodore Stier encapsulated his memories of working with and observing Barker in action:

> There was in Granville Barker's producing a quality of imagination which impelled co-operation from the stage in a way that I have rarely seen equaled. ... So far as Barker was concerned every soul behind the footlights, from the leading lady to the lowest- paid scene-shifter, was automatically bound in a brotherhood of art; that any member of his staff, in any capacity whatever, was not all out for absolute perfection never so much as entered his head. And because he expected so much and put so much of himself into his own work, he succeeded in bringing out the best from everybody else.[26]

Stier was also struck by the musicality of both Barker and Shaw, and the influence of music on their dramaturgy. Shaw's use of operatic aria as a mode of writing dialogue was well known, and was balanced by Barker's

conductor-like comments rehearsal. Stier recalled actors told to be an "oboe" rather than a "trombone" in a scene. Conversely, his first experience conducting at the Court was for Houseman and Barker's harlequinade play *Prunella* in 1904–05 required Stier to match the music to "fit the rhythm of the verse, so that I had to keep my eyes fixed irrevocably on the mouths of the speakers in order to ensure exact synchronization."[27] Barker's subtle but intense touch complemented Shaw's propensity to have actors and actresses gesture boldly as well as project complex thoughts in the dialogue.[28]

Both Barker and Shaw worked with cast members individually as well, to ensure the complete understanding of the intellectual and emotional progressions each play involved, yet they approached rehearsal in polar opposite ways. According to Jan McDonald, Barker did scenes over and over again to ensure the whole was grasped and each part was integrated; Shaw believed in going straight through the play and leaving it up to the actors to work on their own or live with the consequences of audiences' and critics' rebukes. Lillah McCarthy, the leading actress at the Court, noticed that although Shaw was "serious, painstaking, concentrated and relentless in pursuit of perfection," it was equally true that "Even when something was wrong he would say nothing until he had found out how to get it right." Conversely, he would ignore actors doing well. When they asked for notes, he would say "Nothing. You're all right I don't take any interest in you," a maddening sort of compliment.[29]

Lillah McCarthy gave an interview many years later to the *New York American* in 1927. She and Shaw were close friends as well as colleagues and he shared a great deal of his aspirations with Lillah McCarthy. Her "snapshot" of Shaw's ambitions for theatre is a clear illustration:

> Shaw is a realist who always plumbs the depths and attempts to stimulate thought in order that people may shake off the trammels of convention and put the world on a sounder basis. 'To Hell with shame' is his motto, and he would also have men—and especially his country- men—and women—cultivate the power of self-expression and so rid themselves of that strange reticence that up to the war was one of their most characteristic weaknesses.

Lillah McCarthy also credited Shaw with treating men and women in an exceptionally egalitarian way in his work in the theatre as well as his role as a radical socialist. Her own activist leadership in the Actresses Franchise League gives her assessment great credence. She claimed that the "revolution that has been taking place in the status, character and ideals of woman since those days undoubtedly found in his teaching its most able and convincing advocate."[30]

Lillah McCarthy's assertions of Shaw's impact on the emerging New

Women of the early 20th century certainly applied to her own evolution. Margot Peters in *Bernard Shaw and the Actresses* notes McCarthy's credit to Shaw's character Ann Whitefield in *Man and Superman* (1904) for making a new woman out of her, and playing Ann was for McCarthy, in Peters' words, "a personal triumph." This play was broadly considered the first "great" play of the 20th century. For Lillah McCarthy other women on and off stage lacked Ann's "earthy" qualities, which is why the character's audacity and directness in achieving her desires were so important to women of the day:

> Women, many of them, have told me that Ann brought them to life and that they remodeled themselves upon Ann's pattern.... Ann set the leading lady—and with her all the ladies of the theatre—free, and set the world of women free.... Mrs. Pankhurst, who Heaven knows never lack resolution, herself told me that Ann Whitefield had strengthened her purpose and fortified her courage.[31]

To contemporary readers and audiences who don't readily see Ann Whitefield as radical, McCarthy's remarks may astonish. After all, Shaw's character's ability to determine her own future and educate her lover in a romantic relationship goes back at least as far as Juliet. Since the Court productions of *Man and Superman* did not include the philosophical and mythic third act, staged separately in a later season as *Don Juan in Hell*, the play's surface structure and outcome as a social comedy would seem rather conventional. What made Shaw's play "twentieth-century," however, was the open disavowal of gendered norms as well as the time-honored family structures. The play's title would lead an audience to assume the protagonist to be Jack Tanner, but is it really Ann Whitefield, or is theirs a shared centrality, thereby implying an egalitarian balance of power and influence?

Although Jack will confront her about her lying and hypocrisy, Ann is completely transparent in her actions toward Jack. She sees right through his protestations and makes sure the audience and Jack all know that they have loved each other a long time.

Conversely, Jack sees the whole of Ann as well. Following what she claims to be her dead father's wishes, Ann pays lip service to feminine acquiescence even when she is clearly in control of the dynamic; it is only in the play's final moments that she reveals to Jack that she convinced her father to make Jack a guardian. Even without such standard plot contrivances, Shaw shows us that Jack's flight from Ann and romantic entanglement is fleeting by the end of Act II, when he impulsively asks Ann to join him for a car ride across the continent at sixty miles per hour. He suggests that such a venture will give her independence and "make a woman

of her." This one seemingly off-hand comment by Jack allows Shaw to invert the ingrained notion that courting adventure and danger built masculine character. When Jack qualifies the remark by his insistence on the dangers, Ann immediately thanks him and accepts the invitation. Jack is "aghast." The chauffeur, Enery Straker, acknowledges Tanner's impending connection to Ann, astonished that his boss seems oblivious to Ann's feelings towards Tanner. Straker knows that Ann will fulfill her mission to marry Tanner. Tanner is only ready at this point to say that Straker's "golden moment" has arrived and to go as fast as possible before Ann can pack her suitcase and join them.[32]

Tony Stafford offers a multi-layered context for the opposition between Tanner's intellectual shrewdness and Ann's intentionality: the car in the garden. Shaw's own love of technology was shown sensationally when the first car appeared onstage in *Man and Superman*. Stafford places this into the context of Leo Marx's *The Machine in the Garden*, which traces the primacy of technology as new power.[33] Of course, Stafford continues, the machine as "the central instrument of the excitement" in this scene becomes "even more striking with the realization that the machine is the instrument by which Jack Tanner is running away from the Life Force ... and headed toward another garden where the Life Force will triumph."[34]

As Desmond MacCarthy gleaned in the original Court production, this play was the most *"brilliant"* piece of Shaw's work up to that point. Ann is "'Everywoman' according to Mr. Shaw's philosophy, though every woman is not Ann" according to Desmond MacCarthy. Tanner, "with his explosions of nervous energy and exasperated eloquence, is as good as Ann.... Tanner in the end, as Don Juan explains of himself in the dream, yields because he cannot help it." MacCarthy recognizes that the sacrifices each will make as "instruments [in] the creation of the Superman ... is the only aim worth working for in this world." What is fascinating in MacCarthy's analysis is his tacit assumption that woman's highest achievement is motherhood, accompanied by a Shavian skepticism regarding marriage as binding: "that the rest of life will have to be spent together induces men and women to marry for irrelevant reasons, such as affection or self-interest, to the detriment of subsequent generations. That is the moral of a comedy which keeps many people laughing, who would not laugh if they understood."[35]

The ambivalence that Desmond MacCarthy pinpoints in the relation between men and women in *Man and Superman* reflects a composite picture of Shaw's own ambivalence towards women on the personal/sexual plane as well as his clear support for women's autonomy. Sally Peters's biography, *The Ascent of the Superman*, explores the paradoxical nexus of

Shaw's notions and attitude succinctly and convincingly. His mother's resolution to leave George Vandeleur Lee when he sexually harassed Shaw's sister Lucy established his feminist sympathies, for economic as well as personal reasons; "it was his mother assertion of female power and her defiance of assigned female roles concerning sexuality, respectability, and career fulfillment that most affected Shaw."[36] Peters credits Shaw with "creating the most powerful female characters on the English stage since Shakespeare—even while believing that 'no fascinating woman ever wants to emancipate her sex: her object is to gather power into the hands of Man, because she knows that she can govern him.'"[37]

In further reflection on Lillah McCarthy's assertions about the character of Ann Whitefield as empowering to women, it then becomes clear that audiences saw Ann as sure of herself as a full human being. The end of the play, with her admonishment to all assembled to let Jack talk, shows Ann's ease in embracing her future husband as his own full person as well. As the suffrage dramas discussed in Chapter 6 will emphasize, mutual understanding and joint effort between men and women could ensure changes in gender roles in private as well as public roles. This strategy helped convert many to the cause.

And yet, Nietzsche's superman was a decidedly masculine ideal and the play's definite message of children as the highest contribution for women went in a contradictory direction. Shaw's superman, says Peters, was an amalgamation of "saint, artist, and genius—the complete outsider."[38] In play after play by Shaw performed during the Court seasons (1904–1907), these designations could apply to women as well as men. In *Candida*, Shaw's first play at the Court, Candida is a mother figure both to her husband, James Morrell, and her infatuated young suitor, Eugene Marchbanks. Interestingly, her own children are never onstage, but her genius as a household manager and her unfailing reading of everyone's character is evident in all scenes.

Towards the end of the play the two men vie for control of her and Morrell physically pins Marchbanks down when he finally recognizes the depth of the relationship between Marchbanks and Candida. Morrell then declares that she must choose between them. Candida then takes full charge of the situation. Demanding to know if it is "quite settled that I must belong to one or the other" Morrell confirms this, but Marchbanks shows his true understanding of Candida when he tells Morrell "you don't understand. She means she belongs to herself." Referring to Marchbanks diminutively as "Master Eugene," she says she means a whole lot more, confronting them both by saying "I am up for auction, it seems" and then asks what each will "bid" for her.[39]

At this pivotal moment Shaw gives Candida overt expression of what she has always done: look after her husband, much to his oblivion. Marchbanks understands at that moment that she will choose Morrell to continue her sheltering of the weaker man, revealing her saintly side. On the surface this is a Victorian separate spheres exposure, but it is hardly a meek and defeated mother figure who explicates her multiple roles of service in a flash: "Ask me what it costs to be James's mother and three sisters and wife and mother to his children all in one.... I build a castle of comfort and indulgence and love for him, and stand sentinel always to keep little vulgar cares out. I make him master here, though he does not know it, and could not tell you a moment ago how it came to be so."[40]

Desmond MacCarthy refers to Candida as a "practical, clear-headed sympathetic woman." He likens Candida's appreciation of Marchbanks as two-dimensional: "she is grateful to him for understanding her situation, [and] enjoys his adoration without being moved by it."[41] Candida's explanation of what is strong and what is weak in a man may sound Victorian, but the outsider's perspective and understanding from Marchbanks clinches the modernity of the Shavian outlook, as do the closing moments of the play when the Victorian couple embraces and the youthful poet leaves without rancor because, as Candida intuits, "he has learned to live without happiness."[42] Desmond MacCarthy's glowing review called the play "among the best Mr. Shaw has written. The interest is concentrated on the main theme throughout, and it finishes at the point from which the audience, looking back, can best understand all that has happened."[43] Barker's idea of having the play six afternoons a week for two weeks made a profit and proved the veracity of his plan. John Vedrenne agreed to Barker's idea of doing plays in the afternoons beginning the following autumn.[44]

Shaw's premiere of *John Bull's Other Island* in 1904 gave audiences a glimpse of Shaw's ability to portray a cultural heritage, the sting of English oppression, and authentic Irish characters enjoying conversation, humor and sadness all mixed together. Desmond MacCarthy treated the play as a remarkable for reasons quite opposite to what he called the "completeness" of *Candida*. Instead of incidents rising to a clear point, *John Bull* focuses squarely on character "by means of a perfectly natural sequence of events ... no circumstances being created for the sake of exhibiting [character]. Everything that happens has the air of ... chance."[45] Some argue that the play is a political calling for Home Rule, while others appreciate the reversals of "typical" English and Irish characteristics.

Shaw's merging of poetic lyricism and indignation in the dialogue prompts the audience to recognize that the play is about individuals and

not types caught up in economic and psychological conflict. By the same token, the overtones of British elitism and imperialism blend in with the "local" election of an MP to Parliament, with the English visitor, Broadbent as the predicted winner. Is the tone satiric or despairing? A bit of each, perhaps. Alfred Turco begins his analysis by designating the play as "a comic exposure of the way members of different nations mythologize one another." As his argument broadens, Turco focuses on the inverted dynamic between Broadbent and the Irish Larry Doyle, who lives in England, claiming that it is insufficient to say that the Irishman is practical and the Englishman "ineffectual." Broadbent may be a fool but is also efficient; Larry though "insightful ... is sublimely helpless. Thus the opposition between English and Irish becomes a metaphor for a contrast between capacity for action and the lack of it." And of course, for this last point, Broadbent and Doyle conform to more typical behaviors, but Turco provocatively asks how anyone can explain "why the behavior of each man is so at variance with his nature?"[46]

To carry Turco's question further is to return to the play's very clear undertone of horror surrounding the "efficient" Broadbent garnering support from the people he has just met. But are they for him because he is English and may possibly represent their interests as an MP better than those who have achieved nothing? By the play's end Broadbent's imperialistic determination emerges; to help Rosscullen is to build a hotel and create a golf course, regardless of the pristine beauty of the place and the ancient sites all around him that may be destroyed in the process. The scheme may prove impossible if the landowners won't sell to him, but the outcome is beyond the time of the play.

It's a complex albeit inconclusive ending, one in which Shaw combines the primacy of each of three themes: dreams, religion, and action. Larry challenges dreams as the stumbling block to Ireland's chance of economic and social success in Act Three, calling for people to "make room" for those who could give Ireland a chance. "If we can't have men of honor own the land, let's have men of ability. If we can't have men with ability, let us at least have men with capital."[47] Larry's eighteen years away from Ireland have removed the worship of her beauty because he has lived in London and known the pervasive and persuasive pull of power. By Act Four, Larry has lost both the possibility of election to Parliament and Nora Reilly to Broadbent, but he will partner with him all the same. Larry buries his emotional hurts and castigates Father Keegan's insistence on the permanent value of old Ireland's spiritual and mystical ways when the old man says he will go to the Round Tower "dreaming of heaven." Then comes Shaw's trump: Broadbent's childhood dream that he was in heaven, which

seemed to him "a sort of pale blue satin place" where the pious old women were in one place and an "awful person" in another. He "didn't enjoy it" and elicits Father Keegan's vision of heaven. The reply, pure poetry, moved Yeats and many others to tears. Father Keegan sees heaven as "a country where the State is the Church and the Church the people: three in one and one in three.... It is a godhead in which all life is human and all humanity divine.... It is, in short, the dream of a madman."[48]

This Blakean ideal of "higher innocence" doesn't last long; Broadbent regards Father Keegan with affection and predicts "he'll be an attraction here. Really almost equal to Ruskin and Carlyle." Larry's cynical reply: "Yes and much good they did with all their talk!" Broadbent does not bend and insists these men have improved and inspired him and suggests they "choose the site for the hotel."[49] Truly, this closing jolts, but nonetheless serves as the secular version of Father Keegan's vision.

Peter Gahan grounds Shaw's play as a response to the mentality of Empire and Colonialism as well as a confirmation of some of its principles in his essay, "Colonial Locations of Contested Space and *John Bull's Other Island*." Shaw's attitudes cannot be precisely pinpointed. Gahan argues that there is a "strain" in Shaw's 1890s essays between the "attempt to supply 'grand narratives' for his time, such as a religion of Creative Evolution or a political doctrine of socialism, and his critiques—or deconstruction, as we would now say—of Enlightenment reason and of nineteenth-century liberal ideas."[50] Gahan's concluding points speak directly to the ambivalence, wistfulness, and anger that co-exist with Shaw and in the last two acts of this play: "*John Bull's Other Island* was written by a migrant writer and would-be cultural translator who prescribes no one salvation scheme, no primary imperial, liberal, political, economic, or nationalist discourse. The play refuses to offer a Yeatsian unifying national myth, as it refuses to offer a grand narrative of the imperial dream."[51]

The 1904 Court season had opened with the premiere production of Gilbert Murray's new translation of Euripides' *Hippolytus*. Professor Murray's rhymed verse brought Euripides's amazingly contemporary perspectives clearly into view; through what Desmond MacCarthy called his "rare and beautiful translations," Murray gave a modern spectator the ability to appreciate the ancient works "with the same close, effortless sympathy which he might follow the work of a modern imagination." The performances at the Court and the "aim of the management were attempts to carry this transfusion one step further; Mr. Murray had turned Euripides into an English poet-dramatist; Messrs. Vedrenne and Barker tried what could be done towards naturalizing him on the English stage."[52] In the three seasons there were three plays of Euripides translated by Murray;

The Trojan Women (1905), *Electra* (1906) and *Hippolytus* again (1907). Barker was the first to stage Murray's translations, which he began to publish in 1902. The 1904 production of *Hippolytus* was a remounting of the production held the previous May in the New Century Theatre and was only received with "polite encouragement" from the critics.[53]

The other two plays aroused greater responses from audiences; Desmond MacCarthy reports on the rapt audiences for the productions, with particular attention to individual performances but also to the striking relevance of Euripides, saying that he is "so much in sympathy with our way of feeling character and emotion, that it is particularly tempting to bring out the significance of the situations and dialogue by acting them with modern expressiveness." All is well with this approach, except for the handling of the Chorus. Desmond MacCarthy misses the separation between the Chorus and the audience as would have been the staging in classical times, claiming it the one false note in Barker's approach that "had no wish to succeed in an aesthetically archaic performance or in an archaeologically sentimental revival."[54] Yet the combination of Murray's language and Barker's staging broke new ground, and would have lasting impact and influence revival of ancient Greek culture on both sides of the Atlantic.

Actress Edith Wynne Matthison played Electra, and did the role in New York in 1910. In a *New York Times* feature article about Miss Matthison's interpretation of the role, there was definite interest into why the classic heroine was "popular today" and the piece began with announcing that it unlikely that another time would be like 1910, when people were wearing Greek sandals in the streets and Electra will be portrayed for a season run on Broadway.

Children were studying the storyline and learning to dance like the figures portrayed on Grecian urns. The article then mentioned the conflated version of Electra's story (from Aeschylus, Sophocles, and Euripides) by Hugo Von Hofmannstahl to make a "modern version" as a play and the libretto for Richard Strauss's opera, *Elektra* (1905). Von Hofmannstahl used Sophocles's treatment of Electra as the basis of his radical adaptation. Sophocles shows Electra as virtually imprisoned by her mother, Clytemnestra, and very poorly treated; she has never really gone on living since her father's homecoming became the moment of his murder. In this new version grief has become psychosis and vengeance and has made her into "quite an improper girl," according to the *New York Times* reporter. Mrs. Patrick Campbell played in Von Hofmannstahl's play version in 1908 at the Garden Theater in New York, with her daughter Stella as Electra's younger sister, Chrysothemis, and Mrs. Beerbohm Tree as Clytemnestra.

Although the run was not a huge success, Mrs. Campbell's invitation to the theatrical community to a matinee performance resulted in 2500 people coming to the theatre and four policemen brought in to try to handle the commotion. The *New York Times* article about this event unabashedly expressed astonishment because, as the reporter put it, the decision to line people up was impossible because the decision to do so was made by people who "reckoned without the emotional nature of stage folk." Two particular young women, one with "dizzying yellow hair" who had performed with Mrs. Campbell and the other who had met the actress at an afternoon tea were "unruly" and just used their privilege to sweep past authorities in a huff. It became so crowded that people could not go in or out, but all was well by the end of the performance, even if some people were not seated until the last act curtain came down. Mrs. Campbell and her daughter came out afterwards and the star actress spoke graciously to the crowd.[55]

Edith Wynne Matthison's Electra was quite another matter because Euripides's text changed Electra's situation; she had been married off to a poor shepherd and sent away from the palace, thereby changing the focus from Electra's psychological fragility to indignation over her own situation as well as her murdered father's. Miss Matthison played Electra as more subdued. The actress read Euripides' text aloud for two hours for a fundraiser at the Plaza (Hotel) to benefit babies' dairy, so "the powers of tragedy were put to very practical ends in the paying of a milk bill." The reporter emphasizes the actress's ability to hold her audience spellbound, particularly because she had played the role at the Court Theatre in 1906 and has from that time onward "known that Electra had the makings of a modern heroine." More striking was Miss Matthison's remark that "Euripides was the George Bernard Shaw of his day, looked remarkably like him, thought like him, and had the same jarring effect upon the smug self-satisfaction of his audiences. Euripides was the founder of a transition."[56] Recognition of the actress as an intellectual power rather than a merely glamorous presence would be shown again in New York in November of that year when Ellen Terry would deliver her lecture on Shakespeare's women at a New York theater to a capacity crowd.

The article also included Miss Matthison's interpretations of Andromache's heart-rending plight in *The Trojan Women*; Andromache was the Greek role she performed at the Court Theatre. Her performance of Andromache, especially at the moment when she must leave her child just as he would be thrown from Troy's walls, won high praise from the critic of London's *Sunday Times*, who noted that the actress "effected her grief as Andromache so well that when the child was ripped from her arms to be tossed from the walls, 'the theatre became as still as a church in

prayer."⁵⁷ She explained to the *New York Times* reporter that it took her three weeks to get through this speech without breaking down, and even when she could speak it without tears felt the full emotion. With these remark as context, consider how Miss Matthison returned to Electra's state of mind, in order to emphasize that the common assumption that Electra was crazed was not her own view. It was here that the actress's connection between Euripides and Shaw was more than bravura. The actress explained that Electra had plausible grievances: love for her father and the gods, longing for her brother, an impoverished and childless marriage. Simultaneously, Miss Matthison pointed out the critique of the gods inherent in Euripides and his lesson of questioning authority that his plays give over to audiences of any era.⁵⁸

Dennis Kennedy's biography of Granville Barker reaffirms the momentous achievement of Euripides at the Court and abroad under Barker's leadership. Kennedy acknowledges the audience resistance to the Greek chorus, but maintains that *The Trojan Women* production in 1906 "nonetheless showed Barker's courage and control as a director ... in three years the Vedrenne-Barker seasons had reclaimed a great playwright for the stage, and by extension rescued an entire literature from theatrical oblivion."⁵⁹ Kennedy shows that the impact on theatre was almost immediate. Frank Benson had not dared to try Aeschylus's *Oresteia* in a London venue, but did so after Barker's pioneering efforts. Lillah McCarthy would be Dionysus in William Poel's version of Murray's *The Bacchae* in 1908, and she would be in Reinhardt's *Oedipus* at Covent Garden in 1912.⁶⁰

Karelissa Hartigan's *Greek Tragedy on the American Stage* (1995) marks 1915 and the tour of Granville Barker and Lillah McCarthy as the event that "inaugurates the connection between Greek drama and contemporary society in America."⁶¹ They staged their interpretation of the Euripides's *The Trojan Women* and *Iphigenia in Tauris* to open-air arenas in various university stadiums in the Northeast, including City College (NY), Harvard, Princeton, and Yale. In May of 1915, the City College production of *The Trojan Women* drew 7000 people. Lillah McCarthy was Hecuba and Edith Wynne Matthison was Andromache.⁶²

Perhaps these outdoor venues were prompted by the negative critical reception to the Court productions and 19th-century staging failures in New York in the 19th century. Kennedy cites Max Beerbohm's objection to the Vedrenne-Barker handling of Euripides "on the premise that a modern audience could never hope to recapture the spirit of ancient Athens as long as it remained in a modern theatre.... Only in an outdoor theatre, and the play spoken in its original language, Beerbohm thought, could we detach ourselves sufficiently to accepts the demands of antiquity."⁶³ Har-

tigan reminds her readers that indoor productions of Sophocles had failed in the 19th century: *Antigone* because the actress playing her was not able to "grasp the character of the nobled and devoted Antigone"; the indoor venue was deemed inappropriate; *Oedipus Tyrannus* failed on moral grounds: "it was the subject matter.... Sophocles' play touched no chord of understanding of the American audience in the late years of the nineteenth century."[64]

The vastness of an outdoor arena in the 20th century could replicate Greek drama's ever-present reminder of the power of higher powers that surround us and perceive our thoughts and emotions as well as actions. On a less lofty level, open-air performances allowed maximal audiences. Chicago's Little Theatre under Maurice Browne had performed *The Trojan Women* in 1912 in their little theatre. But it would go on to tour for five years during Word War I. Hartigan asserts that this tour "made this troupe and this play a part of America's theater history."[65] Browne and Barker divided the United States between them to ensure as many audiences as possible, especially since the text had become a pacifist statement in 1914. Browne's troupe was in Washington, D.C. the day when the *Lusitania* was sunk by the Germans. He had expected an empty theatre, but there was not one empty seat: just "motionless and silent row after row of ... numb faces." His usual routine was to speak to audiences about the play before the performance began; that night, I merely stepped in front of the curtain with an evening paper in my hand and held up the monstrous headline and said, "This play is about a deed like that."[66]

The theater of ideas reflected the era's need to consolidate contemporary as well as ancient ideas in theatre to push for change. The new plays introduced by the Vedrenne-Barker seasons would challenged supposedly firm beliefs about designations of power, as revealed in personal/family relationships, within and between social classes, and in imperialistic attitudes. The prominence of social rank as immunity to repercussions of immoral actions became an overriding theme. These social issues were presented to audiences as realistic discussion plays or as examinations of character and mood in expressionistic modes, depending on the styles of particular playwrights.

Both Granville Barker and Shaw wrote plays in 1905 that centered on family money and its sources: *The Voysey Inheritance* and *Major Barbara*, respectively. Barker's work premiered at the Court in early November and Shaw's would follow a few weeks later. Barker examines an "inherited" embezzlement scam located within a law firm, and the disillusionment and dilemma that face its protagonist, who presumably will be the next senior partner. Shaw's play is a combination of drawing-room comedy,

complete with secrets and lies, balanced by a true look at life in and around a Salvation Army shelter and a planned workers' community. Despite the many contrasts between the two plays, they share the examination of young adults coming to terms with what they cannot conceive of as proper or decent moral compasses, and then having to reconcile the impossibility of rejecting the sordidness in the circumstances they have been given.

Edward comes to recognize that revealing all about the family business would have worse consequences than his own imprisonment for deeds of generations past; small investors would lose far more than the richest ones would. For Barbara this transformation comes because her father's contention at the end of the play that poverty is the worst of crimes is a compelling argument in the face of the generations of working poor in London's East End. The other crucial commonality is the secrecy surrounding money; wives know but children are unaware of the source of their economic privilege. Mrs. Voysey has an inkling of something untoward in the family finances but has never really cared to know much about it—Barker's way of showing another downside of Victorian separate spheres. None of the adult children know how their money has materialized. In Shaw's text, the three children of their estranged father, Andrew Undershaft, have grown up as the grandchildren of an Earl on their mother's side, so they naturally assumed their material comfort was from Lady Britomart's family. She never lets them know until the action of the play begins that their father, a millionaire munitions manufacturer, has provided all.

Although Edward Voysey often has been compared to Adolphus Cusins in *Major Barbara* because of their bookish and idealistic mindsets, a parallel to Stephen Undershaft is also credible. Edward and Stephen hold set ideas about morality and behavior that privileged upbringings provided. Both of these younger men have been kept ignorant of circumstances that would have shocked them, but which also would have spurred their maturation. Edward Voysey's journey begins when he has found the family secret on his own the night before the action of the play begins. Stephen Undershaft knows that his father is the millionaire armament manufacturer, but does not know he has lived on his father's profits, sheltered much like Vivie Warren in *Mrs. Warren's Profession*. Edward's "inheritance" is multi-layered: he could live a life continuing shady dealings as his father did, so that monies are available to him and his family. The moral and ethical inheritance is that only these illegal activities have been the source of family income.

The opening scenes of the two plays are intriguing mirror images. Barker's play begins with Edward's stark shock and emotional withdrawal

at learning about the family "business" and confronting his father about it in their law offices. Mr. Voysey protects the "tradition" by saying it was so embedded into the history of the family and their clients that there was, in essence, nothing to do but fulfill his obligation to continue the criminal deception. In essence, Mr. Voysey tells Edward to get on with things and come to family dinners to enjoy himself. Stephen Undershaft is taken into his mother's confidence, ostensibly to "advise" her on obtaining more money from his father to provide for his two sisters after they marry. Of course Lady Brit has already contacted her husband and he is due to arrive within the hour. Stephen's embarrassment over discussions of money with a woman—his mother—is more than he can bear, especially on top of the complete shock of learning his father had anything to do with his upbringing. Rather than melodramatic doom, however this is a scene of Shavian wit.

Barker and Shaw illustrate the essential disillusionment that brings the younger generation squarely up against the hypocrisy and underside of the power structure that has flourished undisturbed for centuries. As each playwright works to denigrate the socioeconomic foundation that all classes have lived under, the appalling interconnectedness of ethical and unethical practices converge. Stephen Undershaft's antipathy towards his father's business and his embarrassment when his school fellows chided him about his famous father is offset by his firm belief that he knows right from wrong because he is an English gentleman. Edward's feelings and moral compass are the same as Stephen's, but Barker's play gives the son a much bigger challenge; he is his father's partner, which is the only reason Mr. Voysey had Edward look through the accounts on his own before having this meeting between them. Edward Voysey begins the play on the verge of hysteria and lives in a claustrophobic world of secrecy and terrible dilemma that he must later open up by revealing the shameful truth to his siblings and key clients after his father dies unexpectedly in the middle of the play.

Contrasts between the structuring and tone of these two plays are equally striking and significant. Granville Barker's *The Voysey Inheritance* is an unflinching examination of the impunity of social and financial privilege. Known for his striking use of pause and innuendo, Barker concentrates on the ostensible "invisibility" of the generations-long embezzlement in this family law firm, whose offices are in the best part of Lincoln Park, according to Barker's stage directions. Rather than extensive dialogue around even pivotal plotlines like this, Barker centers the play on unfolding internal struggle. Margery Morgan's encapsulization of the play's structural elements likewise introduces the essence of Barker's dramaturgy:

"Barker's rejection of formulaic construction in his plays appears in *The Voysey Inheritance* in the checking of plot developments, or clearing of them offstage, to give character more room: not least, the communal character of the household."[67] Morgan's last point is especially noticeable in the acts two, three, and five, when the dining room at the Voysey home is "all over the stage."[68]

A recurring theme of the Vedrenne-Barker Court seasons was the patently obvious disparity between social classes regarding crime and punishment. *The Voysey Inheritance* represents this practice through the clerk, Peacey, who has known and kept the family secret for many years, as a faithful employee "ought" to do. Even though Peacey's full importance does not emerge until late in the text, the first moments of the play are with Mr. Voysey. and Peacey. The first words of the play are Mr. Voysey's: "Any news for me?" Their dialogue, with its mention but not explanation of business details appears to serve the purpose of piquing interest into Mr. Voysey's distracted and somewhat anxious mood. He answers Peacey more than once by referring to Edward handling the problem, dodging a question by asking Peacey for the *Times* and finally inquiring if Edward is in the office. When Peacey hands Mr. Voysey the newspaper, it is opened to the financial section (stage directions) and he tells his employer, "I've made the usual notes." "Thank'ee" is the reply.[69]

Once Edward enters his father's office in a state of panic and fear, the office's semblance of order and his father's ambiance of "radiating enterprise" becomes more visible somehow. But more striking is the shift in Mr. Voysey's dialogue. He has given Edward all the accounts so that his son might discover the truth under the seeming solidity of the office furnishings. Could these details be what Peasey has made notes about? Voysey is not, however, a cold or ruthless parent; rather, his responses to Edward shutting himself up in his rooms for days sound more motherly, emphasizing that he had told Edward come to the family home over the weekend. To break the awkwardness, he says he has given his son "a bad forty-eight hours." Expressing concern about how Edward is absorbing it all, he says they will "thresh the thing out now."[70]

Each client's situation is encapsulated and the impending grimness looms. Their intense conversation introduces both the play's obligatory exposition and combination of hypocrisy and financial scrambling that began with Edward's grandfather. Edward's shame over the family's criminal dealings that have heretofore gone without recrimination is balanced by his father's rationalization that he saved his father's reputation by doing what needed to be done to keep the firm going: paying all the clients their annuities and "providing" for his family. And then the more personal, psy-

chological realism emerges when Mr. Voysey muses: "Why is it so hard for a man to see beyond the letter of the law!" He reminds Edward he has worked for all these years to restore what he could to the clients and "they never even knew the danger [they had] been in ... It was I that lay awake.... I stepped out of the law to do that service. For my family. For the firm. For kindness. For England. Was I wrong?"[71] Edward acknowledges that the result proves his father right, but what about the present time? Why have things continued? Edward demands to know what the "security" was for the clients. Mr. Voysey rejoins: "My financial ability."[72]

Edward recoils at the prospect of continuing this legacy. Christopher Innes contends that this play's "plot is propelled by his indecisiveness and self-questioning doubts, and the characterization explicitly counters "the superstition" found (as Barker complained during rehearsal, even in the actor playing Edward) "that a good man on the stage must always be a strong one, and that a sensitively weak character cannot be interesting."[73] The after-dinner scene in Act Two shows the truth of Mr. Voysey's comment to Edward that his next visit home will show the household unchanged; nothing had happened or needs to happen if Edward "keeps his head."[74] The conversation is realistic the way Chekhov's are: constant topic changes as people come in and out and interrupt each other. The enormous dining room table with its pristine white linen tablecloth is all the audience can see. Not only does it represent the way of life of that class, Barker's stage directions calling the dining room the "domestic temple," but its sheer size and the over-abundance of food, drink, and cigars make the *mise-en-scène* control the action. Innes argues that Barker's sets were "designed to limit movement in ways that emphasize dialogue by filling the stage with furniture: seating that turns the actors into debaters."[75]

In Act Three Edward struggles to find a way to fulfill his responsibilities as the senior partner after his father dies, in the same dining room. Moments after the funeral Edward announces to all that "there will be no money" because everything is owed to the clients. Mrs. Voysey announces that she's known about all of it for years and that her own estate has been kept "quite separate."[76] Patterns of characters coming in and out, trying to make sense of the news and struggling to balance their love for their father and his wonderful generosity with the reality. Beatrice, unhappily married to Edward's brother Hugh, remarks that "quite apart from the rights and wrongs of this, only a very able man could have kept a straight face to the world all these years, as your father did."[77]

Edward went into this scene of revelation determined to go to prison, but the perspectives of several family members complicate the situation. Alice Maitland, the woman Edward loves, admired his impassioned state

but warned him not to allow himself to feel "heroic." She shares the story of her guardian, who made Alice look after her own money and reminded her that she hadn't earned it and hadn't any real right to it; she then links that to the clients. Her belief that it would be better for Edward to do as he started to do when his father was still alive—help the small investors—since this was worth doing even if it meant risking criminal behavior.[78]

The incompleteness of the Mr. Voysey's answers and the randomness of his questions to Peacey in Act One are only startling to us when we recall them, in Act Four, the only other part of the play set in the office. Peacey had been given a small "Christmas bonus" annually by Mr. Voysey as a token of appreciation for his silence. When the clerk asks Edward to continue that "tradition," Edward refuses and refers to it as "hush money." When his father's friend and client comes in to remove his money, Edward tells the man the money isn't there and gives him the full story. Stunned, he threatens Edward, who then urges the man to press charges.[79] The complexities are the play's strengths, and the uncertain ending regarding the law firm is provocative for the audience. As a reviewer of the 1989 National Theatre production puts it, "Barker's refusal to resolve neatly the ethical dilemmas he examined provided the play with a wise sophistication."[80]

Major Barbara likewise mixes theatrical genres in its critique. The play begins as a society comedy about marriage and family complications and obligations, with the action rising to a bet between Barbara and her estranged father about who can convert the other. The Salvation Army shelter scene in the middle of the play introduces the world of the have-nots and the effects of unemployment, ageism, and scanty education in the lives of young and old. Barbara's leadership and moxie win us over because she individualizes each conversation and her strategies for gaining donations and converts are impressive. Barbara will not take a donation from visitors to the shelter who need food and work: a detail that matters greatly at the end of the second act and to the play as a whole. Bill Walker, who has come looking for the girlfriend he physically abused, tries to give Barbara money after he has hit a Salvation Lass named Jenny Hill and sees the need of the shelter for funds. Barbara refuses because she is after Bill's soul to save.

The ingenuity of portraying street scenes that audiences could witness on a daily basis in London on the intimate Court stage was a favorite part of this in 1905. Shaw's placement of a good-humored captain of industry participating in the day's events, rather than looking down upon them, appears to stack the odds in Barbara's favor. However, the middle of the act turns the play's mood and alters its focus. Instead of centering on Barbara and her father, Shaw introduces the truly important question for Andrew Undershaft: will his daughter's fiancée help get Barbara to embrace

his world and abandon the idea that bread and treacle and obligatory confessions really help the poor? Undershaft is determined to "pass my torch to my daughter to make my converts and preach my gospel." When Cusins is taken aback by the idea of Barbara preaching Undershaft's version of the Salvation Army's motto of blood and fire, Undershaft doesn't miss a beat and likens money and gunpowder to "freedom and power; command of life and command of death." Cusin counters that Undershaft cannot "buy" Barbara, and Undershaft's answer is equally provocative: "No, but I can buy the Salvation Army."[81]

Of course that is what happens shortly thereafter; Undershaft writes a cheque for half the funding needed to keep the shelter afloat and promises to get the balance from the other captain of industry: Bodger, the distiller. Barbara becomes so disillusioned that General Baines takes her father's tainted money that she takes off her uniform and loses her verve. Bill Walker, who has since learned that Barbara is an Earl's granddaughter and seen the effortless writing of the check, sneers at Barbara: "'Wot prawce selvytion nah?'"[82]

Walker's question to Barbara can be seen as the overarching one for the climax and denouèment of the play. The third act at Undershaft's factory and model workers' town shows how Undershaft has removed the blight of the slums and replaced it with cleanliness and the dignity that comes with a living wage: a Fabian solution. Here is a modern industrialist's version of *noblesse oblige* with none of the social strata between aristocracy and lower classes, yet Emma Goldman, more radical than Shaw in her politics, likens the environment to trickery. For Goldman, the way to make even more money is to establish conditions that "make workers content with their slavery,"[83] thereby implying that once power equals wealth, class issues are inevitable.

But Undershaft, as Shavian superman, prevails. The entire family, who comes with Barbara to fulfill her end of the bargain, all revel in the world of Undershaft. Lady Britomart lays claim to everything except the munitions factory itself, since homes, churches, and gardens are women's realm. But these gifts he cannot bestow, since "It does not belong to me. I belong to it: it is the Undershaft inheritance."[84] Once he has won, Undershaft ceases treating Barbara as a young woman of promise, and dismisses her crushing disappointment of the day before as a "tinpot tragedy" that she should overcome by replacing the mission of the Salvation Army for the potential at Perivale St. Andrews to inspire spirituality in healthy workers.

In this scene, Undershaft's use of "inheritance" and his scorn towards Barbara's disillusionment echo Mr. Voysey's attitude towards Edward at the end of Act One. Undershaft like Voysey reminds his child what a parent

does; Barbara's ability to do so has come from what her father has provided for her. He even claims that he has "enabled Barbara to become Major Barbara"[85] Here Shaw perhaps overlooked a crucial point: anyone could rise in the ranks of the Salvation Army. Social class or educational levels were not requisites. As Sonia Lorichs points out, the Booths created gender equality fifty years ahead of the secular world. It was Catherine Booth who was the first woman to preach in the streets. Shaw's familiarity with the Salvation Army is clear from what he includes in the play[86] as well as from the positive response the Salvation Army gave to *Major Barbara*.

This context only adds to the problematic ending of this play and Barbara's diminished role. Not only does she attain a complete transformation at Perivale St. Andrews, but she also becomes infantilized by the play's end. Barbara Undershaft may not have been living independently, but she certainly had displayed the confidence that comes from education and an awareness of women's emerging power in society. By the time the play premiered at the Court Theatre in November of 1905,[87] the first militant confrontation of the power structure by the WSPU had occurred. On October 13th of that year, Christabel Pankhurst and Annie Kenney interrupted Sir Edward Grey's speech at the Manchester Free Trade Hall multiple times, demanding an answer to whether or not the Liberal Government would give women the vote. Police dragged them away and fined them; they refused to pay so were imprisoned.[88] It is also worth noting that Kenney was a factory girl and trade unionist: mirror image to Pankhurst's university education.[89] Shaw's *mise-en-scène* in this play clearly highlights the mindset and plight of the working poor along with the perspective of the privileged, and centers the action on women in the public sphere and workers' rights.

In Shaw's 1906 premiere, *The Doctor's Dilemma*, Jennifer Dubedat of *The Doctor's Dilemma* is another important variation in Shaw's representation of women and agency. Although introduced diegetically as a frantic (aka hysterical) wife in search of a cure for her tubercular husband, she is in fact the navigator of her own life. She is also a great beauty, and thus a primary model for her artist husband. Dr. Ridgeon, who Jennifer seeks out, has just been knighted for his contributions to medical science and has developed a cure for tubercular lungs, but his hospital is full of patients and he does not want to see her. Many colleagues have come to his offices to congratulate him on his honor that morning. His housekeeper, Emmy, elderly but clearly the manager of the place, manages to get the doctor to see Jennifer. He is smitten at once. Moments earlier, a general practitioner visits; he is in dire straits and suffering from some undiagnosed malady; of all the doctors in the first act, this frail older man is the only one who seems to represent the Hippocratic Oath.

Mrs. Dubedat's artist husband is younger than she, and her small fortune is the backbone of their finances. Louis Dubedat is the prototype of the egotistical artist who has no scruples about borrowing/stealing from people to keep his very prolific sketches and paintings going. Jennifer is not aware of the extent of these habits, nor does she know he had a quasi-legal "marriage" with a hotel maid that lasted three weeks. With this subplot, which feels like melodramatic contrivance, Shaw manages to maintain the guise of sacrificing wife and show her devotion as fiscal manager simultaneously. It also "doubles" for Ridgeon's desire to marry Jennifer when her husband dies. He has made room for one more patient, presumably Dubedat, but two things complicate this decision and create the dilemma: Dr. Blenkinsop's diagnosis of a tubercular lung, and Ridgeon's promise to Jennifer to save her husband. Ridgeon's criteria are hardly ethical medical practices; rather, his choice apparently revolves around which of the people he as the great doctor deems worthy of his cure.

Shaw continues to use staples of the well-made play as backdrop rather than focal points for the audience. Ridgeon invites all of the characters to a celebratory dinner and to meet the artist husband. All goes well until Louis Dubedat's "past" catches up with him. A hotel maid informs the group of doctors who have dined together with the Dubedats that the artist is her husband and she shows her legal document to prove it. By this point in the play, both of the Dubedats have charmed the medical men and each of them has loaned small amounts of money to the artist without his wife's knowledge. The confrontation scene is a device Shaw will use in the next act in order to "double" the meaning of self-absorption, egotism, and greed for the medical men as well as the artist.

Midway through the text, Shaw has audiences primed to know if Jennifer indeed is drawn to Dr. Ridgeon; of course Shaw inverts this expectation, thereby destabilizing the triangle of adultery plot. William J. Doan's contends that Shaw's unorthodoxy places Jennifer as the play's "apex.... Her presence unmasks both the doctor/knight and the scoundrel/artist, though she maintains her allegiance to the artist. In the psychology of the parlor-game played by these characters, a darker farce is played out by artist, scientist, and Muse."[90]

Jennifer remains oblivious to her husband's true character as he is dying. The artist creates a true tableau, witnessed by an experienced and heartless journalist as part of the scene. Louis Dubedat presents himself as a devoted husband to her, evoking sentimentality galore and then asking her not to wear widow's weeds and to marry again.

So many of the characters in the play pity her for believing in him, but Jennifer Dubedat takes her husband's request to be the embodiment

of the beauty of his art seriously, and she prospers. In Act Five, when Dr. Ridgeon and she meet again, the doctor comes to buy some of her late husband's paintings, and explains that he abandoned Louis because he was in love with her. She is astonished and makes him see himself as an old man in her eyes: one she never would have wanted.

Jennifer then understands that Ridgeon, in effect, murdered her husband. He admits it, and uses as justification Dubedat's sacrifice of everyone, including Jennifer, for his art. To which Jennifer replies: "He was one of the men who know what women know: that self-sacrifice is vain and cowardly."[91] Ridgeon thinks he has come to the art show to buy some of Louis Dubedat's paintings as a token of his largesse; instead, he learns that Jennifer has taken her late husband's advice and married again. Her new husband has bought all the paintings for Jennifer.

Writing of the original production, Desmond MacCarthy focuses on the death scene as Granville Barker acted in (as Louis Dubedat) and how the audience responded to it. Barker "acted the death naturally and realistically.... But it was necessary that we should realize that chilly, quiet, matter-of-factness of physical extinction ... at the very moment of feeling pity for a man whose will is still ablaze.... For Dubedat dies in a pose."[92]

John Bertolini points to the doctor's shock at Jennifer's revelation, and argues that it leads Ridgeon to become "a mainly tragic figure by the mere addition of self knowledge," while Jennifer is the "comic figure ... happy in her deluded picture of her dead husband."[93] Ridgeon's chilling comment "Then I have committed a purely disinterested murder"[94] becomes Shaw's final stab at the medical profession in the play. Doan concentrates on Jennifer's growth and success as the true end of the play: "The Muse, Jennifer Dubedat, rejects the doctor and carries the artist's work into the future, adding irony to paradox by penning her own book. The doctor must exit the stage empty-handed, while the Muse takes both the word and the image with her."[95]

Shaw's third premiere at the Court, also in 1906, had a special place in his heart because the central role was written for Ellen Terry: Lady Cicely in *Captain Brassbound's Conversion*. When Francis Fenwick Williams saw the play, she focused her review on Shaw's "creation of a woman who is simultaneously 'advanced,' and 'feminine' ... she is not so much an exception as a type—a type of true womanhood in its modern form. She is not a public character, a saint, or a genius—just a woman of the twentieth century whom no one ignores."[96] Ellen Terry's renown as the best English actress of her generation was well established. Despite Shaw's consternation over the roles she played with Henry Irving—the melodramas to supplement the Shakespeare productions—Terry's designation in the

theatrical profession was "Our Lady of the Lyceum." The public's adoration for "Our Ellen" was celebrated during the run of *Captain Brassbound's Conversion* with a Jubilee celebration, for which several of the Court key actresses appeared.[97]

It is supremely ironic that Terry's character is the foil to Captain Brassbound, who Michael Holroyd describes as having "the style and habits, as he had witnessed them, of Henry Irving." The play had been written in 1899 in hopes of a run at the Lyceum, and Holroyd continues his commentary by noting that the play had been envisioned for the larger venue, so that the intimate Court venue made the play "out of time and in the wrong place." Lady Cicely is between thirty and forty; Ellen Terry was sixty. Gordon and Edy Craig felt that Shaw had "misrepresented" their mother and Terry did have trouble with the part and stumbled over her lines until Shaw gave her the go-ahead to improvise. Then, Shaw told Johnston Forbes-Robertson Terry's performance was "'magnificent.... She simply lives through Lady Cicely's adventures and says whatever comes into her head, which by the way is now much better than what I wrote.'"[98] Holroyd also includes Virginia Woolf's glowing response to Terry onstage in *Captain Brassbound*; as soon as Terry appeared, the rest of the stage seemed to disappear and when she spoke, Woolf noted, it was as if someone drew a bow over a "ripe, richly seasoned cello." Terry's lapse in speech, reaching for her glasses and peering at the back of the setee (for prompt cards) came next. Even forgetting her part "did not matter," according to Woolf.[99]

For Edwardian audiences, the blatant condescension and imperialistic overtones of Lady Cicely and the racist treatment of the African characters by the English and American characters seemed invisible. Desmond MacCarthy did not think the performance at the Court equal to the one given at the Stage Society in 1900, but he thoroughly enjoyed the character of Lady Cicely, whose power "springs from absolute fearlessness and a most kindly sympathy.... She is a gentle, humorous, cheerful, naturally domesticated person, but a very persistent immovable one.... She is always telling people what pleasant faces they have and how much she likes them; and this is how she genuinely feels towards all she meets."[100] On the surface, MacCarthy's remarks ring true; however, her scene with Captain Brassbound at the end of the play, during which she cannot even look at the photograph of his mother is appalling to us now.

Ellen Gainor's reading of the imperialism in Shaw's play places it with other plays he wrote from the 1890s to 1919: "the progress of imperialism abroad and its impact at home." Gainor sees imperialistic enterprise as a "structuring force" for Shaw to stage "images of empire ... a range of views on the colonies and on England's role as an imperial power."[101] Gainor's

perspective on Lady Cicely, part Victorian "lady" and part woman who accepts imperialism and many other aspects of patriarchy, is cogent. For the Court audiences, comparisons to Lady Britomart in *Major Barbara* would have been likely. Shaw's stage directions to introduce Barbara's mother specify that she perceives the world as a household in Wilton Crescent. Lady Cicely's world is much wider, but her approach is the same: the strong womanly Victorian woman who gets her own way by either prodding or maneuvering the men around her. Gainor notes that Lady Cicely is known to treat everyone around her the same, until her British superiority "facilitates the removed semblance of egalitarianism.... Brassbound, the symbol of racial indeterminacy, must be controlled—must be transitioned into a Hallam so that 'proper' distinctions within social order can be maintained."[102]

Earlier in the play, Lady Cicely asks her brother-in-law why he had not helped Captain Brassbound's mother get her property; Howard responds by saying he had no real power then and, besides, the woman had been driven to distraction by injustice. Lady Cicely sees no injustice in what she does to Captain Brassbound at the end though. She attempts to complete his conversion by suggesting he go to England to use his connections to succeed in British society. He doesn't want to be "patronized," which perplexes Lady Cicely since that is the way her world works.[103]

Gainor convincingly argues that Lady Cicely's treatment of the man "leaves him in a void, having destroyed his sense of identity through the elimination of the 'native' component of his self" when she convinces Brassbound to destroy her letters and portrait.[104] Yet Shaw's closing moments—Brassbound's impromptu proposal to Lady Cicely and her refusal, "What an escape!"[105] is a captivating ambiguity, since it can apply to both of them. Brassbound's determination to stay where he is, and Lady Cicely's appreciation of her own freedom as a widow remain intact.

The problematic social elitism and prejudices that Shaw includes in *Captain Brassbound's Conversion* were represented by what Dennis Kennedy terms "two very different examples of social realism, and both unlike anything the capital had offered before"[106]: John Galsworthy's *The Silver Box* (1906) and Elizabeth Robins's *Votes for Women* (1907). Barker shrewdly ran them simultaneously in the spring of 1907: Robins for the matinee and Galsworthy in the evening. Kennedy calls the Galsworthy play "a shrewdly detailed skein of Edwardian life that broadened the Court's range of subjects."

Galsworthy's legal training gave him the way to probe a social injustice from more than one perspective. On the surface, the play reveals the prevailing double standard between rich and poor regarding crime and punishment; two young men steal out of spite, and when drunk, on the

same evening. The rich son of a Liberal MP, in a drunken stupor, steals a purse from his evening's date: a poor young woman. Fumbling with his latchkey, and meeting the husband of the housemaid just at that moment, he asks the man for help with the door and gives him a drink. When the husband also becomes drunk, he steals the young woman's purse and the silver cigarette box that is right there. The poor man also steals out of spite.[107]

But this is where the similarities between the two men halt abruptly. The rich son has no repercussions for his actions; the charwoman is found innocent in court and her husband given thirty days of hard labor. What Galsworthy provides, however, is the difference that all of these circumstances make to the father. Fed up with his son, he wanted some punishment for him; the solicitor persuades him to keep mum for the sake of family reputation. The dire straits of the charwoman's family represent the height the privation level had reached in London, according to Booth's study of 1905.[108] The people in the Salvation Army shelter in *Major Barbara* represent the same circumstances.

Elizabeth Robins's *Votes for Women* in 1907 incorporates much of the grim reality of poverty and violence that Galsworthy's play portrayed. In her text, issues regarding sanitation, abuse of women, and sweated labor come into drawing rooms as well as platform speeches. Although debates ensued then and continue now about whether or not her play was a late version of the fallen woman plot or a suffrage treatise in disguise, it's clear that Robins was incorporating both strands of familiar cultural referents of the era to convey her complex social critique, and vision for the immediate future. Why give Vida Levering a "past?" Critics from 1907 and the present fault Robins for this and its hackneyed use in the melodrama and Pinero and Jones's society dramas. What better way to prod women who were not yet activist to re-examine issues for women in private as well as public life? Julie Holledge calls *Votes for Women* a "subtle pastiche of Paula Tanqueray."[109]

The suffrage plays that followed Robins's also highlighted inversions of melodramatic situations, creating women protagonists who had agency. Whatever their past was, that was either a contrast to their new independent lives, or a means of revealing abuses towards women. Robins' play featured both; its outcome proved the protagonist stronger and happier than ever before because she had true purpose in her life: preventing other women from abuse and/or ameliorating their living conditions.

One of the shrewdest aspects of Robins's dramaturgy was to compress the action of the play into a single Sunday afternoon, thereby allowing her to replicate the simultaneity of life. The best-known and loved act of the

play is the second: the Trafalgar Square crowd scene with platform speeches. But each of the three acts of the play has a big scene: Act One has the Shaw/Barker discussion format around the suffrage and Parliament issue; Act Two has the realization of Trafalgar Square, with more than 40 people on the small stage. Act Three reverses the fallen woman plot: "Robins transforms the 'tainted' female of popular society drama into a champion of women's rights and social justice," says Sheila Stowell.[110] Stowell contends that Robins uses this familiar plot so that Levering can "transform a personal experience into a public and political act."[111] Personal integrity and social justice and archetypal virtues were the core of the movement.

Act One opens at a leisurely gathering before lunchtime in Hertfordshire. Robins introduces a range of political subjects including a discussion of the disruption of Parliament by the WSPU when the House wouldn't bring the question of suffrage to a vote. Several women bemoan this event as the subsequent loss of the resolution in Parliament, and the loss of generations of work to get the measure to the floor of Parliament. The play's protagonist, Vida Levering, who won't be known as a suffrage activist until later in the play, remarks that more attention and publicity was gained by those few minutes than years of more appropriate behavior had produced. The audience knew immediately that the play referred to an event of the previous spring, and knew the news had become international in scope. Open-air meetings drawing hundreds were becoming commonplace, as were exposès of egregious conditions in London's East End as well as "a most unsanitary part of Soho." Vida Levering reported to shocked listeners that she had raised money to build bathhouses and shelters for homeless women in an area that housed brothels, gentlemen's clubs, and music halls with "naughty" tableaux vivants. A well-dressed lady mentioning drains was astonishing, but what Levering does not mention directly is the Contagious Diseases Act that activists were trying to repeal because the prostitutes were subjected to invasive examinations while their male customers were not.

Granville Barker had given the play its title to highlight its great scene: Act II's Trafalgar Square crowd scene. Robins and Barker collaborated to create one-liners ("stage noise") for the spectators in Trafalgar Square. This level of realism onstage managed to combine cutting-edge political strategy and the audience's delight in a visual realization of the photos they saw in the newspapers and on sandwich boards in the streets of the cities where crowds gathered to listen to and interject commentary into platform speaking events. In 1907, Desmond MacCarthy praised the play for including the vote in the "more important demand for 'rights.'"[112] Barker and Robins collaborated on the script and he was given permission to add the

"Mrs. Patrick Campbell as Electra, 1908." HIP/Art Resource, NY. Not only did Gilbert Murray produce a new translation of Euripides's *Electra* in the early 1900s, but Richard Strauss, with the help of a libretto by Von Hofmannstahl, used Sophocles's treatment of Electra, and the great psychological damage done by many years of protracted grief that this playwright emphasized. Sophocles as a military man did much to portray post-traumatic stress in his works. Von Hofmannstahl's play version in 1908 at the Garden Theater in New York, starred Mrs. Pat, with her daughter Stella as Electra's younger sister, Chrysothemis, and Mrs. Beerbohm Tree as Clytemnestra.

"noise." The prompt copy of the Court script, located in the Fales Library at New York University, has about twenty handwritten pages of crowd one-liners and interactions from Barker.

Kennedy notes that the placement of Vida's former lover, his present fiancée, and Vida, along with the range of spectators, who took over the act, "showed the spectrum of Edwardian society face to face with its most intractable political issue."[113] Vida Levering, is a welcome weekend guest in homes of privilege and the last woman anyone would expect to be such a speaker, and that is precisely Robins' point: suffrage supporters need not choose between their radical politics and their fashionable appearance. No one would have known that better than Robins: actress, writer, activist. Vida's story of long-ago love and an unwanted abortion turned her towards activism to ease the suffering of other women in dire circumstances. Vida tells her personal story to the crowd, endures the heckling, and converts the ingénue Jean, engaged to Vida's former lover, to join the cause.

Robins includes the melodramatic frame in order to twist it: in Act I, Vida encounters her "past": Stonor. He is now an MP. A handkerchief gets dropped, but not designedly a la Restoration Comedy. Rather, Stonor retrieves it, and recognizes the initials VL and he tells Jean it's Miss Levering's. How could he know her first name, Jean wonders? When Jean hears Vida speak in Act Two, she solves the mystery. Stonor knew Vida and must have been the man in the story. In Act Three, Jean wants him to do the traditional honorable thing: marry Vida. Vida does not want this—she demands his support for suffrage as payment for his past, which he gives.

The confrontation scene between Geoffrey Stonor and Vida Levering in Act Three was revised quite a lot by Robins.[114] Some of the speeches delving into the details of their past relationship were deleted in favor of a stronger emphasis on Vida's grief over the forced abortion. Stonor had not thought about that in the past decade: rather, he was more focused on her disappearance and refusal to be in touch with him. Such a shift on Robins's part of course emphasizes character over plot, but also highlights gendered perceptions of situations, and distinctions between men and women. Grieving over an aborted child did not fit the image of activist woman portrayed in the popular press any more than her fine clothes. Vida Levering and Ernestine Blunt, the young convert who speaks in Act Two, dress like ladies because the Pankhursts and other leaders found it necessary to appear ladylike in order to garner press coverage. Further, their dress code was indeed a semiotic weapon: women wanted to take care of other women. This play heralds a major thread of the suffrage message of the 1910s: women working together, not competing with each other for the sake of men.

Critics' complaints that Stonor's acquiescence to support the suffrage cause in Parliament seems contrived can be justified, if Stonor is a character who represents manhood and power alone. But that is not the character Robins has drawn. He treats his young fiancée like a child, but she lets him see her as an adult with ideas of her own; he agrees to do what Jean asks him to do. He also genuinely wants to marry Jean, who is now committed to the cause, so giving in to Vida's demand of donation and support of the cause through his influence in Parliament is in his best interest as well.

The kind of collaboration among actors, playwrights, and directors that little theatre, but especially the Vedrenne-Barker seasons, spawned, engendered experimentation that crossed oceans of time as well as space. The contributions of such groups in the United States as well as Britain during the following decades would change the nature of theatrical production and reception, permanently.

5

Breaking News:
Transatlantic Theatrical Activists

> This meeting of actresses calls upon the Government immediately to extend the franchise to women; that women claim the franchise as a necessary protection for the workers under modern industrial conditions, and maintains that by their labor they have earned the right to this defense.—
> Actresses Franchise League Resolution of support for suffrage cause, December 1908, Criterion Restaurant[1]

Parliament's refusal to allow the Woman's Suffrage proposed bill a third hearing in 1908 came with a surprising twist. As Julie Holledge explains it, the bill had carried by a vote of 271 to 92 in members' private ballot, but did not come to the floor again as a result of a "skillful manipulation of parliamentary procedure." More important, however, was the speech by Home Secretary, Herbert Gladstone, who claimed that on this issue

> predominance of argument alone, and I believe this has been attained, is not enough to win the political day.... Men have learned this lesson, and know the necessity for demonstrating the greatness of their movements ... [and] assembled in tens of thousands all over the country.... Of course it cannot be expected that women can assemble in such masses, but power belongs to the masses, and through this ... a government can be influenced into more effective action.[2]

The WSPU (Women's Social and Political Union) rose to the challenge; on June 21, 1908, they transported suffragettes to London on thirty special trains. They had all dressed in white and wore WSPU sashes. Participants were then organized into seven processions. Each of the seven was

headed by a "well-known personality in a four-in-hand coach (one of whom was the actress, Lillah McCarthy)."[3] McCarthy was renowned for her portrayal of many strong women onstage, particularly in plays by Shaw (see Chapter 4).

According to Holledge's research, there were far more than the 250,000 spectators the organizers had hoped for. Holledge cites a *London Times* reporter's remark that people could argue that double or treble that number were there. The crowd included Sarah Grand, who coined the "New Woman" phrase in her 1894 essay, wives of prominent politicians and writers, as well as Bernard Shaw. Twenty speakers' platforms were in Hyde Park, and by the end of the event, three shouts of "Votes for Women" followed the sounding of the bugles.

Six months later, four hundred actresses met to form the Actresses Franchise League (AFL) at the Criterion Hotel in London, and that very afternoon agreed to support all branches of the women's suffrage movement, with the resolution cited as the head quote to this chapter.[4] Very quickly, the Actresses Franchise League determined that theirs would be a multi-pronged program, centered in London but travelling to other major cities where suffrage organizations had branches.

AFL activities included monthly "at home" performances of original suffrage plays, distribution of pamphlets, and programs of recitations/musical performances. Members would also be prominent in suffrage events and marches. Overriding all of these separate functions was an ongoing fundraising program.

AFL efforts dovetailed with the Women Writer's Suffrage League, also founded in 1908 by prominent feminist writers like Elizabeth Robins. These Leagues joined the Artists Suffrage League formed in 1907 and the Suffrage Atelier, associated with the "arts and crafts" movement would follow in 1909.

Lisa Ticker's invaluable study, *The Spectacle of Women*, pulls together the various strands surrounding the evolving role of women artists at this time. More women than ever had been trained in art since the late 19th century, but they had not yet achieved cultural clout. Visual culture was a growing international phenomenon, due to technological advancements and mass culture: a boon for creating what we would now call "branding" for the women's movement.

Visual imagery of the early 20th century, Tickner argues, thrust women's art into prominence. It was "not a footnote to the 'real' political history going on elsewhere, but an integral part of the fabric of social conflict with its own contradictions and ironies and its own power to shape thought, focus debates and stimulate action."[5] The fusion of energy among

women writers, artists, and actresses as activists for women's citizenship ca. 1908–1914 was international news. Although their public roles still caused anxiety among supporters of patriarchal structure, the social justice aspects of their works continued the traditions of social service for upperclass women that was extant from medieval times, and rallied behind exploited, sweated labor, as many factions of the women's movement had done since the mid–19th century.

By the end of the first decade of the 20th century, "The sex" would write speeches, pamphlets and plays, mostly under their own names, that put these marginalized issues in the center of their works and, therefore, in the public eye. Suffrage dramas were published in women's journals, critiqued by women journalists, and performed in venues well outside major cities, and often by suffrage activists who were not professional actresses. These works alongside mass-produced buttons, flyers, sandwich board signs, banners, and posters gave instant recognition to suffrage efforts.

Susan Carlson commends the strategy to place women's action and concerns into the middle of London's public spaces, as well as their creation of new theatre spaces for their pointedly propagandistic plays. Their interconnected efforts were essential to achieving twin overriding goals: establishing women's roles in public domains via large-scale suffrage parades and demonstrations, and offices of operations replete with readily-identified signs and logos, and, through suffrage drama, revealing that woman's home sphere really was *her* space, which she could use as an office, courtroom, and/or welcoming environment.[6]

The shift in attitude that made theatrical women respected rather than disdained in the late–Victorian era was a decided factor in the sweeping success of their combined artistic and political success. Even more recent had been the emergence of the actress/manager who had risen to prominence based upon determination, shrewdness, and artistic gifts. One of the key motivations to launch entrepreneurial enterprises on their own was the static state of roles offered to actresses: fallen women, repressed women, ingénues or soubrettes. As managers, there could be some control over the roles they and other women portrayed and could avoid what prominent actresses like Lena Ashwell described as the "hack work" of the stage. Bernard Shaw, in the Preface to Lillah McCarthy's autobiography, *Myself and My Friends* (1933) encapsulated his scorn towards these representations of women, and the understandable need for Edwardian actresses to more accurately match their onstage roles and their off-stage modern lives: "That horrible artificiality of that impudent sham—the Victorian womanly woman, a sham manufactured by men for men ... had become

more and more irksome to the best of actresses who had to lend their bodies and souls to it—and by the best of actresses I mean those who had awakeningly truthful minds."[7]

As early as 1845, Margaret Fuller located potential for women's agency in the acting profession and the pulpit. In *Woman in the Nineteenth Century*, Fuller reported on her conversations with men who readily admitted women's persuasive powers and influence upon them, and the men's insistence that only in the private sphere could these be tolerable.

Interestingly, women taking up the pen was all right; women could "propose and enforce their wishes" that way. As soon as the idea of politically active women arose, "ludicrous pictures of ladies in hysterics at the polls, and senate-chambers filled with cradles" would emerge and the "beauty" of home, "delicacy" of the sex, and "dignity of halls of legislation" would all be destroyed by women's participation.

Fuller's rebuttal was to emphasize the success of the great actresses and women Quaker preachers as models of "grace and dignity" and proof that "woman can express publicly the fullness of thought and creation, without losing any of the peculiar beauty of her sex." Fuller next pointed out that women routinely participated in processions, songs, and dances of old religion; "no one fancied her delicacy was impaired by appearing in public for such a cause."[8]

The work of suffrage leadership on both sides of the Atlantic would prove both of Fuller's assertions true; more importantly, their relevance to the lives of women as a whole—and not the select few who had achieved success in a public profession—underscores the less obvious point: women's deprivation of social and political power was anything but intrinsic to their "nature."

Unfortunately, Fuller's outline of the contradictions that underlay the woman question would prove truer than her optimistic belief that the removal of all boundaries placed on women because of their sex was on the horizon in her own time. The notion of separate spheres for men and women proffered by Sarah Stickney Ellis in England, and confirmed by Queen Victoria, in the 1840s had a vast impact. Stickney believed that the influence of women on men and society stemmed from their insulation from public life, their devotion to meticulous domestic management, and what she called "the particular observance of all those trifles which fill up the sum of human happiness or misery."[9]

Stickney's stance would echo in John Ruskin's "Of Queen's Garden" 1864, and then be deconstructed by Virginia Woolf in *A Room of One's Own* (see below).

The supposed fragility of economically and socially privileged women had resulted in a huge waste of talent. This was the thesis of Florence Nightingale's 1852 essay, *Cassandra: Or Nothing to Do*. Writing before her work in the Crimea made the world—and even her own family—take her seriously, Nightingale asked directly: "Why have women passion, intellect, moral activity—and a place in society where no one of the three can be exercised? Is man's time more valuable than woman's? or is the difference between man and woman this, that woman has confessedly nothing to do?"[10]

Yet the entrenched and sentimentalized ideology surrounding women's nature and place in the world was insidious in the mid–19th century, and seemed impervious to change. Respectability for women still linked largely to sexual status, even if aspirations for women in the 19th century had widened to include vocational aspirations beyond marriage. Dignity and self-esteem—the quest of heroines of novels or plays—started to come within their grasp.

In his Preface to the 1932 publication of *Ellen Terry and Bernard Shaw: A Correspondence*, Shaw speaks of Ellen Terry's generation of women, and actresses, with emphasis on the confining perceptions and expectations they had endured. As many of her biographers point out, those in the public thought of Terry as "our Ellen," and credit her partnership with Henry Irving at the Lyceum Theatre with removing the social stigma towards women performers and fostering acceptance for the theatre profession as a whole. In his introduction of Ellen Terry, Shaw contrasts "lady" and "actress," since the Victorian era had made these designations polar:

> An actress is not a lady: at least when she is not an actress.... A lady is—or in Ellen Terry's generation was—a person trained to the utmost attainable degree in the art and habit of concealing her feelings and maintaining an imperturbable composure under the most trying circumstances. An actress is a person trained even more severely in the art and habit of displaying her feelings so demonstratively that every occupant of the back row in a remote gallery can read them in her face and see them in her gestures. What to the lady is an emergency, in which dissimulation is her first duty, is to the actress an opportunity for explosive self-expression, however skilled her guidance of the explosion may be.

Shaw's use of the lady/actress dichotomy, therefore, is more about showing its irrelevance to actual lives of individuals, despite the tendency of society to reinforce such boundaries. Shaw notes that Terry did not have to bow to the conventions that most of the women characters onstage struggled against, both internally and outwardly. Her profession made her self-supporting, and her private life was her own to control. It is quite

ironic that Terry's children were born out of wedlock, despite her being married before and after their births; the public was blissfully unaware that the woman who gave depth to the "conventional" heroine or Shakespeare's strong women was herself more like the emerging New Woman than a charming Victorian one.[11]

The fact that Ellen Terry lived her private life without compliance with Victorian convention made no difference to the impact that her stage presence and well-known graciousness and humor had on the public imagination. Thus the import of Shaw's remark: women's roles were performative, onstage and off.

The forthright recognition of this factor would upset the frozen image of the "pleasing woman" touted by Jean-Jacques Rousseau in his treatise on education, *Émile* (1762), and undermined by Mary Wollstonecraft in *Vindication of the Rights of Woman* (1792) and John Stuart Mill's *Subjection of Woman* (1869). The performance of everyday life clearly informed Virginia Woolf's images of the looking glass for men as well as women in Chapter Two of *A Room of One's Own*, when Woolf was in the British Museum trying to find the causes for women's and men's dichotomous lives.

As she discovered more anger than rationale in the readings, Woolf turned to psychological analysis. She concluded that women have served for centuries as looking glasses for men "possessing the magic and delicious power of reflecting the figure of man at twice its natural size" (think fairy tales here). This was necessary, Woolf decided, so that men could go into the public sphere and accomplish things. Such daring requires self-esteem and the innate belief in one's superiority: in other words, the ego boost that allowed men to also "perform." If women gave men negative feedback, it was far more difficult for them to cope with, Woolf argued, because the ideology has given men dominion over women, and if they could not maintain it, men could not look themselves in the eye (or looking glass).[12]

Women's education, a rallying cry since the late 18th century, had made progress, with remaining limitations ascribed to innate, gendered differences. A prime example of the attitude was John Ruskin's 1864 address, "Of Queen's Gardens." Ruskin was emphatic in his thesis that women were innately morally superior to men, and therefore needed to avoid intellectual subjects that would tamper with this essential quality.

While acknowledging the powerful women of Homer and Greek tragedy, and asserting that the only heroic figures Shakespeare's plays are the women, he nonetheless argued that their strength derived from stead-

fastness, virtue (presumably sexual, since that was the only virtue assigned to women at the time), and, thereby, their "natural" rule. For Ruskin, there was apparently no contradiction here because he relied on a key 19th-century precept: the distinction between empirical knowledge and intuitive judgment. His "celebration" of the educational method for his feminine ideal reveals his stance, and its connection to Rousseau, clearly:

> All such knowledge should be given her as may enable her to *understand*, and even to *aid*, the work of men: and yet it should be given, *not as knowledge,—not as if it were, or could be, for her an object to know; but only to feel, and to judge*.... It is of no moment to her own worth or dignity that she should be acquainted with this science or that; but it is of the highest that *she should be trained in habits of accurate thought; that she should understand the meaning, the inevitableness, and the loveliness of natural laws*[13] [italics mine].

Ruskin's conflation of understanding, accurate thought, and feeling as the basis of judgment for apprehending natural laws relegated women to semi-conscious, intuitive thinking: precisely what the increasingly scientific intellectual environment of his time resisted, and on those criteria, women's statements readily discredited. But not for long: the founding of Vassar College in the U.S. and Girton College in Britain (1869) and Newnham in Britain (1871) would prepare women for work across the disciplines. Even those who did not have the privilege of higher learning were stepping up to responsible positions in business and labor agitation.

In the post–Civil War United States, the era became designated as the time of the "coming woman." This phrase preceded New Woman but contained as powerful an image in the popular imagination. Elizabeth Cady Stanton wrote to her friend and supporter, John Hooker, in 1870 regarding his letter to the editor of the Hartford *Courant*. One of her remarks encapsulates the cultural moment: "If the Hartford *Courant* wishes to know whether the 'coming woman' is to be the drudge, the tool, the toy for man she has been in the past, we may as well confess that she will not."[14]

Elaine Showalter, in *A Jury of Her Peers*, asserts that the "coming woman" was the "emancipated woman of the future," as shown by Elizabeth Stuart Phelps' 1871 essay that proclaimed the concept of woman's dependency as obsolescent. In Showalter's interpretation of Phelps, the traditional woman felt fulfilled by the cult of true womanhood alone; "she merged her identity with that of her husband. But she had become, quoting Phelps, an 'enormous dummy,' a scarecrow to frighten the timid ... [only] when every department of politics, art, literature, trade is thrown open ... to the exercise of their energies,' could the true woman arise."[15] Phelps'

metaphor of the dummy/scarecrow could be seen as the ugly "double" of the woman as idol/statue that so dominated 19th-century art and theatrical roles; in contemporary terms we would call it deviant. Women clearly craved alternative images.

From the time John Stuart Mill presented the first bill for women's suffrage to Parliament in 1866, with the Married Women's Property Act soon following in 1870, to the militancy that began in the first decade of the 20th century, women activists and reformers worked steadily and made considerable progress. Kent points out that 1870–1905 has often been termed a "doldrums" period in British suffrage history, but in actuality, women were making inroads in education, working towards reasonable working conditions for women of all classes, pushing for better drainage and sanitation, and striving to repeal the Contagious Diseases Act that kept prostitutes "safe" for the men who bought their services.[16] Attaining Votes for Women in a vacuum never was the women's total agenda. Clearly, the suffrage movement was all about women becoming full citizens.

As Kent and other feminist historians have shown us, the social justice efforts that spawned and expanded the "woman question" confronted the ideology that held onto precepts from English Common Law that treated married women as appendages to men, tolerated white slavery and spousal abuse, which were treated as "private" issues. Those who tried to stem the tide of women's rights ignored the rising numbers of women who were self-supporting, and denied them the workers' rights that were slowly coming via trade unionism.

One of the most famous women's advocates was Bernard Shaw's friend, Annie Besant. In 1887, Besant debated the MP Charles Bradlaugh, who told his daughter that Besant's was the best speech he'd ever heard. In her examination of women's political status, Besant centered on the "nature" question, and also carried through on Nightingale's essential contribution: understanding sanitation, [and her] ability to "organize, to lead, to get things done."[17]

Here is the core of Besant's argument; it is a clear rebuttal to Ruskin:

> It has been remarked, more than once, that, in this contest about the voting of women, men and women have exchanged their characteristics. Women appeal to reason, men to instincts; women are swayed by facts, men by prejudice. To all our arguments ... men answer, "It is unfeminine—it is contrary to nature." I am afraid we women sadly lack the power of seeing differences.... It is unfeminine to study sanitary laws, but feminine to regulate the atmosphere of the nursery, whose wholesomeness depends on those laws. If this natural mental inferiority of woman be a fact, one cannot wonder how nature managed to make so many mistakes.[18]

Besant's thesis: women are more rational than men, intersected the admission that men sought women's advice in private, and that their "management" of the private sphere gave women expertise in group dynamics and listening skills. Besant squarely opposed Ruskin as she argued that women's entrapment within the domestic scene or economic privation required more than individual effort to overcome. Elizabeth Robins's 1907 play, *Votes for Women*, would refer specifically to drainage as a woman's issue, put working-class women and "elegant" spokeswomen for the Cause into her script, mainly in the Act 2 Trafalgar Square scene, but also in the "polite" drawing-room conversations that bookend the play's thematic as well as structural center.

Blending traditional feminine virtues, appearance, and good works with masculine assertiveness and leadership skills wore away at social disapproval for enlargement of women's roles. The women's club movements on both sides of the Atlantic in the late 19th century gave groups of women legitimacy to gather in large numbers and have speakers on key issues. Carol Mattingly's study on the impact of dress on the perception of women speakers, coupled with the need to provide a well-appointed hall—with flowers and artistic decorations—for meetings to receive press coverage, shows the ingenuity in activists' strategies. Mattingly reminds us that those women speakers were already breaching appropriate behavior by being in public arenas, and, more egregiously, looking at audiences directly. Their gaze triggered a fear factor because of the "depth of convention that forbade women to return men's look directly.... Even when approached directly, custom demanded that they keep eyes lowered. Assuming the privilege of looking directly ... undermined the power structure that helped to keep gendered and classed hierarchies in place."[19] One of the trademarks of the New Woman, even if not lampooned, was her direct gaze and freedom of movement in skirts and menswear-inspired blouses and cropped jackets, images made iconic by the pen and ink drawings of Charles Dana Gibson and the paintings of John Singer Sergent. Critics may have labeled them brazen, but the loosening of stays and the raising of eyes made the 19th-century woman-as-idol a mirage by the first decade of the 20th century.

British historian Sandra Holton argues in a similar vein, positing that outdoor suffrage parades and indoor meeting halls became more domesticated to ease the inversion of social space and access the women were determined to achieve. In order to re-envision the prevailing political landscape, women rejected the "masculine qualities" commonly associated with it, and they urged a more "nurturant role" for public life. Holton continues: "The most striking aspect of British suffragism, then, is that it did

not present feminist goals in terms of equivalence with men but in terms of an autonomously created system of values derived from women's particular experience."[20]

Some Americans, most notably Harriot Blatch, Elizabeth Cady Stanton's daughter, Alice Paul, and Lucy Burns, had worked with the Pankhursts and WSPU, so could easily transplant ideology and tactics. Blatch instituted open-air events reminiscent of those in Trafalgar Square in New York beginning in 1907; unlike other leaders, Blatch was determined to include the full spectrum of women in these events and in the consciousness of the movement. Blatch recognized the inherent theatricality of the woman's movement and, for that matter, the woman question. The main goal was to saturate the print media across the U.S. As Blatch put it: "'As this is an advertising age, leaders of any movement do well to study ... the methods of the [theatrical] press agent ... suffrage propaganda must be made dramatic.'"[21]

Professional American theatrical women were prominent suffrage figures, like their British counterparts, albeit in very small numbers. Lillian Russell's mother had been a suffragist, and she co-founded the Gamut Club for professional theatrical women in 1913 with Mary Shaw. Mary Shaw had starred in Ibsen's plays in the 1890s, and revived them in the 1900s. She also starred in Bernard Shaw's *Mrs. Warren's Profession* in 1905 (which the Comstock Laws shut down on opening night because a Madam was unrepentant),[22] and the American premiere of Elizabeth Robins's 1907 full-length suffrage drama, *Votes for Women*, in 1909.

In 1908, the same year that the Actresses Franchise League was formed in London, large-scale suffrage parades began in New York. There was an unexpected development, however: the petition for a permit for the suffrage parade was denied. Rather than cancel, however, the suffragists marched but they did not chant. No confrontation with police arose.

In her 2009 study of the emergence of women's theatrical power in New York in the early 20th century, Pamela Cobrin remarks that this silent march seized silence with their "normal" demure behavior: "Increasingly, suffragists relied on the unspoken as a political weapon—also staging tableaux and [sandwich boards] silent speeches ... held by silent women ... these tactics forced male and female spectators to read through a female-constructed lens of silence."[23] In 1910, organizers opted for a parade of automobiles following marchers since parades were still stigmatized. That year's most interesting tactic was the use of empty baby carriages filled with suffrage symbols, all festooned in the movement's signature color, yellow. The press was impressed.[24]

The May 1911 New York parade, however, embraced the reality of women's experience, from history and the present; this time, working-class women, unmarried women, men, and children were part of the march. The working class visibility clarified the demand for "a social realignment." There was a theme, "Change in Position of Women over last 100 years," with Harriot Blatch at the helm. The parade opened with a woman in a sedan chair "representing the shut-in woman of the past and closed with the Woman Suffrage Party." Floats had scenes that "manipulated traditional male-dominated views of American history, creating instead a women's American history. Blatch's theme moved history forward and assumed women's increasingly public, active roles, with due deference to the women of the past whose achievements had inspired them.[25]

Edith (Edy) Craig created a visually and intellectually stunning pageant for her mother, Ellen Terry's, Jubilee in 1906. It featured twelve tableaux vivant about historically important women from Cleopatra to Joan of Arc to the Madonna. Multi-generational, professional actresses: from Lillie Langtry to Lena Ashwell to Dorothy Minto portrayed these heroic, beloved women. Craig was unabashed in her belief in the propagandistic tool that suffrage plays offered.[26] Her biographer, Katharine Cockin, cites Craig's conviction in the power of these plays to bring in "naïve frivolous people who would die sooner than go in cold blood to meetings" but who might join afterwards."[27]

Edy Craig had acted at the Lyceum, was the original Prossy (the single typist and New Woman) in Bernard Shaw's *Candida* in 1897, and was the Lyceum's costume designer from 1900 to 1906. Craig would begin her career as a director with the suffrage drama era. She had been an integral part of theatre's transition from staging the immense Lyceum to the independent theatre's more intimate spaces. Her sense of costume and visual design likewise complemented her commitment to showing that women's intellectual capabilities and achievements, as well as their personal life choices had long been way beyond gender binaries. Who was in a better position to be the maverick for the multi-layered women's theatre that was about to evolve?

Clearly, Edy Craig saw the potential for fusing the *au courant* pageant format, the expansion of tableaux vivant from private women's theatrical to establishing women's historical leadership tradition, and the use of farce as well as tract to educate and inspire audiences. Her experience in the late–Victorian theatre's visual literacy gave her an insider's access towards new theatre directions to reinforce the best use of visual imagery, while prompting her to disrupt its static appeal. Suffrage parades and floats on

both sides of the Atlantic featured women moving through tableaux, retaining the power of their foremothers while bringing their deeds into the present reality of breaking through the frozen attitudes exemplified by Ruskin, above.

The pageant form gained high visibility and prominence after 1905, which saw a Dorset town, Sherborne, enact its 1200-year history in a castle, with a cast of 900 amateurs: it was filmed.[28] This notion of "the people" embodying their history dovetailed beautifully with the goals of the tableaux-vivant-inspired suffrage pageant.

Rebecca Cameron's article on suffrage pageants also cites the Sherborne event, as well as its importance to the trend for such events in the United States as well as Britain that followed. If Louis Napoleon Parker's pageant was "a deliberate return to Renaissance pageantry inspired by the late nineteenth-century arts and crafts movement," the combined forces of the Women Writers, Artists, and Actresses Franchise Leagues by 1909 can be seen as squarely in this cultural moment: precisely what Lisa Tickner asserts.

As Rebecca Cameron remarks, the suffrage pageant used this tool and trend to appeal to the popular imagination's pleasure in such performance, thereby incorporating it for feminist purposes.[29] The two pageants that emblematized the suffrage push in Britain were the Craig/Hamilton *Pageant of Great Women* (1909) and the Women's Coronation Parade of 1911. In both, professional actresses joined forces with ordinary women across the spectrum of social class. The latter showed women's actual vocations and status in the 1910s, with historical figures marching alongside them, while the former showed that amateur as well as professional actresses could embody the great figures of the past to carry forward their stories. Cameron notes:

> Through this correlation between performer and character, the production links the suffragists who perform these roles to a group of highly accomplished women of historical distinction, imbuing the suffrage movement with a dignity, grandness, and historical significance that directly counters suffrage opponents' dismissal of the movement as a ridiculous and short-lived aberration.[30]

Following the AFL's first and most-often revived hit, *How the Vote Was Won*, Cicely Hamilton's *A Pageant of Great Women*, premiered at La Scala Theatre in November 1909, directed by Edy Craig. A theatre reviewer for the feminist newspaper, *Votes for Women*, had written:

> There is not one play on the London stage at the present time which takes any account of women except on the level of housekeeping machines or

bridge players—the actual or potential property of some man, valuable or worthless as the case may be. It is strange to go out of the world where women are fighting for freedom, into the theatre, where the dramatist appears unaffected by this new Renaissance.[31]

A Pageant of Great Women stands as a work to continue the thread of preserving and promoting women's contributions throughout history that began in ancient times. The text was not a pageant in the strictest sense because the work went beyond visual realization of an historical topic; it contained an argument, like a discussion play.

Hamilton's project spans centuries and cultures. The Pageant's dramatic action revolves around the petition of Woman to Justice for freedom, with Prejudice in hot pursuit. Hamilton's text mirrors the ongoing pursuit of women's legal and individual rights in Parliament, and the prejudices that have stymied its resolution. As soon as their particular contributions and evidence are needed, groups of women enter, in this order: The Learned Women, from Hypatia to a new college Graduate; the Artists, from Sappho to Nance Oldfield, one of the first actresses; the Saintly Women, from St. Hilda to Catherine of Siena; the Heroic Women: Charlotte Corday, Flora Macdonald, Kate Barlass, Grace Darling; the Rulers, from Victoria to Deborah; the Warriors, from Joan of Arc to Florence Nightingale.[32] In each grouping are women from the distant past, early modern Europe, and those then actively engaged working for women's recognition and changed status.

Hamilton's text featured allegorical figures: Woman, Justice, and Prejudice (the only man in the cast). Only one other performer stood out from the rest because she spoke and used humor: Ellen Terry as Nance Oldfield, one of London's first actresses. The rest struck tableau vivant poses and also moved, thus combining private and public theatricality. As working actresses who banded together for the cause of womankind, they epitomized leadership, savvy, and also the womanly virtues their prejudiced critics refused to acknowledge. The text incorporates Justice (a woman) allowing all to speak as they enter.

Sir Prejudice maintains the position that Woman cannot have freedom because her world is too narrow and personal, but the evidence of the rulers and warriors dissuades Justice who declares that Woman has won her freedom, and warns that she has much to learn. Justice tells her, "Go forth: the world is thine…. Oh, use it well! Thou hast an equal, not a master, now," and Woman agrees to "go speak with him as peer with peer, Free Woman with free man." Justice cautions: "Then let thy words Be just and wise." Woman then has the last speech, in which she declares that she has no quarrel with man but "I stand For the clear right to hold my life

my own.... To mould it as I will, Not as you will, with or apart from you.... No thin, grey shadow of the life of man! ... The work I set my hand to, woman's work, Because I set my hand to it. Henceforth For my own deeds myself am answerable To my own soul."[33]

Just as Home Secretary Gladstone's actions had spawned the huge suffragette spectacle in Hyde Park in 1908, so did his more direct treatment of the suffrage activists in 1909. Two months after Gladstone ordered prison doctors to administer forced feeding for the imprisoned women in Holloway Gaol, the *Pageant of Great Women* opened.[34] The argument of the play, and its large, mostly silent, cast centered on women's right to self-determination and freedom. Woman's last speech placed into the context of the thoroughly abominable force feedings that were decried by the press and pictured in women's suffrage posters is truly stunning.

Even if many of the figures portrayed by the tableaux figures entering one at a time were unfamiliar to audiences, the Pageant "gave fifty-two actresses the opportunity to express on stage their support for the suffrage cause in an endless stream of positive images for women." Holledge cites a *London Times* review that emphasized the dominance of suffrage supporters in the audience, but also noted that even opponents "'must have been struck by the intense earnestness and absolute good taste with which these ideas were presented.'"[35] This journalist's diction seems to be a masterstroke: within this conservative newspaper, great praise for the radicals was couched in mid–Victorian terms. Katharine Cockin focuses on a polar opposite media response: the premiere performance of *A Pageant of Great Women* as front-page news in the *Daily Mirror*. The coverage was a photograph of eight performers, including Ellen and Marion Terry. Here was an example of the "new photojournalism, its minimal captions and the implication that the-picture-says-it-all depoliticized the play as a gathering of famous and beautiful women in fancy dress."[36] No better exemplification to prove the enormity of the cultural shift of that era could be found. Yet the play's success was uncontested, as troupe after troupe of professional and amateur casts performed the play throughout England for the next two years.

As Hamilton's play was propelling women forward, it also represented the designations of women that Ellen Terry would lecture and write about when she toured the United Kingdom, United States and Australia between 1910 and 1921. New York welcomed her in 1910 with enormous crowds attending her lecture. She asserted that Shakespeare's women: "have more in common with our modern feminine revolutionaries than is ordinarily supposed.... In the fifteenth century there was a regular woman's movement. Woman's position was different perhaps, but no less important

than man's." And then as now there was opposition to what is commonly called unfeminine attributes.[37]

Terry's remarks were not received with universal warmth; Susan Carlson cites a review that claimed that the women's movement is so virulent that all bastions of cultural values now belong to them: "'they would plant their banner upon every vantage point of thought and action which history and literature bid us reverence; they would discover in all great impulses that ever moved their sex something with which their own revolutionary spirit can claim kinship and from which it can draw perpetual inspiration.'"[38] Clearly provoked the reviewer might have been, yet women's inroads towards re-configuring cultural history as well as the contemporary scene were clearly front and center.

Terry's younger colleague, the aforementioned Lillah McCarthy, took advantage of a unique opportunity to act for the Cause, and thus fulfill the unhappy critic's contention that women with the revolutionary spirit wasted no chance to make a statement. Invited to give a private performance for the King and Queen at the Prime Minister's residence at 10 Downing Street, McCarthy found herself alone in the Cabinet Room at rehearsal time; it was just days after Prime Minister Asquith rescinded on the women's suffrage Conciliation Bill and 10,000 activists had marched to Albert Hall. In her autobiography, she recalls her unplanned but impassioned decision to leave a particular kind of message for Asquith. After describing the baskets of papers and blotting paper as "solid ornaments" suddenly

> "fervour for the cause took hold of me. I felt like a Joan of Arc of the ballot-box. Martyrdom or not, the occasion must be seized. I opened my box of grease paints, took out the reddest stick I could find, and wrote across the blotting paper 'Votes for Women.' I went out of the room exultant." When the Prime Minister asked her why she felt women should vote she "poured out arguments in no unstinted measure." His "quizzical smile" as response made McCarthy wonder "whether the weight of her arguments was as great as their volume."[39]

Asquith would remain obdurate, but the Woman's Army was equally as dogged in its confrontation with the status quo. Yet the major event of 1911 would be the women's contribution to the Coronation ceremonies of George V. Elizabeth Robins, a key organizer, described the upcoming event in an article published in the *Westminster Gazette* on June 16, 1911, the day before the Woman's Coronation Parade would be among the ceremony of the occasion. Robins reminded her readers of the military pomp of such occasions, and noted that the normally invisible half of Britain's army of loyal subjects—the women—had been involved in massive preparations. Robins noted the international participation that would be featured, as

well as the extremely long hours volunteers had put in to make the costumes and banners, travel from many countries, and be ready to represent their cultures, professions, and devotion. Many segments of the women's movement would be represented with its own symbol and theme. The parade route of four miles would move to Ethel Smyth's original music.[40] Robins's encapsulization of what the morrow would bring is still stirring:

> Here will be the greatest gathering of women the world has ever seen in the world's greatest city. Four miles of women marching toward one goal. Many of them have not come lightly by the power to do this thing the public will be looking at to-morrow. Those who have marched before have noticed many a woman looking out of windows with troubled eyes at the regiments going by in the mud or the dust of London streets. Hundreds of those who last year watched the others will be found to-morrow among the marchers.[41]

Over 40,000 women participated, and almost all wore white. People watched along the route and also from upper-story windows. The spectacle was dazzling. Cameron cites a report in the *Daily Sketch* that posited the visual display of unity, and the impressiveness of the extended march momentarily overshadowed the deep divides surrounding the goal of gaining votes for women the same year a new monarch came to power.[42]

Overall, it is clear the leaders of the suffrage movements in the early years of the 20th century, whether writing in feminist periodicals, or structuring parades in the streets and/or onstage plays and pageants, were consciously reflecting the changes they were helping to effect. As DiCenzo puts it, influential women thought of themselves as "modern," and "advanced," and were more concerned with "innovation at the level of ideas and attitudes, rather than with formal experiments."[43] While it is true that many of the younger generation of suffrage leadership on both sides of the Atlantic were single, well educated, and/or leaders in labor agitation, their recruits, especially in Britain, crossed social class lines. More importantly, the themes of suffrage plays and speeches involved the concerns of the exploited workers, wives, and children—with the hope that social changes would allow them access to full citizenship.[44]

Alongside the arts critics and commentators in the commercial press, the proliferation of independent, feminist periodicals after 1909 afforded the women journalists a freedom of expression and means of influence heretofore beyond their grasp.

Like many of the suffrage plays that were either performed or printed in these very periodicals, the journalists were reaching towards men in order to truly shift the social and political time to come, and men also wrote plays and gave speeches. DiCenzo cites Lisa Rado's point that the women writers strove to "theorize modernity and women's place in it."[45]

Cicely Hamilton and Lillah McCarthy, stars of Shaw's "anonymous" hit of 1911, *Fanny's First Play*, staged at Lena Ashwell's Kingsway Theatre, London. Courtesy Bernard F. Burgunder Collection of George Bernard Shaw. Division of Rare and Manuscript Collections, Cornell University Library. This photograph originally appeared in London newspapers of 1911. Imagine the delight of the audiences who knew both of these women for their work in theatre and activism, to see them in this "anonymous" work together. This play includes many of the suffrage issues of this era. Hamilton plays McCarthy's religious mother, while McCarthy herself has taken to finding herself on the streets and even in jail for a fortnight.

If women in private life already "scripted" their behavior through dress, facial expression, and modulated voices, groups of women in public spaces would need to at once reinforce and re-invent the behaviors. Women's inherent moral superiority as stated by patriarchal standards would be on display, on the streets, in the journalism, and in the plays and pageants. A major remaining challenge was to confront the virulent verbal and visual lambasting of the Anti-Suffragists (aka Antis), who promulgated masculinized, dour, hysterical images of the suffrage supporter and New Woman. Mary Holland Kinkaid's article and photo spread in *Good Housekeeping* in 1912 tried to "domesticate" her image. Kinkaid emphasized the

"personal attractiveness and housewifely attainments, exceptional charm, beauty and talent" of suffrage leaders.[46] Susan Glenn extends the strategy to incorporate the domestic virtues that were already in place: "The image of the righteous female militant also encompassed that of the courageous female wage earner, whose economic and family security … would be protected by woman suffrage."[47]

The suffrage plays that are discussed in the next chapter represent the attitudinal and strategic aims of the transatlantic suffrage leadership, and its swelling army of women and men ready to stage change.

6

Tandem Stages: Transatlantic Suffrage Drama

> The result of the suppression of actual women in the classical world created the invention of a representation of the gender "Woman" within the culture. This "Woman" appeared on the stage, in the myths, and in the plastic arts, representing the patriarchal values attached to the gender of "Woman" while suppressing the experiences, stories, feelings, and fantasies of actual women.—Jill Dolan, "Classic Drag: The Greek Creation of Female Parts" (1985)[1]

> The life which is fading from our immediate consciousness—it is the life of our mothers, or of our grandmothers, rather than of ourselves. Here and there, however, pioneers are to be found who refuse to accept the theatrical, conventional view of humanity, who insist upon showing people as they are today....—Marjorie Stratchey, "Women and the Modern Drama" (1911)[2]

If the two quotations that begin this chapter are considered jointly, the achievement of suffrage drama gains considerable credence, particularly in relation to those plays that posit a radical departure from fixed private roles for women and men. As Dolan points out "Woman as text" in literature, plastic arts, and performing arts, beginning in the classical era, continued to be distinct from actual women's lives into the 20th century. Men and women journalists and theatre reviewers in the 1910s chronicled the seismic shift that sought to sever the distinction between women's lives and their representations onstage. Such efforts enabled audience members to adjust their expectations, if not win their approval, of the new drama.

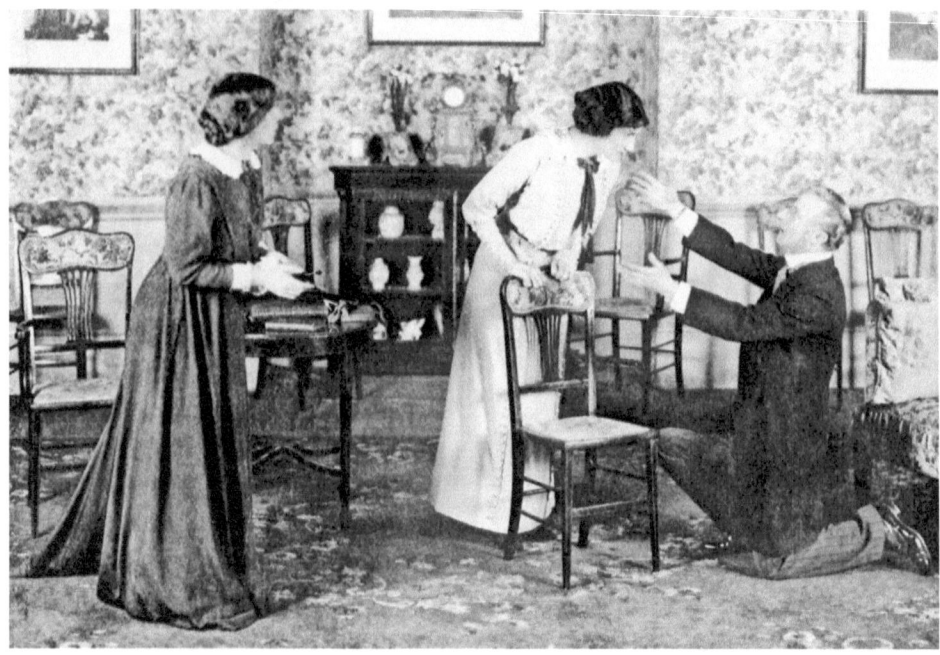

Scene from Shaw's 1911 hit, *Fanny's First Play*, staged at Lena Ashwell's Kingsway Theatre, London. Courtesy of Bernard F. Burgunder Collection of George Bernard Shaw. Division of Rare and Manuscript Collections, Cornell University Library. In the middle of Shaw's play, Margaret (McCarthy) has just returned home after spending a fortnight in jail; no, she hadn't joined the suffragettes, but was with them in Holloway. Note the father imploring her not to disclose her adventure for the sake of his drapery business.

Note Stratchey's implication that "theatrical and conventional" were a combined reference to the static Victorian assumptions about family life, onstage as well as at home. The struggle for enfranchisement was broad-based enough to encompass not only the factions within the movement but also the kinds of structure familiar to theatre audiences. As Elizabeth Robins did in *Votes for Women* (1907) at the Barker-Vedrenne Royal Court third season (see Chapter 4), the suffrage playwrights altered form and content of existing styles as part of the process of "writing over conventional dramatic/social representations of womanhood."[3] Sheila Stowell, in *A Stage of Their Own*, emphasizes that the term suffrage drama referred to "the auspices under which these plays were produced, not their specific content."[4]

The performative strategies of the suffrage movements intersected with the early 20th century's more sophisticated international communi-

cation outlets. The leaderships' instinct for publicity championed the imagery, iconography, and sound bites of feminism. Thereby mass media served as linchpins for infusing the cause and its many components into the minds and vocabulary of the popular imagination. Matinee audiences had been supremely important for all the forms of new drama since the 1890s, and the predominance of middle-aged women and adolescent girls who made up these audiences was a clear boost to the ability of the suffrage plays to encourage audience participation on a whole new level. Characters in the suffrage plays reflected the situations they themselves could alter. The dialogue and plot points mirrored the articles in newspapers and magazines; these acknowledged women as decision-making figures. This extended *mise-en-scène* blurred the separation between staged and actual reality and gave the theatre-going experience a dimension of practical application to ordinary lives. The strategy of non-professional actors in the plays—and even totally amateur productions—cemented the dialogic relationship between performing roles off as well as on stage.

As the short discussions of the works in this chapter will show, these works aimed to illustrate gender roles for men as well as women could blend, and thereby create less dichotomous intimate partnerships. Plays illustrated what had already been the reality: women's increasingly public functions, whether in paid or volunteer capacities. What is equally intriguing is the complementary focal point of many of the suffrage plays: their goal of easing the anxiety surrounding active, self-assertive women shown within their domestic lives. Equally true was the rise of women working in offices, department stores, and as activists, journalists, seamstresses, charwomen, and domestic servants. Suffrage plays represented these women's lived experience. Through the simultaneity of these theatrical works and public events that inspired and shaped them, the younger generation embraced what we now would call a "new normal."

By the time the Actresses Franchise League (AFL) was formed in 1908, the suffrage movement and its push towards full citizenship for women had finally begun to work across class lines. Whether the play was a serious drama or a farcical comedy, it could waste no time in elaborate exposition. The cause was urgent, and a sense of immediacy pervades them. These were problem plays that also functioned as case studies across the social spectrum. Part of their impact surely reflected their pared-down structure.

Historian Claire Hirshfield asserts that the Actresses Franchise League knew that the "major part of its mission lay in theatrical performances." In 1912 alone, more than seventy such performances were logged, and entertainers were regularly traveling beyond London ... on a sort of

suffrage society circuit." Constant fundraising matinees at the Aldwych and Lyceum Theatres in London brought in considerable funds. These were triple bills of suffrage plays performed by AFL members, always seeking to "reinforce the emotional commitment of their audiences to feminist causes. The theme rarely varied: female righteousness triumphing over male iniquity.... Departure from this tried-and-true formula was not encouraged."[5]

There was more breadth and depth than Hirshfield's last remark might imply. In reviewing British and American plays, more than one thematic thread emerges within what Hirshfield rightly labels the righteousness of the changes the movement wanted to effect. Some works were tracts, representing women's victimization in terms of sexual harassment, abandonment during or after pregnancy, and the laxity of laws and punishments for violence against women. Another primary focus was economic privation—either within sweated labor, domestic service, the surge in prostitution when no social services were available, or marital entrapment, financial and psychological. Conversely, portrayals of women and work documented the schism between family support and negation of these expanding opportunities.

Key full-length plays from the 1900s, written by and/or managed (directed) by women, established ideological and structural elements of the one-act plays soon to follow under the auspices of the Actresses Franchise League. Edith Lyttleton's *Warp and Woof* (1904) was an exposé of the mistreatment of seamstresses by an ambitious woman designer with no regard for her workers. The play was produced by Mrs. Patrick (Stella) Campbell, who also took the starring role, not as the designer but as the fitter. The women worked upwards to sixteen hours a day for clients who thought nothing of showing up in the morning and demanding a ball gown by evening, which is what happens in Act I. That evening is a major social event, and the staff is already stretched to its limit; their meal breaks are taken away and they have five minutes for lunch and tea and work well beyond the licensed hours once again.

In a succession of quick-paced scenes that manage to develop characters and conflict, the ever-present privilege of class and gender pervade each act. The designer, Madame Stéfanie, is crueler than the demanding clients. Lyttleton also includes the romantic elements of cup and saucer dramas, particularly the murky waters pervading relationships across class lines. Theo, the protagonist, has what she believes is a friendship with a man. Towards the end of the play, he offers to set Theo up in her own business, as long as sexual favors are included. Phoebe, Theo's younger sister, is engaged to one of Madame Stéfanie's workers, but they can't afford to

marry yet; his proposed arrangement would include help for Phoebe as well. Theo, as representative of the self-sustaining New Woman, refuses his offer: "How dare you come here and dangle these things in front of me. I thought you wanted to be a friend.... Leave me alone.... Don't come here with your sympathy. We'll live our own lives! We're honest anyway."[6]

Phoebe is ill and forced to continue her work; she faints and coughs up blood and Madame Stéfanie sends Phoebe home, but Theo must finish the work. At ten-thirty the final gown is brought to the client: not quite finished. The client upbraids Theo for this, saying that it's "disgraceful" and asks what Theo has been doing all day. Theo's calm veneer shatters and she lets the client know that this gown has cost her and her sister their places. Her "friend" Percy cautions her to hold her tongue, but she cannot. Theo then divulges the reality of the past three weeks, working from seven in the morning to as late as one in the morning, all because their boss has taken in too much work without sufficient time. Theo says she knows the clients are unaware of this, but also that their gowns are not merely made of silk and satin: "our life and strength goes into them too."[7]

When Madame Stéfanie arrives and finds the gown not fitted, she is perplexed. When the client tells her what Theo has shared with them all, not only is Theo dismissed, but also she will not receive the wages she and Phoebe have earned. At this point, Theo must accept the bargain from Percy she had just refused. Percy gives her a ten-pound note; she does not thank him. He is astonished and she retorts that he has what he wanted so no thanks are needed. By the time Theo gets home, Phoebe has died. If this seems "melodramatic," think again.[8]

The clothing industry as well as the multi-faceted connections between women and clothing had been a consistent bone of contention between pro and anti suffrage campaigns throughout the Victorian and then Edwardian eras. As Kaplan and Stowell point out in *Theatre and Fashion*, Lyttleton's play draws upon rich traditions of both "seamstress iconography" and literary ones, especially Thomas Hood's "Song of the Shirt" from 1843. As a member of high society, Lyttleton pointedly focused on the mistreatment of the sweated seamstress by oblivious clients as well as harsh supervisors.

Cicely Hamilton's *Diana of Dobson's* (1908) zeroed in on the plight of the live-in shop assistant.[9] This play opened in February: nine months prior to the formation of the AFL. The reviews, "anticipated, and fuelled, its great success."[10] *Diana of Dobson's* was Hamilton's first full-length play. It was commissioned and produced by Lena Ashwell, who had recently refurbished the Kingsway theatre and aimed to present new plays that, according to her biographer, Margaret Leask, expressed "the concerns,

interest and spirit of the time." Given Ashwell's own slow rise to prominence, and personal beliefs, it is inevitable that as theatre manager she was "attracted to plays dealing with women's issues ... suffrage, financial independence and equality." Ashwell played Diana precisely when with her own multi-faceted involvement in the suffrage movement was about to begin.[11]

Like Lyttleton's, Hamilton's play involves the plight of a working-class young woman, but this play is dubbed a romantic comedy. Hamilton's protagonist and plot revolves around Diana's hasty decision to leave Dobson's when she receives a small inheritance at the end of Act I. The remaining three acts of the play show her pose as a rich widow in Europe, develop a love interest with a fortune-hunting man, reveal the truth about her identity, and then return to London and dire straits. Even with this skeletal view it is clear that Hamilton's text nods to various comic genres: plays of intrigue, the adventuress plot, and mistaken identity. Diana's actions and key speeches reveal her integrity as well as her clear-eyed intelligence.

Through her title character, Hamilton illustrates how thin these formulaic plays are. Diana breaks through the boundaries of theatrical "type": she is no dewy-eyed ingénue in search of a rescue, nor is she willing to buckle under the harsh treatment of the forewoman at Dobson's who fines her for every infraction of grooming or behavior. The unpleasantness of this supervisor evokes the punishment scene at Lowood School in Charlotte Bronte's *Jane Eyre*, by then an established cultural reference.

There were two scenes in Hamilton's play that were considered best by critics. The first is in Act I, during which Diana finds out she has been left a small annuity of 300 pounds. The shop girls are shocked by Diana's decision to spend her entire inheritance by indulging in a month-long trip to Switzerland. The scene shows the girls undressing for bed. Kaplan and Stowell note that this scene aimed to replace the romance attached to "shop girls" in musical hall revues with "a gritty matter-of-factness." The girls are so tired that it was impossible for audiences to see anything but mechanical, unimpassioned motions in their costume change. People saw beyond the display of the body, which has double impact because they display merchandise for long hours each day. By so doing, the play implied the need for "new myths by which to live." Since all classes of women were linked to the spectacle of the clothed body, this added to the plays' agitprop intentions.[12]

Diana poses as a rich widow in Act II, and meets a man in search of a rich wife to supplement his 600 pounds a year: men marrying well was just as common as the reverse in novels and plays. The second scene that garnered a rave review for *Diana of Dobson's* was at the end of Diana's

month-long impersonation of a wealthy widow, in the third act. Her present suitor, Bretherton, wanted to marry her because his own inherited income is not enough for him; when she removes the facade of her guise, he backs away, accusing her of being an adventuress. Rather than wring her hands, Diana challenges him in turn.

This same combination of resolve and self-possession emerges in Act III, when her funds run out. Bretherton proposes, and Diana strips away all the assumptions about her social class as well as financial comfort. Despite his feelings for her, the situation becomes "moral impossibility for a man in my position." Diana's contempt for the class ideology that allowed him to believe that he had been slighted by her ruse, when he had been brought up "in sloth and self-indulgence and therefore incapable of seeing life as it really is" leads her to challenge him. Diana dares him to "manage" as she will have to upon her return to England. She chides him by letting him know that she had lived for six years on meager earnings, and doubts he can do so for six months; how dare he look down upon her?[13]

J.T. Grein, who had founded the Independent Theatre Society in 1891 and introduced Bernard Shaw's plays, continually sought top-notch drama. Grein lauded this particular scene of Hamilton's play because Diana's speech is "'one of the finest and sincerest to be found in ... modern English drama.... *Diana of Dobson's* is exactly the type of play which we have been yearning for, it depicts life of today, it cuts into the lower stratum ... the greatest merit of all ... is the veracity, the simplicity, and directness of the play.'"[14]

Grein's remarks are an effective segue to Act IV, which begins with tragic implications. Diana is in rags and out of work; she was employed on her return, but when she became ill, lost the job. Bretherton finds her on the Embankment in the wee hours of the morning: no longer a privileged idler. He has spent three months trying to answer to her challenge to him in Act III, without financial success. But he has not gone for help or used any of his income; he has lived on whatever he could earn, and recognizes that his privileged upbringing prepared him for nothing marketable. As is the case in agitprop plays, Bretherton has learned to value more than money, and offers Diana marriage and life within the means of his inheritance. It can be said that Hamilton's use of this ending pandered to the mores of the times, but also can be seen as a larger reality: lack of full citizenship and opportunities for women. *Diana of Dobson's* does not sugarcoat, nor does it sentimentalize the ending. Diana is amazed that her speech and its challenge wrought such a change in him, and of course thinks of his income as a fortune. On a borrowed shilling from a police officer, they have breakfast at the coffee stand. Their future is discussed

with mouths full of food, rather than the long, lingering kiss of romantic comedy, as the curtain falls.[15]

Suffrage comedies used these same ideological principles but allowed their teachable moments to come in the form of discovery; once men recognized the full extent of women's economic contributions, even within marriage, led to clearer perspectives regarding single women working in limited jobs at lower pay than their male colleagues. Since unions/collective bargaining were high profile during this period, fairness towards their female counterparts by play's end was not at all far-fetched. The most comprehensive treatment of these concepts, and a runaway hit on both sides of the Atlantic, was Cicely Hamilton and Christopher St. John's one-act hit, *How the Vote Was Won* (1909).

They set the play on a Thursday afternoon, on "a spring day in any year in the future" to show that the coordinated efforts of the AFL were bound to coalesce and to convince the audience that the play would chronicle the road to victory. This "future" lens may not have been consistently in mind as audiences watched the play since all of its elements, from brief exposition to dénouement, were obviously from the day's headlines. The gist of the play is that all unmarried women leave work at 3:00 p.m. and go to their nearest male relatives to demand full economic support because society believes them incapable of thinking for or taking care of themselves. Those without family were directed to the workhouse, and very long lines (queues) to that infamous institution soon surface, according to reports that come from the newsboys and men returning home by teatime.

The women were to remain in these respective locations until the "Bill for the removal of the sex disability" is passed by Parliament, thereby granting women not only the vote but also the privileges of full citizenship.[16] Such strategy put the multiple strands of the issues surrounding gender equality squarely to the audience to identify, consider, and re-envision. The masterstroke of the play's construction is that it did not show what was ongoing in the streets of London; instead, we are contained within one married woman's small home in a working-class neighborhood, and the several women who come inside to claim support from this unsuspecting husband, including his sister, a niece, and several cousins.

One of the strike organizers, whose affiliation with the Pankhursts and WSPU is identified in the script, explains the purpose of the women's strike to her married sister, Ethel, whose home is the center of the action. Ethel protests that her husband's weekly earnings and their small house could hardly lodge and provide for all of the women who would be coming. That's the precise strategy, as her suffragette sister, Winifred, explains:

That's why he'll want to get rid of them at any cost—even the cost of letting women have the Vote. That's why he and the majority of men in this country shouldn't for years have kept alive the foolish superstition that all women are supported by men. For years we have told them it was a delusion, but they could not take our arguments seriously.[17]

A great strength of the play is the opportunity given for women in all stages of life and various economic vocations to share their individual thoughts and feelings about women's capabilities as well as loyalties.[18] By focusing their one-act farce on a particular Thursday afternoon, and telling the audience that by evening the city is starting to shut down, the power of the anonymous collective, epitomized by the suffrage marches, emerges. Because the characters in the play represent the private face of the ideological issues being broadcast outside the home (offstage), the play removes the possibility of separating private and public views on the issue. The women's strike within Ethel's home includes servants, her sister-in-law, who is a governess, her husband's aunt, who runs a boardinghouse, a niece who writes a book that Ethel's husband, Horace, calls scandalous, one cousin who runs a fashionable dress shop, and another cousin who's a comedienne, as well as theatrical professionals: all women who are self-supporting and single.

Horace and his friend are anything but supporters of the cause; suffrage isn't permissible "table talk" at the neighbor's home. The men ignore the sandwich boards and newsboys, until the reality literally hits home, with numbers of female relatives who had been self-supporting until that afternoon. The conversion of the men comes first from financial and personal reasons: they can't afford to support more people. As the issues are aired in conversation and echoed by the public media just outside the door, they re-evaluate the women's right to full citizenship. For Horace, his respectable aunt's situation and absolute belief in the cause is the turning point. He admits he had been an Anti, but only because he "didn't realize things. I thought only a few howling dervishes wanted the vote but when I find that you—Aunt—Fancy a woman of your firmness of character, one who has always been so careful with her money, being declared incapable of voting! The thing is absurd."[19] Horace's aunt has idealized "womanly" virtue along with business savvy: Hamilton and St. John proclaim gender blending without a label.

As the scene continues, it is clear that the men come to see that these women had been self-supporting and had already earned the privilege. It is truly an epiphany for Horace, who manages to express his understanding that not all women can marry, that voting doesn't take that much time and women have already been canvassing during elections, so why shouldn't

those who earn money and pay taxes have a say and a vote? Vote gives "status" and he vows to take care of it for his women. He and his friend take up the colors and join the throng of other men in the street. Is it purely comic or ironic that Horace's reassurance to the women relies on gendered language? He proclaims that they may "depend on me—all of you—to see justice done. When you want a thing done, get a man to do it! Votes for Women!" Hamilton and St. John's play ends with their march to Parliament to ensure women's suffrage, after Ethel croons "My hero."[20] Melodramatic means to revolutionary ends surely must have roused the audiences.

Later that year came Bernard Shaw's *Press Cuttings*. Shaw's play was written for the London Women's Suffrage Society and satirized anti-suffrage sentiments and politicians. It was censored because public figures were all-too recognizable.[21] Shaw termed *Press Cuttings* "A topical sketch compiled from the editorial and correspondence columns of the daily papers during the Woman's War in 1909."[22] Like Hamilton and St. John, Shaw sets his play in the future, "The forenoon of the first of April, three years hence."[23] Despite the comedy in this play, however, the future setting emphasizes the stasis rather than the progression of the suffrage/women's issue, linking its mood more to the play's present moment. By the time the play had its first performance, the Women's Freedom League staged a 540-hour picket of Parliament (dramatized in Alice Chapin's *At the Gates*, below). While Shaw's sympathies were long known to be with the women, this satire's structure centers on the often-ludicrous perceptions of those who witnessed suffrage activity without sympathy.

At the play's opening, the General hears from the sentry that someone has chained "herself" to his door. It turns out to be the Prime Minister, who dresses as a suffraget (the way Shaw spells it in this play) as the only way to get safely to the General's from Downing Street. The PM acknowledges that the phone lines and indeed much of the infrastructure is controlled by the "shrieking" women, but is equally outraged that the General thinks the parliament should abolish itself since the mob is using is power to "lay hands on property." He suggests that the PM should bribe the Members of Parliament with titles. PM asks, "Do we dare?" to which the General says, "Dare! Dare! What is life but daring man?' Here is Shaw's follow-up: Voice from the street: Votes for Women!"[24] This opening scene would lead audiences to expect the next moment to include the crusaders, but Shaw only insinuates that they are well organized and determined, apparently expecting his audiences to appreciate their "invisible" power. Shaw uses this ironically to counterbalance the Antis' preference for supposedly unobtrusive private power.

Rather than have a "typical" Shavian argument between the two sides,

Shaw chose to have no suffragettes in the play. Rather, Shaw chose for his focus one of the key strategies of the suffrage drama: countering the Anti-Suffrage movement that the writer Mary, Mrs. Humphrey, Ward in began in 1908. The two anti-suffragists, based on Mrs. Humphrey Ward and her followers, are shown to be more controlling than the militants who only influence the play *in absentia*. One of the two women, Mrs. Banger, is described as a "man in petticoats," Shaw's apparent nod to the gender wars of the late 18th century, when gender as a social construction was a nascent notion, and any hint of women in politics was considered "petticoat government." The earlier era's arguments over women's education—the extent and the suitable subjects—as well as the alarm over women beginning to write in periodicals as well as creatively was clearly extended by the 19th-century *fin-de-siècle* frenzy over single women working and living on their own, chafing against compulsory marriage as career, and having sexual freedom. The enormity of the suffrage movement in 1909, the sheer numbers of women participating in militant street activities, is squarely Shaw's point in this farce.

His dialogue in the play regarding the power structure's response to such flagrant behavior—it's better to shoot them than to forcibly feed them—cuts both ways, however. The undercurrent in the text is that the PM has submitted himself to military power, so he should forfeit concern for public opinion, negotiation, and the like in exchange for military absolutes. Shaw's outrage over the forced feedings was likewise absolute, and in 1913 he would make a speech about it at a suffrage meeting entitled "Torture by Forcible Feeding is Illegal." At that same meeting, he also explained that he was not a regular on the suffrage circuit because the women "were exceedingly well able to take care of themselves ... [and the men who did speak] looked so horribly ignominious and did it so very much worse than the women" that he wouldn't come forward because "his personal vanity would not permit" it.[25]

Conversely, as Sheila Stowell and other feminist critics have maintained, Shaw's clear sympathy with the cause did not prevent him from incorporating sexual stereotypes both in the wit of the dialogue and the plot structure. Stowell points out that the play is as much about compulsory military service and "England's hysteria over possible German invasion" as it is about feminist issues.[26] Even though the granting of suffrage seems to be forecast by play's end, this play hardly offers the *esprit-de-corps* that marks the close of *How the Vote Was Won*. Yet, Shaw's wry comments that the women's vote does not seem to have made that much difference in countries where it has been granted can also be read as less a slight towards the suffrage movement than it is a clear recognition that

fundamental social change will take more time and energy than the vote can bring all at once.[27]

Other suffrage plays that used the "Antis" to convert women characters to the suffrage cause; in *Press Cuttings*, conversion here concerns the two men giving up bachelorhood, and recognizing that it is better to support the suffragets than put up with the mistreatment given them by the Antis. A more prototypical use of Antis as foils for the suffrage argument is in Beatrice Harradan's representation of professional women's solidarity, *Lady Geraldine's Speech* (1909). The title character has decided to give her first speech—as an Anti-Suffragist. Needing help in composing it, she turns to a friend she's had since school days: Dr. Alice Romney, even though she knows Alice is a suffragette. Alice's friends appear for their weekly suffrage meeting and talk to Geraldine while Alice is writing the speech for her. These women are prominent: one is a painter, another a pianist, a third a literature professor, and Lady Geraldine is welcomed as a presumed suffrage supporter; she, in turn, is amazed by being in the presence of women whose work she has idolized. Nonetheless, Dr. Alice crafts an Anti speech with what she calls the main points of their position:

> Degradation of Womanhood. Degradation and disintegration of entire Empire. Dominant female vote in all matters concerning the Army and Navy, our relations with foreign Powers, with our Colonies, and with India. Physical force argument. Women have to safeguard the past and the future, and it is the men's work to look after the present.... Absolute denial that the vote will improve the economic position of women. Indirect influence of women quite sufficient. Emphatic, nay passionate, insistence on your own brainlessness. A few passing allusions to us Suffragists as obscure vulgarians ... there's so little to say, it must sound well, my dear girl, or else the Cause perishes.[28]

Lady Geraldine throws the speech into the fire. She realizes that the circle of women she has just conversed with offer far more to her and to society than any thing she had observed for herself or through the Antis. The youngest member of the suffrage circle, a typist and shorthand writer, tells them that one person bought six copies of that week's *Votes for Women* because his attendance at an Anti event converted him.[29]

A mirror image to Shaw's *Press Cuttings* is Alice Chapin's *At the Gates: Being a Twentieth Century Episode* (1909), a straightforward agitprop piece. Chapin shows one of the nights in 540-hour picket of Parliament held by the Women's Freedom League.[30] The Suffragette attending the gates interacts with the police officers, who are cordial, sympathizers, passers-by, and, of course, a hostile individual. The women wanted the petition to consider the vote: a half-hour for the House of Commons to discuss the issue. The Suffragette recalls the Book of Esther, and Esther dressing up in her best to catch the attention of the King, just as the well

dressed, well-spoken suffragettes are doing in their picket. The King in Esther's time acknowledged a petitioner by extending his scepter, which he did for Esther, and did not keep her waiting. The situation of the moment is quite different: "I feel like that poor Jewish girl. Here I stand. Absolute sees me. Bad temper—'Away with her—Police Court. Offence?' 'Obstruction.' '40 shillings or 7 days.' After the 7 days here I am again.... Stand there if you like, but you mustn't worry me. Don't be silly."[31]

Chapin's reference to Esther would not be lost on the women sitting in the audience; she was one of the biblical figures used in panegyrics for women saints. From this "text" Chapin turns to meta-theatricality, as one of the police officers tells the Suffragette that he had attended the theatre last night and was annoyed by people who laugh loudly and interrupt the flow of the script. He likes to think it over afterwards and "make no disturbance while there." The suffragette demurs and notes that actors appreciate the applause and laughter as "a sign that the audience is sympathetic." Double meaning emerges here: the women at the gates wait for the departing MPs to bow to them when leaving the House of Commons. That evening, five had bowed. The officer thinks that is something; she replies: "Yes, they will learn manners in time.... Some still find it amusing to see a woman standing at these gates. They evidently forget that we pay taxes for the upkeep of all this, and that we are seriously influenced by some of their stupid laws. Still, five remember us. We can afford to be hopeful."[32]

A seamstress engages the Suffragette and Sympathizer in conversation, thankful for the movement's efforts. This woman's brief bio, including a loving husband who died under thirty, years of struggle to keep her and her children alive, and recognition that the poor workers cannot fight for themselves is Chapin's point here. The women have no union behind them: the men have begun to get theirs.[33] The sympathizer next offers handbills to passersby. One elderly woman refuses it, saying she is womanly, and then hits him on the head with her umbrella: almost a vaudeville moment. The only really light touch of the play is here, when the Suffragette remarks, "These Antis are so militant."[34]

Just as Chapin has shown a range of women in this play, she also represents a spectrum of men. In addition to the officers and sympathizer, a bitter, drunk man—out of work—carps at the Suffragette for "grinding us down" and taking work from men. He sees her clothing as expensive enough to link her to "Tory gold."[35] The officer sends him away but he returns again to ask the same questions. Shortly afterwards, an MP comes over to her; the audience could assume it's in sympathy. But instead, a short discussion of the extreme militant tactics by the WSPU (which the WFL—Women's Freedom League—did not always agree with) was the

problem. The suffragette blames the forcible feeding that has become illegal, as Shaw argued, because one of the prisoners died as a result.

The suffragette answers his accusation of the women's methodology with cool logic and recognition of the ideological buzzwords of the day: "You talk to me about leaving them [the lawmakers] to take care of us women, about chivalry which we are destroying. The chivalry in many of your sex today is so dead that it needs to be buried in a pit with quicklime thrown over it. It is liable to breed a pestilence." The MP is taken aback by her reply but does admit that their perseverance is admirable. Her long reply contains a key point of suffrage drama: "we are working not only for the betterment of our sex but of humanity. We realize by uplifting womanhood the whole race will be ennobled." Impressed, he suggests she go into Parliament. "Thanks. As at present constituted I shouldn't care to," she replies. The MP goes away and the drunk asks one more question and staggers away. She is alone at her post as the play ends.[36]

More pervasive in the suffrage plays than the resistant attitudes of men across social classes is the tension between pro and anti suffrage women. Since the Anti-Suffrage Society was not formed until 1908, it makes sense that people on either side of the argument would be embroiled in the publicity as well as ideology surrounding the cause. In suffrage plays written and performed in Britain and the U.S., two overriding strategies prevailed to overturn the anti-suffrage position: firstly, the anti-suffrage women were not thoroughly informed on the economic and political issues, and, secondly, the Anti-Suffrage women *were* actively political in their canvassing during election time. This contradiction was treated comically as well as didactically.

Plays that foreground the schism between women also brought another important new perspective to theatre: working and middle-class women shared the stage. As seen in Chapin's *At the Gates*, the seamstress is thoroughly informed and supportive of the cause and relies on the suffrage organizations to help women like her. In several plays, women who are in domestic service are likewise grounded in the arguments and help convert their less-informed employers who have assumed they are anti-suffrage until key conversations and/or incidents occur.

In Evelyn Glover's *Miss Appleyard's Awakening* (1911), the protagonist has been canvassing in the neighborhood for hours. Her tour took her past the suffrage speaker, who she would like "to shake." This subject delights the parlormaid, Morton, who comments sympathetically about what the suffragist would probably have spoken about. Miss Appleyard also canvassed the factory, where the chimneys were "simply raining blacks!" Her hands are too full of coal dust to eat when she arrives home,

but Miss Appleyard does not speak of the plight of the factory's workers in this speech. A contemporary audience might flinch at the insensitivity, but these remarks are preceded by her suggestion that her two women servants attend the town hall meeting that evening. Morton hums "March of the Women"[37] when she brings in Miss Appleyard's tea tray.[38]

Mrs. Crabtree, a represent of the Anti-Suffrage Society, arrives to talk to Miss Appleyard. She asks Morton is she and the other servants will sign her petition. Morton asks what it's about, and Mrs. Crabtree points out that it is against the women who would turn away from domestic responsibility, etc. Morton does not think women should leave their homes "to go to rack and ruin," but disagrees with Mrs. Crabtree's point about women wanting to the vote to "swamp" the men and rule in their place.[39]

The petition is actually about women who believe they are anti-suffrage, like Miss Appleyard, but who believe that women have earned the municipal vote and canvass. When Mrs. Crabtree speaks of the traitor in the midst it is clearly Miss Appleyard. The fine twist is that the protagonist of the play "awakens" to her true position, which is more pro than anti-suffrage, when Mrs. Crabtree warms up to her true contempt for Suffragists:

> "Suffragists think that a woman should take what they call an intelligent interest in the affairs of her country! Suffragists maintain that a woman doesn't unsex herself by political activity. Suffragists declare that the average woman is a capable of forming an opinion in these matters as hundreds of the men voters of today!"[40]

Miss Appleyard's recognition of course earns the scorn of Mrs. Crabtree, who wonders why this woman has been among the Antis; she leaves in a huff. Miss Appleyard then asks Morton for the suffrage literature that she might have thrown away. Morton once again clinches the scene and wraps up the play by telling her employer that she and the cook have the literature in the kitchen, have read it, and believe there's "a deal of sound common sense in this Suffrage business," to which Miss Appleyard, in the play's closing line, admits: "D'you know, Morton, I'm beginning to think it's quite possible that you may be right!"[41]

Gertrude Jennings' *A Woman's Influence* (1909) incorporates the stark contrasts between women who rely on wiles to fulfill selfish wishes and "manage" men, the women Shaw lampooned in *Press Cuttings*, and women who reject the strategies of melodrama, so thereby are less likely to persuade their husbands to effect the social changes these women hold dear. In this play, Margaret asks her husband, Herbert, to speak to someone about the working conditions of sweated women workers. He ducks her request because he is not interested, but then says immediately that she

should ask her husband because that's more influential than votes.[42] Herbert leaves once Margaret's friend Miss Thicket arrives, exposing the issues confronting the workers: an average weekly wage of six shillings for doing piecework. Most of the workers have five or six children to support. Miss Thicket and Margaret agree the situation is "heartrending" and thus their frustration over a member of Parliament and his reluctance to meet with Margaret. Miss Thicket calls his attitude "impertinence" because Margaret earns money writing and seeks to improve the community. She adds that he would come to tea at Margaret's home without a moment's hesitation. Margaret replies: "Can you wonder? Why should he consider a creature who in political life doesn't exist?" To further the irony, Herbert only votes if he is "badgered into it."[43]

The woman with influence comes in next: Aline Perry. Unlike Lady Geraldine in Beatrice Harradan's play, who has not thought through the issues, Aline is flagrantly elitist and unsympathetic towards the sweated workers, her servants, and the interest Margaret takes in such causes. She will, however, offer to persuade Herbert to do what Margaret wants. At this moment, Mary Ball enters: a sweated worker who has lost her place because she had to stay home with her sick baby; she will have to do "outside" work for a penny an hour now. Aline does show interest once an actual example is right in front of her: someone who cares for her child, and protects her husband, who, as Margaret says, is unreliable because he drinks. Mary has gotten thirty-five women in her circle to sign petitions in favor of suffrage. Aline replies in classic Anti style that speaking with one of the powerful men for five minutes would yield more than a hundred votes could accomplish. Jennings has Mary answer Aline:

> Then in 'evin's name, my lady, I wish you'd do it.... It's a pretty rough life down there, and it's a rough lot that live it. But we ain't beasts though we've bin treated like 'em. I'm not saying anything against the men—they're as God made 'em—but there are some things no man can understand ... it's not men as can help us any more, it's women—it's ourselves, and that's the truth.[44]

Jennings's theme and plot foreground men's indifference and disinterestedness regarding social justice issues because the world apparently revolves around their own concerns, but the true power of this play lies in the "typical" scene between the scheming Aline, trying to win her bet with Miss Thicket that she can influence Herbert, and the double-edged outcome that comes by its end. Aline feigns tears and Herbert comes to rescue her. Aline then flatters him by pointing out his "strength and self-control" and when he shows concern for her, she assures him that she is wrought up over the women in the factories, claiming that "what the weak, faltering instinct of a woman discovers the strong hand of a man can put

right. Dear Mr. Lawrence, won't you help me?" Immediately he agrees, but when she asks him to go to Mr. Reed, Herbert gives Aline a similar response to the one he gave Margaret. However, her reply is vastly different: "I have heard that he (Mr. Reed) is most unsympathetic, that he cares very little about other people's troubles, so different from *you*, dear, kind Mr. Lawrence." He is instantly at her service, flattering her for being willing to let her own dividends go down for a few years to help the women, and wants her to tell him what he should do next. Horrified to learn that she is one of very stockholders, she tells Herbert to wait until she devises a plan.[45]

Such a revelation and exit could certainly have signaled the end of the play: so cleverly has Jennings usurped the well-made play's climactic moment. But there is more. Margaret comes in immediately following, not in the least upset by Herbert's flirtation. On the contrary, she merely says she does not understand why Aline made her "mission" so mysterious. Herbert is astonished that his wife knew that Aline was going to ask for his help; Margaret then deepens the wonder when she knows that Herbert has been asked not to do anything for this factory. Only at this point does he recognize that Aline's money is attached to the factory his wife wants reformed. He's horrified, and Margaret lets him know that the whole scene was a bet between Aline and Miss Thicket. He is not amused, and now Jennings is ready for the "big speech" by Margaret, in which she implores Herbert to see

> the helplessness of Woman using her one weapon, sometimes beautifully, sometimes merely frivolously (like today) ... If you men would only give us *another* one, the use of our intelligence, so that we could realize that we are reasonable creatures, fit to be heard equally with men, not parasites. ... I want you to love and respect Woman for my sake, to give her that place in social life which is her right. She *is worthy*, she will be *more* worthy—help her then, and some day you will be proud of what you have done.[46]

Margaret has broken through and Herbert no longer offers to do something for his wife, but with her. This joint effort as conclusion was a favorite for audiences of suffrage drama, as the immense popularity of Hamilton and St. John's *How the Vote Was Won* continued to prove in its performances by professional and amateur casts all over England. It was this play that was taken across the Atlantic and performed at Barnard College in 1910 and in Philadelphia in 1911 to great acclaim. Bettina Friedl contends that *How the Vote Was Won* was probably the most popular suffrage drama in the U.S. as well as England.[47] Dale Spender's introductory remarks to the play include a 1909 review of the premiere performance from the *Pall Mall Gazette* that captured the cultural moment: "'The story

is funny enough, but the way in which it is told is funnier still.... The fact that it is so acutely controversial ... is rather a virtue than a defect, for the Theatre of Ideas is upon us.'"[48]

The commentary from the 1910 *New York Times* focused less on the play—the title was inaccurately given— than on the increase in suffrage at Barnard College: "'Unless appearances are deceptive, woman's suffrage has been gaining adherents. The college is not pledged to the cause by any means, but some 150 women students advocate it openly.'" It would be another year before that newspaper would alter its anti-suffrage stance. Because the Barnard performance was free, the usual pretty girls selling tickets were absent.'" But the commercial spirit was manifested in suffrage literature, which was sold at the door to help pay expenses.'"[49] Professionally mounted suffrage plays were done either in commercial theatres or at large hotels like the Waldorf Astoria, which had large enough facilities for theatricals,[50] similar to the Criterion in London.

The February 1911 suffrage fundraising event in Philadelphia was a far greater success. American actress Cornelia Otis Skinner teamed up with British actress Beatrice Forbes-Robertson (whose aunt was the President of the Actresses Franchise League). Three British suffrage pieces formed one program; in addition to the Hamilton/St. John were Bessie Hatton's *Before Sunrise* and Gertrude Jennings's *A Woman's Influence*.[51]

A month earlier, prominent society women in New York participated in their first public tableaux appearances at the Maxine Elliott theatre. The project's sponsor was Mrs. Clarence Mackay, who headed the Equal Franchise League. Friedl points out that the coverage in the *New York Times* went on for two days and was "far less condescending" than the previous year, but the story was placed in the society columns, and is therefore "an excellent example of ... newspaper writing that tries to avoid mentioning the political issue."[52] Yet the headline on the first day, January 16, couldn't be clearer or more positive: "Society in Tableaux Aid Suffrage Cause." The mention of the historical accuracy of the costumes, and the extensive listing of the prominent women from the ancient times to the early 20th century might have created interest for women who had not yet fully considered suffrage allegiance. These model women included Hypatia, St. Ceclia, St. Elizabeth, Mme. Roland, Catherine of Russia, Queen Louise, Mary Wolstonecraft (misspelled in article), Mrs. Siddons, Molly Pitcher, Florence Nightingale, Marie Curie, and Joan of Arc. A great number as well as classification of women represented coincided with Cicely Hamilton's *Pageant of Great Women* (1908), which had toured extensively in Britain and the U.S. Four additional tableaux were included. The Women's Political League presented "Inside a Home in the Eighteenth

Century" and "Outside a Factory in the Twentieth Century"; The College Equal Suffrage League presented "The Court of Love" and "The Conferring of Degrees."[53]

An American suffrage drama from 1911 managed to place the current situation squarely within another suffrage debate from the 1860s: the fifteenth amendment, which gave the vote to African-American men but to no women at all. Written by Catharine Waugh McCullough, *Bridget's Sisters or The Legal Status of Illinois Women in 1868* focused on the plight of an Irish-American laundress whose husband's bar bills absorbed much of their income. Bridget and one of her customers had an arrangement: Mrs. Bradley stores Bridget's wages in her clock case. Bridget is doing all she can to keep her five children fed and clothed on her own earnings. The play turns on the husband's demand for his wife's wages and the police arriving at Mrs. Bradley's home one evening to demand that the money be turned over to Bridget's husband.[54] Neither Mr. nor Mrs. Bradley are involved in the woman suffrage movement of the day, but both believe that Bridget's money should be hers to do with as she wished; they obviously do not understand the law.

Then the Justice explains that Mr. Bradley was obviously confused about a law passed in 1861, which allowed fathers to pass land to a daughter before her marriage, as long as it was through a trustee's hands. Even this law had no effect regarding a wife's earnings. Mr. Bradley argues that Bridget's earnings are now in a "trust fund which my wife has held sacred for the use of this noble, self-respecting woman. You would put my wife in a very uncomfortable position and force her to be untrue to her trust. Decide this case solely with the thought of doing righteousness."[55]

Although the Justice agrees with Mr. Bradley in principle, he feels bound to make his decision based on the law, which dates back to the time of the old English common law. Only a change in the law could prevent the husband taking the wages. The Justice comments that when the kind of protection that the fifteenth amendment offers will extend to women he will no longer have to enforce such laws. In the actual historical incident, Mrs. Bradwell turned the money over but she and other sympathizers did change the law.[56] McCullough's play alters the events somewhat, in a manner that is greatly satisfying. That very day, Bridget had told Mrs. Bradley that she was going to take some of her saved money with her to buy shoes for the baby; in actuality, she took it all and bought things for all the children, so there was no money in the clock at all. When she whispers this to her husband, he laughs.[57] But when Mr. Bradley wants Bridget to testify, she cannot, of course: a wife cannot testify against her husband.

The couple leaves the courtroom and some of the women (also Brid-

get's customers) vocalize their discontentment when the Justice also leaves to speak to a man in the next room. The play also heightened attention to two other pivotal issues of women's rights: custody of children and legal age of sexual consent. One of the women describes a case of a husband deserting a wife to move in with another woman and taking the children with him. The law was on his side. A ten-year-old orphan was sent to the poor house, where she had been sexually abused by the poor-master. Ten years old was the age of consent; the sympathetic judge gave the woman a doll to give the child since he could not punish the man. Mrs. Bitter comments: "This was as bad as asking bread and getting a stone. I asked justice and got a doll." Mrs. Equity feels they must save other girls by raising the age of consent, and Mrs. Bradley, who had criticized the woman suffrage movement, declares: "we must all be Bridget's sisters and help her." The women, including Bridget, band together to form the Illinois Equal Suffrage Association Mr. Bradley also joins.[58] Bridget's husband declines his right to her wages as the play ends.

Margaret Wynne Nevinson's play from the same year, *In the Workhouse*, is a quick, intense portrayal of the plight of women, married or unmarried, in the workhouse. Several of Nevinson's characters are unmarried mothers, including a mentally challenged woman who has several boys all named Bill after their father. One of these women plans to marry the next day until they all learn that a married woman, Mrs. Cleaver, cannot leave the workhouse if her husband wants to "detain 'is wife ... by his marital authority." This woman is a dressmaker who can move in her sister, and make a living. She went to the Committee and explained that her husband "lost 'is work through being drunk on duty ... the drink allus taking 'im in the legs," which is why he lost his license. Instead, she must remain in the workhouse with her newborn. They all are horrified by the news and the revelation of a law they knew nothing about.[59]

Clearly, twin aims of suffrage drama were legal education and moral awakening for audiences. Charlotte Perkins Gilman, known best for her short story, "The Yellow Wallpaper" (1892), published her own journal, *The Forerunner*, which included essays and creative work by women to heighten awareness of social justice and gender issues. Her 1911 play, *Something to Vote For*, divulges the tiered class system that existed around commercially produced milk. Gilman's choice of setting, the comfortable home of the president of a woman's club, makes the title somewhat elusive. The known conservatism of woman's clubs is something Gilman counted on to underscore the moral indignation that surrounded her subject. Bettina Friedl's introduction to the play emphasizes the contradiction. Women's clubs worked for a range of social causes but avoided suffrage issues

because they wanted to "avoid a fundamental split on political grounds. The more radical suffragists ... often regarded all women's clubs as sources of conservatism and anti-suffrage sentiments. Friedl cites a 1980 study that claimed that club women preferred to see their activities in what Karen Blair called 'domestic feminism.'"[60]

This apparent irony is what makes the play so successful, especially in combination with Gilman's use of the elements of the well-made play. The club president, Mrs. Carroll, has a suitor who produces milk. One of the women attending the meeting is a woman doctor, who has invited a milk inspector to come as well. The club members are more interested in the romance than the subject of the meeting. Dr. Strong has brought a working-class woman dressed in black to explain the reality of milk distribution in poorer neighborhoods. It is Mrs. Carroll who brings this woman into the room. When Dr. Strong is introduced as a new member she expresses her pleasure in the women's concern for Pure Milk, "a most important question—one that appeals to the mother-heart and housekeeping sense of every woman." But when she connects this to the vote, the members protest.[61]

When the milk producer, Mr. Billings, and the milk inspector, Mr. Arnold, meet they are affable and at ease, despite the surprise for Mr. Arnold that the head of the milk trust is there. Dr. Strong turns out to be the character with the apparent scheme: to expose the likelihood of bribery to cloak impure milk. She speaks privately with each man. Earlier in the scene she had asked Mrs. Carroll for some red ink and has marked a bill with it. Through this marked bill, Dr. Strong exposes Mr. Billings' shady business practices. Dr. Strong confides in Mr. Arnold that she will ensure Dr. Billings' offer of a bribe and asks him to accept it; he is shocked and insulted. Dr. Strong assures him that it is a marked bill and that he should bring this to everyone's attention once Billings has shown the quality of the milk to the club members. Dr. Strong has another sample in her bag: the "common grocery kind."[62] Billings is evidently distressed when the "second quality" bottle is there and wants to get another from his car, but Mr. Arnold dismisses the idea since there is no time to do that. At this point, Mr. Billings offers him the marked bill.

Of course Mr. Billings speaks of the sanctity of his business and its connection to every aspect of domesticity. But then the milk is tested. If starch has been added the milk will turn blue when iodine is put into the sample: it turns blue. Starch is not poison but of course dirt is dangerous; the sample has dirt. The poor woman has lost a child to this kind of milk and she tells the women "That's what killed my Patsy!" and she points at Mr. Billings, which causes commotion.

When Billings tries to dismiss the situation by saying the wrong milk had been delivered, that is the end of his connection to Mrs. Carroll, who now believes that the club can use the influence the town believes it has: "Rich or poor, we are all helpless together unless we wake up to the danger and protect ourselves. That's what the ballot is for, ladies—to protect our homes! To protect our children! To protect the children of the poor! I'm willing to vote now! I'm glad to vote now! I've got something to vote for!" She calls for the women who think as she does to say ay and they all rise and do so, and also wave their handkerchiefs.[63]

The collective call to consciousness that concludes Gilman's play evokes the same kind of solidarity found in the street marches, but also remains focused on the importance of each individual making the decision to choose activism. Key also is the joined force of the women across class lines.

Other plays of the era strove to illustrate the cross-generational conversation that is central in *How the Vote Was Won*. Despite her sister being a key organizer for the WSPU, Ethel, whose home in Brixton now houses her husband's unmarried female relatives, had not thought of the suffrage issues as her own until they were all there together. Middle to upper-class young women did not necessarily have either the social calling or the awareness that they should participate in the widening of women's opportunities. Bernard Shaw also chose to highlight characters who came into awareness but did not rise in the ranks of the leadership. Chief among these is Fanny Dowda, the protagonist and author in *Fanny's First Play* (1911).

Produced by Lillah McCarthy, Shaw's play was billed as "anonymous," which is quite ironic considering the relative newness of women writing under their own names in lieu of a male *nom-de-plume* that their Victorian counterparts felt obliged to use. Shaw's play featured a heroine and anonymous author of the play-within-the-play who embraces Fabianism and women's suffrage, uses women's private theatricals as a technique, and places the guise of anonymity as intrinsic part of the plot as well as thematic structure.

What makes the play memorable is the reversal and/or blending of public and private behaviors that Shaw's contemporary audiences would have recognized instantly as belonging to both Edwardian sexual politics and suffragette agitation. The plot turns around a supposedly sheltered young woman fresh from her Cambridge education who wants a private performance of an anonymous play to be given at her father's estate with London critics in the audience: highly unusual and thereby intriguing from the start. Shaw front-loads the absurdity of resistance to change in the Induction scene; Fanny's father has raised his daughter in Italy until her

Cambridge education, and he prefers to live as if the 19th century never existed. Clearly he has no conception of the co-curricular activities a young woman at Cambridge in the 1910s could have been involved in.

Fanny's First Play starred Lillah McCarthy and Cicely Hamilton: two of the executive Board of the Actresses Franchise League (AFL), with names instantly recognizable for their work for women onstage and off. In Fanny's play, the play-within-the-play, Margaret Knox (McCarthy) is the daughter of a religious mother (Hamilton) who knows that happiness lies within us. Margaret discovers her true self when she wanders into a theatre after a Salvation Army meeting left her exhilarated and wanting more music. Once there, she encounters a mature and married Frenchman, Mr. Duvallet, who dances with her and buys her champagne, but when the Oxford and Cambridge student crowd comes along, drunk and rowdy, the police entered the scene. Mr. Duvallet becomes outraged when women were roughed up—recalling Black Friday, 1910, when suffragettes were so egregiously abused by police.[64] Margaret goes to Holloway Gaol, experiences the literal arm twisting that activist endured, but did not joined the suffragettes: a decision she now regrets.

Shaw doesn't show us what Margaret experienced: it is all her unapologetic explanation of a fortnight absence from home upon her return. Her mother (played by Hamilton) asks with astonishment: "My daughter in Holloway gaol?" to which Margaret replies "All the women in Holloway are somebody's daughters.... I'm not in the mood to be gaped at while you're trying to persuade yourself that it can't be real. These things really do happen to real people every day; and you read about them in the papers and think it's all right. Well, they've happened to me: that's all."[65] One of the critics discerns that Fanny is the author and that she herself must be a suffragette. She confirms this, acknowledging the experience as one she is prouder of than anything she had ever done or is likely to do again.[66]

Audiences in 1911 who had seen Lillah McCarthy in Hyde Park in the huge 1910 rally (see Chapter 4) could not help but feel Shaw's nudge and wink towards the need for people to make history rather than merely live through it. Conversely, the conclusion of Margaret's story with a marriage of her own choosing does not confirm a permanent change on her part. Unlike Fanny, her creator, Margaret may well take personal stock of this experience but not necessarily add to the collective good that might have come out of it.

Shaw's recognition that more people observe than participate in groundbreaking change reflects his clear-sighted understanding of his own role to provoke questioning within the audience as at least a first step in encouraging their open-mindedness. A few months after the premiere run

of *Fanny's First Play* Gertrude Vaughan's suffrage drama *The Woman with the Pack* opened. The Woman of the title is a Joan of Arc figure who serves as a guide to social awakening. A review of the play in the WSPU journal, *Votes for Women* echoes Shaw's perception about public ambivalence. Mary Turner reflects as much on the audience and readers as on her praise of the play itself:

> It seems terrible to me that, always, a struggle should appear ugly on the surface. And of all ugly struggles that of the suffragists against the Government is one of the most self-misrepresenting at first sight. We, the outsiders, see a crowd of women in Parliament Square, torn and battered by a crowd of men. We see hats awry and hair disheveled and garments torn; and we feel, however we may not want to feel it, that the sight is horrible. We see again women tramping the prison yard at Holloway, doggedly cheerful with a courage that makes us turn sick when we get home to our comfortable firesides. And we resent it all fiercely because of the contrasting beauty of our own quietness that we do not want invaded.[67]

Turner recognizes that the impact of Vaughan's play is multi-dimensional; the Woman in the play, who appears in the first tableau as a storm rages at night on a rough mountain path, carries a lantern, a possible allusion to the iconic image of Florence Nightingale on the Crimean war front. She defines herself as "the outcasts of every clime, To whom is said 'Go' but never 'Come.'" She "knows no time" and represents the double load of the women who "have been shamed—Used for men's pleasure and cast away."[68] Turner describes her as the woman of "sorrow, of labor, and of quietness ... and [appears with] a child on her arm." For Turner, the Everywoman figure to represent hardship and urge reform makes this play is the "incarnation of the woman's movement.[69]

Vaughan's play also spanned class lines and genres; it featured an upper-class with a son and daughter attending Oxford and illustrates their family's dynamic in the first scene when the daughter wishes she could get a degree and be a lawyer, and her brother backs her. The Woman appears again towards the end of Scene I and begins to weave and talk to the daughter, Phillipa. She calls the girl "a rose who won't yet open."[70]

In the second scene, Phillipa divulges her innermost thoughts, especially her desire to do real good in the world, especially for the babies born unwanted. Rather than a romanticized idealism as frame, Vaughan has Phillipa recall the day she recognized her fortunate life when she saw a field mouse crushed. She tells the Woman: "I had had so much of the beauty of life ... and had never thought of the other girls who had been working in the shadow, while I had been playing in the sun." Since then, she has paid attention to the struggle for workers and gender equality. She sees the women of the future "not weighed down by fear of the unknown,

women free and strong and happy, with all the gates thrown open so they may work unfettered.... I see men and women working together as equals."[71]

Scene III zeroes in on the plight of sweated labor within an individual family: their home is the epitome of Dickensian squalor. The mother of the family, who had met the family in the earlier scenes, has an intense conversation with Phillipa about the need for the children to have a better life than their parents. Vaughan's play thereby continues the theme of working-class women and educated upper-class young women recognizing their need to band together. Unlike Margaret in *Fanny's First Play*, Phillipa goes directly to the demonstration that is happening just outside this family's home with her brother Dick. Newsboys come in to announce "1000 women in Westminster and Parliament Square besieged." The diegetic technique of *How the Vote Was Won* is shown onstage; Vaughan not only threads the various social issues together in dialogue, but also has the visual emphasis of doing so at the end of a critical scene. Phillipa declares there will be "1001 if I can get there in time."[72] She and her brother go and are imprisoned and they recount their experiences to their parents when they return home in Scene IV, very like the scene in *Fanny's First Play*. But there the similarity ends, for Vaughan closes her play with a second tableau: "Phillipa as Joan of Arc in armor, holding a great banner."[73]

Turner's assessment that Vaughan's play epitomized the woman's movement certainly becomes persuasive with the transformation emblematized by the final scene. This replaces the victimized woman of sorrow who opened the play. Images of Joan of Arc, verbal as well as visual, abounded in the 1910s, the era that completed her canonization process. Patriot, military leader, devotee of the Church, and unabashed iconoclast are all metonymic labels for Joan's and rationale for her iconic status. Joan of Arc was on suffrage banners, was a favorite figure in Hamilton's *Pageant of Great Women* and was impersonated in suffrage parades on both sides of the Atlantic, as well as the Coronation Parade of 1911 (see Chap. 4). Phillipa adds another dimension to Joan: education.[74]

The actress/activists that created the plenitude of positive women's actions in suffrage plays also remembered their own professional roots at this critical juncture. 1911 also saw the premiere of Christopher St. John's *The First Actress*. This play was staged at Lena Ashwell's Kingsway Theatre, was directed by Edy Craig, and celebrated a groundbreaking event for women: the night Mrs. Margaret Hughes defied *de rigeur* theatrical practice in 1660 and performed the role of Desdemona in an unlicensed theatre. Her action, coupled with King Charles II's proclivity towards women as performers, abolished the prohibition of women onstage. Not only had

his mother performed in private theatricals, but she had other ladies at Court do so as well. Charles's mistress, Nell Gwynn, also had a passion for acting and swayed the King's opinion.[75]

St. John's homage involved particular innovations and an overall appreciation for the courage, fortitude and genius of actresses as proto-feminists. The play opens just after this first performance. Margaret Hughes, played by Nancy Price, asks her fellow actor why the audience thought she should be ashamed of herself. She believes that "sober-thinking people must see that it's really more proper for Desdemona to be represented by a woman than a boy in a woman's habit." Ned Kynaston, the most revered Desdemona, knew of her performance and sent people to hoot at her, but Kynaston does not appear in the scene. She bemoans her lack of technique as the reason for her failure in performance; her fellow actor retorts that women were not fit to tread the boards because "acting is art of assuming the character, not the accident of being it."[76] His real argument, however, centers on the point that women lack the creative imagination and have no artistic historical credit to be able to act. They can do other things "demanding a much smaller sacrifice of womanly delicacy" to which she retorts: "Do you think my appearance on the stage tonight has rubbed the bloom off mine? Say we oughtn't act because we are inferior to you in ability ... don't speak as if we must be preserved from it because of our delicacy!"[77] Mrs. Hughes then falls asleep and visions come to her: the tributes of the women who followed her onto the stage.

Nell Gwynn, played by Ellen Terry, is shown as an orange seller but says she will enter the Kings Playhouse and become an actress "in great vogue.... Be merry Mrs. Hughes You've led the way, and I who was at first no better than a Cinderwench will follow."[78] Nance Oldfield tells Mrs. Hughes: "Only sixty years after they threw pippins at you, and the world will see an actress buried in Westminster Abbey—buried like a queen!"[79] Mrs. Siddons intermingles snippets from *Macbeth* and is costumed for the sleepwalking scene. Mrs. Siddons claims "all the prejudice in the world shall not keep us off the stage ... screw your courage to the sticking place, and *we'll not fail.*"[80]

Madame Vestris, dressed as Macheath from John Gay's *The Beggar's Opera*, rose to prominence for her breeches roles but also as a theatre manager. As Macheath, she takes off his hat "to you, Mistress Hughes, and begs the public, who once thought it unbecoming of us to tread the stage, even in our skirts, never to be too sure of anything!"[81]

The landmark achievements St. John highlights all lead to the actress of "Today": Lena Ashwell played that part and how fitting that it would be on a stage where the woman representing her time would be the man-

ager of that theatre. The actress of Today recalls the geographical division of the exploration age—she can "see an old map where the world is divided into two by a straight line." She is referring to Spain and Portugal dividing the world they wanted to take over; in her own time, the division is one of gender. The artificial division by Spain and Portugal will seem "comical indeed" to modern people, it is still "foolish" to divide the "world of humanity" for women and men. It was when women mounted the stage that the division of the world (the gendered, separate spheres) first appeared "foolish." "Brave Hughes—forgotten pioneer—your comrades offer you a crown!" The play ends when all of the "visions of the future rise from the front of the theatre and come forward. Mrs. Siddons holds a crown over the head of the sleeping Mrs. Hughes. Music and disappearance of visions" lead to the final curtain.[82] This stirring tribute to the women artists of the theatre cements their enormous contribution to the rise of women to participate in and shape culture and public space. How logical it then appears that an Actresses Franchise League would have been formed and would foster the new theatre directions that were truly beginning in the 1910s.

7

Crossing Aisles & Isles: 1908–World War I

> It is an open secret that the theatre is universally fascinating. Its power lies in the fact that it is a place where you may hear a story told in terms of emotion as you sit with others whose society enforces your private feelings with overtones of their own.—Richard Burton, *The New American Drama* (1913)[1]

> In these days, when art at least is international, and when freer trade than that which already obtains between the theaters of New York and London could hardly be promised by any one of the political parties, in these days there is only one boundary to our hopes of the English drama and that is ... where the English language ceases to be spoken.— P.P. Howe, "England's New Dramatists" (1913)[2]

When the seasons at the Royal Court by Vedrenne-Barker (1904–1907) ended, many gathered for a "Complimentary Dinner" at the Criterion Hotel on July 7, 1907, to pay tribute to them for their enormous contribution to theatre and cultural life. The committee included J. T. Grein, William Archer, J. M. Barrie, John Galsworthy, and Bernard Shaw.[3] The Chairman, Lord Lytton, began the festivities by offering a *précis* of what audiences had gleaned from the productions: "occasions of real intellectual pleasure" because the plays and their style of representation had "rescued English drama from a chain of stupid convention.... These two gentlemen have ignored the supposed taste of the public and set up for themselves a different standard of merit."[4]

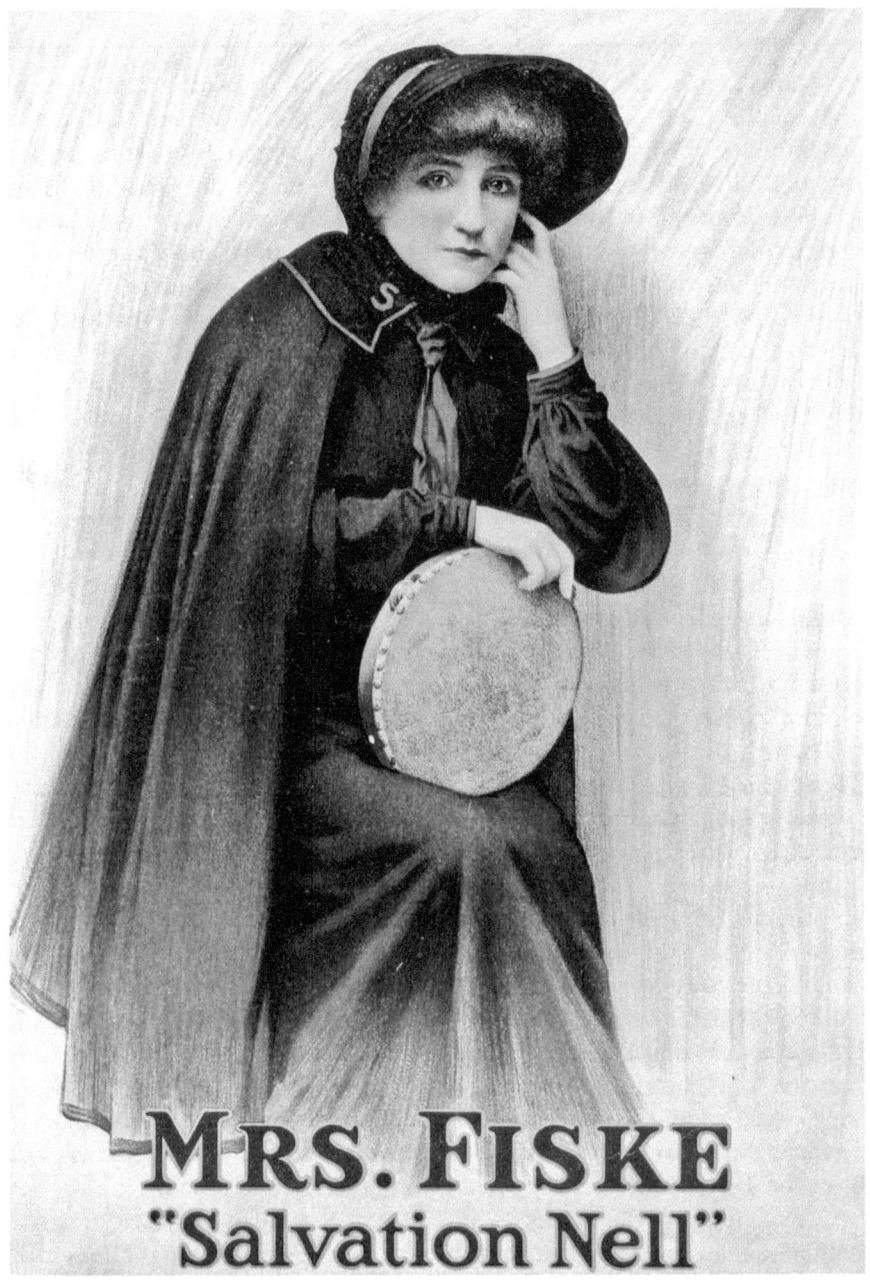

Mrs. Minnie Maddern Fiske in Edward Sheldon's 1909 play *Salvation Nell*. Library of Congress. Mrs. Fiske was a major American actress, theater manager, and activist for women's rights. This play reverberated with the reform spirit of the Progressive Era, as well as extraordinary stage realization of the slum neighborhoods of New York and other cities.

Lord Lytton completed his point by explaining how the management style of the Court seasons, from the emphasis on excellent acting and ensemble performance to a repertory-style system of short runs, would undoubtedly lead to the fulfillment of the real goal: "I cannot believe that it will be long before the next step is taken and we meet together again to congratulate our two guests of tonight on the completion of their experiment in the establishment of a real National Repertory Theatre."[5] It would not be until 1938 that Bernard Shaw would get the keys to the National Theatre, but the influence of the Royal Court seasons would be clear on both sides of the Atlantic, as little theatres and some Broadway venues would offer the new plays that premiered at the Royal Court, and several key actresses would work with their American counterparts to empower more women as theatrical managers and decision-makers.

Vedrenne-Barker did continue their partnership a bit longer in other venues. In 1908, Shaw premiered *Getting Married* at the Haymarket Theatre under the Vedrenne-Barker management. Shaw's tradition-bound title belies its iconoclasm and social critique, in the "best practices" of high comedy. Labeled by Shaw as "A Disquisitory Play," *Getting Married* deconstructs what truly underlies the decision to marry, and the entrenched ideological constraints for both parties once they are married. In Shaw's nod to favorite comedies, he alludes to and finally quotes from Shakespeare's *Much Ado About Nothing*, and also includes the true discussion that precedes "getting married" found so frequently in Jane Austen's novels. Most of the play takes place awaiting the ceremony (and delaying it for several hours), while fierce debates about what is and is not proper, natural, or livable ensue, reminiscent of the best of Restoration Comedy. Like Austen, Shaw does not show the wedding of Edith and Cecil; rather the play revolves around the couple grappling with the dilemma of societal circumstances, examining their own hearts and then going through with their plans. While their eventual nuptials signal a classic comic ending, the actual "getting married" of this young couple takes place late in the play, offstage, and after they visit a solicitor's office. Once they have enough legal information to confirm their knowledge they marry, the bride sans a wedding gown, and after the guests in the Church had given up and gone home.

The genius of the play is its portrayal of a range of domestic arrangements in relation to functional or dysfunctional relationships. The central couple of the title, Edith and Cecil, are onstage less than many other characters. While family members begin to arrive, the nuptial pair first determines, independently, that the marriage laws contained in a pamphlet they each receive that morning have shaken their equilibrium. Each of them is locked in a bedroom reading and refuses to let anyone in or get ready

for their wedding ceremony. After people hunt them down, they enter the stage. First Cecil arrives, properly dressed for the occasion, but distraught because he has just learned he will be financially responsible for any untoward speech or action of his wife, and Edith is a social activist who speaks in public. His mother and sisters depend on him for income, which is at the root of his distress, but he is an honorable gentleman. Cecil goes to Edith's father, the Bishop, to announce that he never would have proposed marriage with the knowledge he now possesses, but will not go back on his promise. He just wants Edith's father to know that he is at the Bishop's "mercy: marry me [to his daughter, that is] if you insist. But take notice that I protest."[6]

Edith comes downstairs to tell Cecil she doesn't want to get married since she has heard his voice. She enters and announces that she wants to talk to Cecil "very particularly," the standard phrase for a man about to propose to a woman at the time, and asks, not very politely, that her father and everybody else leave the room. All obey, if only momentarily, except for Uncle Reginald and Hotchkiss, the Best Man. It is Hotchkiss who mentions Cecil's "objections," which are all on "public grounds." Edith then finds out he has already announced similar feelings to the assembled family at large. Unpleasantly surprised by this, she asks him directly if he has been "raising difficulties about our marriage?" Cecil denies raising difficulties, and only asks that she takes care of what she says when they are married for the sake of his mother and sisters because he feels he has no right to "sacrifice them." Her response, "You needn't be alarmed. I'm not going to be married," signals Cecil's turn for indignation, and he asks if she had planned to "throw him over." She replies: "How can I? you have been beforehand with me?"[7]

Cecil's denial of this is absolute, and again he pleads for her prudence in public, and says he is ready to marry her. Edith, taken aback by Cecil's unsupportive attitude towards her work, turns the tables, and here the scene truly evokes Elizabeth and Mr. Darcy: "Then I think you shew great weakness of character; and instead of taking advantage of it I shall set you a better example." Edith then discloses what she had spent the morning reading: an exposé of a woman whose husband had committed a murder and was imprisoned for twenty years, during which time she had to support their three children on their own; she could not divorce him. Edith turns to her father and he says it is true and invokes "for better or worse," but the Bishop is anything but pedantic in nature. He believes that people must accept human frailty. Edith won't have this; she insists that the marriage contract is "wicked" and that she "never would have consented ... no woman would if she knew what she was doing." Further, "my husband's

conduct is of more importance to me" than that of the Prime Minister, and "what sort of Prime Ministers should we have if we took them for better for worse for all their lives? We should simply encourage them in every sort of wickedness."[8]

In the Preface to *Getting Married* Shaw acknowledges that there is "no question of abolishing marriage," but advocates a better legal framework. He pinpoints "for better or worse" as the clause "not to be tolerated," especially because dissolution of marriage has long been practiced, even by the Church. The Preface probes far more deeply to the 10th commandment, and its designation of women as property, as the true root of current marriage and divorce laws. Shaw clearly hoped that "Englishwomen will one day succeed in obliterating from the walls of our churches by refusing to enter any building where they are publicly classed with a man's house, his ox, and his ass, as his purchased chattels."[9] Shaw's argument includes many key sticking points of the era's controversies: his contention that people don't object to a moral compass, but don't want people labeled "good" or "bad." Instead, Shaw suggests, we want a "high quality for our normalpeople who can be much better than what we now call respectable without self-sacrifice."[10] These concepts are not shocking; however, Shaw continues to suggest that the norms of marriage are unacceptable. If marriage is about reproduction and child rearing, he separates the latter. Motherhood should be considered a real profession, and Old Maids have a perfect right to motherhood.[11] Most confrontational for 1908, Shaw supports civil unions, acknowledges ménage-a-trois from history and his present time, and concludes that family life will never be "decent, much less ennobling, until this central horror of the dependence of women is done away with."[12]

How do these bold confrontations to "getting married" blend into the play? Shaw illustrates the happy marriage of the Bishop and his wife: happy because they have not expected everything of each other. The Bishop is far more emotionally attached; he married his wife, Alice, because he was in love with her and still is, no matter how cognizant he is of their life as nowhere near ideal. Alice appears to have a clear identity She makes no bones of complaining about her bookish husband dodging unpleasant things with the excuse of his work. She runs things, as Shaw believed women usually did, and believes in marriage because the world has to keep going. Their implied compatibility is their enjoyment of life as it really is. Her sister Lesbia is quite different; she wants to be a mother without the trouble of having a husband around to "untidy" the house and smoke everywhere. She would have an alliance with a man but not live with him and Lesbia firmly believes that all husbands should be out of the house altogether for a child's first two years since they are only in the way and

a mother's attention should be entirely on the child at that stage. Once again, the man is the one who suffers; the Bishop's brother, Boxer, has been pining and proposing to Lesbia unsuccessfully for many years, and he cannot grasp why a husband who can provide a home is not ultimately desirable.[13] As we say now, those who have privilege are often blind to it.

The Bishop's other brother, Reginald, is about to be officially divorced, and his estranged wife has taken up with Hotchkiss, Cecil's best man. Before either Reginald or Leo, his wife, arrive at the house we hear of Reginald's physical abuse of his wife in the garden. Despite the reality not matching that scenario (once again), Shaw adroitly uses a key issue of the suffrage movement. Without full citizenship, how could women obtain freedom, safety, and economic self-sufficiency if still considered men's literal property in the early 20th century? Shaw nods to and confirms what Elizabeth Robins's *Votes for Women* had argued for in the Royal Court production of 1907 and what many suffrage plays, speeches, and printed materials would emphasize. Catherine Welch, the theatre critic for the *New York Times* in 1908, interviewed Shaw in London when the play opened. Welch acknowledged the mixed reception to this play and stated that all of the reviewers should have been women because Shaw contended that *Getting Married* was "a woman's play." Welch believed Shaw "better fitted than were the many talented critics who discussed it for the benefit of Londoners," and she then admitted that her opinion on the matter derived from her own perspective as a woman.[14]

The scenario surrounding Leo clearly shows the two sides of Welch's remarks. What Leo really wants in *Getting Married* is the right to have two husbands. She does not ask for what men already had: the double standard. She wants to take care of Reginald in a Victorian mother-wife way, and she wants the stimulation of Hotchkiss. Is this play a wink to Shaw's own pre-married life as the asexual "third" of married couples, or a "remix" of Shaw's 1894 *Candida*, but with the young man actually more interested in the husband's company rather than the wife's in this later play? *Getting Married* is a wider canvas than *Candida*, balancing the foundation and viability of several relationships. Despite the constant debate, this later play surely provides a fuller and more positive view about our need for love, in whatever manner we choose to pursue it.

Perhaps the most original character in the play is the clairvoyant Mrs. George. She is the anonymous admirer of the Bishop, and has written the best love letters he has ever received under the *nom-de-plume* Incognita Appassionata. He shares these with Alice, who finds her fascinating, and a "good sign" that the letters have no return address. Alice provides this snapshot of Incognita Appassionata: "She says she is happily married, and

that love is a necessary of life to her, but that she must have, high above all her lovers ... some great man who will never know her, never touch her, as she is on earth."[15]

We know about the sister-in-law of the Greengrocer who's in charge of the wedding breakfast and her several escapades of falling in love at a moment's notice and running away from home, only to return. Her husband has tolerated this. When we realize the sister-in-law *is* Mrs. George, and Hotchkiss is in love with her, it does not feel like Shaw playing puppeteer. To the contrary, the adaptability of people and their individuality is the comic overtone of Shaw's very serious ideology as expressed in the Preface of the play. The Greengrocer, Collins, has relied on Mrs. George's judgment in "affairs of the heart" because of her earthly experience of multiple lovers, but also because of her authority as a clairvoyant. This spiritual power is of course a foil to organized religion. But as Susan Shelangoskie argues, the spiritualist was highly regarded from Victorian times forward, and thus she is enlisted as consultant when the debate/contract scene regarding marriage is truly building to the critical moment:

> [Her] bohemian experience is so respected that when the marriage debate among the other characters threatens the wedding between Edith and Cecil, Mrs. George's authority is appealed to as a last resort, after, as Boxer puts it "The Army has failed. The Church has failed." Boxer's next appeal is to Collins as a representative of the "Municipality," but again, Collins wishes to substitute the experienced woman for himself: "I don't trust my judgment on the subject. There's a certain lady that I always consult on delicate points like this. She has very exceptional experience, and a wonderful temperament and instinct in affairs of the heart." Because of her experience, Mrs. George is represented, even before her appearance on stage, as an authority who can be summoned to provide guidance and solutions to the other characters' problems.[16]

Shelangoskie's article focuses on the Shaw Festival's 2008 production of *Getting Married* and its switch of the center of the play from the contract scene to the entrance of Mrs. George into the set as the play's only interval. For Shelangoskie: "This deliberate choice of structure emphasizing one of the few characters not interested in the outcome of the doomed marriage-alternative contract suggests that a different reading of thematic stress is possible, one that is concerned not just with marriage but also with the larger issue of women's political and social authority."[17]

In Leonard Conolly's study of the Shaw Festival, he speaks of the two successful productions of *Getting Married*. For the 2008 production program, director Joseph Ziegler emphasized that this play has plenty of laughs but also conveys a "deep understanding of the need for love, companionship, and children."[18] In contrast, the 1999 production directed by

Jim Mezon won the audiences and critics over because Mezon and his ensemble made the discussion scenes "scintillating," according to a critic who had never before enjoyed the play.[19] These two successful variations speak to the depth as well as breadth of Shaw's text.

Within months of the original production of *Getting Married*, the question of women's suffrage again stalled in Parliament; a speech by Home Secy. Gladstone implied that women could not organize supporters as the men trade unions had. As Chapter 5 explains, this comment spurred direct action by the Women's Social and Political Union, and the greater involvement of women in the theatre. By the end of 1908, the Actresses Franchise League and the Women Writers Suffrage League joined other burgeoning activist leagues run by and for women. Cicely Hamilton provided landmark theatre pieces that have been discussed in earlier chapters: *Diana of Dobson's* (1908), *The Pageant of Great Women* (1909), and *How the Vote Was Won* (1909), with Christopher St. John. Edy Craig, the original Bishop's wife in *Getting Married* directed Hamilton's plays. Like Shaw, Hamilton was disturbed by the institutional aspects of marriage, which she analyzed in *Marriage as a Trade* (1909) and in the play that followed it, *Just to Get Married* (1910).

In her tract, Hamilton's examination of the underlying power dichotomy between men and women in marriage questions why it was a profession or trade for women; personal relations between men and women should not rest upon ownership, as Shaw's Preface has also argued. Her premise was straightforward: women are individuals and should not be identified according to their sexual status, as they had been since medieval times. The Estates of men were designations of class and public role; women were known simply as maid, wife, or widow. While Hamilton does not specify the medieval framework, her remarks nonetheless make it readily apparent that she has this in mind when she characterizes the stereotypical attitude of man toward woman: "he looks upon her as something having a definite and necessary physical relation to man ... without [which] ... she is not woman at all—until man has made her so. Until the moment when he takes her in hand she is merely the raw material of womanhood—the undeveloped and unfinished article."[20] Hamilton's own perspective is the polar opposite: each woman is an individual "whose life is her own concern"; as a woman she never thinks of another woman in connection to her sexual or maternal relations with other people.[21]

Hamilton's point of view about gender relations was elucidated several generations earlier by the protofeminist George Sand, who believed staunchly that the fundamental basis of relationships between men and women had to be reformed before any real change could happen in gov-

ernment. In 1848, she refused to be part of government for that very reason. In a letter to those who wanted her to stand for election she explained:

> Women must and will participate in politics in the distant future, she argued, but in order for them to do so, society must first be radically transformed. As long as they are "under the tutelage and under the dependency of a man by marriage," women cannot be freethinking agents in political matters. Civil and educational equality must precede political equality. Until then, women will display the "ruses of the slave," characteristic of all oppressed people.[22]

Hamilton and her feminist colleagues were going in a slightly different direction: attempting to change the laws as well as the personal connections between men and women. Or, put another way, the international women's movement of the early 20th century aimed at the two goals as two halves of the same whole. They also recognized a clear distinction between the ideological givens for different social classes. Hamilton speaks of class discrimination for men as well as women when she notes that clerks are not seen as individual people; rather, the word calls to mind "something in the shape of a man who is continuously occupied in driving a pen. In other words, we lose sight of the man himself in one of his attributes ... woman, as a rule, is still regarded—not as a human being with certain physical and mental qualities ... but as a breeding machine and the necessary adjunct to a frying-pan."[23] But working-class relations had long been more egalitarian because the wages and efforts of each person mattered a whole lot more. It was middle to upper-class women who appeared most frozen in the expectations for marriage as a trade.

Hamilton's own play from 1910, *Just to Get Married*, premiered at the Little Theatre managed by Gertrude Kingston, who played the leading role of Georgiana Vicary, a twenty-nine year old woman living as a dependent with her aunt and uncle. The scenario is quite simple: she met an eligible bachelor, Adam Lankester, at a house party who was quite attentive, so her guardians invited him to spend a fortnight with them. When the play opens, it is the last day before his departure and no proposal to Georgiana has yet happened. We meet Georgiana's friends first: Mrs. Macartney and Frances Melliship, an artist who lives in a small studio in London. Mrs. Macartney explains to Frances that Georgie wants to get married because she wants to relieve her aunt of uncle of their financial support of her. She is not romantically attached to Mr. Lankester, but wants to do what is expected of her; she dreads equally that he will not propose and that she will have all the "bother" of engagement. Unlike Frances, Georgie is not "exceptional," so cannot venture out on her own to pursue special talents. Here Hamilton hints at the era's recognition that the women who

have true gifts can become the exception to the rule for marriage. Frances believes no one should marry someone without caring. She proposes that Georgie come live with her so the cost to her uncle would be very small and Georgie could "respect herself." Georgie couldn't imagine living in a small studio and eating fried sausages and cold potatoes as Frances does.[24]

Georgie will be humiliated if no proposal comes, and her aunt feels similarly. Lady Catherine is determined that her husband will confront Mr. Lankester if he does not propose; Sir Theodore is horrified by the prospect. The proposal does happen just before the first act curtain. He is elated, and she is awkward because, although she accepts, the feelings she professes for him are a sham. The second act shows the flurry of activity the night before the wedding. As the bridegroom arrives, Georgie cannot continue to lie and she breaks the engagement. Adam is crushed and then angry. Hamilton's dialogue between them illustrates the issues she raises in *Marriage as a Trade*. Georgie's speeches carry two major themes: with no resources, economic or vocational, a poor relation has to take her chance when it comes along, and the humiliation of feeling unwanted even if treated kindly. But, true to Hamilton's statement of people as individuals, Georgie breaks the engagement because Adam really cares for her and has been nothing but kind and generous. She tells him the whole truth here: "I didn't realize at first what it would be to take everything from you—your love and your money and your gentleness—and give you nothing in return—nothing. It was so mean—it was cheating you.... I'd got to like you so much—so very much—and I was sorry for you.... It was such a shame."[25] Georgie will go to Frances and try to find her way towards independence.

Needless to say, a debacle follows, but Georgie refuses to obey her aunt and uncle and sets off for the train station. En route, in the pouring rain, she falls into a ditch and is bedraggled and cold when she gets there. A kindly porter is trying to help her when Mrs. Macartney and her aunt's daughter, played by Dorothy Minto of the Vedrenne-Barker seasons, arrive to bring her home. Georgie will not go. Then Adam arrives at the station and Georgie gives him his jewelry back and then explains that she has left her home. Adam is moved by her situation and says she can't rid herself of his friendship. The first surprise in this act is Adam's appreciation of the lesson Georgie gave him about the reality of dependence: "You've made me understand to-day what it means to be entirely dependent on other people.... It was because you were dependent on other people that you—engaged yourself to me; and for the same reason you tell me have got to go back to a life you dislike and relatives who don't want you." He offers her money, as he would to any other friend. That she cannot do, but she has realized that she does care for him, especially after the wall of pretense

has come down. She says to make her happy he could marry her, as long as it's not out of pity. Georgie also has had a realization: "You're good enough for any woman to love. I don't know how it was that I didn't find it out before—it was because I was so ashamed of myself, I think—and I thought what I felt for you was nothing but pity." She encourages him to think it over, feel free to throw her over, but he is overjoyed. She wonders, "And you don't think it awful of me to have asked you?" Adam responds, "I think it was very brave of you." So they will marry in London, without fuss, and send a wire to her family.[26]

Not all plays about marriage concentrated on the bourgeoisie or marriages crossing class lines. Elizabeth Baker's *Chains* (1909) portrayed the everyday lives of people in the lower middle classes; her characters are limited by small incomes and have few illusions about climbing an economic ladder. Family life is the prize, albeit on a small scale: thus the chains for men as well as women. Baker introduces complication when a boarder in a clerk's home decides to give up his position and emigrate to Australia. The clerk, already shown to chafe at the constriction of his mandated clothing for work, begins to consider a similar move, and sending for his wife Lily once he can establish himself. His wife is content with their lifestyle and seems oblivious to the entrapment her husband feels from his job, until she realizes her husband may leave her.

The play both broadens and deepens once Baker introduces Lily's family and the setting goes to her parents' home. As more characters enter the scene, Baker's argument that the Victorian ideal family is a powerful barrier to individual ambition clearly emerges. The play turns on Lily's announcement that she is pregnant, thwarting her husband's wanderlust, and inverting the usual sacrifice of woman for man. Further, Baker adds the other twist: the working class Maggie turns down the proposal of the well-off man who loves her because she does not love this man and opts for the adventure that Lily's husband can no longer pursue. Maggie cannot live with the duplicity, and tells Lily she was only marrying him to escape the shop, which she recognizes as trading one self-compromise for another.[27]

In 1908, one of the most important realistic plays by an American hit the boards: *Salvation Nell* by Edward Sheldon, starring Minnie Maddern Fiske in the title role. A combination of melodramatic sentiment and the unflinching portrayal of the working poor, Sheldon's text is also reminiscent of Stephen Crane's exposé of the tenements and street life in his novella *Maggie: A Girl of the Streets* (1896). In Crane's text the central figure, Maggie, was a loving and strong little girl who negotiated some safe space for her brothers when her alcoholic parents brawled, and, remark-

ably, became a pretty and level-headed girl, went to work making collars in a sweatshop, and then took up with her brother's friend. When her lover abandoned her, she had nowhere to go but the streets. Maggie's spirit and her seeming insusceptibility to the dirt and bitterness could not last in that crushing environment.[28] In Sheldon's play Nell suffers physical abuse from the father of her child and near starvation when he's imprisoned. The Salvation Army lasses of the neighborhood made her one of them, and saved her from the prostitution and suicide that Crane's Maggie suffered.

The production itself was simply remarkable. According to Katie Johnson, the Producer of *Salvation Nell*, Grey Fisk "utilizing an almost photodocumentary approach, bought Sid Empire's bar in Hell's Kitchen and literally reassembled it onstage." The stage design team accomplished a similar feat by "photographing the slum and copying these images onstage, even including real fire escapes, lampposts, and laundry hung on lines." One 1909 reviewer thought the set too realistic, and *The Saturday Evening Post* termed it "slum realism." *Everybody's Magazine* emphasized the "allure for upper-class audiences," in spite of perhaps because the play "did portray the lower depths."[29] Mrs. Fiske was the era's most famous and successful actress-manager, as well as a women's rights activist. She was hailed by a headline in the *New York American* for her performance as Nell: "Mrs. Fiske at her Best: Play Held Audience Amazed."[30] The importance of this play was not lost on a young Eugene O'Neill, who wrote "*Salvation Nell* first opened up my eyes to the existence of a 'real theater.'"[31]

A very different neighborhood filled with artists, immigrants, and iconoclastic well-to-do youth was beginning to make an imprint on New York culture at that moment: Greenwich Village. The year 1910 saw the premiere of Rachel Crothers's *A Man's World* on Broadway, set in a Greenwich Village apartment building. The play portrays the distinctive character of this burgeoning neighborhood of free thinkers. Its protagonist, Frank Ware, is a successful writer who only recently "leaked" her identity as a woman. She is also raising an adopted son alone, often with the help of her male neighbors. Three of them are there with the child, waiting for her to come home. With this gender reversal, Crothers links her play to the new women fiction of the era, particularly the short stories of Charlotte Perkins Gilman that appeared in her journal *The Forerunner* and which featured couples sharing domestic as well as vocational work.

Very early in Act I, one of her male neighbors reads a review of Frank's latest work from the newspaper:

> *The Beaten Path* is the strongest thing Frank Ware has ever done. Her first work attracted wide attention when we thought Frank Ware was a man, but now that we know she is a woman we are more than ever impressed by the

strength and scope of her work. She has laid her scenes this time on the East side in the wretched poverty of the tenement houses, and the marvel is that any woman could see and know so much and depict crime and degradation so boldly. Her great cry is for women—to make them better by making them freer. It is decidedly the most striking book of the year.[32]

Three of the men in the building are there, and are all impressed by the review, yet wonder along with the reviewer how a woman can write the way Frank does. How can she get places to do the research without the help and/or direction of a man? The title of the play gets its first layer of meaning: Frank Ware must have a "past" to account for the mystery of the child and her success. One man says: "don't know whether Kiddie's her child or not—don't care—none of my business—but after she's had the courage to adopt the boy, and refuses to explain who he is—after she's made people respect her and accept the situation—I can't see for the life of me, why she lets *another* thing come up for people to talk about."[33] True to the formula of melodrama comes the question: was there a secret lover who guided her and could he be the son's father? Impressively, before Frank Ware appears onstage, Crothers has set up a dialectic between the old drama and the new.

When Frank arrives, the interchange between her and the men and her son is strikingly modern, and she is described in the stage directions as: "one of them—strong free, unafraid, with the glowing charm of a woman at the height of her development." What she wears is not new but indicates a "certain artistic individuality and style."[34] In her conversation with Fritz, Frank tells the story of the child's mother, abandoned by a lover, and taken in by Frank and her father, when they lived in France. The woman died in childbirth, and Frank's father two years afterwards. Frank named the boy Kiddie and gave him her own surname because she never wanted to know who the man was who had left a pregnant woman to starve and possibly die.[35] So much for the "woman with a past plot," it seems, until Crothers adds another speculation. Another tenant in the building, Leone, suspects that Frank is a somewhat promiscuous flirt, and is convinced that the journalist, Malcolm Gaskell, is her lover because the child looks like him. Leone is a diva personality and believes life to mirror the world of opera.

Gaskell arrives when all the others have left for the evening, heightening the suspicions aroused by Leone's comments, and returning to Crothers's more impassioned plotline: Frank's book. It is the content of the review of Frank's muckraking book that is the link to women's drama of the early 20th century. The focus on the plight of sweated women workers and the call for their freedom (which would include a vote and thereby full citizenship) reveals Frank Ware to be a supporter of women's rights

and a member of the new generation of professional women. The suffrage movement on both sides of the Atlantic had focused almost exclusively on the interests of middle-class white women. But the agitprop plays for suffrage that followed Elizabeth Robins's *Votes for Women* (1907) routinely included working-class characters, not only as the victims of capitalistic greed or recipients of upper-class largesse, but as comrades in arms for the cause.

In 1909, the year of the women's Shirtwaist Strike in New York in protest of unsafe workspaces and appalling wages, Robins's *Votes for Women* was produced in New York under the auspices of the Actors Society. American actress and activist Mary Shaw portrayed Vida Levering, the protagonist of the play. New York critics were not receptive to the play as a whole; the *New York Times* felt the structure of the play was neither complete as a theatrical work, nor the resolution of the past via support for women's rights rather than belated marriage plausible. The headline of the New York critic's piece compliments the star, Mary Shaw, but the sub-head only compliments the play as an "Interesting Study of a Crowd, but Play Unconvincing as Drama or Argument." The critic completely misinterpreted the plot, even the way Robins had placed the chance meeting of Vida Levering's past into Act One. Both the London and New York productions were lauded for the Trafalgar Square scene in Act Two.

Yet the *New York Times* critic felt the scene was "dragged in for a purpose, having no real bearing on the familiar story of the appearance in a man's life of a woman who, years before, had been his victim, and who now arrives to block his marriage to another woman."[36] It is the younger woman, Stonor's fiancée, who expects the conventional reparation and the protagonist, Vida Levering, who refuses to marry the man or bar his marriage to the younger woman. Ironically, Mary Shaw's performance received glowing reviews by the *New York Times*, despite her very prominent role in American women's suffrage campaigns. A recent scholar, Robert Schanke, not only focuses on Mary Shaw's performance, but also contends that for some theatergoers, presumably those involved in the women's movement, "Vida's thoughts sounded so much like Mary Shaw's that [they] wondered if she were really acting."[37]

With the context of the prominent suffrage events in the 1910s, as well as Robins's play in the minds of audiences, it is likely that they would have predicted that one male character in particular in Crothers's *A Man's World* would have been compatible ideologically with Frank: the journalist, Malcolm Gaskell. Yet he turns out to be the conventional man, who believes it's "a man's world." Gaskell's appraisal of Frank's work is similar to theatre critic Walter Pritchard Eaton's review of the 1910 production of this play.

Eaton contends that Crothers "just misses the masculinity of structure and the inevitableness of episode necessary to make it dramatic literature."[38] Gaskell wants to re-read Frank's book to "see what everyone is talking about," and to take her to dinner. He had bought a copy but thrown it away because it "irritated" him. Gaskell's half-baked ideas are spouted in a critique that includes the naming of the play's title:

> Your story's all right—a man couldn't have done it any better—your people are clean as a man's.... But it's only a story. You haven't got at the social evil in the real sense. You couldn't tackle that. It's too big for you.... You've let your daredevil profligate girl rail against men and the world.... You keep banging away about woman—woman and what she could do for herself if she would. Why—this is a man's world. Women'll never change anything.[39]

Despite the review cited above, Crothers was able to successfully write and direct "feminist plays for a mainstream audience," according to Pam Cobrin. Cobrin locates Crothers's winning combination in three factors: first, to control the material she directed by writing plays that focused on women; second, her style of directing placed the "feminist content" in clear connection to "her artistic and social vision"; third "she created a pleasing aesthetic," thereby avoiding critics labeling her plays as "feminist,"[40] the new word of the 1910s to describe the radical turn in the women's movement from suffrage alone to the economic and sexual confinement that affected all classes of women under patriarchy.

A clear illustration of Cobrin's assessment of Crothers's style is in Act II of *A Man's World*. The blending of the melodramatic "past" and Frank's feminist attitudes are presented with familiarity because the focus is on the romantic interest between Gaskell and Frank. The mystery of Kiddie's father has become a conflict between Fritz and Leone, who loves Fritz, Fritz and Gaskell, and Gaskell and Frank. Fritz loves Frank, who apparently does not know this, but Gaskell is jealous of the friendship between them. Crothers sets the scene in Leone's apartment. Now that she's set up the typical scenario to debunk it, Crothers gets into the rising action or "complication" by problematizing the potential love relationship between Frank and Gaskell. Frank's friend Fritz turns down a chance to play his violin for money (an opportunity offered by Gaskell). He refuses, which makes Gaskell angry and Frank perplexed. Gaskell assumes she's protecting Fritz because she's interested in himwhich of course prompts his declaration of love to her.

But what's really bothering Gaskell is his belief that Fritz knows all about the secrecy surrounding Kiddie's origins. Once Gaskell tells Frank he loves her, he expects that to be the be all and end all and she will comply with all of his wishes. Not the case! Frank wants to know why he's no

longer willing to accept Frank, in her words "just as you see me here—just as you accept a man." Gaskell's next speech is how Crothers cements the double standard between men and women: "In the beginning I thought I did. But when a man loves a woman—the whole world changes to him." Frank questions/challenges Gaskell, demanding to know what gives him the right to require a full disclosure of her past. Gaskell is fixated on his belief that Fritz knows all. When Frank tells him Fritz never asked her, all Gaskell can think of is whether Frank loves Fritz and plans to marry him. When Frank says no, his reply truly astonishes: "Then I'm going to make you love me. I love you. I love you—I tell you. This child is the most important thing in your life. I ask you to tell me what he is to you."

Frank retorts: "How dare you say that to me?" Gaskell: "Because I love you. That gives me the right." When Frank turns the tables and says what if she demanded from him full disclosure for her approval he again reverts to the ideology he believes is on his side: "I'm a man. You're a woman. I love you. I have the right to know your life." Frank: "You mean if Kiddie were my own child, you couldn't ask me to marry you?" Gaskell: "Is he?" Frank: "And if he were? Can't a woman live through that and be the better for it? How dare a man question her! How dare he!" Brilliantly, Crothers has their conversation interrupted, by Leone. The suspicion about Kiddie's parentage comes up and Frank misinterprets the mystery. When Kiddie's resemblance to someone in their midst is spoken aloud, Frank assumes that people think the boy looks like her.[41]

In the remaining two acts of the play, Crothers continues to fuse modern drama and 19th-century melodrama to clinch her interconnected themes of the perniciousness of the double standard, the impunity men were granted under it, and the deep impression of Frank's upbringing by her father and their rescue of Kiddie's mother. Rather than the build-up to the tell-all moment, Crothers favors the discussion play mode of the new dramatists. Leone and Frank have a conversation and Leone explains her belief that Gaskell is Kiddie's father but that Frank should accept his past and cleave to Gaskell's love for her as the greatest gift of life. Gaskell now gleans that Frank means what she says about helping women because these ideas grew out of the experience of Kiddie's mother. But then he returns to dominance and demands that she let everyone know that she is not Kiddie's mother. In the midst of this, Frank realizes—with horror—that Gaskell is Kiddie's father; she sees it in his profile, and confronts him with the name of Kiddie's mother. Gaskell owns it but without remorse: "I never said anything about marrying her. She knew what she was doing."[42] Frank tells him the rest—once again, Gaskell fails to grasp that it is his past that will preclude a future with Frank.

Frank's refusal to accept the double standard is not a turning away from love. Rather, her disaffection with Gaskell stems directly from her horror that he could have treated a woman the way he treated Kiddie's mother. His impunity remains as far as he is concerned. When she presses him, Gaskell admits that he doesn't think his actions wrong because he is a man. It is this attitude that makes it clear that Frank could not be with Gaskell, for her own future self-respect as well as the past he thinks she should forgive because he claims to love her. Crothers's ending dialogue is radical and blunt. It should not be seen as ideological purity in Frank that makes her send Gaskell away; it is not a sacrifice of personal happiness for a higher cause, as Pam Cobrin suggests.[43] Frank Ware sees the core of Gaskell's character and, like Nora Helmer in Ibsen's A *Doll House*, loses her love for a man whose self-absorption precludes his ability to recognize a woman's actions outside her submissive connection to himself.

Women's options and/or limitations was an overriding theme in plays written before World War I, not only as suffrage drama per se (see Chapter 6) but also in little and commercial theatres on both sides of the Atlantic. Since economic questions were at the forefront, it is no surprise that plays centering on women in the workplace or as daughters of business owners proliferated. A popular family business portrayed onstage involved drapers (department stores) or factory owners: Granville Barker's *The Madras House* (1910); Shaw's *Misalliance* (1910), *Fanny's First Play* (1911), a play by Shaw discussed in Chapter 6, and Githa Sowerby's *Rutherford and Son* (1912).

Clearly influenced by each other's vantage points, *The Madras House* and *Misalliance* were part of Barker's repertory season produced by the American theatre man, Charles Frohman at the Duke of York's Theatre. Barker's play (written first) represents a range of women: Victorian mothers, wives, and daughters (Act I); employees of the Madras House (Act II); the live model/mannequins (Act III); domestic struggles of two generations of married couples (Act IV). In this way, Barker examines the rungs of society and their connection to the making and selling of clothing and, by extension, cultural standards. As Dennis Kennedy encapsulates: "Instead of being teleological or plot-driven, the play is a series of layers; a composite. Each act shows a different type of sexual problem connected with business, marriage, or family, and all involve women's economic dependence upon men."[44] Not only does the dramaturgy represent another innovation from Granville Barker, but it also locates the nexus of women playwrights' scripts of the time: economic dependence.

The play's first act is its most conventional: family at home on Sunday afternoon. Barker does due diligence in setting up the past: Constantine

Madras, who abandoned his wife years earlier to live in the eastern part of the Empire, will return on the morrow to sell the Madras House to an American.[45] Constantine's son Philip, the play's protagonist, must negotiate not only the business transactions, but also his mother's chronic despair and the romantic entanglements of employees and his own marriage. Constantine's brother-in-law and business partner, Henry Huxtable, represents the Victorian husband, businessman and father that Shaw's father in *Misalliance*, John Tarleton, emblematizes. Beginning his play with the Huxtable family was Barker's way of relegating typical family drawing-room comedy to exposition; the six unmarried daughters and their mother only appear in this first act. Christopher Innes's analysis of the play goes immediately to the point of Barker's layered writing. Innes notes that Philip's "uncle's family of six unmarried daughters advancing into a middle-aged wasteland of rigid respectability—the first segment of society put under the microscope—is paralleled with the closely supervised and segregated salesgirls who are forced to 'live in' the establishment that employs them."[46]

Cicely Hamilton's *Diana of Dobson's* (1908), discussed in Chapter 6, staged the dormitory of the workers, highlighting the bare surroundings, outrageous work hours, and pay docking that would occur for something as small as a broken glass. Hamilton's protagonist is a shopgirl who escapes Dobson's via a very small inheritance, and cannot find work of any kind when the money runs out. The second act of Barker's play revolves around the pregnancy of one of those who live in, and who won't disclose the father of her unborn child. Philip must preside over a meeting with the accused man, also an employee of the Madras House, the man's distraught wife, and the unrepentant young woman. Harshest of all is the matron who punishes the young women who live in. Here we see Philip as a scrupulous and highly effective executive: he dismisses the false accusation of the married man, tries to "put himself" in the place of the pregnant shopgirl, and doesn't demur when the matron becomes outraged that neither the man she accused nor the young woman are dismissed from the store. The matron feels she must leave the store; Philip says merely that she has overstepped her boundaries and, secondly, that she must not say it was his decision that she leave. Innes focuses on the way each act of the play incorporates another aspect of the selling of and selling to women that fashion houses did in this era, but he is particularly incisive on the third act, which reveals the literal objectification of women via the mannequins. It is this act of *The Madras House* that cements its significance and its audience impact. The men in power have all gathered to determine the future of the Madras House itself and the other stores under its man-

agement. Once again, however, the plot points are not Barker's concern; the act probes the inner workings of the fashion world as well as the individuals around the conference table. True to his genius for visualization, Barker literally demonstrates the packaging of women's bodies while Constantine touts the Mohammedan practice of polygamy to fulfill women's pivotal potential: childbirth. Innes specifies:

> The show room of the fashion house provides an emblem of the way male domination perpetuates itself through promoting stereotyped images, which is reflected in the theatrical context. Mannequins parade across the stage while the owners and the American purchaser of the firm—as audience—discuss price and business philosophy, living illustrations of the hypocrisy of their principles.[47]

As the mannequins appear, called by number only, the perspective of the American man buying the firm, Mr. State, combines an industrialist zeal for profit and the exploitation of the woman suffrage movement towards his own ends. State contends that his focus will be on the middle-class woman: "She must have *her* chance to Dazzle and Conquer. That is every woman's birthright.... And remember, gentlemen, that the Middle-Class Women of England ... think of them in bulk ... form one of the greatest Money-Spending Machines the world has ever seen."[48] The deal is completed. Constantin, for all his blatant sexism, makes one of Barker's most important points: the shopgirls are as much a harem as the women in his Mohammedan world. Moreover, the irony that French courtesans set fashion trends becomes a more complex point once Constantin points out that industrialists "buy them on the open market ... you keep them under lock and key ... coin your profits out of them by putting on exhibition for ten hours a day ... their good looks, their good manners, their womanhood. And when you've worn them out your turn them out."[49] But Barker doesn't stop there.

After implicating western and eastern attitudes towards women as commodities throughout the British Empire, he clinches the play's exposé of male power and privilege in Act Four by having Constantin be the father of Miss Yates's baby. When a 1910 audience would anticipate what Granville Barker would do with the woman-with-a-past plot, they would see that she has refused money from the rich man because she has managed to put money away over the years and intends to raise the child alone. Miss Yates's unabashed explanation to Philip in Act Two that she wanted the affair as an adventure—when sexual desire was something women were not supposed to have of their own volition—reveals Barker's intention to confront that stereotype as well. Constantin urges Philip to dismiss her and then locate a better position for her once Mr. State reorganizes the

stores because State will pay very well. The subject drops, although we assume Miss Yates will have to be dismissed once her pregnancy is far enough along for her to show. Philip is thoroughly disgusted with his father and his sympathies lay with the exploited women as the clearest manifestation of the skewed Edwardian ideology. In true 20th-century style, Philip blames both of his parents for his emotional coldness, declaring: "As the son of a quarrelsome marriage, I have grown up inclined to dislike men and despise women. You're so full of getting the next generation born. Suppose you thought a little more of its upbringing."[50]

Then the closing scene turns to Philip's private life: his decision to refuse the directorship of the Madras House under Mr. State, the sexual and values conflict within his marriage, and proposed changes to the upbringing of their eleven-year-old daughter (who never appears onstage). Jessica, his wife, embodies the upper-crust woman who is, as Barker describes her in the stage directions in Act Two, "an epitome of all that aesthetic culture can do for a woman. More: She is the result—not of thirty-three years—but of three or four generations of cumulative refinement. She might be a racehorse! ... fastidious—fastidious—fastidious."[51]

These "damning with faint praise" remarks are only hinted at between Acts Two and Four; she is unkind to her mother-in-law and is aloof from others in Philip's family. But when Philip wants to run for the County Council and deal with drains and disinfectants,[52] and thereby reduce their income and lavish lifestyle by sending their daughter Mildred to a less exclusive school, Jessica is anything but supportive: "If you Idealists want Mildred to live in the East End ... make it a fit place for her." It is at this juncture that Granville Barker reveals a Fabian social justice and conscience; Philip realizes that his wife lives in a bubble of the arts and rarefied company. She tells her husband that art "makes life possible" for many women, implying but never stating that their day-to-day lives offer little stimulation or purpose. He asks Jessica if she has ever really looked at a London street when she is on it. She has and finds it "loathsome." When he asks what she has done about it, Jessica dodges the question by asking what one can do. Philip wants his daughter to find ways to love the world that alienates her mother. Jessica, in turn, cannot imagine a world without the arts or beauty. But Philip's recognition of the price of all of this is too high: "We good and clever people are costing the world too much. Our brains cost too much if we don't give them freely ... even your virtue may cost too much, my dear. Rags pay for finery and ugliness for beauty, and sin pays for virtue. These are the riddles this Sphinx of a world presents."[53]

In his unusual but still recognizable full circle in *The Madras House*, Granville Barker closes the play with a family scene in Philip's home. It is

an honest emotional confrontation between husband and wife that considers the conventions of sexual "play," the true harm that comes from emotional distancing, and, finally, re-establishment of their emotional attachment. No fanfare, only one kiss that occurs when they literally meet each other halfway onstage, and a literal half-uttered thought by Jessica ends the play. Hardly a dénouement in the strictest sense of it, yet the fragmented conversation suggests a true recognition that they will need to grow and change.

Shaw's *Misalliance* premiered shortly after Barker's play. While the two works share some subject matter and feature the mercantile class, the tone of each is clearly distinct. Barker's nuanced dialogues with pauses to explore psychological realism are offset by the potent visuals. Shaw's stunning visual would come through technology onstage.

The opening scenes of Shaw's play allow audience to witness the stand off between a fiancé and his lady's brother, and "listen in" on the world-weariness of the affianced young woman in conversation with her mother and her fiancé's father. Structurally a quintessential drawing room comedy, this act is not nearly as conventional as Barker's Act One. Barker had used his opening to represent the stasis of the past masquerading as the present moment. In *Misalliance* Shaw chooses to represent a young woman from a rich mercantile family, one who is aware of the activism around her but is not an active participant. Hypatia has had some education, but hardly enough to give her a true vocation other than the traditional "profession" for middle and upper class women: marriage. Hypatia has no intention of being handed over to anyone by her father, and has chosen to betroth herself to someone she does not love. Even if she is far from satisfied with her options, Hypatia has stagnated all the same. She asks her mother, "Do you think marriage is as much a question of fancy as it used to be in your time and father's?" Mrs. Tarleton replies that it wasn't fancy exactly; her father wouldn't take no for an answer and, as a poor young woman, she was "only too glad to be his wife instead of his shop-girl." Her mother doesn't think her daughter needs to marry Bentley if she doesn't love him.

Hypatia, far from being shocked by her mother's true story, tells her mother she and her set would not risk marrying for love because "it would make a perfect slave of you. There's a sort of instinct against it." As much as Hypatia derides all the talk in the play, she too only talks about what frustrates her in her conversation with her mother, while intending to settle for the role her parents and society have carved out for her; she feels she must marry somebody: "what better can I do?"[54] Hypatia speaks to the limitations for young women of her class, and the activists out on the

streets working to undo these constraints. So the question becomes, why name this character Hypatia when this character remains on the sidelines of activism? The obvious link is to the young woman from Alexandria whose father gave her mathematical mind training in pagan Egypt.[55] But Shaw may have had another Hypatia in mind: Hypatia Bradlaugh, the daughter of the MP Charles Bradlaugh who debated Shaw's friend Annie Besant in 1887. The quote that follows is from Chapter 5, and worth repeating here. It shows the long-term efforts to address key issues. Besant centered on the "nature" question, and also carried through on Nightingale's essential contribution: understanding sanitation, [and her] ability to "organize, to lead, to get things done."[56] Here is Besant in 1887:

> It has been remarked, more than once, that, in this contest about the voting of women, men and women have exchanged their characteristics. Women appeal to reason, men to instincts; women are swayed by facts, men by prejudice. To all our arguments ... men answer, "It is unfeminine—it is contrary to nature." I am afraid we women sadly lack the power of seeing differences.... It is unfeminine to study sanitary laws, but feminine to regulate the atmosphere of the nursery, whose wholesomeness depends on those laws. If this natural mental inferiority of woman be a fact, one cannot wonder how nature managed to make so many mistakes.[57]

The years between 1870 and 1905 were often labeled the "doldrums" of the woman suffrage movement in Britain by historians who mistakenly assumed the movement was only the push for women's votes. The reality is that this was an era of enormous reform and considerable progress for women. Their work for more comprehensive sanitation laws, repeal of the contagious diseases laws, Poor Laws, and push for suffrage as a means to implementing legal protection for women were all integral.[58]

Shaw further cements the link to Besant and the suffrage campaign by including Mrs. Tarleton's chagrin over the loss of an infant child because of her ignorance about sanitation for the nursery. She explains to Hypatia that one of the women "told me, downright brutally, that I'd better learn something about them before my children died of diphtheria. That was just two months after I'd buried poor little Bobby; and that was the very thing he died of." Hypatia replies, "There was a physiology and hygiene class started at school, but of course none of our girls were let attend it."[59] Clearly, Hypatia was not given sufficient background on women's issues, nor did she seek it.

Shaw's inclusion of the drainage systems issue in *Misalliance* also echoes Elizabeth Robins's *Votes for Women* (1907). In Robins's text, Vida Levering, the play's protagonist and platform speaker, knew and spoke about drainage as a key issue in the first act of Robins's play, nonplusing the country house gathering that does not know Levering's leadership role

in the suffrage movement. Further, Vida Levering models the platform speaker as educator role; Robins's plot and dialogue reflect the effort of women activists and artists to escape the static choices and ramifications for women who think for themselves. Hypatia Tarleton resembles the women Vida Levering attempts to convert in *Votes for Women*, a play Shaw supported as part of the Vedrenne-Barker season of 1907 (see Chapter 4).

After Hypatia's conversation with her mother, she has a very frank conversation with Lord Summerhays about her longing for excitement. Hypatia speaks freely to this man, the father of her fiancée, Bentley, admitting that she "loathes home, parents, family, duty—she'd like to see them all blown to bits." Summerhays responds with words sympathetic to her feminist talk: "Living your own life, I believe the suffragist phrase is." Hypatia responds: "Living any life. Living, instead of withering without even a gardener to snip you off when you're rotten." To a 1910 audience, the WSPU slogan "Deeds, Not Words" was easily recognizable in this exchange, especially with Hypatia's follow-up remark that she wants to be "an active verb." Lord Summerhays replies: "Oh, I see. An active verb signifies to be, to do, or to suffer."[60] His answer can be read as a paraphrase of Hamlet's soliloquy or can refer directly to what the suffragettes chose to be and do. Shaw delivers this message as a recognizable part of Edwardian conversation but not in the frame of agitprop drama.

Moments after Hypatia's and Lord Summerhays's exchange, Shaw's text promptly grants Hypatia's wish—adventure literally "falls from the sky" as an airplane crashes into the pavilion, smashing glass and some decorative pieces to bits. Shaw had already astonished audiences at the Royal Court in 1905 by bringing a car onstage in *Man and Superman,* so once again for *Misalliance* Shaw tapped into the latest craze, reminding audiences that the play unfolding before them was thoroughly modern, and using a mode of transportation to kick start—as it were—the romantic chase.

Another first arrived in the ebullient year of 1910: powered flight. Popular songs embodied the romance of flying: a favorite was "Come Josephine in my Flying Machine."[61] And so the machine does, literally. When the airplane lands close to the greenhouse, it is a coincidence well suited for comedy. Since Lina Szczepanowska and Joey Percival's arrival by airplane signals the adventure beginning, they become Shaw's technological *dei-ex machina*. Lina, the cross-dressed passenger on the airplane, a professional acrobat with courage, practical savvy, and mother wit, is already the "active verb" Hypatia described. Lina avoided a crash by leaning out of the plane and steering. Once the goggles are off, and everyone realizes the passenger is a woman, they are astonished. Hypatia's father, a lover of books and

ideas, mouths Shaw's supportive view of feminism. He realizes we are all human: "When the dress is the same the distinction vanishes." Lina eschews woman's clothing, saying that gowns "hamper me and make me feel ridiculous."[62] All the men pursue her.

Lina touts the feminist's capabilities—as well as traditionally masculine virtues. Further, the casting of Lena Ashwell for this role premiere embodied everything Shaw put into Lina. Ashwell by 1910 had risen to the heights as an actress was the manager of the Kingsway Theatre and a leader in the Women's Freedom Party.[63] Lina represents feminist attitudes and behavior in her blatant disapproval of the English country house filled with people who think of nothing but making love. Not only does she turn down Tarleton's sexual proposal, but she also chides him and Lord Summerhays for their materialistic culture and their physical laziness. Lina requests six oranges and a Bible so she can juggle them while reading her Psalms; this is an exercise to "quiet her soul" so she can be in top condition for performing. The two older men are clearly in awe of her, and Lord Summerhays had seen her perform in a European city. The men are glad she does an "ordinary" thing like praying; Lina's reply is another confrontation to their assumptions; she asserts that common people don't pray—they "only beg."[64]

Joey Percival, a friend of Bentley's, immediately captivates Hypatia, who pursues him vigorously. Percival resists because he is Bentley's friend, and because her amorous chase breaks the social bond, which he describes as similar to a corset: "It's a support to the figure even if it does squeeze and deform a bit." To this remark Hypatia retorts: "Men like conventions because men made them." Percival wonders what kind of house he finds himself in; must he "throw all good manners to the winds?" Yes, Hypatia urges; he and she must take full advantage of this chance encounter and what it may promise.[65] So rather than a reformer role in the world at large, Hypatia fulfills the Life Force, in the footsteps of Ann Whitefield in *Man and Superman*.[66]

Misalliance does not expose any of the downsides of the clothing industry, other than to acknowledge that even the owner, John Tarleton, probably would have preferred to be a scholar than a tradesman. In the middle of the play, however, the other modern novelty onstage—the Turkish Bath—suddenly enters the action, albeit as a hiding place for a young man with a gun. Through the gunner Shaw introduces working-class economic hardship and moral indignation. The young man implicates John Tarleton as his biological father in a manner reminiscent of the well-made play Shaw satirized: producing photographs of his dead mother as a young woman who knew Tarleton and then as a worn-out woman before her death.

In his "hiding place" the young man overhears the seduction of Percival by Hypatia, and later shows his contempt for their bad manners. Shaw combines elements of melodrama and farce to emphasize the social class and gender inequalities at the center of 1910 politics, and their continuation of Victorian issues. Shaw also includes a semi-autobiographical sketch of himself in this character, who works as a clerk, educates himself through the free public library, spouts Socialistic attitudes, and feels adrift from society. The class privilege of Hypatia and Percival emerges when the man is forced to sign a confession of his "lies" to avoid police intervention. As he so often did, Shaw threw the situation to the audience to sort out before settling the matter onstage. Mrs. Tarleton recognizes the woman in the photographs, and calms the young man by telling him the story of his mother and truly listening to him. From Victorian motherhood Shaw turns to emerging modernity. Bentley Summerhays is literally carried off by Lina, while Hypatia convinces her father that Percival is the man she wants to marry so demands her parent "buy the brute" for her.[67]

Hypatia does not become the enlightened ingénue who will save the world, but Shaw does respond to the Edwardian examination of marriage and economics when he gives Lina a potent feminist speech in response to Johnny Tarleton's marriage proposal to her. As Christopher Innes notes in "Nothing but talk, talk, talk," it is to Lina that Shaw gives the fullest measure of the liberated individual: a New Woman with her own moral code and a balanced sense of what is natural for her.[68] Her long speech near the play's end encapsulates all of the threads of the cultural moment of *Misalliance*. Lina is honest, has no pretenses, is self-supporting and has clear moral guidelines. Like Shaw, she is a teetotaler and able to distinguish what is foolish (her financial support of Bentley, the adventurous but not dishonorable older men) and what is an insult: Johnny's proposal. Lina is outraged by his telling her that her profession is not for a "nice woman" and by what she perceives as his proposal to "buy" her: "I earn my living. I am a free woman: I live in my own house.... I am unbought: I am all that a woman ought to be."[69]

In this same Duke of York's season, Ashwell would also play Kate in J.M. Barrie's short play, *The Twelve-Pound Look*. Barrie, like Shaw, zeroed in on women's self-sufficiency and the machine that empowered them. Kate had left her oppressive marriage fourteen years earlier. Her husband and presumably everyone in their circle thought she had run away with a lover. In actuality, Kate has earned her own living through the purchase of a typewriter; this machine "purchased" her freedom for the price of twelve pounds. The play turns on Kate being the typist hired to write thank you letters for her ex-husband's upcoming knighthood in their for-

mer home. The new wife has accepted the passive role that Kate could and would not. Kate remains, in Ashwell biographer Leask's words, "unimpressed by his success." She also tells him that she did not escape from their home to join another lover, but to gain her own freedom. In his usual subtle way, Barrie implies that the couple will be changed by this chance encounter with Kate. Ashwell would naturally have a proclivity towards this role because of her own self-made career and her key role in representing the urgent necessity of women's full citizenship to a Parliament that repeatedly dodged the issue. Ashwell revived Barrie's play several times at the Kingsway and felt very "proprietorial" about this role.[70]

Perhaps the most penetrating representation of the psychological and emotional weight of women's economic oppression and subsequent entrapment came from a young playwright from the England's north country: Githa Sowerby. Her 1912 play *Rutherford and Son* made the most of realism's themes and staging. The set resembled Granville Barker's *Voysey Inheritance* dining room table that subsumed the stage, with characters representing a cross-section of class and gender factors that gave them no clear pathway towards growth and fulfillment. Rutherford's is the family business, a glass factory—referred to as the Works in the play. John Rutherford, Sr., believed he lived in a glass house, even if the reference would be too poetic for him.

Sowerby has, in a sense, placed this family in a glass-domed snow globe in the play's dreary winter landscape. The "snow" of the globe descends inside the dark interior of the house, but not like the lovely ornamental miniature worlds that children love to shake and watch, spellbound. Sowerby's airless family home does anything but nurture life. Instead of innocence and halcyon days, John Rutherford's world has drained the life from everyone, yet he has no self-recrimination. His belief in the ideology of class and propriety serves both as blinders to and substitution for all human feelings except resentment. The first act's exposition plays out as the family awaits the patriarch's return; the rhythmic pacing of lamps lit, table setting, and food preparation all evoke the iconic demands of an iron-willed provider: instant availability of creature comforts when he deigns to step foot in his domicile. His son John, who has come home only a few months ago with a young wife and newborn son, likens communicating with his father to "talking to a lump of granite."[71] Rutherford's maiden sister tries to ensure all will be as he desires, while Janet, the protagonist, chafes but also chooses the path of compliance to avoid confrontation.

Emma Goldman proclaimed in 1914 that Sowerby was the first major woman dramatist to emerge on either side of the Atlantic. In her discus-

sion of *Rutherford and Son*, Goldman encapsulated the character of Mr. Rutherford as "possessed by the phantom of the past—the thing handed down to him by his father and which he must pass on to his son with undiminished luster; the thing that has turned his soul to iron and his heart to stone; the thing for the sake of which he has never known joy, and because of which no one else must know joy."[72] Goldman, the socialist, would of course condemn the capitalistic stronghold, but Sowerby offers plenty of critique of like kind. As owner of the Works, Rutherford sees his family as socially superior, thus rejecting all suitors for Janet when she was younger, and condemning his son's choice of a "mere shopgirl" for his wife.

Rutherford's son has an invention to improve the glass factory that he would like his father to pay for; Rutherford won't hear of it. John's catastrophic mistake—to trust his father's long-time worker, Martin, with the secret information—backfires in many directions; this nexus shows how and why Sowerby's dramaturgy has such high impact. Martin's loyalty to Rutherford supersedes all other, including the clandestine relationship he has with Janet Rutherford. When Rutherford elicits the information about the invention from Martin, the loyal employee loses his job, walks away from Janet, and will remain a kind of slave to Rutherford even in the aftermath. Goldman pinpoints the pivotal conversation between Janet and Martin as evidence of the slave mentality the man has for his employer, and the all-too-familiar trap women find themselves in when they are cast out of their home, which for Janet is the beginning of freedom, and her harsh realization that the man she thought she knew was more her father's toy than a partner for her.[73]

Theatergoers of Sowerby's era would have recognized these absolutes as tropes by 1912, as well as the rebellious labor and women's rights activists striving to demolish these. Maria DiCenzo's article on women theatre critics of the Victorian era cites the reviewer C.N.B. for *The Vote* who calls Sowerby's work a great suffrage play: "'no play has ever been written that in the truest, strongest sense was so really a "Suffrage" play, although the word is never uttered and the thought never enters the minds of the people portrayed. Straight from the heart of life she picks the truth, and we stand aghast as she reveals it.'"[74] Sheila Stowell consolidates the power of Sowerby's play as a representation of some pivotal issues of the Edwardian era: "Waste, inheritance, capitalistic enterprise ... cross-class alliance, and marriage [are present] as she exposes with unremitting grimness the agony of life ... moves to indict patriarchy itself."[75]

In Sowerby's far-reaching exposure on all the aspects of patriarchy's stranglehold on people, she places a man, Martin, at the center of the con-

flicts. Janet's brother John steals some money when his father cheats him out of his invention because Martin has betrayed John's secret to his father. John flees cast the house when Mary won't agree to leave with him and their baby. Her responsibility to her son overrides all, including her marriage.[76] The situation between Janet and Martin is the inverse: Martin cannot leave with Janet because his absolute loyalty belongs to her father. Janet's crushing disappointment comes when the man who had sworn she was the world to him declares that he cannot deny his employer anything. Martin offers her money but refuses to start a life with her; she refuses the money and walks out in the wintry landscape with only a shawl over her head.[77]

Perhaps Rutherford's true comeuppance comes through his working-class daughter, Mary who has the last scene and the last word with Rutherford. The "bargain" she offers is to stay with Rutherford, perform the womanly household tasks, and raise her baby until he is ten years old. If all goes well, then Rutherford may have him as the inheritor of the Works; by that time, Rutherford will be old and no longer able to inspire fear in anyone. It was this scene that haunted Goldman when she saw it in the theatre:

> When I saw the masterly presentation of the play on the stage, Mary's bargain looked unreal and incongruous.... But after repeatedly rereading the play, I was convinced by Mary's simple statement [that Rutherford would be an old man]. Most deeply true. The Rutherfords are bound by time, by the eternal forces of change.... Change and innovation are marching on, and the Rutherfords must make place for the young generation knocking at the gates.[78]

By 1994, the National Theatre mounted the first revival of the play. Critic Robert King recognized yet another layer to this dènouement:

> Mary, who has been in the dark edges of the room and in the margins of the text, takes over the play. Her diction has a contemporary ring: she is not interested in "right and wrong" but in "power." She has it, and he reduced to virtually nothing agrees to her terms. At the end, he is left alone onstage as she answers her baby's cry ... [Yet] Her power reconstructs the Rutherford prison.[79]

Sowerby's complex examination of the intersections across lines of gender and social class go far beyond the concerns of romantic love or money. Rather, her play lays bare the pernicious effects of inherited power and the impunity of a patriarch, but it also ensures that Mary's son will have a chance for a self-determined future, as long as his protective mother can outwit the old man who will provide it. Stowell comments that this last scene is a response to Ibsen's *A Doll House* with Mary talking to her

father-in law as an equal, and letting him know that these first ten years he cannot interfere with the child's upbringing. Stowell calls this a "calculated risk for Mary, who places her faith in a reformulation of the doctrine of "separate spheres" to undo patriarchy itself."[80]

A year later, Shaw would create a play that represented Edwardian drama's consistent outcry against a power structure that objectifies individuals and stifles their potential in a most unusual way. In *Androcles and the Lion*, a modern version of Aesop's fable, Shaw retains the germ of the tale of a man who shows compassion for a wounded lion, and therefore is not eaten in the Coliseum because the lion recognizes his benefactor. Shaw also adds emphasis to the religious persecution that informed the era of Aesop. Rather than a runaway slave, Androcles is transformed into a recent Christian convert. But that is not the point of the play; instead, Shaw treats the folktale as true human history. Granville Barker and Lillah McCarthy staged the London premiere in 1913 and the New York one in 1915,[81] the same year that their outdoor Greek productions created a sensation (see Chapter 3).

Lavinia, Shaw's representation of an early Christian woman, gives us a portrait of a strong, outspoken individual struggling with her faith, but unwilling to surrender herself to the Roman officer who desires her to be with him if she would renounce it. In Lavinia, a role written for Lillah McCarthy, Shaw brings us a model of human dignity. She lives her life with clarity and commitment, which the character reveals with composure as well as with daring, a Shavian staple for admirable individuals. The depth as well as charm of this play would become even more important in American theater of the 1930s, when the Negro Units of the Federal Theater Project would choose this play to represent the struggle of their people as slaves and with the racist ideology that persisted long after the end of the Civil War in 1865. Michael O'Hara brings this aspect of Shaw's prominence in that era vividly to life.[82]

Shaw's better-known re-envisioning of ancient mythology is of course *Pygmalion*, which inverts Ovid's plot and ideology in fundamental ways. Firstly, it is absolutely a modern play. Written and set in 1912 but not produced in London and New York until 1914, Shaw centers this work also around a young woman who struggles within society. Shaw returns to his theme of poverty, but presents a character who recognizes her own worth as an individual, even before Eliza Doolittle has any idea of how much she and her life are about to change. This play manages to touch upon social snobbery, income disparity, suffrage ideology, and center around a young woman who has the will of Nora Helmer and the savvy Ibsen's heroine had not developed because of her social standing and its limitations for

women. Shaw's comic triumph would include both classical and Ibsenite allusions.

Separated by a generation as well as several layers of social class, Nora Helmer and Eliza Doolittle can nonetheless form a pair. Their dramatic texts revolve around money, doors opening and closing, and coming of age moments that come when they cast off costumes and their semiotic meanings. Nora enters *A Doll House* through a door and tiptoes towards her husband's closed office door. Torvald is out of sight and the play's first word is "hide." In stark contrast, Eliza is selling flowers on the street in the pouring rain, not even allowed to be on the sidewalk. *Pygmalion* opens in a bustling London street. Her available shelter is the overhang of the buildings, and only if she isn't actively hawking her wares. Nora as a protected wife and Eliza as struggling independent woman each recognizes her need to break out of stifling circumstances psychologically as well as literally: Nora in Act 3 and Eliza in Act 1.

Eliza Doolittle could feel at home with the working-class women of the suffrage dramas discussed in Chapter 6, and given practical advice to Barbara Undershaft and her colleagues at the Salvation Army in Shaw's *Major Barbara*. All of these contexts surround Shaw's upending of the Pygmalion myth: a Victorian staple in theatre and in visual art because it valorized silent women and statues that could only breathe when a male artist desired them.

In 1871, W.S. Gilbert wrote a version of Ovid's Pygmalion story. Gilbert's overt misogyny turns the myth in a decidedly Victorian direction, making Pygmalion's wife the stand-in model for his Galatea, which of course leads to squabbles. We could view Gilbert's twist on the story as a nod to the growing tendency of women to demand better treatment. But the opening night review in 1871, has a very different perspective: appreciative and paternalistic. Note particularly the comment on the jealous wife:

> For Mr. W. S. Gilbert's mythological comedy "Pygmalion and Galatea" to fill three acts shows much audacity on the part of the author ... the ingenuity with which it is solved is remarkable. Mr. W. S. Gilbert blesses Pygmalion with a jealous wife, who is *not* the statue, but merely sat as a model for it. A spring of action is thus at once provided.... What the gods did for the sculptured figure, Mr. Gilbert has done for the myth.[83]

Shaw's *Pygmalion* runs contrary to Ovid's myth's love interest and statue, and Gilbert's adaptation, but Pygmalion (Higgins) retains his self-absorption and contempt for people around him—men as well as women. Eliza may be poor, but she's supported herself since she was fourteen, when her father tossed her out, and she has a head for figures and a knack for observing strangers. She knows what she can or cannot do –sell flowers

from the street, but not on the kerb—and also recognizes an opportunity to improve her life when she overhears Higgins explain to Col. Pickering that it is really this flower girl's "kerbstone English" that will keep her down. Eliza has also imbibed some of the "penny weekly" periodical stories that taught young Victorian women that respectability was their ticket to opportunity, economic and romantic.[84] Eliza wishes to work in a flower shop, but knows she must speak better to obtain the position; she knows that language and "style" are her means to higher social level. Even though neither Higgins nor Pickering realizes that Eliza has overheard their conversation and Higgins's boast, the effect on Eliza is instantaneous; she takes the money he literally tosses her and takes herself in hand in pursuit of a brighter future. As Nicholas Grene notes: "Built into the very conception of *Pygmalion* were two conflicting beliefs. One was the capacity for the human being to completely refashion him/herself, to expose the shibboleths of class and voice as the mere costume drama of arbitrary social system.... Yet equally there was the conviction that the persons so transformed were always themselves even before their metamorphosis."[85] Eliza dresses as well as she can and takes a taxi to Higgins's house at the start of Act 2. She knows what lessons should cost based upon the experience of a friend. Her constant insistence that she's a "good girl," what Higgins will term her "Lisson Grove prudery," illustrates Eliza's belief in genteel relations, even between the social classes. Higgins' reference to Eliza as "squashed cabbage leaf" on the one hand, but on the other, his pleas that she learn to speak her language reverently because she "has a soul" is about the clearest contradiction in comedy.[86]

More disturbing are the threats of violence leveled at Eliza by Higgins before and after her father comes to Higgins to sell his daughter for five pounds and advises Higgins to give her the strap.[87] But Alfred Doolittle has a far more complex character than this abusive and opportunistic side reveals. Both Higgins and Pickering are outraged at Doolittle's request and "advice," and Higgins asks him if he has any morals at all. "Cant afford 'em. Neither could you if you was as poor as me," replies the unflappable Doolittle. What Eliza's father wants to avoid at all costs is "middle-class morality."[88] Doolittle's encapsulization of the hypocrisy of charities that pigeonhole people as deserving or undeserving is yet another echo of the Salvation Army Scene in *Major Barbara*, Act 2 (see Chapter 4). Ironically, Doolittle becomes part of this class when Higgins's recommendation of him as "England's most original moralist"[89] to a rich American results in an income for Doolittle when the man dies.

Throughout the play, however, Higgins's own character reveals elitism, misogyny, and iconoclasm. His manners offend everyone, especially

his housekeeper, Mrs. Pearce, and his mother, who shows her displeasure each time he visits her. Both of the women chastise Henry for his lack of consideration and manners, and are clearly irritated by his childish self-absorption. Not only are these two scenes fundamental in showing Shaw's truly modern confrontation with Victorian ideology, but his use of two women from two different social classes to deliver this message cement the play firmly within the ideology that informed suffrage agitation and drama. In Act 2, Mrs. Pearce is snobby and harsh with Eliza at first, but is also stern with her employer, making it clear that he can't just pick up a young woman like a "pebble on the beach."[90] It is Mrs. Higgins who reproves Henry and Pickering in Act 3 for being a "pretty pair of babies playing with your live doll,"[91] a reference to Ovid and, more importantly, Ibsen's Nora, simultaneously. Mrs. Higgins recognizes what her son and Pickering cannot: Eliza is not only a young woman but one unprotected by economic and social privilege. She tells them that Eliza brought something with her when she arrived at Wimpole Street to request language lessons from Henry Higgins: "A problem." Mrs. Higgins voices the same concerns as Mrs. Pearce: under what circumstances is Eliza living under that roof and what will become of her after the "experiment" is completed. Mrs. Higgins also voices what Eliza herself will realize in Act 4: what is to become of her after a transformation that can alter her internally but is opaque to the society she lives in.[92]

Shaw's *Pygmalion* emerged at the height of suffrage agitation, which influenced the worlds of women of all classes. Full citizenship for women across class lines was the goal of all factions of the Cause and the Actresses Franchise League supported them all. London's original Eliza Doolittle, Mrs. Patrick Campbell, was a prominent member of the League. True to the suffrage message, Shaw's older women watch out for Eliza and help her develop her confidence as a young woman, rather than prepare her for subservience to a man. The question becomes whether Shaw's "Pygmalion" figure in the play cares more about his "creation"—lady-like Eliza—and the possibility for individuals to rise in social status based upon their speech- or the power that he wields to produce this result.

After the triumph of Eliza passing for the Duchess at the end of Act 3, Higgins and Pickering ignore her while they simultaneously congratulate themselves on their "victory" in the opening moments of Act 4. The behavior of Higgins and Pickering at this moment serves to relegate Eliza to the "finished" object status of other artist models with no individuated identity. Eliza is stunned, then crushed, then angered, and finally frantic about what she should do next.

Eliza, like Ibsen's Nora, is shocked into recognition. Clearly, this scene

both duplicates and answers act 3 of *A Doll House*, in form but not in tone, as Eliza has never been completely subservient to Higgins even in her own eyes. Nora's belief in her life is torn as readily as the I.O.U. that Torvald tosses into the fire in Ibsen's play. Eliza, on the other hand, returns to her former self-sufficiency. Yet, she is saddened to recognize that as a flower seller she sold a product. Now, as a "lady," she can only sell herself.

Like Nora, she changes her clothes, first removing the hired jewels and returning them to Higgins so she won't be accused of stealing: a clear completion and inversion of her first entrance into Higgins' home in Act 2. But what has not changed are Eliza's practical nature, or her understanding that money separates class as well as gender. Despite her years-long commitment to avoid a man's dominion over her, however, Eliza sees that her participation in the experiment had given a man clear power over her. Consciously or not, Eliza had granted Higgins more credit than was due for his inner character, mirroring Nora's mistake once again. Nora's flight in the middle of the night, finding safe passage in the home of a woman reoccurs in Shaw's play. When they wake and find Eliza gone the next morning, Higgins and Pickering panic and go to Mrs. Higgins. Like Torvald, Higgins appreciates the doll when she's gone.

Of course audiences on both sides of the Atlantic craved a romantic ending for Higgins and Eliza, and possibly expected it because the play did not end with the argument between Eliza and Higgins in Act 4. As Nicholas Grene notes, the original London Higgins, Herbert Beerbohm Tree, threw flowers at Mrs. Patrick Campbell at every night's performance,[93] which infuriated Shaw but, ironically, gave him the big success he had wanted to achieve since 1892. What Shaw's text envisions is far more feminist and open-ended than that. In Act 5, Mrs. Higgins once again remonstrates the men for their treatment of Eliza, this time echoing what Eliza had already said to Higgins the night before. Eliza has recognized what she has learned from her months with Higgins and Pickering. Her fuller definition of "lady" extends Shaw's thesis about the role of language to establish social status when Eliza dates her pathway to becoming a lady to Col. Pickering's attitude towards her: "Your calling her Miss Doolittle that day when I first came to Wimpole Street ... was the beginning of self respect for me.... You see, really and truly, apart from the things anyone can pick up (the dressing and the proper way of speaking...), the difference between a lady and a flower is not how she behaves, but how she's treated."[94]

Moments later, she stands up to Higgins once again, from a new position of strength: all along, she suddenly sees, she had only to speak to him without deference. She could "just kick herself" for that. Interestingly, Higgins also has a recognition in this scene, very much in keeping with the

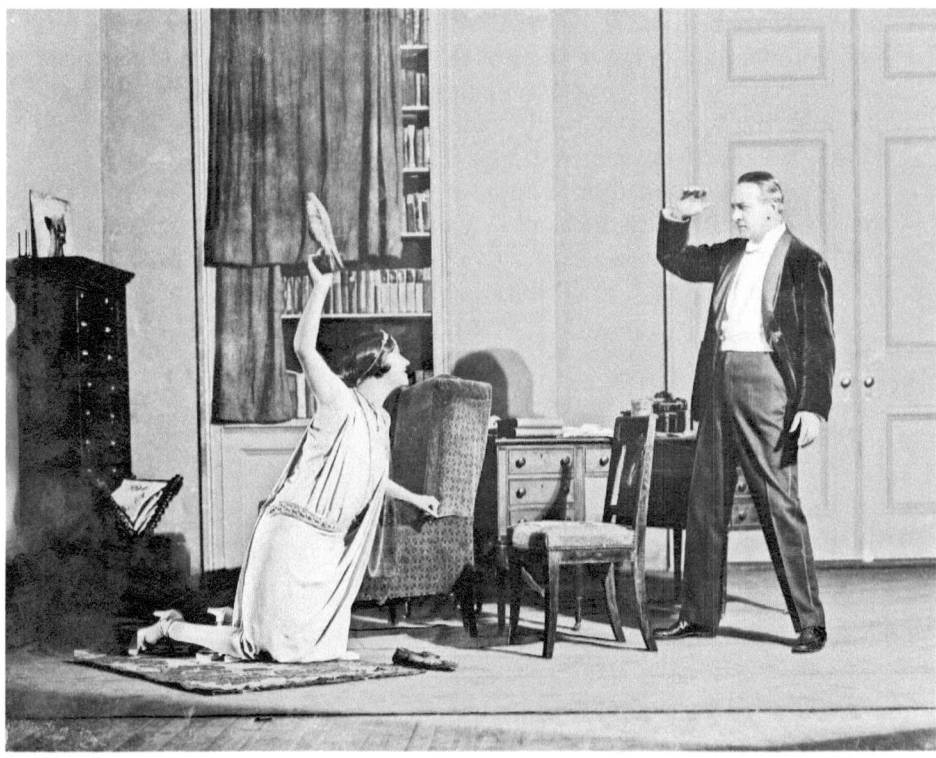

"Lynn Fontanne as Eliza Doolittle and Reginald Mason as Professor Higgins." Photograph by Vandamm Studio © Billy Rose Theatre Division, The New York Public Library for the Performing Arts. In this iconic moment from Act Four of Shaw's play, Eliza shies slippers at Higgins when he and Pickering make her into an invisible presence after her triumph at the Garden Party. The joke is also a Shavian wink and reversal of Cinderella's missing glass slipper.

original Pygmalion: he cannot imagine life without her; he's "grown accustomed to her face and voice" and when Eliza says he has his recording to keep him company, Higgins declares that he "cannot turn [your] soul on." Eliza's ready answers bring out Higgins's most spontaneous line in the play: "By George, Eliza, I said I'd make a woman of you; and I have. I like you like this." She is no longer a "millstone round [his] neck. Now you're a tower of strength: a consort battleship."[95]

Shaw's Eliza Doolittle epitomizes the breakdown of the myth of the static, malleable female figure; her complete awakening from Act 4 to Act 5 is bookended by her two confrontations with Higgins after the triumph at the garden party. Clearly, Shaw answers Ovid and Gilbert when he presents us with a poor flower seller with clear self worth that would evolve

from the very beginning of her play. She *chooses* to be Galatea to Higgins' Pygmalion, and finally conflates both roles within herself. She slams the door to Higgins' house and Shaw offers multiple ways for Eliza to escape the myth by the play's multiple endings. Regardless of her choice, Eliza truly is her own woman.

Pygmalion opened in London in April of 1914, and in New York in the late fall of 1914. By the New York opening, Britain was already at war, but the U.S. was not yet involved. The world of the moment that Shaw had captured in such great detail in *Pygmalion* was about to change, utterly.

8

Splintered Souls: 1914–1924

> Never such innocence,
> Never before or since,
> As changed itself to past
> Without a word.—Philip Larkin, "MCMXIV"[1]

Philip Larkin's backward glance in "MCMXIV" was not composed until 1964, but nonetheless he pinpoints the unfathomable shift that was the First World War. The alacrity with which men joined the fight, and the great efforts made to soften the portrayal of the battle at home could not belie the enormity of the loss of life and the belief system that had sent the world spinning into this global conflict. The previous chapters of this study have surveyed the changes from status quo to forging change of social and/or economic status. But the grimmest and most ironic transition to motion from stasis was the beginnings of modern warfare. The First World War came a century after the Napoleonic Wars, and as war historian Paul Fussell notes, people were "unaware of the potential effects of industrialism on an activity conceived largely in terms of cavalry, chivalry, and 'honor.'" Specifically, the European alliances that had been in place over the span of many decades, had to be honored,[2] even though the war lacked any reason remotely worthy of the wholesale slaughter it produced. The modernity of machine guns, the biological weapon of mustard gas, and the beginnings of airplanes in battle swept away any concepts of battle in living memory. The enemy could not be seen during battle and the long-held concepts of honor and purpose on battlefields evaporated instantaneously.

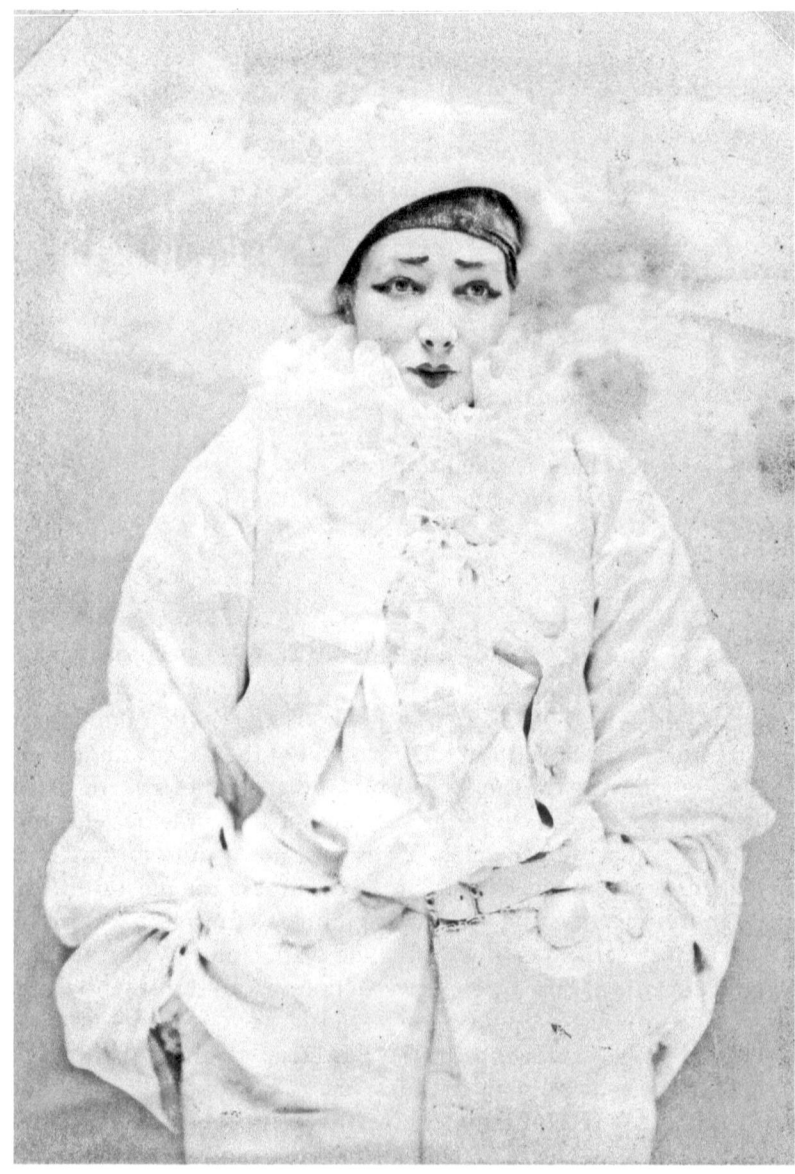

Sarah Bernhardt in Jean Richepin's 1882 *Pierrot Assassin*, photograph by Félix Nadar. Courtesy Philip H. Ward Collection of Theatrical Images, Kislak Center for Special Collections, Rare Books and Manuscripts, University of Pennsylvania Libraries. Despite the early date of the performance and the photograph, note the make-up as well as the expression and stance of Bernhardt. As modernist harlequinade would begin in the 1890s, the gender-bending, mask-like characterization, and criminality are already in place here.

Stanley Weintraub's *Journey to Heartbreak* includes the 1912 article Bernard Shaw had sent into the press to urge attention to a war that was on the horizon; he proposed a brilliant strategy to "avert the disaster ... an agreement between Britain, France, Germany, and the United States that any country which made war on a neighbor without first submitting its grievance to the judgment of the signatory powers would find itself at war with the four." Response, not surprisingly, was negative. On January 1, 1914, Shaw repeated the idea in the London *Daily News*, noting that he knew the idea would, "like most sensible proposals ... be received at first blush as revolting and impracticable." Shaw then completed his plea by stating that he liked "courage and active use of strength for the salvation of the world."[3] By August 11, 1914, Shaw agreed to submit a personal statement about the war now that Britain had joined the week before. Weintraub remarks that the tone of the piece was "businesslike, on the order of a Shaw preface." Shaw's statement for the press dealt squarely with what was the basis of the war: "This war is a Balance of Power war and nothing else." What was needed, according to Shaw, was an "intelligent and patriotic foreign policy—patriotic in the European as well as the insular sense."[4]

As these pieces showed, Shaw himself was against the ideology that underlay the war that he knew was necessary, and therefore he became vilified as a result. His "Commonsense About the War," an 80-page tract, railed against the jingoism and the romanticized version of patriotism that would be condemned by any of the soldiers who survived the horrors of the biological warfare and technologically advanced machine guns in battles that went on interminably and did not yield much of anything at all, except the worst slaughter ever recorded to that time. Weintraub notes that Shaw's writing was condemned as "perverse frivolity" when he actually tried to persuade people to emerge from their "inertia and blindness." His oft-quoted snippet—that the soldiers on both sides shoot their officers and go home—was of course read as an affront.[5] Here is this remark in the fuller context of Shaw's piece:

> I do not see this war as one which has welded Governments and peoples into complete and sympathetic solidarity as against the common enemy. ... I see both nations duped, but alas! not quite unwillingly duped, by their Junkers and Militarists into wreaking on one another the wrath they should have spent in destroying Junkerism and Militarism in their own country. And I see the Junkers and Militarists of England and Germany jumping at the chance they have longed for in vain for many years of smashing one another and establishing their own oligarchy as the dominant military power in the world. No doubt the heroic remedy for this tragic misunderstanding is that both armies should shoot their officers and go home to gather in their harvests in the villages and make a revolution in the towns; and though this is not at present a practicable solution, it must be frankly mentioned.[6]

A century later it is clear to us what Shaw implicates by his hyperbolic, satiric remark: the propaganda images that prompted the flood of young men enlisting for the fight, and appeared on the war posters that featured women urging their men on, children asking their father what they did in the war, and Lord Kitchener's "Your Country Needs You" from 1914. David Welch explains: British recruitment posters changed in tone, from appealing to an individual's honor to "mobilization by shame."[7]

Poet Rupert Brooke captured the young men's wide-eyed fervor and his generation's desideratum for a great challenge in his 1914 poem, "Peace":

> Now, God be thanked Who has matched us with His hour,
> And caught our youth, and wakened us from sleeping,
> With hand made sure, clear eye, and sharpened power,
> To turn, as swimmers into cleanness leaping,
> Glad from a world grown old and cold and weary,
> Leave the sick hearts that honour could not move."[8]

Rupert Brooke, president of the Fabian Society at Cambridge, and follower of Shaw, Barker, Wells and the Webbs,[9] nonetheless fell prey to the warmongering jingoism of 1914. He never lived to see the trenches or the gas; thus his lines bespeak what poet and officer Wilfred Owen would term "the old lie" in his horrifying depiction of war in "Dulce Et Decorum Est" (see below).

The *New York Times* Company published *Current History: A Monthly Magazine*, Vol. 1, including articles from August 1914 to 1915. It contains Shaw's *Commonsense About the War*, but also many articles from Britain show the support of the war and oppose Shaw's stance. H.G. Wells was very fervent. Wells foresaw the grave dangers that threatened the international community because of the power-hungry and land-grabbing German government, and the absolute necessity for the war. Here is the opening paragraph from his article: "The monstrous vanity that was begotten by the easy victories of '70 and '71 has challenged the world, and Germany prepares to reap the harvest Bismarck sowed. ... The victory of Germany will mean the permanent enthronement of the War God over all human affairs. The defeat of Germany may open the way to disarmament and peace throughout the earth."[10]

One document in particular, from 17 October 1914, was a statement of support from fifty-three British writers, including Archer, Barker, Barrie, Murray, Galsworthy, Masefield, Pinero and Wells: Shaw's colleagues in the theatre and/or Fabian Socialism. Their position stemmed from Germany's betrayal of her promise to respect neutral Belgium, a tiny country:

> Without even the pretense of a grievance against Belgium she [Germany] made war on the weak and unoffending country she had undertaken to pro-

tect, and has since carried out her invasion with a calculated and ingenious ferocity which has raised questions other and no less grave than that of the willful disregard of treaties.... When Belgium in her dire need appealed to Great Britain to carry out her pledge, that country's course was clear ... even if Belgium had not been involved, it would have been impossible for Great Britain to stand aside while France was dragged into war and destroyed. To permit the ruin of France would be a crime against liberty and civilization.[11]

Concurrently with these writings on the war, Shaw's *Pygmalion* ran on Broadway from October to December 1914. Stella (Mrs. Patrick) Campbell continued as Eliza Doolittle from the production that had premiered in London before the War in April, 1914. That spring, Eliza's use of the expletive "not bloody likely" had been the big news about Shaw and the boundaries he pushed against, and, ironically, had made the play his first resounding commercial success. He refers to this notoriety in his war writings when almost all London theatres had shut down.

On November 7, 1914, Shaw published an open letter to President Woodrow Wilson in Massingham's *Nation*. Shaw urged Wilson to ask all belligerents to leave Belgium for the sake of that tiny country's sovereignty and the reality that the West needed to rely on friendship.[12] He wrote to Stella Campbell a few days later about his despair and anger, with direct reference to the enlistment propaganda discussed above: "London is darker than ever. They are trying to frighten the men into enlisting.... The Kaiser asks from time to time for another million men to be killed; and Kitchener asks for another million to kill them. And now ... they have settled the fact that their stupid fighting can't settle anything, and produces nothing but a perpetual Waterloo that nobody wins."[13]

The U.S. held fast to its isolationism, a foreign policy dating back to the Monroe Doctrine a century or so earlier. American theaters were operating as usual. More Shaw was featured the following year in the first season of the Neighborhood Playhouse. This little theater, connected to the Henry Street Settlement House, was located in the heart of the Jewish ghetto on Manhattan's lower East Side on Grand Street. The founders of the theater project, the Lewisohn sisters, were committed to bringing artistic experimentation as well as diverse realistic plays to their audiences. Ellen Terry did one of her lectures on Shakespeare's women on the Bard's birthday, April 23. Interestingly, Gertrude Kingston brought her touring company of *Captain Brassbound's Conversion* to that same season,[14] playing Lady Cicely, the role Shaw wrote for Ellen Terry. Harley Granville-Barker and Lillah McCarthy were touring their outdoor Greek plays in 1915, and Maurice Browne's Chicago Little Theatre was in the midst of their *Trojan Women* tour,[15] so plays that protested war outright or at least questioned its merits were an integral part of American theater that year.

Gertrude Kingston had played Helen in Granville Barker's production of *The Trojan Women* at the Royal Court at the suggestion of Bernard Shaw in 1905. Her sensational performance, noted by Edith Hall, was punctuated by Kingston's removal of a garment to seduce Menelaus, and which fell onto the stage, coiled like a snake.[16] Such powerful use of visuals on small stages would impact Kingston's own Little Theatre and others on both sides of the Atlantic.

The 1916 Neighborhood Playhouse program featured three strong woman protagonists and what John Harrington calls "exoticism in Incan, ancient Egyptian, and Russian royalty." Two were Shaw's: *Great Catherine*, about Russia's Catherine the Great, and *Inca of Perusalem*, which portrayed a caricature of the Kaiser and was an American premiere. These plays starred Gertrude Kingston, who had played both of these roles in London; both women easily dominate their male counterparts. Harrington's encapsulization of Kingston and her connection to material from Shaw shows her importance: "She found in Shaw, with his relish for reversing stereotypes, an ample source of witty and frivolous playlets … [to be] played by an actress who had already transformed herself."[17] Kingston had established the Little Theatre of London in 1911, which the Neighborhood Playhouse had considered one of its models. Kingston's London theatre had opened with *Lysistrata*: a play right in step with the dialogic relationship then ongoing between women's rights and ancient Greek plays. As had been the case with several of Euripides's texts, the Aristophanes play became transmogrified as a modern tract for enacting social change. The small stage and the keen visual sense that Barker had brought to the Court continued with Kingston at the Little Theatre. The translator of *Lysistrata*, Laurence Housman, was an activist for women's suffrage and, according to Edith Hall, felt the opportunity to produce this Greek play was a purely political one because of its feminist message and easy alignment with 1910s jokes about women's legal disenfranchisement. Further, Kingston performed scenes from *Lysistrata* at an Actresses Franchise League matinee that same year, and American suffragists went on to stage it as well.[18]

The other playwright at the Neighborhood Playhouse in 1916 was Lord Dunsany. Dunsany's *The Queen's Enemies* was a world premiere: "an Egyptian fable" that connected with the audience because of the power of the Queen and its anti-war sentiments. The set called for an underground vault beneath the Nile. The Queen enters with a lament about men and their "horrible wars" and asks why they "must slay each other." To add to the power of this moment in the play, the sound of rising waters occurred while the audience sat in the dark. Dunsany expected the flood to be staged in the way melodrama had done so: with gauze conveying the effect of

rippling water. But the Neighborhood Playhouse production, "much to his delight, contrived a more vivid effect with its new lighting console."[19]

What actresses in Britain's Actresses Franchise League and their American counterparts had accomplished by the war years was to combine their understanding of performance in real time—as activism—with the management skills they had amassed during the era of suffrage parades, platform events, and plays. When war came to Britain in 1914, suffrage leaders and Parliament leaders came to an understanding: agitation for suffrage would end and war efforts begin; Parliament would address the issue of women's rights in earnest. Activist organizing had enabled rapid mobilization of women to implement key services to women and children once conscription took so many men away. Lena Ashwell's biographer, Margaret Leask, notes that all of Ashwell's activity with the Actresses Franchise League gave her three things she would need for the next phase of her life: her voice, determination, and stamina. Very quickly after war was declared, Ashwell and three other Franchise League actresses formed the Women's Emergency Corps (WEC). They compiled a list of women and their skills and had 10,000 women registered by September 4, 1914: astonishing alacrity that did not go unnoticed by the public or Parliament. Actresses on the home front also spearheaded crucial relief for women and children, forming hospitals, finding inexpensive housing, clothing, and opening cheap restaurants to ensure nutrition. Ashwell also ensured that troops at the front were entertained and performers would continue to work for the public.[20]

Stella Newsome's history of the Women's Freedom League, formed in 1907 as a less-militant branch of the WSPU (Women's Social and Political Union), confirms the importance of this shift: the Women's Suffrage National Aid Corp worked on behalf of women and children, cooperating with AFL (Actresses Franchise League) Women's Emergency Corps. Women Police Volunteers formed and remained long after the war. These women were "a trained body of professional women willing to go anywhere."[21] Images of women were changing visibly and rapidly in the public eye. Leask succinctly observes of Ashwell and others: "The conditions of war shifted many previously male responsibilities onto women.... Priorities were identified and pursued very quickly: militant suffragettes became committed war workers and many women set about to change forever attitudes which had relegated women to a secondary ... role in society."[22] Newsome provides the specific gains. By 1916, suffrage came under serious consideration, even to Prime Minister Asquith and most of the press. The Representation of the People Bill passed on its third reading in December 1917, granting suffrage to propertied women over 30 (younger women

would have to wait until 1928). Royal Assent came in February 1918. That same year, British women were admitted to the legal profession and appointed as Justices of the Peace.[23]

As public opportunities for women widened during the war, motherhood retained its centrality, but also transformed into something beyond biological in a key image of wartime propaganda. Suzanne Raitt and Trudi Tate explain: "'Woman' as a category became ever more contested ... as [it] struggled both to mobilize and to renegotiate femininity.... Indeed war can remake the world in terms of maternity ... oddly displaced from gender to emerge as a fantasy of tenderness and power."[24] J.M. Barrie's war play *The Old Lady Shows Her Medals* tells the story of a London charwoman who poses as a mother of a solider. In the play's opening scene, four charwomen are having tea and discussing their contempt for pacifists and, as Mrs. Twymley notes, "females that have no male relations, and so they have no man-party at the wars. I've heard of them, but I don't mix with them." Mrs. Mickeham adds: "What can the likes of us have to say to them? It's not their war." Three women in all speak of their sporadic mail from sons at the front. Mrs. Dowey, the hostess and imposter-mother shows a bundle of letters that have come once a week. Shortly afterwards, a man comes to tell her that her son has a five-day leave and is in London.[25]

Moments later the soldier comes into the room and confronts her; he has surmised that as a charwoman she has access to envelopes in wastebaskets and could change addresses. She does not try to deny his correct inference. The letters are blank, and he is about to cast the empty things in the fire when "she flames up with sudden spirit. She clutches [the letters]. 'Don't you burn them letters, mister.' He replies, 'But they are not real letters.' 'They're all I have.' The soldier returns to irony. 'I thought you had a son.' She admits that she has never had a man or a son. 'What made you do it?' he demands to know. 'It was everybody's war, mister, except mine.... I wanted it to be my war too.' He needs her to be 'plainer' then immediately calls her a 'lying old trickster.'"[26]

Barrie of course sets the audience up to pity the woman while being slightly ashamed of her. The soldier, Kenneth, tells her about the gifts his "young lady" from London has sent; "She's a titled person ... equally popular as maid, wife, and munition-worker." Cakes and a worsted waistcoat have reached him at the front. Of course it was the charwoman who had done these things. And it turns out that Kenneth has no family relations, and never knew who his parents were. Barrie's trademark light touch prevails, even as the poignancy of the connection between these two isolated people becomes a bond. When Kenneth's leave is over the real letters begin, and continue until his death in action. She receives everything that

belonged to him, as he had her listed as his next of kin when his leave ended. She continues to honor him as she had from the outset—even before she ever dreamed she would meet him—because the war was now hers, thereby implying her kindness as well as her need to belong. Written in 1918, by which time Britain had lost half a generation of young men, Barrie's bitter irony towards the success of the propaganda and the protection of women at home from the true horror would be placed before the public by the war poets.[27]

Instead of Brooke's "swimmers into cleanness leaping/Glad from a world grown old and cold and weary" Wilfred Owen crystallizes the horror of biological warfare in "Dulce Et Decorum Est." Owen, as an officer, endured survivor guilt; his poem places us in the throes of a gas attack, when a man did not get the mask on in time: "But someone still was yelling out and stumbling/And flound'ring like a man in fire or lime.... As under a green sea, I saw him drowning.... In my dreams, before my helpless sight,/He plunges at me, guttering, choking, drowning." Owen commands us to follow among the mortally wounded men who were hurled into wagons and dragged along, and throws the horrible responsibility on readers: "If you could hear, at every jolt, the blood/Come gargling from the froth-corrupted lungs,/Obscene as cancer."[28] How could anyone wonder what shell shock was all about after reading poems like this from those who were there?

Shaw's own conclusion in *More Commonsense About the War*, reprinted in Stanley Weintraub's *Journey to Heartbreak* is strikingly similar in its exposure of the futility and irrelevance of the cultural norm: "In vain do we play at being romantic schoolboys, stupefying ourselves with Quixotic reveries, lashing ourselves into virtuous indignations and calling the clay we were born on our mother."[29] Here are Owen's lines from "Anthem for Doomed Youth," a poem that agonizes over the impossibility to even take a moment to pay respects to the dead in No Man's Land: "What passing-bells for these who die as cattle? ... Only the stuttering rifles rapid rattle/ The shrill, demented choirs of wailing shells." The second half of Owen's poem turns to the women at home who perform the rituals of mourning with no understanding of how their beloved died. Their oblivion serves as the pall and flowers for the dead: what Owen terms "the tenderness of patient minds,/And each slow dusk a drawing-down of blinds."[30]

Amy Lowell's iconic poem "Patterns" provides the mirror image: the woman receiving the news of her fiancée's death just weeks before their intended marriage. She walks the garden path "in her stiff brocaded gown" and contemplates the existence of patterns in nature, including "a pattern called a war./Christ, what are patterns for?"[31] The jarring disconnection

and harm caused by the sheltering of the public at home, particularly women from the atrocities and horrors of modern warfare, were clearly explicated by a writer Shaw knew well, Rebecca West.

In *The Return of the Soldier* (1918), West provides an exposé of the real impact of shell shock in the only novel of its kind written while the war was still ongoing. West's narrator is Jenny, Chris' cousin, an unmarried woman who hides her love for him; West uses Jenny to symbolize the construction of woman and mother during the war as a "fantasy of tenderness and power" that Raitt and Tate described. The novel opens in the midst of a conversation between Jenny and Chris's wife, Kitty. Jenny is frantic that there has been no mail for a fortnight, but Kitty believes her husband will be fine. She tells Jenny if he had been sent somewhere where the fighting was "really" hot he would have found a way to let her know that. Jenny's inner fears are based on the news she follows that has finally begun to show the reality:

> By nights I saw Chris running across the brown rottenness of No-Man's Land, starting back here because he trod upon a hand, not even looking there because of the awfulness of an unburied head, and not till my dream was packed full of horror did I see him pitch forward on his knees as he reached safety, if it was that. For on the war-films I have seen men slip down as softly from the trench parapet, and none but the grimmer philosophers could say they had reached safety by their fall.[32]

Chris Baldry is sent home with a head wound; he contacts Margaret, a woman he dated fifteen years earlier rather than the wife he has forgotten. It is Margaret who comes to Chris Baldry's house to bring the news that he had been sent home, and that he had shell shock. Margaret's maid and Mrs. Baldry's were related, which is how Margaret gleaned that no one had contacted Kitty Baldry. Despite Chris receiving psychiatric care when he comes home, it is only who Margaret can reach Chris, allowing herself to see him during the novel as if fifteen years had not passed. Through these encounters and Margaret's empathic nature, readers can see the trauma caused by war. At the novel's end, Margaret eventually re-introduces Chris to time present, by bringing down a piece of clothing and a toy that belonged to the young son that Chris and Kitty had lost. Margaret had also lost a child: another example of West doubling and re-doubling every aspect of psychological repression and loss. By breaking her heart and his anew, Margaret apparently jolts Chris out of the lifetime these two had shared years before they each married and Chris went to the war.

West doesn't give us the scene between Chris and Margaret. Jenny sees Chris walking back towards the house and notices his youthful walk and manner were gone. Jenny knows he is back in the present; in all like-

lihood he has returned to the war itself, which Jenny intuits: "he would go back to that flooded trench in Flanders, under that sky more full of flying death than clouds, to that No-Man's-Land where bullets fall like rain on the rotting faces of the dead." Kitty comes up to the nursery just at this moment to peer out and asks Jenny how Chris looks. Jenny's reply is "every inch a soldier," which Kitty turns into a belief that he's "cured." This closing line of the novel, spoken by the aloof and emotionally frozen wife, epitomizes the damage done by the wartime propaganda and sheltering of women on returning men who could not communicate their experiences with their loved ones.[33]

The aftermath of the war became inextricably intertwined with the conscious chase of pleasure for many who survived the front, and the shock and disillusionment spilled over into the predominance of psychology in all forms of the arts and in everyday life. Built into arts' protest against the privileged class that had allowed the First World War to happen in the first place was an old form as well the new ones: commedia-dellarte. Harlequinade took on special importance for modernism, beginning in the 1890s. According to Martin Green and John Swan, past or present, commedia was a "recoil from our respectable values by nonserious means ... defiantly frivolous or sullenly crude, which distinguishes it from other forms of protest."[34] On a deeper level, the two clowns, Harlequin and Pierrot came to emblematize archetypes: essentials of what became known as modernist thought: emphasis on erotic, the unconscious, habitual anxiety, social and political skepticism and belief that God is dead.[35]

Some features of commedia remained intact, especially the physicality and the use of stock characters to evoke universal behavior. Two other features came to the fore: criminality and the "female figure of incarnate sexuality."[36] As with other lowbrow art forms, cross-dressing was a long-established convention in commedia; Sarah Bernhardt as the sad clown Pierrot in the late 1880s is an iconic image. The androgyny that permeated the post–World War I era, in terms of sexual identification as well as men's and women's fashions, also linked to commedia style. Swan and Green point out that women's cosmetics were "something like clown's make-up (circles of red on their cheekbones, white noses and chins) while the men had hairless faces and brushed their hair back to form a skullcap like Pierrot's.... Reacting against Edwardian elaborateness, both men and women wore ... pullovers or sports clothes ... that made the two sexes look like each other and like acrobats."[37]

Commedia's harlequinade as satire was a tradition for centuries because it combined the familiarity of character types that could be placed into situations ranging from petty to weighty, and thereby foreground the

narrowness of people's proscribed visions. Clearly, the Lost Generation (as Gertrude Stein dubbed it) would be drawn to such a framework; it seemed especially apt for war plays. Two works that premiered in New York, Edna St. Vincent Millay's *Aria da Capo* (1919) and Bernard Shaw's *Heartbreak House* (1920) examined the disaster that sprang from the frivolity and self-absorption of the upper classes. Millay, a recent graduate of Vassar College was quickly emerging as a key poetic voice who avowed anti-war sentiments as well as new woman freedom. Millay also loved theater, acting the part of Marchbanks in Shaw's *Candida* and befriended by Edith Wynne Matthison of the Actresses Franchise League while she was still a student. Millay moved to Greenwich Village and became an actress and playwright for the Provincetown Players. *Aria da Capo* was written for that troupe, and starred Millay's sister, Norma, as Columbine.[38] The eminent *New York Times* critic, Alexander Woollcott, referred to *Aria da Capo* as a "spiritualistic war play ... [a] bitterly ironic little fantasy by Edna St. Vincent Millay ... the most beautiful and most interesting play in the English language now to be seen in New York. It is a study of heart-breaking tragedy considered as an interlude between the laughters of fluffy satiric comedy."[39]

The beauty Woollcott refers to is Millay's compressed and evocative language, and her sure visual and aural coordination as dialogue meets action. Millay uses the form of aria da capo the classical composers followed: statement/departure/return. Columbine and Pierrot languish over dinner to begin the work: each in a daze of sorts, and chattering meaninglessly about food, whether kisses can be given on Wednesdays as well as Tuesdays, or lightly touching upon visual art and the theatre. Pierrot plays light and loose with each topic and, apparently, his feelings for Columbine, who is either distressed or irritated by him. Columbine begins the scene by saying she cannot *live* without a macaroon, a sure throwback to Nora's guilty pleasure in the opening scene in Ibsen's *A Doll House*. Within several moments of dialogue, Pierrot bolsters his status as a student who must consider all things by declaring that "I am become" painter, pianist, socialist. He claims to be a philanthropist, "I know I am, Because I feel so restless."[40]

When Columbine answers this speech by declaring her inability to *live* without her vinaigrette, Pierrot declares that she should be an actress and he immediately announces "I am become Your manager." Millay fixates Columbine on sensual pleasure and Pierrot on intellectual shallowness, and emotional distance. It is Columbine who thinks things through and objects to the idea of her as an actress, something she feels she "cannot" do. Pierrot summarily dismisses her reaction. What does it matter if she

can't act if she is "blonde" and has no education? She underrates herself, according to Pierrot, who will teach her how to cry, die, and other little tricks that will make the house [audience] love her.[41] When Columbine wants to know why the audience will love her, Pierrot only can say, "It's just a matter of form"—a line that can be high society behavior or artistic form, which was changing moment by moment in 1919. She sees through Pierrot and his teasing which he "by yon black moon" wrongs them both.[42] There is no moon, however; just as Millay seemed to invoke the changeability of lovers in Shakespeare's *Midsummer Night's Dream*, we realize it is the mechanicals plot/rehearsal that Millay really uses metatheatrically here. Like Bottom, Pierrot wants to play all the parts.

Cothurnus interrupts their scene and tells the pair of them to exit. Columbine complies, while Pierrot argues to retain their place on the stage, but to no avail. Instead, Cothurnus finds a high perch upstage, and the Virgilian Ecologue plot begins; Judith Barlow notes that Millay uses the two older forms "woven together into a modernist collage."[43] The two pastoral friends are as indignant as Pierrot about the change in the scene schedule; they are not ready to do their scene. With moments it is clear that Millay uses rehearsals and words/actions done by rote metaphorically, as segue to her piercing attack on the jolt of the First World War and the ease with which friends become enemies and a fight to the death ensues over a game gone awry. Unlike the Pyrramus and Thisbe tragedy of death due to mistaken inference, the two friends in Millay's play murder each other because they have forgotten their friendship when they imagine the other person has the prized commodity on his side of the wall they put between them. The dialogue shifts so swiftly that audiences are pulled into the scene and the unfolding horror that plays out in front of them.

At first their scene feels like the banter of Pierrot and Columbine, especially since their lighthearted making of a wall is emblematized by its being crepe paper, and pronounce it an excellent wall (echoing the playing of wall in *Midsummer Night's Dream*). But as children all know, games are serious and the rules take over. This happens as quickly in Millay's play as Pierrot and Columbine's mood shifts from romance to alienation. As tension builds, the sheep may dehydrate and the stones (jewels) will not be shared. And yet each of them wishes the game to be over but cannot let it go because each suspects the other of tricking him. Best friends to strangers and enemies; the transition happens almost instantaneously. Lack of trust, selfishness, and brute force cause their double murder.

Edd Winfield Parks sees the scene between the shepherds Thyrsis and Corydon as a brief allegory that completely embodies "two larking shepherds who built a wall between themselves, and whose friendly game

ends in jealousy, then tragedy. [Neither] had aimed at such a result: a theatrical war, painted, ghastly, leaving the stage in ruins and the gay farce ended. Like the world war, a tragic, senseless interlude, without reason, without hope—and after it all, the world can only frolic and forget."[44]

Parks's closing line is a *précis* of the closing moments of Millay's play. True to the musical form of her title, the scene changes back to Columbine and Pierrot; once again, there is protest. Columbine first complains about the mess of the set, then screams when she sees the bodies under the table. Pierrot calmly tells her they are the actors from the other scene, until he realizes they are dead. Pierrot calls for Cothurnus to say they can't possibly sit down and eat with two bodies under the table. Cothurnus intervenes one last time. Having placed the dead bodies in full view of the audience but not the actors, his words only underscore his implication of the public: "Pull down the tablecloth/On the other side, and hide them from the house,/And play the farce./The audience will forget." They follow his directions and begin from the beginning.[45]

Shaw's *Heartbreak House*, published in 1919, was written during the First World War and includes his own experiences of awe and thrills at the bombing in the skies that he witnessed at home as the Battle of the Somme dragged on in France. Not a war play on the surface, *Heartbreak House* is nonetheless an indictment of what he terms in the Preface the "cultured leisured" class before the War. It is a dark comedy, yet its sense of futility and incompleteness tinges the play with sadness as well as contempt for wasted lives. Once again, the world premiere of the play in 1920 was in New York; his earliest successes in the 1890s were also New York productions: *Arms and the Man* (1894) and *The Devil's Disciple* (1897). These earlier plays also dealt with war, attempting to rob the subject of its glory, and dispel its myth of noble enterprise by assuring audiences that men in charge in battle think more about staying alive than they do about courting death. A similar perspective is in Shaw's Caesar, one of his superman characters in the 1898 play, *Caesar and Cleopatra* (see Chapter 3). Decades later, his wisdom on the subject had made no difference, and, as discussed at the beginning of this chapter, his protestations about the First World War earned him contempt.

Heartbreak House does have a Shavian mouthpiece in Captain Shotover, but he is "in his dotage" and not the fiery model of power Shaw had used in his earlier plays. The characters in this play are stymied, emotionally frayed, and anything but social activists. Alexander Woollcott's dichotomous 1920 review of the New York world premiere of Shaw's *Heartbreak House* feels quite appropriate for an initial encounter with this text:

> *Heartbreak House* is "brilliant comedy ... quite the larkiest and most amusing one that Shaw has written in many a year, and in its graver moments the more familiar mood of Shavian exasperation gives way to accents akin to Cassandra's.... *Heartbreak House* is Shaw's Bunyanesque name ... his picture of the idly charming but viciously inert and detached people ... loitering at the halfway station on the road to sophistication."[46]

The malaise that plagues the characters represents and condemns the blindness that characterized the pre war privileged society. The play infuses comedy's classic function into modernism's world in fragments through its incomplete exposition, jaded views of relationships and motivations, and the kind of isolation that goes beyond self-indulgent pity. Consider Woollcott's praise of the work as "larkiest" in the context of the jazz age relish for dangerous fun, sexual freedom, and the ever-quickening pace and scope of social change, and it becomes immediately apparent that Shaw's mercurial structuring places *Heartbreak House* squarely in its cultural moment. The fact that the play straddles both sides of the War—in both its composition and its time present—enlarges the impact of the play's multi-layered and moody critique of a society whose underpinnings were now in flux. Woollcott's "Cassandra" reference acknowledges Shaw's vilification for his refusal to join the jingoistic wartime media blitz and instead maintain his curmudgeon status as the man who understood that the war would do anything but recognize that the old world order needed to address the inequities of its privilege.

In her study *The Perfect Summer: England 1911, Just Before the Storm*, Juliet Nicolson, the granddaughter of Vita Sackville West and Nigel Nicolson, examines the factors that contributed to the social breakdown Shaw decries in this play. The rise of discontent among have-nots was everywhere, while the disparities became more glaringly obvious. Nicolson notes:

> The country had not known war first hand for many years, and people were growing both restless and complacent. Artistic, sexual and political boundaries were being breached. ... As the Countess of Fingall put it, "We danced on the edge of an abyss." Socialites crammed in their gaiety as intensively as the poor made their grievances apparent. It was as if time was running out.... The lives of the disadvantaged as well as the materially blessed, their hardship, and their glamour, were clasped together in a single drama.[47]

Shaw's *Heartbreak House* includes both the content and the *ambiance* that Nicolson pinpoints. A lack of grace pervades Heartbreak House and its careless, moment-by-moment lifestyle. From the opening moments, the house belies its association with "a weekend in the country" society. Characters range from the leisure class to the genteel poor, and the issues of money, status, and love are shrouded in deception and false pretenses.

Ellie Dunn, not a child of privilege, represents the generation that has learned self-determination within what Shaw would deem Victorian as well as modern woman's boundaries. Possibly because she is not upper class, Ellie believes that she can see and understand reality and seek her place within it. Clearly, Ellie recognizes that money and power consistently merge. Raised on poetry and Shakespeare, Ellie begins the play balancing two incompatible notions: a belief that her life can be a page as romanticized as Othello's wooing of Desdemona, accompanied by a determination to marry for money alone.

Woolcott's designation of the play's title as "Bunyanesque" reminds us of the allegory Shaw intersperses into individual characters' momentary, generalized insights about the state of their world. Shotover mixes sagacity with sadness, sure that impending doom will be upon them soon, disgusted with the rule of the greedy and the sloth and indifference of his daughters' generation. Shotover is the Victorian voice of reason on the one hand, and a foreshadowing of a Beckett character on the other.

Charles Isherwood's 2006 review of the play calls the Captain "the straight-talking old salt ... the man talks such good sense that you might not notice that a major plank in his platform is blowing up the human race."[48] Shotover is Andrew Undershaft's alter ego; in Shaw's 1905 play, *Major Barbara* (see Chapter 4), Shaw could say that Undershaft (arms manufacturer) and Bodger (gin distiller) were the government and chide Stephen Undershaft for thinking he knew, as an English gentleman, the difference between right and wrong. A decade or so later, big business are "hogs," the universe their machine, and moral certitudes up for grabs in post-war disillusionment.

In the later play, Capt. Shotover's prescience and wisdom—inspired by the seventh degree of concentration, rum—does reflect the indignation of a Victorian witnessing the frittering of time that replaced the work ethic and moral center that existed in his own lifetime. He occasionally shares his deeper understanding with other characters in the play. He has experienced war and physical danger and survived, and counsels others to heed the outside world and to make choices that feed the soul more than the body. For all that, Shotover also neglected his daughters and became a self-absorbed recluse, indifferent to Hesione and Hector, who live with him, and hostile to Ariadne, who escaped the household she terms bohemian years ago to marry an imperialistic governor in the Empire. When Ariadne returns, Shotover neither recognizes her nor acknowledges her, citing her desertion of the family and intimating that she has no heart to break when she pleads for affection. Shotover's daughters are far from weak, however, despite their empty flirtations with men. Each has retained

some of the womanly woman values and practices; they have raised families and settled for the indirect power of women.

Like Undershaft, Shotover influences the life of a young woman. But Ellie Dunn and Barbara Undershaft could not be more different. Ellie wants the money and privilege that Barbara has lived with all her life; she has had enough of worrying about keeping her gloves looking decent. But while Barbara believes in purposeful work, Ellie reflects the values of an earlier era, saying marriage is a woman's business and has not pursued work, despite her middle-class status. Not the ingénue character who educates herself and answers the call to service, as Barbara has done, Ellie can be considered a prototype of the lost generation. She eschews sentimentality, has a commanding presence, as shown by her hypnotism of Boss Mangan, and she wants life to be easy. She may speak as readily and flippantly as a flapper, but nowhere are the ideals of the New Woman in her. Ellie can be assertive, but she never follows through on anything, which makes her boldness more like petulance than vision. Shaw has not turned away from his support of gender equality in this play; rather, he reflects Ellie's generation correctly—they wanted rights and romance.

It was Hector Hushabye who seduced Ellie with stories of misfortune—under the name of Marcus Darnley. Ellie tells Hesione of this wonderful man after talking of her love for Othello and how fortunate Desdemona was to have such a man to talk to. Hesione questions Ellie's complete belief in the play, as well her gullibility regarding Marcus's stories. "Desdemona would have found him out had she lived. Maybe that's why he strangled her," observes Hesione.[49] When Marcus turns out to be Hesione's husband, Ellie experiences heartbreak, but sans melodrama. Ellie mistakes disillusionment for heartbreak, which is how and why she can be "cured" within moments. Hesione tells her that particular experience of heartbreak is "Just life educating you."[50] In Act Two, Ellie shows herself to be "hard as nails" when she fixes on what she sees as a desire, or has to give up as a necessity of circumstances. She talks like a realist, but each scene deepens our awareness that apart from practical understanding and concern to improve her economic situation, she has nothing solid at the base of her character.

Indeed, why Desdemona as a model for Ellie? Ellie, like Desdemona, has all of her strong acts early in the play, and then seems to lose her grit, but never her loyalty. Ellie has chosen to marry Boss Mangan "in honor and gratitude" for his helping her father's business, and to attain material comfort for herself. When Mangan in turn is cash poor, then that "commitment" can vanish as well. In Act 3, Captain Shotover warns her that if she marries for money alone "she will eat but she will not live."[51] Poof! Ellie

attaches herself to Shotover, in a mystical union. Although she knows the seventh degree of concentration is rum, she believes she can wean him from his need for drink: yet another version of illusory romance. Christopher Innes points out that the musical structure (fantasia) features Ellie Dunn's three acts aligned with three different men, with no strong relationship. Although Innes sees her final alliance as redemptive,[52] I see the series of hasty decisions as prediction for post-war floundering. After heartbreak, Ellie muses, comes peace. So at age eighteen, she's turned away from active life in any form. Will the War arouse her consciousness and commitment, one wonders?

The play's subtitle, "a Fantasia in the Russian manner on English themes," aligns the play with Chekhov's emphasis on worlds/worldviews in flux, particularly in *The Cherry Orchard*. In Act II of that play, the student urges the ingénue to go beyond the loveliness of the cherry orchard, to see its part in oppression:

> Do not human spirits look out at you from every tree in the orchard, from every leaf and every stem? Do you not hear human voices? ... When I walk through it in the evening or the night, the rugged bark on the trees glows in a dim light, and the cherry trees seem to see all that happened one hundred and two hundred years ago in painful and oppressive dreams....
> We have achieved nothing at all as yet; we have not made up our minds how we stand with the past; we only philosophise, complain of boredom, or drink vodka ... before we can live in the present, we must first redeem the past and have done with it.[53]

While some read Chekhov as drearier than Shaw, the reverse is true in considering these plays together. Even if hope turns out to be ephemeral or based on fantasy, Chekhovian characters long for connection; Shaw's flinch from their failed attempts. Chekhovian self-pity and self-indulgence stem directly from the jarring contrasts between characters' pasts and the social changes that have transformed the present in ways they cannot grasp. Mme. Vanevsky and her brother Vayev adore the cherry orchard's natural beauty, but also relish their privilege of ownership. *The Cherry Orchard* shows the shift from aristocracy/serf to the rising middle class just a few years before the Russian Revolution. The change is epitomized by the man whose grandfather's ghost is in the cherry trees but whose own business acumen makes him owner of the orchard by the end of the play. It is he who chops it down to make way for summer cottages. We recoil, yet the inaction and inability for the owners of the cherry orchard to save their land/orchard seals its doom.[54] And herein lies the potential for Shaw's nod to Chekhov's play in his own treatment of similar themes.

Shaw's awe of Chekhov's dramas was well known. *Heartbreak House* is both a tribute to Chekhov and an enrichment of Shaw's own method of

revealing the underside of social stratification. Shaw's play focuses on characters whose illusions/delusions have contained and stagnated them: a collection of one-trick ponies in a house without horses. The text confronts war literally on its doorstep with almost no one cognizant of it or its ramifications. The faithful servant of the family in *The Cherry Orchard* is left behind at the play's end and his death ends the play; in *Heartbreak House*, two characters are killed in the explosion and there is barely a pretense of grief—quite the opposite. Ironically, the bombing has awoken and exhilarated them and they hope the bombers will return on the morrow.

Despite their individuation and overt psychological commentary, *Heartbreak House* is a work that can be seen as commedia. John Gassner argues persuasively that the characters in this play are inverted commedia types; namely Shotover as a Pantalone who, "unlike his ancestors, marries the Immorata who, unlike hers, chooses to marry him. Hector Hushabye is Il Capitano, a *miles glorioso* in reverse; instead of boasting of feats of heroism as a sham, he has a drawerful of medals to show that he is really brave," according to his wife, Hesione. Gassner contends that Shaw needed the "'freer form'" of commedia to reflect European values as well as political realities. The musical form, fantasia, signifies the "absence of formal restrictions ... a combination of airs arranged in an irregular pattern ... a dramatic fantasia is a combination of themes similarly arranged."[55] For Shaw as for Millay, the old form of commedia and the use of an iconic musical form frame their social indictment. It is especially effective because the fixed character roles that show no growth have the counterpoint of evolving concepts of gender, class, sexuality, and social justice peeking out of the shadows.

Shaw also called the play his Lear, but Shotover alone is not the true Lear figure: the ideological breakdown in the generation that allowed the Great War to occur is the ruler gone mad. Shaw might be suggesting that his characters across generations are not in their "perfect minds." The final scene's dialogue incorporates Shaw's own community's startling reaction to the zeppelins overhead in 1915: excitement and utter callousness to the death and destruction.[56] And yet Shaw is representing a similar kind of blindness to Chekhov's: privileged people behave like spoiled children, living only in the momentary present of their whims and desires.

Gassner also cites Lillah McCarthy, whose assessment of the play as a whole and its specific connection to Lear, are perspicacious. McCarthy feels the play is an anomaly in Shaw's works because it is "untidy," which she knew was antithetical to Shaw's work as well as personal style. Like Lear, McCarthy asserts, there is a quality in *Heartbreak House* not present in any of Shaw's other plays: spaciousness ... there is no stage. It is life

speaking from the stage of life, a voice crying in the wilderness.'"[57] Lillah McCarthy has pinpointed the true heartbreak in the play.

Unquestionably, the final moments of *Heartbreak House* compel audiences to share the jarring dichotomy between the sudden violent actions and the characters' equally startling exuberant speeches. Shaw masterfully shows the underside of spontaneous actions derived from depraved sources. Hector's outrageous demand to light the house up completely rather than comply with air raid darkness, and the conclusion by Hesione and then Ellie that the skies' eruptions are like Beethoven reconfirm their inability to believe horror has approached. The blur over the "time present" of *Heartbreak House* abruptly ceases as Ariadne's command to Randall to play "keep the home fires burning" on his flute. Here is the only clear and direct reference to the Great War. The song was written in 1914, and includes the lines: "And although your heart is breaking/Make it sing this cheery song.... There's a silver lining,/ Through the dark clouds shining/Turn the dark cloud inside out/Till the boys come home."[58] Randall's flute ends the play.

Did the premiere audience for *Heartbreak House* in 1920 wonder if they were supposedly in the present or the past until the final moments? The bombs at the end of *Heartbreak House* allude to the war not yet begun for the people in the play, but already past by the time their story unfolds onstage. In the final scene of *Heartbreak House*, Shaw echoes all of these. There are no appropriate words to describe what they have just experienced; they are too out of touch to recognize that their world is about to crumble.

Millay's overt and Shaw's more implied juxtaposition of commedia served to reinforce people's tendency to focus on minutiae when faced with overwhelming crises. The audience members, like the commedia characters, became the "frozen living figures" of Martin Meisel's stage tableau, while the war represented the horrific face of motion beyond comprehension, confirming the fear of change that Nina Auerbach had ascribed to the Victorians.[59]

A more comprehensive examination of historical moments and power dynamics mark Shaw's masterpiece, *St. Joan* (1923). It was a play his wife and several actresses asked him to undertake, and he began planning it in 1913 while on holiday in France. Joan's story is the war story, and because of the First World War Shaw could no longer conceive of his play solely as the aftermath of the burning and the incrimination of those who abandoned her.[60] Shaw told Joan's whole story, but he did not stage the battle scenes or the pageantry of the Coronation. Instead, *St. Joan* begins with her third request to speak to Capt. Robert de Beaudricourt to obtain soldier's clothing, horse, and escort to Chinon, the home of the Dauphin.

Shaw's Joan is young, brash, and fearless—she is also funny, disarming, and sometimes out of her depth. The first two scenes are primarily historical record, except for the modern slang, and Shaw's emphasis on the comic. Joan's presumption of addressing her betters by their first names bring the history to life, especially when the steward tells Robert de Beaudricourt that Joan is impossible to dismiss, even if she is only a "slip of a girl." (51). When she recognizes the Dauphin among the courtiers, the exchange between him and Joan is tellingly modern. His known weak character against Joan's combined awe and alacrity towards getting to Orleans emerges when she calls him Charlie and is startled by his wanting to mind his own business. She charges him to face what God has brought him and, in effect, to "man up." Shaw refused to highlight the spectacle of the expected "big scenes." No battle, coronation, or burning happen onstage. Most interesting is Shaw's reversal of chronology: the tent scene divulges her demise, but happens before the coronation. By the end of this scene, Joan sees that she has alienated almost everyone, and the play's tone transitions to the tragedy.

The Trial scene *is* the spectacle, not only because of his meticulous use of the trial materials, but because Joan experiences classical tragedy—the recognition of her own fate and the hollowness of the system that condemns her. At her trial, Joan faced a tribunal completely alone. She was chained, exhausted, and ill, and yet said many extraordinary things. For the reversal of fortune with Joan owning all when she tells them "Light your fires" rather than abjure falsely for life imprisonment. As was the case with Joan of Arc's actual Trial of Condemnation in 1431, Shaw's Joan would only answer what pertained to the trial, and she found an inner strength based in mother-wit and candor. Asked whether St. Michael appeared to her naked, she countered with: "Do you think God cannot afford clothes for him?"[61] Shaw's dialogue in *St. Joan* contains some of these words, which theatre critics in the 1920s found incomprehensible; people thought he was using contemporary language rather than the words from 1431. They couldn't have been more wrong about the dialogue or Shaw's portrayal of the real Joan. But in light of the activists who broadcast Joan as their symbol and acted out, were their assumptions really ludicrous? Conversely, don't these responses to a 1923 play reverberate with the ongoing question of rights for young women? Certainly this would have been the case in London, when they wouldn't get enfranchisement for another four years.

What reviewers' reactions broadcast to readers illustrated what Shaw laid out so meticulously in the Preface. His analysis of Joan as a personality and a "type" he termed the "born boss" identified the social construction of iconoclasm. Shaw placed her alongside historical greats like Socrates

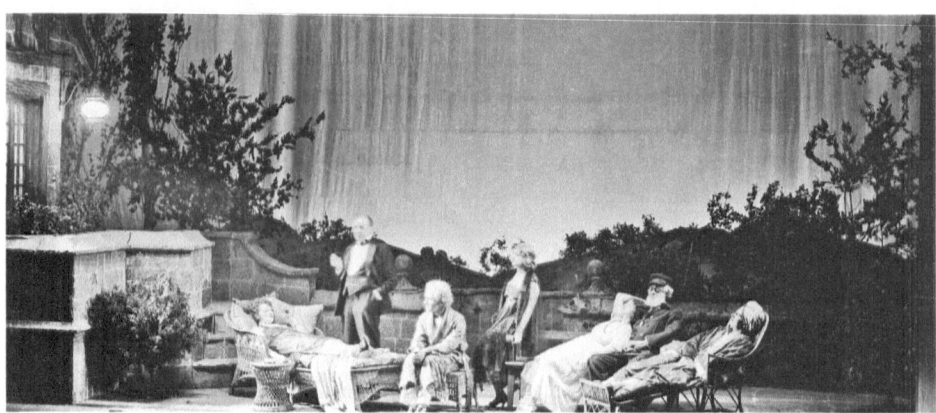

Effie Shannon, Dudley Digges, Ralph Roeder, Lucille Watson, Elizabeth Risdon, Albert Perry and Fred Eric in the world premiere of Shaw's *Heartbreak House* in 1920. Photograph by Vandamm Studio © Billy Rose Theatre Division, The New York Public Library for the Performing Arts. This final scene in Shaw's play takes place in the garden: an idyllic setting with a lovely moon. Within moments, bombing will occur but be mistaken as rousing renditions of Beethoven by the "cultured leisure class" Shaw blamed for allowing World War I to occur.

and Florence Nightingale to show us that many outstanding individuals have traditionally been perceived as "cracked" or dangerous. He attributes Joan's rise and fall to her genius and her naiveté, which he presented as indivisible. For him, Joan was both a genius and a saint. In his exposé of the melodramatic images of Joan he detested, Shaw claimed they were worse than the mud thrown against Joan because sentimentality's "whitewash ... disfigures her beyond recognition."[62]

Joan is one of Shaw's clearest feminist figures. After tracing the suffrage drama's evolution in the early 20th century, and the courage of those who scripted the plays as well as the platform speeches that often led to imprisonment, it is no longer surprising that the people of the 1920s might see Shaw's Joan as eerily like the women around them who were shaking the world as their icon had done centuries earlier. London's Joan in 1924 was Sybil Thorndike, for whom the role was written. Thorndike, a member of the Actresses Franchise League, was also known at this time for her frequent revivals of Gilbert Murray's *Medea* until 1928, when young women got the vote.[63] Thorndike told the London press that playing the role of Joan was like a dream come true for her because Joan's story was one she had cherished since childhood.

All of the Trial scene prepared the ground for the Epilogue post-canonization. Shaw conflated the Rehabilitation of 1456 and the canon-

ization of 1920 to reveal what might have been if Joan could have "known" she was a saint. It is the play's Epilogue that definitively separates Shaw's post-canonization portrait of Joan from the sentimentalized, sensationalized ones that he detested. To invert people's expectations of familiar portrayals of Joan, Shaw once again shows his true modernism by constructing an Epilogue with Freudian dream-theory overtones. Giving Joan the final word in the Epilogue where all others are dreaming is hardly akin to Shakespeare's assurance that the audience could wake up from their dream if "we shadows have offended." The repeated abandonment of Joan one by one only confirmed the truism that people (the audience) prefer the idea of a saint to living with one. "What? Must I burn again?" she asks? Finally, Joan is alone again, invoking Psalm 6, "How long O Lord, how long?"[64]

Here is Shaw's last masterstroke: Joan's traditional prayer and her glance towards the heavens, reminiscent of so many visual representations of Joan, whether on the canvas, in sculpture or onstage. Shaw recognized that Joan's story remains unfinished, a factor apparently lost on the 1920s audiences. Shaw's use of Joan's prayerful plea and pose—a last jab at a melodramatic tableau freeze—turns the theatre into a congregation in search of an answer.

Chapter Notes

Preface

1. Martin Meisel, *Realizations: Narrative, Pictorial and Theatrical Arts in Nineteenth-Century England* (Princeton: Princeton University Press, 1983), 30, 47.
2. Nina Auerbach, *Ellen Terry: Player in Her Time*, 2d ed. (New York: W.W. Norton, 1997), 171–4.
3. "Real Joan of Arc No Window Smasher," *New York Times*, April 2, 1912, nyt.com.
4. *Ibid.*
5. See the Introduction for more from Edith Hall's article on Medea in the Edwardian era.
6. The various versions of the script are in the Fales Library, New York University, complete with handwritten notes by both Robins and Barker.
7. See Chapter 5 for the American suffrage parades, particularly material from Pam Cobrin's *From Winning the Vote to Directing on Broadway* (2009).
8. See the discussion of the specific events that led to this organization's formation in Chapter 5, and in Julie Holledge, *Innocent Flowers* (1981).

Introduction

1. Bernard Shaw qtd. in Jean Clothia, Introduction, *The New Woman and Other Emancipated Woman Plays* (Oxford: Oxford English Drama/Oxford World's Classics, 1998), xxiv.
2. Julie Holledge, *Innocent Flowers: Women in the Edwardian Theatre* (London: Virago, 1981), 8–9.
3. Viv Gardner, "The Invisible Spectatrice: Gender, Geography & Theatrical Space," in *Women Theatre and Performance: New Histories, New Historiographies*, ed. Maggie Barbara Gale and Vivien Gardner (Manchester: Manchester University Press, 2000), 38.
4. A full description of these tableaux vivants and the reason for them is in the opening chapter of Nina Auerbach's biography of Ellen Terry, *Player in Her Time*.
5. Nina Auerbach, *Private Theatricals: The Lives of the Victorians* (Cambridge: Harvard University Press, 1990), 4.
6. *Ibid.*, 12.
7. Elaine Hadley, "The Old Price Wars: Melodramatizing the Public Sphere in Early-Nineteenth-Century England," *PMLA* 107, no. 3 (May 1992): 524–36.
8. Peter Brooks, *The Melodramatic Imagination: Balzac, James, Melodrama and the Mode of Excess*, 2d ed. (New Haven: Yale University Press, 1995), vii.
9. *Sarah Bernhardt: The Art of High Drama*, exhibit notes, New York, Jewish Museum, 2005–6.
10. *Ibid.*
11. *Ibid.*
12. Lillie Langtry, *The Days I Knew* (North Hollywood: Panoply Productions, 2005 [1925]), 105–6.
13. See Sarah Bernhardt, *My Double Life:*

The Memoirs of Sarah Bernhardt, trans. Victoria Tietze Larson (Albany: State University of New York Press, 1999), 212.
 14. Ellen Terry, "The Triumphant Women," in *Four Lectures on Shakespeare*, ed. and intro. Christopher St. John (London: Benjamin Blom, 1932, reissue, 1969), 81–2.
 15. See Chapter 2 for further discussion of their reaction to the play and Janet Achurch's portrayal of Nora Helmer, as well as American critics' response to the play/playwright.
 16. Sidney Grundy, "The New Woman," in *The New Woman and Other Emancipated Woman Plays*, ed. Jean Clothia (New York: Oxford University Press, 1998), 1–59.
 17. See Chapter 3 for Shaw's criticism in context.
 18. Gay Gibson Cima, *Performing Women: Female Characters, Male Playwrights and the Modern Stage* (Ithaca: Cornell University Press, 1996), 42.
 19. Edith Hall, "Medea in British Legislation Before the First World War," *Greece & Rome, Second Series* 46, no. 1 (April 1999): 42–77. Published by Cambridge University Press on behalf of The Classical Association. Jstor.org.
 20. Virginia Woolf, *Moments of Being*, ed. Jeanne Schulkind (New York: Harcourt/Harvest, 1985), 67–70.

Chapter 1

1. Nina Auerbach, *Private Theatricals: The Lives of the Victorians* (Cambridge: Harvard University Press, 1990), 31–2.
 2. Neil Flax, "From Portrait to Tableaux Vivants: The Pictures of Emilia Galotti," *Eighteenth-Century Studies* 19, no. 1 (Autumn 1985), 45.
 3. Peter M. McIsaac, "Rethinking Tableaux Vivants and Triviality in the Writings of Johann Wolfgang von Goethe, Johanna Schopenhauer, and Fanny Lewald," *Monatshefte* 99, no. 2 (Summer 2007), 156.
 4. *Ibid.*, 153.
 5. Stéphane Michaud, "Artistic and Literary Idolatries," in *A History of Women*, Vol. IV—*Emerging Feminism from Revolution to World War*, ed. G. Fraisse and M. Perrot, (Cambridge: Belknap Press of Harvard University Press, 1993), 121–2.
 6. "Swan Lake," http://www.balletmet.org/Notes/SwanHist.html.
 7. Gail Marshall, *Shakespeare and Victorian Woman* (Cambridge: Cambridge University Press, 2009), 3.
 8. Julie Sanders, "Caroline Salon Culture and Female Agency: The Countess of Carlisle, Henrietta Maria & Public Theatre," *Theatre Journal* 52, no. 4 (December 2000), 450, fn4.
 9. *Ibid.*, 449.
 10. Samuel Pepys, "18 Aug. 1660," *Diary*, www.projectgutenberg.
 11. Jeffrey Hatcher, *Compleat Female Stage Beauty* (New York: Dramatists Play Service, 2006), 24.
 12. See Chapter 6 for analysis of Christopher St. John's suffrage play, *The First Actress* (1911): homage to "Mrs. Hughes" as the person who changed everything for women by treading the boards.
 13. Hatcher, 79.
 14. Ellen Terry, *Four Lectures on Shakespeare*, ed. and intro. Christopher St. John (New York: Benjamin Blom, 1932), 130–1.
 15. Jane Austen, *Persuasion*, Norton Critical Edition, ed. Patricia Meyer Spacks (New York: W.W. Norton, 1995), 19.
 16. *Ibid.*, 155–61.
 17. Paula Byrne, *Jane Austen and the Theatre* (London: Hambledon & London, 2002), 11. Byrne notes that some of the dialogue in this scene is a tamer version of her brother James's epilogue to the Austen family's private theatrical performance of *The Wonder: A Woman Keeps A Secret* (1714) by Susanna Centlivre: a play about sexual politics in which a woman risks her own marriage and reputation to help a friend avoid a disastrous arranged marriage.
 18. George Henry Lewes qtd. in Byrne, ix.
 19. Bernard Shaw, *The Road to Equality: Ten Unpublished Lectures and Essays 1884–1918*, ed. Louis Crompton (Boston: Beacon Press, 1971), 212, 216.
 20. Rachel M. Brownstein, *Tragic Muse: Rachel of the Comédie-Française* (Durham: Duke University Press, 1993), 117.
 21. *Ibid.*, 121.
 22. *Ibid.*, 172.
 23. *Ibid.*, 174, 185–90.
 24. *Ibid.*, 226.
 25. Qtd. in *Ibid.*, 224–6.
 26. Martin Meisel, *Realizations: Narrative, Pictorial and Theatrical Arts in Nineteenth-Century England* (Princeton: Princeton University Press, 1983), 10.
 27. *Ibid.*, 38.
 28. *Ibid.*, 351–2.
 29. In the midst of the Woman Question, the clothing worn in these paintings gave rise to "aesthetic dress," which was more feminine than the Bloomer costume but far less restrictive than mid–Victorian styles. See Patricia A. Cunningham, *Reforming Women's Fashion 1850–1920: Politics, Health & Art* (Kent: Kent State University Press, 2003), 107–9.

30. Gail Marshall, *Actresses on the Victorian Stage: Feminine Performance and the Galatea Myth* (Cambridge: Cambridge University Press, 1998), 1.
31. Monika Elbert, "Striking a Historical Pose: Antebellum Tableaux vivants, 'Godey's' Illustrations, and Margaret Fuller's Heroines," *The New England Quarterly* 75, no. 2 (June 2002), 236.
32. Florence Nightingale, *Cassandra* (New York: Feminist Press, 1979).
33. Gilbert & Sullivan Archive, boisestate.edu, retrieved March 21, 2011.
34. Elbert, 240.
35. William Garrison, "Intelligent Wickedness," in *Feminism: The Essential Historical Writings*, ed. Miriam Schneir (New York: Vintage, 1992), 87.
36. John Stuart Mill, *The Subjection of Women* (1869), Penn State Electronic Classic Series Publication, 90.
37. Elbert, 250.
38. *Ibid.*, 256.
39. Margaret Fuller, "The Great Lawsuit: Man versus Men, Woman versus Women," expanded in *Woman in the Nineteenth Century* (New York: Dover Thrift Editions, 1999 [1845]), 94, 14–5.
40. *Ibid.*, 14–15.
41. Elbert, 262–3.
42. See Charity Cannon Willard, *Christine de Pizan: Her Life and Works—A Biography* (New York: Persea, 1984), 220–22. According to Charity Willard, Horace Walpole praised dePizan in a letter to Hannah More, telling her she was worthy to live in de Pizan's allegorical city. The true rediscovery of her writings began in 1838 with a publication of some of her political writings; further studies followed and a 1927 biography was considered very thorough and fine.
43. Elbert, 256.
44. Nina Auerbach, *Ellen Terry: A Player in Her Time*, 2d ed. (New York: W.W. Norton, 1999), 10.

Chapter 2

1. Bernard Shaw, *The Road to Equality: Ten Unpublished Lectures and Essays 1884–1918*, ed. Louis Crompton (Boston: Beacon Press, 1971), 212, 216.
2. Nina Auerbach, *Private Theatricals: The Lives of the Victorians* (Cambridge: Harvard University Press, 1990), 3–4.
3. Emma Goldman, *The Social Significance of Modern Drama* (New York: Applause, 1987), 5.
4. *Ibid.*, 10–1.
5. Mildred Aldrich, from "A Harlequin," *Boston Home Journal*, November 2, 1889, 4, in *American Women Theatre Critics: Biographies and Selected Writings of Twelve Reviewers, 1753–1919*, ed. Alma Bennett (Jefferson, NC: McFarland, 2010), 83.
6. *Ibid.*, 84.
7. Clement Scott and R. H. Hervey qtd. in Margot Peters, *Bernard Shaw and the Actresses* (New York: Doubleday, 1980), 57.
8. Miriam Schneir, Introduction, Note to excerpt of Ibsen's *A Doll's House* in *Feminism: The Essential Historical Documents*, 179.
9. Peters, 56.
10. Elizabeth Robins qtd. in Peters, 56.
11. Annie Nathan Meyer, from "Ibsen's Attitude Toward Woman," *The Critic* 22 March 1890, in Bennett, 148.
12. The image of a woman sounding such a clarion call would be prominently featured in the graphics used by suffrage groups in the U.S. and U.K. in the early 20th century. This assumption of the military bugler role is likewise a link back to the idealized portrayals in women's private theatricals and tableaux vivant. See Chapter 1.
13. Joan Templeton, "The *Doll House* Backlash: Criticism, Feminism, and Ibsen," *PMLA* 104, no. 1 (1989): 28–40. Jstor.
14. Joan Templeton, *Ibsen's Women* (Cambridge: Cambridge University Press, 2001), xv.
15. "Mary Shaw in Ghosts," *New York Times*, 27 January 1903, nyt.com, retrieved 26 April 2011.
16. *Ibid.*
17. Robert Corrigan, "The Sun Also Rises: Ibsen's 'Ghosts' As Tragedy?" *Educational Theatre Journal* 11, no. 3 (October 1959): 171–80. Jstor.
18. Annie Nathan Meyer, from "A Prophet of the New Womanhood," *Lippincott's Monthly Magazine*, March 1894, 375, in Bennett, 151.
19. Meyer in Bennett, 150–1.
20. Joan Templeton, "Of This Time, of This Place: Mrs. Alving's Ghosts and the Shape of the Tragedy," *PMLA* 101, no. 1 (January 1986): 67–8. Jstor.org.
21. Bernard Shaw, "Ideals and Idealists," *The Quintessence of Ibsenism* (London, 1891), in *Eight Modern Plays*, ed. Anthony Caputi (New York: W.W. Norton, 1991), 484–5.
22. Alvin Klein, "Shaw's Candida, One Tough Lady," *New York Times*, 14 December 1997, nyt.com.
23. Bernard Shaw, "Candida," in *Man & Superman and Three Other Plays*, ed. John Bertolini (New York: Barnes & Noble Classics, 2004), 128–9.
24. Anita Gates, "In 'Candida,' Tribute to

Women's Strength," *New York Times*, 1 April 2011, nyt.com.

25. "*Candida* Not As Well Received As In America," *New York Times*, 8 May 1904, nyt.com.

26. Desmond MacCarthy, *The Court Theatre, 1904–1907: A Commentary and Criticism. With an Appendix Containing Reprinted Programmes of the "Vedrenne-Barker Performances"* (London, 1907 [Nabu Public Domain Rpts.]), 66–7.

27. Shaw, "Candida," in Bertolini, 186–7.

28. Christopher Innes, *Modern British Drama 1890–1990* (Cambridge: Cambridge University Press, 1992), 18.

29. Kerry Powell, "Wilde and Ibsen," *English Literature in Transition, 1880—1920* 28, no. 3 (1985), 230.

30. Oscar Wilde, "An Ideal Husband," in *The Plays of Oscar Wilde* (NY: Modern Library, n.d.), 1, 3.

31. *Ibid.*, 20–6.

32. *Ibid.*, 32–5.

33. Gary Schmidgall, Introduction, *Two Plays by Oscar Wilde: An Ideal Husband/A Woman of No Importance* (New York: Signet, 1997), xxiii.

34. Innes, 217.

35. Wilde, 124.

36. Susan Torrey Barstow, "'Hedda Is All of Us': Late Victorian Women at the Matinee," *Victorian Studies* 43, no. 3 (2001): 387–8.

37. *Ibid.*, 392.

38. *Ibid.*, 394.

39. Julie Holledge, *Innocent Flowers: Women in the Edwardian Theatre* (London: Virago Press, 1981), 28.

40. *Ibid.*, 28.

41. Mary Wollstonecraft, from *Vindication of the Rights of Woman*, in *The Feminist Papers: From Adams to de Beauvoir*, ed. Alice Rossi (New York: Columbia University Press, 1978), 50.

42. Angela John, *Elizabeth Robins: Staging a Life* (London: Routledge, 1995), 55–6.

43. Henrik Ibsen, "Hedda Gabler," *Works of Henrik Ibsen: One Volume Edition* (New York: Walter J. Black, 1928), 23.

44. Gustave Flaubert, *Madame Bovary*, trans. Alan Russell (New York: Penguin, 1988), 100–1.

45. Barstow, 397.

46. Gay Gibson Cima, *Performing Women: Female Characters, Male Playwrights & the Modern Stage* (Ithaca: Cornell University Press, 1996), 41.

47. *Ibid.*, 47.

48. Penny Farfan, *Women, Modernism and Performance* (Cambridge: Cambridge University Press, 2004), 11.

49. Elizabeth Robins, *Way Stations*, 1913, free Google ebook, retrieved 1 May 2011.

Chapter 3

1. Ellen Terry qtd. in Margaret Leask, *Lena Ashwell: Actress, Patriot, Pioneer* (Hatfield: Hertfordshire University Press, 2013), 1.

2. Vanessa R. Schwartz, *Spectacular Realities: Early Mass Culture in Fin-de-Siècle Paris* (Berkeley: University of California Press, 1998), 9–25.

3. *Ibid.*, 88–92.

4. *Ibid.*, 10.

5. Joan Templeton, *Ibsen's Women* (Cambridge: Cambridge Univ. Press, 2001), 112.

6. *Ibid.*, 112–3.

7. Qtd. in Templeton, 110.

8. Judith Walkowitz, *City of Dreadful Delight, Narratives of Sexual Danger in Victorian London* (Chicago: University of Chicago Press and London: Virago Press, 1992), 25–6.

9. *Ibid.*, 55–6.

10. *Ibid.*, 56.

11. Una Chaudhuri, *Staging Place: The Geography of Modern Drama* (Ann Arbor: University of Michigan Press, 1997), 8–9.

12. *Ibid.*, 10.

13. *Ibid.*

14. Margaret Stetz, "Politics and the Two Irish 'Georges': Egerton Versus Shaw," *Shaw and Feminisms: On Stage and Off*, ed. D.A. Hadfield and Jean Reynolds (Gainesville: University Press of Florida, 2013), 133.

15. Gail Marshall, *Shakespeare and Victorian Women* (Cambridge: Cambridge University Press, 2009), 13.

16. See further discussion of Terry's lectures in chapters 1 and 5.

17. Bernard Shaw, "Review of *The Notorious Mrs. Ebbsmith*," *The Theatrical "World" of 1895* (London, 1896), in Harold Fromm, *Bernard Shaw and the Theatre in the Nineties: A Study of Shaw's Dramatic Criticism* (Lawrence: University Press of Kansas, 1967), 87.

18. *Ibid.*, 85–6.

19. Fiona Gregory, "Performing the Rest Cure: Mrs. Patrick Campbell's Ophelia, 1897," *NTQ* 28, no. 2 (May 2012), 108–9.

20. See Gregory 109 for selected quotes from critics and spectators ranging from Clement Scott to Bernard Shaw. The Lyceum revived this production for about 20 years, making it even more firmly stamped in the popular imagination.

21. Michael Holroyd, *A Strange Eventful History: The Dramatic Lives of Ellen Terry, Henry Irving, and Their Remarkable Families*

(New York: Farrar, Straus and Giroux, 2008), 116–7.
22. William Shakespeare, *Hamlet*, ed. Sylvan Barnet (New York: Signet Classics, 1998), 1, 2, 158–9 and 86.
23. Gregory, 107–8.
24. Gilman later wrote an essay "Why I Wrote 'The Yellow Wallpaper'" which confirms the success of the story in reaching physicians and their choices.
25. See Gregory 110 for further discussion.
26. Bernard Shaw qtd. in Gregory 116.
27. Kerry Powell, *Women and Victorian Theatre* (Cambridge: Cambridge University Press, 1997), 27–30.
28. Sarah Grand, " A New Aspect of the Woman Question," in *The New Woman Reader: Fiction, Articles, Drama of the 1890s*, ed. Carolyn Nelson (Ontario: Broadview Press, 2001), 143.
29. Clothilde Graves, *A Mother of Three. Plays and Performance Texts by Women: 1880–1930: An Anthology of Plays by British and American Women from the Modernist Period*, ed. Maggie Gale and Gilli Bush-Bailey (Manchester: Manchester University Press, 2012), 90–150.
30. Oscar Wilde, "The Importance of Being Earnest," in *The Plays of Oscar Wilde* (New York: Modern Library, n.d.), 67
31. Wilde is also likely referencing Jane Austen's *Northanger Abbey* when Henry Tilney tells Catherine Moreland he can predict her representation of their initial meeting in the lower rooms of Bath in her journal. His familiarity with the young ladies' inclination to record everything from clothing worn to memorable phrases and resulting psychological and emotional states leads to an exchange between them reminiscent of theatrical comedy.
32. Oscar Wilde, "The Importance of Being Earnest," in *The Plays of Oscar Wilde*, 102.
33. *Ibid.*, 96.
34. John Bertolini, "Wilde and Shakespeare in Shaw's *You Never Can Tell*," *SHAW: The Annual of Bernard Shaw Studies* 27 (2007): 156–64, 156.
35. Charles Isherwood, "A Stylish Monster Conquers at a Glance," *New York Times*, 13 January 2011, nyt.com.
36. See Kerry Powell, "New Women, New Plays, and Shaw in the 1890s," *The Cambridge Companion to George Bernard Shaw*, ed. Christopher Innes (Cambridge: Cambridge University Press, 1998), 87.
37. *Ibid.*, 94.
38. Bernard Shaw, "You Never Can Tell," *Complete Plays With Prefaces*, Vol. 6 (NY: Dodd, Mead & Company, 1962), 672.
39. David Staller, "The Importance of Being Shaw," Pearl Theatre Company/Gingold Theatrical Group Program, 2013, 5–6.
40. Kate Farrington, "Have Some Madeira, My Dear: The Influence of Shaw's Enchanted Isle," Pearl Theatre Company/Gingold Theatrical Group Program, 2013, 8.
41. Oscar Wilde, "Lady Windermere's Fan," 152–3.
42. Shaw's play was performed privately in 1902, mounted in New York in 1905 and closed down, performed by The Pioneer Players in 1912 and not performed on the "legitimate" London stage until 1925. See Leonard Conolly, "Mrs Warren's Profession and the Lord Chamberlain," *SHAW: The Annual of Bernard Shaw Studies* 24 (2004): 46–95.
43. Sos Eltis, "The Fallen Woman on Stage," in *Victorian and Edwardian Theatre*, ed. Kerry Powell (Cambridge: Cambridge University Press, 2004), 229.
44. Leonard Conolly, "Mrs Warren's Profession and the Lord Chamberlain," *SHAW: The Annual of Bernard Shaw Studies* 24 (2004): 46–95.
45. See Clothia, xv.
46. Bernard Shaw, "Preface to Mrs. Warren's Profession," *Plays Unpleasant*, ed. Dan Laurence (New York: Penguin, 1957), 183–4.
47. Sally Mitchell, "The Forgotten Woman of the Period: Penny Weekly Family Magazines of the 1840s and 1850s," in *The Widening Sphere: Changing Roles of Victorian Women*, ed. Martha Vicinus (Bloomington: Indiana University Press, 1977), 34.
48. *Ibid.*, 229.
49. Shaw, "Mrs. Warren's Profession," 251.
50. Ian Clarke, *Edwardian Drama: A Critical Study* (London: Faber, 1989), 28.
51. Eltis, 228–9.
52. Richard F. Dietrich, *British Drama 1890 to 1950: A Critical History* (Boston: Twayne, 1989), 86.
53. Phillipa Fawcett and other women could not earn a B.A. so could not compete in the awards. But her score on the exams was higher than the senior wrangler. Shaw's inclusion of Vivie participating in mathematical contests at Newnham clearly shows his admiration and support of new women. For more on Phillipa Fawcett see Stephen Siklos, "Biographies: Phillipa Garrett Fawcett, 1868–1948," http://www.newn.cam.ac.uk/about-newnham/college-history/biographies/content/philippa-fawcett, 2004, retrieved 26 May 2014.
54. Shaw, "Mrs. Warren's Profession," 280–6.
55. Dorothy Hadfield, "Writing Women: Shaw and Feminism behind the Scenes," in *Shaw & Feminisms*, 112.

56. *Ibid.*, 112.
57. Qtd. in Leask, 6.
58. Shaw qtd. in Leask, 9.
59. Margot Peters, *Bernard Shaw and the Actresses* (New York: Doubleday, 1980), 310.
60. Margery Morgan, comp., *File on Shaw* (London: Methuen, 1989), 28.
61. See various chapters in Katharine Cockin, *Edith Craig (1869–1947) Dramatic Lives* (London: Cassell, 1998).
62. Shaw, "Preface to"Mrs. Warren's Profession," 187.
63. Bernard Shaw, *Caesar and Cleopatra* (New York: Penguin, 1964 [1913]), 7.
64. *Ibid.*, 11.
65. Doris Adler, "The Unlacing of Cleopatra," *Theatre Journal* 34, no. 4 (December 1982), 453.
66. Adler, 465. See fn61.
67. Shaw, *Caesar and Cleopatra*, 26, 28.
68. *Ibid.*, 30–1.
69. *Ibid.*, 111–12.
70. Judith Walkowitz, "The 'Vision of Salome': Cosmopolitanism and Erotic Dancing in Central London, 1908–1918," *The American Historical Review* 108, no. 2 (April 2003), 348.
71. *Ibid.*
72. *Ibid.*, 349.
73. Udo Kultermann, "The Dance of the Seven Veils: *Salome* and Erotic Culture Around 1900,"
Artibus et Historiae 27, no. 53 (2006): 187–92.
74. Carmen Trammell Scaggs, "Modernity's Revision of the Dancing Daughter: The Salome Narrative of Wilde and Strauss," *College Literature* 29, no. 3, Literature and the Visual Arts (Summer 2002), 125.
75. Joseph Donohue cited in Skaggs, 127.
76. The influence of Wilde's *Salome* would be reinforced by the multiple versions that would come in the Edwardian era. See Chapter 7 for examples of these.

Chapter 4

1. Desmond MacCarthy, *The Court Theatre, 1904–1907; A Commentary and Criticism. With an appendix containing the reprinted programmes of the "Vedrenne-Barker Performances"* (London: A. H. Bullen, 1907 [Nabu Public Domains rpt.]), 2–3.
2. Angela John, *Elizabeth Robins: Staging a Life 1862–1952* (New York: Routledge, 1995), 55–6.
3. *Ibid.*, 58–9.
4. *Ibid.*, 59.
5. Margery Morgan, comp., *File on Shaw* (London: Methuen, 1989), 8.

6. Christopher Innes, "Granville Barker and Galsworthy: Questions of Censorship," *Modern Drama* 32, no. 3 (Fall 1989): 331–44, 332.
7. This play is discussed in Chapter 3 alongside Wilde's *Importance of Being Earnest*.
8. James Woodfield, *English Theatre in Transition: 1881–1914* (Lanham, MD: Rowman & Littlefield, 1984), 172.
9. Alan S. Downer, ed., *Twenty-five Modern Plays*, rev. ed. (New York: Harper & Bros., 1948), 75.
10. Maggie Gale and Gilli Bush-Bailey, eds., *Plays and Performance Texts by Women 1880–1930: An Anthology of Plays by British and American Women from the Modernist Period* (Manchester: Manchester University Press, 2012), 151.
11. For full evolution of Edy Craig's powers as director/theatre manager see Katharine Cockin, *Dramatic Lives: Edith Craig (1869–1947)* (London: Cassell, 1998).
12. *Ibid.*
13. Desmond MacCarthy, 1.
14. Dennis Kennedy, *Granville Barker and the Dream of Theatre* (Cambridge: Cambridge University Press, 1985), 18.
15. Morgan, 9.
16. Kennedy, 18–20.
17. Walkley qtd. in Kennedy, 20.
18. Kennedy, 20.
19. Shannon Jackson, *Lines of Activity: Performance, Historiography, Hull-House Domesticity* (Ann Arbor: University of Michigan Press, 2000), 44–5.
20. Todd London, "How America's First Art Theatre Came to Be" (excerpts from Jane Addams, *Twenty Years at Hull House*, 1910) *American Theatre* (January 2006), 82.
21. Stuart J. Hecht, "Social and Artistic Integration: The Emergence of Hull-House Theatre," *Theatre Journal* 34, no. 2, Insurgency in American Theatre (May 1982): 172–82, 173.
22. *Ibid.*, 173.
23. See Christopher Gray's article in the *New York Times*, "The Drama Queen of the Lower East Side," 23 December 2010, nyt.com.
24. Addams in London, 86.
25. Desmond MacCarthy, 7–8.
26. Theodore Stier, "Barker and Shaw at the Court Theatre: A View from the Pit," *The Shaw Review* 10, no. 1 (January 1967): 18–33, 20.
27. *Ibid.*, 21 and 18.
28. See Martin Meisel, *Shaw and the Nineteenth-Century Theatre* (1969) for full details about Shaw attending Irish plays as a child in Dublin.

29. Jan McDonald, "Shaw and the Court Theatre," in Innes, 261–282, 274–5.
30. Lillah McCarthy, "How Bernard Shaw Produces Plays," *PERFORMANCE* (1983): 163–168, 163–4.
31. Lillah McCarthy qtd. in Margot Peters, *Bernard Shaw and the Actresses* (New York: Doubleday, 1980), 282.
32. Bernard Shaw, "Man and Superman," in *George Bernard Shaw's Plays*, ed. Sandie Byrne (New York: W.W. Norton, 2002), 119–20, 127.
33. Tony Stafford, *Shaw's Settings: Gardens and Libraries* (Gainesville: University Press of Florida, 2013), 64–6.
34. *Ibid.*, 67.
35. Desmond MacCarthy, 82–3.
36. Sally Peters, "Shaw's Life: A Feminist in Spite of Himself," In Innes, 3–24, 6.
37. *Ibid.*, 17.
38. See Lucy Delap's article on the superwoman in Edwardian culture and its connection to that era and second-wave feminism. She focuses broadly but zeroes in on the new term, feminism, ca. 1911 to denote the more radical part of the movement for full citizenship for women and also examines the schism between the "cause" and "sisterhood" and the goal of exceptionality to advance women's status as well as opportunities. "The Superwoman: Theories of Gender and Genius in Edwardian Britain," *The Historical Journal* 47, no. 1 (March 2004): 101–126.
39. Bernard Shaw, "Candida," in *Man and Superman and Three Other Plays*, ed. John Bertolini (New York: Barnes & Noble Classics, 2004), 186–7.
40. *Ibid.*, 189.
41. Desmond MacCarthy, 66–7.
42. Shaw, "Candida," 190. For further discussion of *Candida* and Shaw's assertion that it inverts Ibsen's *A Doll House*, see Chapter 2.
43. Desmond MacCarthy, 71.
44. Kennedy, 20.
45. Desmond MacCarthy, 73.
46. Alfred Turco, Jr., *Shaw's Moral Vision: The Self and Salvation* (Ithaca: Cornell University Press, 1976), 176–7.
47. Bernard Shaw, "John Bull's Other Island," *Modern Irish Drama*, ed. John Harrington (New York: W.W. Norton, 1991), 165.
48. *Ibid.*, 203.
49. *Ibid.*
50. Peter Gahan, "Colonial Locations of Contested Space and *John Bull's Other Island*," *SHAW: The Annual of Bernard Shaw Studies* 26 (2006): 202–229, 202.
51. *Ibid.*, 229.
52. Desmond MacCarthy, 10.
53. Kennedy, 22–3.

54. Desmond MacCarthy, 12.
55. "Rush at Campbell Play: Extra Police Called in to Line Up Guests for Professional Matinee," *New York Times*, 19 February 1908, nyt.com.
56. "Electra as Edith Wynne Matthison Sees Her," *New York Times*, 15 March 1910, nyt.com.
57. Qtd. in Kennedy, 49.
58. *New York Times*, 15 March 1910.
59. Kennedy, 49.
60. *Ibid.*
61. Karelisa Hartigan, *Greek Tragedy on the American Stage: Ancient Drama in the Commercial Theater* (Westport, CT: Greenwood Press, 1995), 11.
62. *Ibid.*, 15–6.
63. Kennedy, 49.
64. Hartigan, 12.
65. *Ibid.*, 17.
66. *Ibid.*, 18–19.
67. Margery Morgan, "Introduction," *Granville Barker Plays: One* (London: Methuen, 1997), xxi.
68. Kennedy, 80.
69. Granville Barker, "The Voysey Inheritance," *Harley Granville Barker Reclaimed* (Mint Theater Company Performance Texts) (New York: Mint Theater Company, 2007), 80.
70. *Ibid.*, 82.
71. *Ibid.*, 86.
72. *Ibid.*
73. Christopher Innes, "Granville Barker and Galsworthy: Questions of Censorship," *Modern Drama* 32, no. 3 (Fall 1989): 331–44, 334.
74. Barker, "The Voysey Inheritance," 89.
75. Innes, 334.
76. Barker, "The Voysey Inheritance," 106–7.
77. *Ibid.*, 111.
78. *Ibid.*, 114–16.
79. *Ibid.*, 117–26.
80. Michael C. O'Neill, "*The Voysey Inheritance* by Harley Granville-Barker," *Theatre Journal* 42, no. 3 (October 1990): 377–79, 377.
81. Bernard Shaw, "Major Barbara," *Pygmalion and Three Other Plays*, introd. and notes John Bertolini (New York: Barnes & Noble Classics, 2004), 98–100.
82. *Ibid.*, 109.
83. Emma Goldman, "George Bernard Shaw—*Major Barbara*," in *The Social Significance of Modern Drama* (New York: Applause Theatre Book Publishers, 1987 [1914]), 104.
84. "Major Barbara," 138.
85. *Ibid.*, 145–6.
86. Sonia Lorichs, "'The Unwomanly Woman' in Shaw's Drama," in *Fabian Femi-*

nist: Bernard Shaw and Woman (University Park: Pennsylvania State University Press, 1977), 103–4.
87. See the theatre program in Desmond MacCarthy, 145.
88. Sheila Stowell, A Stage of Their Own: Feminist Playwrights of the Suffrage Era (Ann Arbor: University of Michigan Press, 1992), 9.
89. The two women met when C. Pankhurst addressed an ILP meeting in spring 1905. See Andrew Rosen, Rise Up Women! The Militant Campaign of the Women's Social and Political Union. (London: Routledge, 2012), 43.
90. William J. Doan, "The Doctor's Dilemma: Adulterating a Muse," SHAW: The Annual of Bernard Shaw Studies 21 (2001): 151–161, 152.
91. The Doctor's Dilemma, 357.
92. Desmond MacCarthy, 97.
93. Bertolini, Introduction, Pygmalion and Three Other Plays of George Bernard Shaw, xxv.
94. The Doctor's Dilemma, 357.
95. Doan, 152.
96. Francis Fenwick Williams qtd. in Maria DiCenzo, "Feminism, Theatre Criticism, and the Modern Drama," South Central Review 25, no.1 (Spring 2008): 36–52, 47.
97. See further discussion of the Jubilee in Chapter 5 and the opening chapter of Nina Auerbach's biography, Ellen Terry: Player in her Time, 2d ed. (New York: W.W. Norton, 1997).
98. Michael Holroyd, A Strange and Eventful History: The Dramatic Lives of Ellen Terry, Henry Irving, and Their Remarkable Families (New York: Farrar, Straus and Giroux, 2008), 412–13.
99. Woolf qtd. in Holroyd, 413.
100. Desmond MacCarthy, 84–5.
101. Ellen Gainor, "Bernard Shaw and the Drama of Imperialism," in The Performance of Power: Theatrical Discourse and Politics (Ames: University of Iowa Press, 1991), 56–74, 57.
102. Ibid., 65.
103. Bernard Shaw, "Captain Brassbound's Conversion," Complete Plays with Prefaces Vol. 1 (New York: Dodd, Mead, 1963), 684–5.
104. Gainor, 65.
105. Shaw, "Captain Brassbound," 685.
106. Kennedy, 61.
107. Ibid., 55.
108. Charles Booth's survey of poverty showed that more people were living under the poverty line in 1905 than there had been in the late 1880s.

109. Julie Holledge, Innocent Flowers: Women in the Edwardian Theatre (London: Virago, 1981), 46.
110. Sheila Stowell, A Stage of Their Own: Feminist Playwrights of the Suffrage Era (Ann Arbor: University of Michigan Press, 1992), 111. Ibid., 32.
112. Desmond MacCarthy, 34.
113. Kennedy, 59–60.
114. With gratitude to the Fales Library, which has several versions of the script for this play.

Chapter 5

1. Julie Holledge, Innocent Flowers: Women in the Edwardian Theatre (London: Virago, 1981), 49–50.
2. Ibid., 52–3.
3. Ibid., 53.
4. Ibid.
5. Lisa Tickner, The Spectacle of Women (Chicago: University of Chicago Press, 1988), ix.
6. Susan Carlson, "Portable Politics: Creating New Space for Suffrage-ing Women," New Theatre Quarterly 17, no. 4 (November 2001): 334–46.
7. Bernard Shaw, Preface to Lillah McCarthy, Myself and My Friends: A Life on the Stage (New York: Dodd, Mead, 1933).
8. Margaret Fuller, "Woman in the Nineteenth Century," in Miriam Schneir, ed., Feminism: The Essential Historical Writings (New York: Vintage, 1992), 65–6.
9. Sarah Stickney Ellis, from The Women of England (1839) in Victorian Prose, ed. Rosemary J. Mundhenk and LuAnn McCracken Fletcher (New York: Columbia University Press, 1999), 54.
10. Florence Nightingale, Cassandra, intro. Myra Stark (New York: The Feminist Press, 1979), 15, 32.
11. In Ellen Terry and Bernard Shaw: A Correspondence, ed. Christopher St. John (New York: G.P. Putnam Sons, 1932), xi.
12. Virginia Woolf, A Room of One's Own (New York: Harvest/Harbrace, 1989), 34–6.
13. John Ruskin, "Of Queens Gardens," from Sesame and Lilies; The Two Paths; The King of the Golden River, intro. Sir Oliver Lodge (London: Dent, 1937), 62–3.
14. Elizabeth Cady Stanton, "Letter 118- to John Hooker, 2/22/1870," in The Selected Papers of Elizabeth Cady Stanton and Susan B. Anthony, Vol. 2: Against An Aristocracy of Sex, 1866–1873, ed. Ann D. Gordon (New Brunswick: Rutgers University Press, 2000), 306.
15. Elaine Showalter, A Jury of Her Peers:

American Women Writers from Anne Bradstreet to Annie Proulx (New York: Knopf, 2009), 164–5.
 16. Susan Kingsley Kent, *Sex and Suffrage in Britain, 1860–1914* (Princeton: Princeton University Press, 1897), 184ff.
 17. Stark in Nightingale, 1.
 18. Annie Besant, *Autobiographical Sketches*, ed. Carol Hanbery MacKay (Ontario: Broadview Press, 2009), 330.
 19. Carol Mattingly, *Appropriate[ing]Dress: Women's Rhetorical Style in Nineteenth-Century America* (Carbondale: Southern Illinois University Press, 2002), 137.
 20. Sandra Holman qtd. in Sheila Stowell, *A Stage of Their Own: Feminists Playwrights of the Suffrage Era* (Ann Arbor: University of Michigan Press, 1992), 28–9.
 21. Qtd. in Susan Glenn, *Female Spectacle: The Theatrical Roots of Modern Feminism* (Cambridge: Harvard University Press, 200), 131–2.
 22. See Glenn, 138.
 23. Pamela Cobrin, *From Winning the Vote to Directing on Broadway: The Emergence of Women on the New York Stage, 180–1927* (Newark: University of Delaware Press, 2009), 37.
 24. *Ibid.*, 38–41.
 25. *Ibid.*, 46–9.
 26. For a fuller discussion of Edy Craig's 1906 tableaux vivants for Ellen Terry's Jubilee see Chapter 1.
 27. Katharine Cockin, *Edith Craig (1869–1947): Dramatic Lives* (London: Cassell, 1998), 90.
 28. Christian Hayes, "Sherborne Pageant, 1905," BFI (British Film Institute), *http://www.screenonline.org.uk/film/id/1186123.*
 29. Rebecca Cameron, "From Great Women to Top Girls: Pageants of Sisterhood in British Feminist Theatre," *Comparative Drama* 43, no. 2 (Summer 2009): 145.
 30. *Ibid.*, 147.
 31. Holledge, 70.
 32. Cicely Mary Hamilton, *A Pageant of Great Women* (London: The Suffrage Shop, 1910 [Nabu Public Domain Rpt.]), 16–21.
 33. *Ibid.*, 45–7
 34. Holledge, 69.
 35. *Ibid.*, 71.
 36. Cockin, *Edith Craig*, 94.
 37. "Warm Welcome for Miss Ellen Terry: Actresses Discusses Shakespeare's Heroines and Interprets Passages from the Poet," *New York Times*, 4 November 1910, nyt.com.
 38. Qtd. in Carlson, 334.
 39. Lillan McCarthy qtd. in Holledge, 75.
 40. Elizabeth Robins, "Come and See!" rpt. in *Way Stations* (New York: Dodd, Mead,

1913) and digitized on http://www.jsu.edu/depart/english/robins/waysta/way14see.htm, 262–3.
 41. Robins, "Come and See," 264.
 42. Cameron, 155–6.
 43. Maria DiCenzo, "Feminism, Theatre Criticism, and the Modern Drama," *South Central Review* 25, no. 1 (Spring 2008): 36.
 44. In the U.S., however, the schism between white middle to upper-class women's interest in legal rights and the vote superseded their sisterly responsibility to women of color and immigrant women from Eastern Europe or Asia: a blight on their slogans to be sure. That the American women's movement began in response to women being denied a voice in an Anti-Slavery society meeting in London in 1840 underscores the cruel irony.
 45. DiCenzo, 40.
 46. Qtd. in Glenn, 133.
 47. Glenn, 133.

Chapter 6

 1. Jill Dolan, "Classic Drag: The Greek Creation of Female Parts," *Theatre Journal* 37, no. 3, Staging Gender (October 1985): 317–27, 317.
 2. Marjorie Stratchey qtd. in Maria DiCenzo, "Feminism, Theatre Criticism, and the Modern Drama," *South Central Review* 25, no. 1 (Spring 2008): 47.
 3. Sheila Stowell, *A Stage of Their Own: Feminist Playwrights of the Suffrage Era* (Ann Arbor: University of Michigan Press, 1992), 42.
 4. *Ibid.*
 5. Claire Hirshfield, "The Suffragist as Playwright in Edwardian England," *Frontiers: A Journal of Women's Studies* 9, no. 2 (1987): 3.
 6. Edith Lyttleton, "Warp and Woof," in *Plays and Performance Texts by Women 1880–1930: An Anthology of Plays by British and American Women from the Modernist Period*, ed. Maggie B. Gale and Gilli Bush-Bailey (Manchester: Manchester University Press, 2012), 182–3.
 7. *Ibid.*, 199.
 8. I attended the premiere run of Lynn Nottage's 2004 play *Intimate Apparel*, part of the Roundabout Theatre Company's season. The play is set in 1905 and is dedicated to her grandmother. At intermission I overheard one audience member tell another that her great aunt had worked till almost midnight on a client's dress during this era and did not even have the carfare for a taxicab to make the delivery to her home. She walked from a bus stop a long way in drenching rain,

after having delivered the order, and died shortly thereafter of pneumonia.

9. Joel H. Kaplan and Sheila Stowell, *Theatre & Fashion: Oscar Wilde to the Suffragettes* (Cambridge: Cambridge University Press, 1994), 4–5.

10. Margaret Leask, *Lena Ashwell: Actress, Patriot, Pioneer* (Hatfield: University of Hertfordshire Press, 2012), 74–5.

11. *Ibid.*, 74.

12. Kaplan and Stowell, 5.

13. Cicely Hamilton, *Diana of Dobson's* (1908), ed D. Gillespie and D. Birrer (Ontario: Broadview Press, 2003), 132.

14. Qtd. in Leask 76.

15. Hamilton, *Diana of Dobson's*, 146.

16. Cicely Hamilton and Christopher St. John, "How the Vote Was Won," in Susan Croft, ed., *Votes for Women and Other Plays* (London: Aurora Metro Books, 2009), 153.

17. *Ibid.*, 145.

18. My current students especially appreciate each woman having her own story, taking her own stand, and being willing to give up whatever they had for the benefit of women as a whole—a unity they feel is lacking now.

19. Hamilton and St. John in Croft, 160.

20. *Ibid.*, 161–3.

21. Stowell, *A Stage of Their Own*, 63.

22. Bernard Shaw, "Press Cuttings," in *Getting Married and Press Cuttings* (New York: Penguin, 1957), 223.

23. *Ibid.*, 226.

24. *Ibid.*, 232.

25. Bernard Shaw, "Torture by Forcible Feeding Is Illegal," in Rodelle Weintraub, ed., *Fabian Feminist: Bernard Shaw and Woman* (University Park: Pennsylvania State University Press, 1977), 229.

26. Stowell, *A Stage of Their Own*, 64.

27. Shaw, "Press Cuttings," 262–4.

28. Beatrice Harradan, "Lady Geraldine's Speech," in Dale Spender and Carol Hayman, eds., *How the Vote Was Won and Other Suffragette Plays* (London: Methuen, 1985), 98.

29. Harradan in Spender and Hayman, 96.

30. The picket was held between July 5 and October 28, 1909, according to Susan Croft, who includes a description of its strategy: "'an example of patient endurance which should go far to silence the foolish cry of "hysteria" as applied to the Suffrage Movement.'" Susan Croft, ed., *Votes for Women and Other Plays* (London: Aurora Metro Books, 2009), 122.

31. Alice Chapin, "At the Gates: Being a Twentieth-Century Cpisode" in Croft, ed., 128.

32. *Ibid.*, 130.

33. See the beginning of Chapter 5—the remark by Home Secy. Herbert Gladstone that men got their unions through mass action, but of course women could not muster this—and the huge Hyde Park event that rose to the challenge. Hundreds of thousands of spectators attended the speeches on twenty platforms in June 1908.

34. Chapin, 134.

35. *Ibid.*, 134.

36. *Ibid.*, 136–8.

37. Ethel Smyth wrote this song, and lyrics were by Cicely Hamilton, 1911, http://www.thesuffragettes.org/resources/anthems/.

38. Evelyn Glover, "Miss Appleyard's Awakening," in Spender and Hayman, 117.

39. *Ibid.*, 118.

40. *Ibid.*, 123.

41. *Ibid.*, 124.

42. Gertrude Jennings, "A Woman's Influence," in Spender and Hayman, 129.

43. *Ibid.*, 130.

44. *Ibid.*, 133.

45. *Ibid.*, 134–5.

46. *Ibid.*, 137.

47. Bettina Friedl, ed., *On to Victory: Propaganda Plays of the Woman Suffrage Movement* (Boston: Northeastern University Press, 1987), 9.

48. In Spender and Hayman, 20.

49. Cited in Friedl, 9.

50. Friedl, 9.

51. *Ibid.*, 10.

52. *Ibid.*, 8.

53. "Society in Tableaux Aid Suffrage Cause," *New York Times*, 16 January 1911, nyt.com, retrieved 15 September 2013.

54. Catharine McCullough, "Bridget's Sisters…" in Friedl, 164. McCullough included an "introductory note" to the printed version of her play that explained that the play refers to an actual situation from 1868. Mrs. Bradley in the play does not fully represent her historical alter ego, however, because Myra Bradwell was a lawyer. Apparently, McCullough wanted to show her character as a home-loving woman who would become an advocate for a wife's right to her own wages through the course of the court scene.

55. McCullough in Friedl, 173.

56. McCullough, "Introductory Note," in Friedl, 164.

57. McCullough in Friedl, 176.

58. *Ibid.*, 178–9.

59. Margaret Wynne Nevinson, "In the Workhouse," in Croft, 203.

60. Friedl, 25.

61. Charlotte Perkins Gilman, "Something to Vote For," in Friedl, 151.

62. Gilman in Friedl, 152.

63. *Ibid.*, 160–1.

64. "Unladylike Behaviour," *The Guardian*, http://www.theguardian.com/education/2007/nov/13/research.highereducation
65. Bernard Shaw, "Fanny's First Play," *Complete Plays With Prefaces*, Vol. 6 (NY: Dodd, Mead & Company, 1962), 124–5.
66. *Ibid.*, 169–70.
67. Mary Turner, "The Woman with the Pack," *Votes for Women*, 31 May 1912, 561. http://www.news.google.com/newspaper.
68. Gertrude Vaughan, "The Woman With the Pack," *Women's Suffrage Literature—Volume III: Suffrage Drama*, ed. Katharine Cockin, Glenda Norquay and Sowon S. Park (London: Routledge, 2007), 477.
69. Turner, 561.
70. Vaughan's reliance on the features of fairy tales would have been particularly familiar and important to her audiences at this time. Fairy tales as solidly women's traditional storytelling for moral edification matches the tone of this play perfectly.
71. Vaughan in Cockin, Norquay and Park, 511.
72. *Ibid.*, 528.
73. *Ibid.*, 543.
74. Audiences of the time automatically would recognize this character's name as a nod to the daughter of Millicent Fawcett, longtime leader of the NUWSS (National Union of Women's Suffrage Societies); Phillipa Fawcett won the mathematical tripos at Newnham College, Cambridge, in 1890 and had a long career of personal and public achievement. See Newnham College (Cambridge) biographical sketch of Phillipa Fawcett online at *http://www.newn.cam.ac.uk/about-newnham/college-history/biographies/content/philippa-fawcett.*
75. See Chapter 1 for the progression of royal women and performance from the reign of James I onward.
76. St. John in Cockin, Norquay and Park, 6.
77. *Ibid.*, 13.
78. *Ibid.*, 18.
79. *Ibid.*, 20.
80. *Ibid.*, 21.
81. *Ibid.*, 23.
82. *Ibid.*, 23.

Chapter 7

1. Richard Burton, *The New American Drama* (New York: Thomas Y. Crowell, 1913), 8.
2. P.P. Howe, "England's New Dramatists," *The North American Review* 198, no. 693 (August 1913): 218–226, 218. Jstor.org.
3. "The Complimentary Dinner to Mr. J.E. Vedrenne and Mr. H. Granville Barker: A Transcript of the Proceedings." *Shaw Review* 2, no. 8 (May 1959): 17–34, 17.
4. *Ibid.*, 18.
5. *Ibid.*, 19–20.
6. Bernard Shaw, "Getting Married," *Getting Married/Press Cuttings*, ed. Dan Laurence (New York: Penguin, 1986), 147.
7. *Ibid.*, 151–2.
8. *Ibid.*, 154–5.
9. *Ibid.*, 16–7.
10. *Ibid.*, 34.
11. *Ibid.*, 42–50.
12. *Ibid.*, 61.
13. *Ibid.*, 119–21.
14. Catherine Welch, "George Bernard Shaw on *Getting Married*," *New York Times*, 24 May 1908, nyt.com.
15. Shaw, "Getting Married," 138.
16. Susan Shelangoskie, "Spiritualism and the Representation of Female Authority in Shaw's *Getting Married*," *UPSTAGE: A Journal of Turn-of-the-Century Theatre* 2 (Summer 2011), http://www.oscholars.com/Upstage/issue2/susan.htm.
17. *Ibid.*
18. Leonard Conolly, *The Shaw Festival: The First Fifty Years* (Oxford: Oxford University Press, 2011), 252.
19. *Ibid.*, 124.
20. Cicely Hamilton, *Marriage as a Trade* (dodopress.co. rpt. of 1909 text), 2.
21. *Ibid.*, 1–2.
22. George Sand, *Correspondance*, VIII, 407, http://www.ohio.edu/chastain/rz/sand.htm.
23. Hamilton, *Marriage as a Trade*, 33.
24. Cicely Mary Hamilton, *Just to Get Married* (Washington: Library of Congress digital scan of 1914 publication), 16- 17.
25. *Ibid.*, 56–7.
26. *Ibid.*, 83–6.
27. Elizabeth Baker, *Chains* (Boston: John W. Luce, 1911), 68.
28. Stephen Crane, *Maggie: A Girl of the Streets & Other Short Fiction* (New York: Mass Mkt. rpt., 1986).
29. Katie Johnson, "Salvation Nell," *The Columbia Enclyclopedia of Modern Drama Vol. 2*, ed. Gabrielle H. Cody and Evert Sprinchorn (New York: Columbia University Press, 1987), 1183.
30. *Ibid.*
31. *Ibid.*, 1182.
32. Rachel Crothers, "A Man's World," *Plays by American Women: 1900–1930*, ed. Judith Barlow (New York: Applause, 2001), 7.
33. *Ibid.*, 9.
34. *Ibid.*, 12.
35. *Ibid.*, 20.

36. "Mary Shaw Superb in 'Votes for Women,'" *New York Times*, 16 March 1909, nyt.com.
37. Robert. A. Schanke, "Mary Shaw: A Fighting Champion," *Women in American Theatre*, rev. ed., ed. Helen Krich Chinoy and Linda Walsh Jenkins (New York: Theatre Comm. Group, 2005), 88–96, 93.
38. Qtd. in Sally Burke, *American Feminist Playwrights: A Critical History* (Boston: Twayne, 1997), 38.
39. Crothers, 22.
40. Pam Cobrin, *From Winning the Vote to Directing on Broadway: The Emergence of Women on the New York Stage, 1180–1927* (Newark: University of Delaware Press, 1909), 182.
41. Crothers, 43–6.
42. *Ibid.*, 62.
43. Cobrin, 190.
44. Dennis Kennedy, *Granville Barker and the Dream of Theatre* (Cambridge: Cambridge University Press, 1985), 110.
45. Harry Selfridge opened his department store in March of 1909; the store ushered in a whole new way to hire staff, market products, and make history part of everyday business. Barker's 1910 audience could not have failed to connect this to this play's exposé of the mistreatment of women and the Empire.
46. Christopher Innes, "Granville Barker and Galsworthy: Questions of Censorship," *Modern Drama* 32, no. 3 (Fall 1989): 331–344, 336. Project Muse.
47. *Ibid.*, 337.
48. Harley Granville Barker, "The Madras House," *Harley Granville Barker Reclaimed* (New York: Mint Theater Co., 2007), 54.
49. *Ibid.*, 60.
50. *Ibid.*, 69.
51. *Ibid.*, 39.
52. Here Barker alludes to the subjects emphasized by Elizabeth Robins and the suffrage campaign in the play he directed at the Royal Court, *Votes for Women*, in 1907. Other aspects of *The Madras House* echo Robins's characters and the indifference she portrayed in the first act of that play. See Chapter 4 for the discussion of Robins's play.
53. *Ibid.*, 72–3.
54. Bernard Shaw, "Misalliance," in *Complete Plays With Prefaces*, Vol. 4 (NY: Dodd, Mead & Company, 1962), 125–6.
55. Florence Nightingale, *Cassandra* (1852), intro. Myra Stark, 3.
56. Stark in Nightingale, 1.
57. Annie Besant, *Autobiographical Sketches*. Ed. Carol Hanbery MacKay. Ontario: Broadview Pr., 2009: 330.
58. See Chapter 5, Susan Kingsley Kent, *Sex and Suffrage in Britain, 1860–1914* (Princeton: Princeton University Press, 1897), 184ff.
59. Shaw, "Misalliance," 123.
60. *Ibid.*, 142–3.
61. Alfred Bryan (lyrics) and Fred Fischer (music), "Come Josephine in my Flying Machine," 1910, http://webapp1.dlib.indiana.edu/inharmony.
62. Shaw, "Misalliance," 151.
63. See Margaret Leask, *Lena Ashwell: Actress, Patriot, Pioneer* (Hertfordshire: Hertfordshire University Press, 2012), 92–7. Ashwell would be one of four women who went to Parliament to confront leadership in 1911.
64. Shaw, "Misalliance," 158.
65. *Ibid.*, 165.
66. See Chapter 4 for a reading of this play at the Court Theatre. It premiered there in 1905 and was revived several times during the 1904–7 Vedrenne-Barker seasons. Lillah McCarthy created the role.
67. Shaw, "Misalliance," 194.
68. Christopher Innes, "Nothing But Talk, Talk, Talk—Shaw Talk: Discussion Plays and the Making of Modern Drama," *The Cambridge Companion to George Bernard Shaw*, ed. Christopher Innes (Cambridge: Cambridge University Press, 1998), 175–6.
69. Shaw, "Misalliance," 201.
70. Leask, 92.
71. Githa Sowerby, *Rutherford and Son: A Play in Three Acts* (London: Sidgwick & Jackson, 1912). Accessed through Internet Archive, 12.
72. Emma Goldman, *The Social Significance of Modern Drama* (New York: Applause Theatre Book Publishers, 1987, [1914]), 130–1.
73. *Ibid.*, 135–6.
74. Maria DiCenzo, "Feminism, Theatre Criticism, and the Modern Drama," *South Central Review* 25, no. 1 (Spring 2008): 36–56, 48.
75. Sheila Stowell, *A Stage of Their Own: Feminist Playwrights of the Suffrage Era* (Ann Arbor: University of Michigan Press, 1992), 131, 133.
76. As Stowell's commentary on the play points out, Mary's elevation of a mother's need to be with her young baby was considered paramount by the feminists of the day. See 148.
77. Sowerby, 45–56.
78. Goldman, 137.
79. Robert L. King, "Versions" (review), *The North American Review* 279, no. 6 (November-December 1994), 48, 52. Jstor.org.
80. Stowell, 149.
81. Margery Morgan, comp., *File on Shaw* (London: Methuen, 1989), 67.

82. Michael M. O'Hara, "Federal Theatre's *Androcles and the Lion:* Shaw in Black and White," *SHAW* 19 (1999), 129.
83. Review in *The Times*, December 1871, Gilbert & Sullivan Archive, boisestate.edu.
84. See Chapter 3's discussion of the penny weekly stories in connection to Kitty Warren.
85. Nicolas Grene, Introduction to Bernard Shaw, *Pygmalion* (New York: Penguin, 2003 [1916]), xiv.
86. Shaw, *Pygmalion*, 18–9.
87. See Ellen Gainor's chapter on *Pygmalion* in her study *Shaw's Daughters*.
88. *Ibid.*, 45.
89. *Ibid.*, 88.
90. *Ibid.*, 30.
91. *Ibid.*, 65.
92. *Ibid.*, 67.
93. Grene, Intro. to Shaw, *Pygmalion*, xvii.
94. Shaw, *Pygmalion*, 95.
95. *Ibid.*, 100, 104–5.

Chapter 8

1. Philip Larkin, "MCMXIV," in Paul Fussell, ed., *The Norton Book of Modern War* (New York: W.W. Norton, 1991), 38–9.
2. Fussell, 30.
3. Stanley Weintraub, *Journey to Heartbreak: The Crucible Years of Bernard Shaw 1914–18* (New York: Weybright and Talley, 1971), 10.
4. *Ibid.*, 29.
5. *Ibid.*, 55–6.
6. George Bernard Shaw, "Commonsense About the War," *The Project Gutenberg E-Book of Modern History, The European War, Vol. 1* (New York: New York Times Company, 1915), 11–2. Accessed 13 August 2014. http://www.gutenberg.org.
7. David Welch, "Patriotism for Patriotism and Nationalism," British Library, World War I exhibit, http://www.bl.uk/world-war-one/articles/patriotism-and-nationalism.
8. Rupert Brooke, "Peace," in Paul Fussell, ed., *The Norton Book of Modern War* (New York: W.W. Norton, 1991), 37.
9. See Ian Britain, ed., *Fabianism and Culture: A Study in British Socialism and the Arts 1884–1918* (Cambridge: Cambridge University Press, 2005), 262.
10. H.G. Wells, "The Fourth of August—Europe at War," *The Project Gutenberg E-Book of Modern History, The European War, Vol. 1* (New York: New York Times Company, 1915), 73. Accessed 13 August 2014. http://www.gutenberg.org.
11. "British Authors Defend England's War," *The Project Gutenberg E-Book of Modern History, The European War, Vol. 1* (New York: New York Times Company, 1915), 83–5. Accessed 13 August 2014. http://www.gutenberg.org.
12. The paraphrase is largely Stanley Weintraub's in *Journey to Heartbreak*, 50–1.
13. Qtd. in Weintraub, 52.
14. John P. Harrington, *The Life of the Neighborhood Playhouse on Grand Street* (Syracuse: Syracuse University Press, 2007), 65.
15. See Chapter 7 for the details about the Barker-McCarthy and Browne tours.
16. See Edith Hall, "The English-Speaking Aristophanes: 1650–1914," in *Aristophanes in Performance, 421 BC-AD 2007*, ed. Edith Hall and Amanda Wrigley (London: Legenda, 2007).
17. Harrington, 80–1.
18. Hall, 87–8.
19. Harrington, 85–6.
20. Margaret Leask, *Lena Ashwell: Actress, Patriot, Pioneer* (Hatfield: University of Hertfordshire Press, 2012), 107–8.
21. Stella Newsome, *Women's Freedom League 1907–1957* (London: Devenport Press, 1960), 11.
22. *Ibid.*, 109.
23. Newsome, 12–13.
24. Suzanne Raitt and Trudi Tate, eds., *Women's Fiction and the Great War* (New York: Oxford University Press, 1997), 4, 7, 10.
25. J.M. Barrie, "The Old Lady Shows Her Medals," in *Echoes from the War*, 1918, Nook ebook version, 6–8.
26. *Ibid.*, 8–10.
27. *Ibid.*, 18–21.
28. Wilfred Owen, "Dulce Et Decorum Est," *The Collected Poems of Wilfred Owen* (New York: New Directions, 1965), 55.
29. Stanley Weintraub, *Journey to Heartbreak*, 146.
30. Wilfred Owen, "Anthem for Doomed Youth," *Collected Poems*, 44.
31. Amy Lowell, "Patterns," *The Norton Anthology of Poetry, Shorter 5th ed.*, ed. Mary Ferguson et al. (New York: W.W. Norton, 2005), 810–12.
32. Rebecca West, *The Return of the Soldier*, intro. Ann V. Norton (New York: Barnes & Noble, 2006 [1918]), 1,3.
33. *Ibid.*, 87.
34. Martin Green and John Swan, *The Triumph of Pierrot: The Commedia dell Arte and the Modern Imagination* (New York: Macmillan, 1993), xiii. Accessed via Google Books, December 28, 2011.
35. *Ibid.*, 7–8.
36. *Ibid.*, 6, 16.

37. *Ibid.*, 8.
38. See Nancy Mitford's biography of Millay, *Savage Beauty: The Life of Edna St. Vincent Millay* (New York: Random House, 2002).
39. Alexander Woollcott, "Second Thoughts on First Nights: There Are War Plays and War Plays," *New York Times*, 14 December 1919, nyt.com, accessed 9 July 2011.
40. Edna St. Vincent Millay, "Aria da Capo," in *Women Writers of the Provincetown Players*, ed. J. Barlow (Albany: Excelsior Editions/SUNY Press, 2009), 261–4.
41. *Ibid.*, 264.
42. *Ibid.*, 264–5.
43. Judith Barlow, Introduction to Millay's *Aria da Capo*, 256.
44. Edd Winfield Parks, "Edna St. Vincent Millay," *The Sewanee Review* 38, no. 1 (January 1930), 43.
45. Millay, 272–82.
46. Alexander Woollcott, "The Play: The New Shaw Play," *New York Times*, 11 November 1920, nyt.com, accessed 9 July 2011.
47. Juliet Nicolson, *The Perfect Summer: England, 1911, Just Before the Storm* (New York: Grove Press, 2006), 2–3.
48. Charles Isherwood, "British Gentry, Fiddling While the Abyss Looms," *New York Times*, 12 October 2009, accessed 9 July 2011.
49. George Bernard Shaw, "Heartbreak House" (1919) in *Pygmalion and Three Other Plays*, ed. J. Bertolini (New York: Barnes & Noble Classics, 2004), 540.
50. *Ibid.*, 546.
51. *Ibid.*, 602.
52. Christopher Innes, *Modern British Drama: 1890–1990* (Cambridge: Cambridge University Press, 1992), 47.
53. Anton Chekhov, "The Cherry Orchard," in *Five Major Plays by Anton Chekhov*, trans. Ronald Hingley (New York: Bantam, 1988), 302.
54. *Ibid.*
55. John Gassner, "Heartbreak House," in *A Treasury of the Theatre Vol. II: From Henrik Ibsen to Robert Lowell* (New York: Simon & Schuster, 1970), 304.
56. See Stanley Weintraub, *Journey to Heartbreak* for Shaw's reflections on this experience near his home in Hertfordshire
57. Gassner, 306.
58. Ivor Novello and Lena Gilbert Ford, "Keep the Home Fires Burning," recorded 1914, 1915, 1917. Accessed online 9 July 2011.
59. My references to Meisel and Auerbach are from the Preface.
60. See letter in Stanley Weintraub, *St. Joan Fifty Years After: 1923/24–1973/74.*
61. Willard Trask, *Joan of Arc: In Her Own Words* (New York: Books & Company, 1996), 105.
62. Bernard Shaw, *St. Joan* (New York: Penguin, 1951 [1923]), 10.
63. See Edith Hall, *Medea and British Legislation*, 72.
64. Shaw, *St. Joan*, 159.

Bibliography

Adler, Doris. "The Unlacing of Cleopatra." *Theatre Journal* 34, no. 4 (December 1982): 450–66.

Auerbach, Nina. *Ellen Terry: Player in Her Time*, 2d ed. New York: W.W. Norton, 1997.

_____. *Private Theatricals: The Lives of the Victorians*. Cambridge: Harvard University Press, 1990.

Austen, Jane. *Persuasion*. Norton Critical Edition. Ed. Patricia Meyer Spacks. New York: W.W. Norton, 1995.

Baker, Elizabeth. *Chains*. Boston: John W. Luce, 1911.

Barker, Harley Granville. "The Madras House." *Harley Granville Barker Reclaimed*. New York: Mint Theater Co., 2007.

_____. "The Voysey Inheritance." *Harley Granville Barker Reclaimed*. Mint Theater Company Performance Texts. New York: Mint Theater Co., 2007.

Barlow, Judith, ed. *Plays by Women: 1900–1930*. New York: Applause, 2001.

_____. *Women Writers of the Providence Players*. Albany: Excelsior Editions/SUNY Press, 2009.

Barrie, J.M. "The Old Lady Shows Her Medals." *Echoes from the War*, 1918. Nook ebook version.

Barstow, Susan Torrey. "'Hedda Is All of Us': Late Victorian Women at the Matinee." *Victorian Studies* 43, no. 3 (2001): 387–8.

Bennett, Alma. *American Women Theatre Critics: Biographies and Selected Writings of Twelve Reviewers, 1753–1919*. Jefferson, NC: McFarland, 2010.

Bernhardt, Sarah. *My Double Life: The Memoirs of Sarah Bernhardt*. Trans. Victoria Tietze Larson. New York: State University of New York Press, 1999.

Bertolini, John. "Wilde and Shakespeare in Shaw's *You Never Can Tell*." *SHAW: The Annual of Bernard Shaw Studies* 27 (2007): 156–64.

_____, ed. *Man and Superman and Three Other Plays—George Bernard Shaw*. New York: Barnes & Noble Classics, 2004.

_____, ed. *Pygmalion and Three Other Plays—George Bernard Shaw*. New York: Barnes & Noble Classics, 2004.

Besant, Annie. *Autobiographical Sketches*. Ed. Carol Hanbery MacKay. Ontario: Broadview Press, 2009.

Britain, Ian, ed. *Fabianism and Culture: A Study in British Socialism and the Arts 1884–1918*. Cambridge: Cambridge University Press, 2005.

_____. *Modern British Drama: 1890–1990*. Cambridge: Cambridge University Press, 1992.

"British Authors Defend England's War." *The Project Gutenberg E-Book of Mod-*

ern History, The European War, Vol. 1. New York: New York Times Company, 1915. Accessed 13 August 2014. http://www.gutenberg.org.

Brooke, Rupert. "Peace," in Paul Fussell, ed. *The Norton Book of Modern War.* New York: W.W. Norton, 1991.

Brooks, Peter. *The Melodramatic Imagination: Balzac, James, Melodrama and the Mode of Excess,* 2d ed. New Haven: Yale University Press, 1995.

Brownstein, Rachel M. *Tragic Muse: Rachel of the Comédie-Française.* Durham: Duke University Press, 1993.

Bryan, Alfred (lyrics), and Fred Fischer (music). "Come Josephine in my Flying Machine." 1910. *http://webapp1.dlib.indiana.edu/inharmony/detail.do?*

Burke, Sally. *American Feminist Playwrights: A Critical History.* Boston: Twayne, 1997.

Burton, Richard. *The New American Drama.* New York: Thomas Y. Crowell, 1913.

Byrne, Paula. *Jane Austen and the Theatre.* London: Hambledon & London, 2002.

Byrne, Sandie, ed. *George Bernard Shaw's Plays.* New York: WW Norton, 2002.

Cameron, Rebecca. "From Great Women to Top Girls: Pageants of Sisterhood in British Feminist Theatre." *Comparative Drama* 43, no. 2 (Summer 2009): 143–66.

Carlson, Susan. "Portable Politics: Creating New Space for Suffrage-ing Women." *New Theatre Quarterly* 17, no. 4 (November 2001): 334–46.

Chansky, Dorothy. *Composing Ourselves: The Little Theatre Movement and the American Audience.* Carbondale: Southern Illinois University Press, 2004.

Chaudhuri, Una. *Staging Place: The Geography of Modern Drama.* Ann Arbor: University Michigan Press, 1997.

Chekhov, Anton. "The Cherry Orchard." *Five Major Plays by Anton Chekhov.* Trans. Ronald Hingley. New York: Bantam Classic, 1988.

Cima, Gay Gibson. *Performing Women: Female Characters, Male Playwrights and the Modern Stage.* Ithaca: Cornell University Press, 1996.

Clarke, Ian. *Edwardian Drama: A Critical Study.* London: Faber, 1989.

Clothia, Jean, ed. *The New Woman and Other Emancipated Woman Plays.* Oxford: Oxford English Drama/Oxford World's Classics, 1998.

Cobrin, Pam. *From Winning the Vote to Directing on Broadway: The Emergence of Women on the New York Stage, 1180–1927.* Newark: University of Delaware Press, 1909.

Cockin, Katharine. *Edith Craig (1869–1947): Dramatic Lives.* London: Cassell, 1998.

_____, Glenda Norquay, and Sowon S. Park, eds. *Women's Suffrage Literature-Volume III: Suffrage Drama.* London: Routledge, 2007.

"The Complimentary Dinner to Mr. J.E. Vedrenne and Mr. H. Granville Barker: A Transcript of the Proceedings." *Shaw Review* 2, no. 8 (May 1959): 17–34.

Conolly, Leonard. "Mrs Warren's Profession and the Lord Chamberlain." *SHAW: The Annual of Bernard Shaw Studies* 24 (2004): 46–95.

_____. *The Shaw Festival: The First Fifty Years.* Oxford: Oxford University Press, 2011.

Corrigan, Robert. "The Sun Also Rises: Ibsen's 'Ghosts' As Tragedy?" *Educational Theatre Journal* 11, no. 3 (October 1959): 171–80. Jstor.org

Crane, Stephen. *Maggie: A Girl of the Streets & Other Short Fiction.* New York: Mass Mkt. rpt., 1986.

Croft, Susan, ed. *Votes for Women and other plays.* London: Aurora Metro Books, 2009.

Crothers, Rachel. "A Man's World." *Plays by American Women: 1900–1930.* Ed. Judith Barlow. New York: Applause, 2001.

Cunningham, Patricia A. *Reforming Women's Fashion 1850–1920: Politics, Health & Art.* Kent: Kent State University Press, 2003.

Delap, Lucy. "The Superwoman: Theories of Gender and Genius in Edwardian Britain." *The Historical Journal* 47, no. 1 (March 2004): 101–126.

DiCenzo, Maria. "Feminism, Theatre Criticism, and the Modern Drama." *South Central Review* 25, no. 1 (Spring 2008): 36–52.

Dietrich, Richard F. *British Drama 1890 to 1950: A Critical History.* Boston: Twayne, 1989.

Doan, William J. "*The Doctor's Dilemma:* Adulterating a Muse." *SHAW: The Annual of Shaw, Bernard Studies* 21 (2001), pp. 151–161.

Dolgin, Ellen Ecker, *Modernizing Joan of*

Arc: Conceptions, Costumes & Canonization. Jefferson, NC: McFarland, 2008.
Dolan, Jill. "Classic Drag: The Greek Creation of Female Parts." *Theatre Journal* 37, no. 3, Staging Gender (October 1985): 317–27.
Downer, Alan S., ed. *Twenty-five Modern Plays*, rev. ed. New York: Harper & Bros., 1948.
Elbert, Monika. "Striking a Historical Pose: Antebellum Tableaux Vivants, 'Godey's' Illustrations, and Margaret Fuller's Heroines." *The New England Quarterly* 75, no. 2 (June 2002): 235–75.
"Electra as Edith Wynne Matthison Sees Her." *New York Times* March 15, 1910. nyt.com.
Ellen Terry and Bernard Shaw: A Correspondence. Ed. Christopher St. John. New York: G.P. Putnam Sons, 1932.
Ellis, Sarah Stickney. From "The Women of England" (1839) in *Victorian Prose*, ed. Rosemary J. Mundhenk and LuAnn McCracken Fletcher. New York: Columbia University Press, 1999.
Eltis, Sos. "The Fallen Woman in Edwardian Feminist Drama: Sex and the Single Girl." *ELT* 50, no. 1 (2007): 27–49.
Farfan, Penny. *Women, Modernism and Performance*. Cambridge: Cambridge University Press, 2004.
Farrington, Kate. "Have Some Madeira, My Dear: The Influence of Shaw's Enchanted Isle." Pearl Theatre Company/Gingold Theatrical Group Program, 2013.
Flax, Neil. "From Portrait to Tableau Vivant: The Pictures of Emilia Galotti." *Eighteenth-Century Studies* 19, no. 1 (Autumn 1985): 39–55.
Friedl, Bettina, ed. *On to Victory: Propaganda Plays of the Woman Suffrage Movement*. Boston: Northeastern University Press, 1987.
Fuller, Margaret. "The Great Lawsuit: Man versus Men, Woman versus Women." Expanded in *Woman in the Nineteenth Century*. New York: Dover Thrift Editions, 1999 (1845).
Gahan, Peter. "Colonial Locations of Contested Space and *John Bull's Other Island*. *SHAW: The Annual of Bernard Shaw Studies* 26 (2006): 202–229.
Gainor, J. Ellen. "Bernard Shaw and the Drama of Imperialism." *The Performance of Power: Theatrical Discourse and Politics*. Ames: University of Iowa Press, 1991, 56–74.
_____. *Shaw's Daughters: Dramatic and Narrative Structures of Gender*. Ann Arbor: University of Michigan, 1992.
Gale, Maggie B., and Gilli Bush-Bailey, eds. *Plays and Performance Texts by Women 1880–1930: An Anthology of Plays by British and American Women from the Modernist Period*. Manchester: Manchester University Press, 2012.
_____, and Viv Gardner, *Auto/biography and Identity: Women, Theatre and Performance*. Manchester: Manchester University Press, 2009.
Gardner, Viv. "The Invisible Spectatrice: Gender, Geography & Theatrical Space." *Women Theatre and Performance: New Histories, New Historiographies*, ed. Maggie Barbara Gale and Vivien Gardner. Manchester: Manchester University Press, 2000.
Garrison, William. "Intelligent Wickedness." *Feminism: The Essential Historical Writings*. Ed. Miriam Schneir. New York: Vintage, 1992.
Gassner, John, ed. *A Treasury of the Theatre Vol. II: From Henrik Ibsen to Robert Lowell*. New York: Simon & Schuster, 1970.
Gates, Anita. "In 'Candida,' Tribute to Women's Strength." *New York Times* April 1, 2011. Online.
Gilbert & Sullivan Archive. Web. boisestate.edu. Retrieved March 21, 2011.
Glenn, Susan. *Female Spectacle: The Theatrical Roots of Modern Feminism*. Cambridge: Harvard University Press, 2000.
Goldman, Emma. *The Social Significance of Modern Drama*. New York: Applause Theatre Book Publishers, 1987 (1914).
Grand, Sarah. "A New Aspect of the Woman Question." *The New Woman Reader: Fiction, Articles, Drama of the 1890s*. Ed. Carolyn Nelson. Ontario: Broadview Press, 2001.
Graves, Clothilde. "A Mother of Three." *Plays and Performance Texts by Women: 1880–1930: An Anthology of Plays by British and American Women from the Modernist Period*. Ed. Maggie Gale and Gilli Bush-Bailey. Manchester: Manchester University Press, 2012, 90–150.
Gray, Christopher. "The Drama Queen of the Lower East Side." *New York Times* December 23, 2010. nyt.com.

Green, Marti, and John Swan. *The Triumph of Pierrot: The Commedia dell Arte and the Modern Imagination*. New York: Macmillan, 1993. Google Nooks. Retrieved December 28, 2011.

Gregory, Fiona. "Performing the Rest Cure: Mrs. Patrick Campbell's Ophelia, 1897." *NTQ* 28, no. 2 (May 2012): 107–21.

Grene, Nicolas. Intro. to Bernard Shaw-*Pygmalion*. New York: Penguin, 2003 (1916).

Grundy, Sidney. "The New Woman." *The New Woman and Other Emancipated Woman Plays*. Edited by Jean Clothia. New York: Oxford University Press, 1998.

Hadfield, D.A., and Jean Reynolds, eds. *Shaw and Feminisms: On Stage and Off.* Gainesville: University Press of Florida, 2013.

Hadley, Elaine. "The Old Price Wars: Melodramatizing the Public Sphere in Early-Nineteenth-Century England." *PMLA* 107, no. 3 (May 1992): 524–36.

Hall, Edith. "The English-Speaking Aristophanes: 1650–1914." *Aristophanes in Performance, 421 BC-AD 200*. Ed. Edith Hall and Amanda Wrigley. London: Legenda, 2007.

_____. "Medea in British Legislation Before the First World War." *Greece & Rome, Second Series* 46, no. 1 (April 1999): 42–77. Published by Cambridge University Press on behalf of The Classical Association. Jstor.org.

Hamilton, Cicely. *Diana of Dobson's*. 1908. Ed. D. Gillespie and D. Birrer. Ontario: Broadview Press, 2003.

_____. *Just to Get Married*. Washington, D.C.: Library of Congress digital scan of 1914 pub.

_____. *Marriage as a Trade*. UK: dodo press.co. rpt. of 1909 text.

_____. *A Pageant of Great Women*. London: The Suffrage Shop, 1910. [Nabu Public Domain Rpt.]

_____, and Christopher St. John. "How the Vote Was Won." Ed. Susan Croft, *Votes for Women and Other Plays*. London: Aurora Metro Books, 2009.

Harding, Desmond. "Bearing Witness: Heartbreak House and the Poetics of Trauma." *SHAW: The Annual of Bernard Shaw Studies* 26 (2006): 6–26.

Harrington, John P. *The Life of the Neighborhood Playhouse on Grand Street*. Syracuse: Syracuse University Press, 2007.

Hartigan, Karelisa. *Greek Tragedy on the American Stage: Ancient Drama in the Commercial Theater*. Westport, CT: Greenwood Press, 1995.

Hatcher, Jeffrey. *Compleat Female Stage Beauty*. New York: Dramatists Play Service, 2006.

Hayes, Christian. "Sherborne Pageant, 1905." BFI (British Film Institute), http://www.screenonline.org.uk/film/id/1186123.

Hecht, Stuart J. "Social and Artistic Integration: The Emergence of Hull-House Theatre." *Theatre Journal* 34, no. 2, Insurgency in American Theatre (May 1982): 172–82.

Hirshfield, Claire. "The Suffragist as Playwright in Edwardian England." *Frontiers: A Journal of Women's Studies* Vol. 9, No.2 (1987), pp. 1–6.

Holledge, Julie. *Innocent Flowers: Women in the Edwardian Theatre*. London: Virago, 1981.

Holroyd, Michael. *Bernard Shaw. Vol II: The Pursuit of Power, 1898–1918*. New York: Vintage, 1991.

_____. *A Strange Eventful History: The Dramatic Lives of Ellen Terry, Henry Irving, and Their Remarkable Families*. New York: Farrar, Straus and Giroux, 2008.

Howe, P.P. "England's New Dramatists." *The North American Review* 198, no. 693 (August 1913): 218–226, 218. Jstor.org.

Ibsen, Henrik. "Hedda Gabler." *Works of Henrik Ibsen: One Volume Edition*. New York: Walter J. Black, 1928.

Innes, Christopher, ed. *The Cambridge Companion to George Shaw, Bernard*. Cambridge: Cambridge University Press, 1998.

_____. "Granville Barker and Galsworthy: Questions of Censorship." *Modern Drama* 32, no. 3 (Fall 1989): 331–344. Project Muse.

_____. *Modern British Drama-The Twentieth Century: 1890–1990*. Cambridge: Cambridge University Press, 2002.

Isherwood, Charles. "British Gentry, Fiddling While the Abyss Looms." *New York Times* October 12, 2006. nyt.com. July 9, 2011.

_____. "A Stylish Monster Conquers at a Glance." *New York Times* January 13, 2011. nyt.com.

Jackson, Shannon. *Lines of Activity: Performance, Historiography, Hull-House*

Domesticity. Ann Arbor: University of Michigan Press, 2000.

John, Angela. *Elizabeth Robins: Staging a Life 1862–1952*. New York: Routledge, 1995.

Johnson, Katie. "Salvation Nell." *The Columbia Encyclopedia of Modern Drama, Vol. 2*. Ed. Gabrielle H. Cody and Evert Sprinchorn. New York: Columbia University Press, 1987.

Kaplan, Joel H., and Sheila Stowell. *Theatre & Fashion: Oscar Wilde to the Suffragettes*. Cambridge: Cambridge University Press, 1994.

Kennedy, Dennis. *Granville Barker and the Dream of Theatre*. Cambridge: Cambridge University Press, 1985.

Kent, Susan Kingsley. *Sex and Suffrage in Britain, 1860–1914*. Princeton: Princeton University Press, 1997.

King, Robert L. "Versions" (review). *The North American Review* 279, no. 6 (November-December 1994). Jstor.org.

Klein, Alvin. "Shaw's Candida, One Tough Lady." *New York Times* December 14, 1997. nyt.com.

Kultermann, Udo. "The Dance of the Seven Veils: *Salome* and Erotic Culture Around 1900." *Artibus et Historiae* 27, no. 53 (2006): 187–92.

Langtry, Lillie. *The Days I Knew*. North Hollywood: Panoply Productions, 2005 [1925].

Larkin, Philip. "MCMXIV," in Paul Fussell, ed. *The Norton Book of Modern War*. New York: W.W. Norton, 1991.

Leask, Margaret. *Lena Ashwell: Actress, Patriot, Pioneer*. Hertfordshire: Hertfordshire University Press, 2012.

London, Todd. "How America's First Art Theatre Came to Be" (excerpts from Jane Addams *Twenty Years at Hull House*, 1910). *American Theatre* (January 2006).

Lowell, Amy. "Patterns." *The Norton Anthology of Poetry- Shorter 5th ed.* Ed. Mary Ferguson et al. New York: W.W. Norton, 2005.

Lyttleton, Edith. "Warp and Woof." *Plays and Performance texts by women 1880–1930: An Anthology of Plays by British and American Women from the Modernist Period*. Ed. Maggie B. Gale and Gilli Bush-Bailey. Manchester: Manchester University Press, 2012.

MacCarthy, Desmond. *The Court Theatre, 1904–1907; A Commentary and Criticism. With an appendix containing the reprinted programmes of the "Vedrenne-Barker Performances."* London: A. H. Bullen, 1907. [Nabu Public Domains rpt.]

Marshall, Gail. *Actresses on the Victorian Stage: Feminine Performance and the Galatea Myth*. Cambridge: Cambridge University Press, 1998.

_____. *Shakespeare and Victorian Women*. Cambridge: Cambridge University Press, 2009.

"Mary Shaw in Ghosts." *New York Times* January 27, 1903. nyt.com. Accessed April 26, 2011.

"Mary Shaw Superb in 'Votes for Women.'" *New York Times*. March 16, 1909. nyt.com. Accessed April 26, 2011.

Mattingly, Carol. *Appropriate[ing]Dress: Women's Rhetorical Style in Nineteenth-Century America*. Carbondale: Southern Illinois University Press, 2002.

McCarthy, Lillah. "How Shaw, Bernard Produces Plays." *PERFORMANCE* (1983): 163–168.

McIsaac, Peter M. "Rethinking Tableaux Vivants and Triviality in the Writings of Johann Wolfgang von Goethe, Johanna Schopenhauer, and Fanny Lewald." *Monatshefte* 99, no. 2 (Summer 2007): 152–76.

Meisel, Martin. *Realizations: Narrative, Pictorial and Theatrical Arts in Nineteenth Century England*. Princeton: Princeton University Press, 1983.

_____. *Shaw and the Nineteenth-Century Theatre*. New York: Limelight, 1984.

Michaud, Stéphane. "Artistic and Literary Idolatries." *A History of Women, Vol. IV—Emerging Feminism from Revolution to World War*. Ed. G. Fraisse and M. Perrot. Cambridge: Belknap Press of Harvard University Press, 1993.

Mill, John Stuart. *The Subjection of Women*. 1869. Online. Penn State Electronic Classic Series Publication.

Millay, Edna St. Vincent. "Aria da Capo." *Women Writers of the Provincetown Players*. Ed. J. Barlow. Albany: Excelsior Editions/SUNY Press, 2009.

Mitford, Nancy. *Savage Beauty: The Life of Edna St. Vincent Millay*. New York: Random House, 2002.

Morgan, Margery. "Introduction." *Granville Barker Plays: One*. London: Methuen, 1997 (rpt).

_____, comp. *File on Shaw*. London: Methuen, 1989.
Newnham College (Cambridge) biographical sketch of Phillipa Fawcett. http://www.newn.cam.ac.uk/about-newnham/college-history/biographies/content/philippa-fawcett.
Newsome, Stella. *Women's Freedom League 1907–1957*. London: Devenport Press, 1960.
Nicolson, Juliet. *The Perfect Summer: England, 1911, Just Before the Storm*. New York: Grove Press, 2006.
Nightingale, Florence. *Cassandra*. New York: Feminist Press, 1979.
Novello, Ivor, and Lena Gilbert Ford. "Keep the Home Fires Burning." Recorded 1914, 1915, 1917. Online.
O'Hara, Michael. "Federal Theatre's *Androcles and the Lion:* Shaw in Black and White.'" *SHAW* 19 (1999): 129–48.
O'Neill, Michael C. "*The Voysey Inheritance* by Harley Granville-Barker." *Theatre Journal* 42, no. 3 (October 1990): 377–79.
Owen, Wilfred. *The Collected Poems of Wilfred Owen*. New York: New Directions, 1965.
Parks, Edd Winfield. "Edna St. Vincent Millay." *The Sewanee Review* 38, no. 1 (January 1930): 42–9.
Pepys, Samuel. "18 Aug. 1660." *Diary*. Online. www.projectgutenberg.
Peters, Margot. *Shaw, Bernard and the Actresses*. New York: Doubleday, 1980.
Powell, Kerry. "Wilde and Ibsen." *English Literature in Transition, 1880–1920*. Vol. 28, no. 3 (1985).
_____. *Women and Victorian Theatre*. Cambridge: Cambridge University Press, 1997.
_____, ed. *Victorian and Edwardian Theatre*. Cambridge: Cambridge University Press, 2004.
Raitt, Suzann, and Trudi Tate, eds. *Women's Fiction and the Great War*. New York: Oxford University Press, 1997.
"Real Joan of Arc No Window Smasher." *New York Times* April 2, 1912.
Review in *The Times* Dec. 1871. Gilbert & Sullivan Archive. boisestate.edu.
Roberts Miller, Renata. "Caste." *The Columbia Encyclopedia of Modern Drama, Vol. 1*. Ed. Gabrille H. Cody and Evert Sprinchorn. New York: Columbia University Press, 2007, 230–1.
Robins, Elizabeth. "Come and See!" *Way Stations*. New York: Dodd, Mead, 1913 and digitized on http://www.jsu.edu/depart/english/robins/waysta/way14see.htm, 262–3.
_____. "Votes for Women" in Croft, Susan, ed. *Votes for Women and Other Plays*. London: Aurora Metro Books, 2009.
_____. *Way Stations*, 1913. Free Google ebook. Retrieved May 1, 2011.
Rosen, Andrew. *Rise Up Women! The Militant Campaign of the Women's Social and Political Union*. London: Routledge, 2012.
"Rush at Campbell Play: Extra Police Called in to Line Up Guests for Professional Matinee." *New York Times* February 19, 1908. nyt.com.
Ruskin, John. "Of Queens Gardens." *Sesame and Lilies; The Two Paths; The King of the Golden River*. Intro. Sir Oliver Lodge. London: Dent, 1937.
St. John, Christopher. "The First Actress." *Women's Suffrage Literature: Vol. III—Suffrage Drama*. Ed. Katharine Cockin et al. London: Routledge, 2007, 6–23.
Sand, George. *Correspondance*, VIII, 407. http://www.ohio.edu/chastain/rz/sand.htm.
Sanders, Julie. "Caroline Salon Culture and Female Agency: The Countess of Carlisle, Henrietta Maria & Public Theatre." *Theatre Journal* 52, no. 4 (December 2000), 449–464.
Sarah Bernhardt: The Art of High Drama. Exhibit notes. Jewish Museum, New York, 2005–6.
Scaggs, Carmen Trammell. "Modernity's Revision of the Dancing Daughter: The Salome Narrative of Wilde and Strauss." *College Literature* 29, no. 3, Literature and the Visual Arts (Summer 2002).
Schanke, Robert. A. "Mary Shaw: A Fighting Champion." *Women in American Theatre*, rev. ed. Ed. Helen Krich Chinoy and Linda Walsh Jenkins. New York: Theatre Comm. Group, 2005.
Schwartz, Vanessa R. *Spectacular Realities: Early Mass Culture in Fin-de-Siècle Paris*. Berkeley: University of California Press, 1998.
Shakespeare, William. *Hamlet*. Ed. Sylvan Barnet. New York: Signet Classics, 1998.
Shaw, Bernard. *Caesar and Cleopatra*. New York: Penguin, 1951.
_____. "Candida." *Man and Superman and*

Three Other Plays. Ed. John Bertolini New York: Barnes & Noble Classics, 2004.

_____. "Captain Brassbound's Conversion." *Complete Plays with Prefaces Vol.* 1. New York: Dodd, Mead, 1963.

_____. "Commonsense About the War." *The Project Gutenberg E-Book of Modern History, The European War, Vol. 1*. New York: New York Times Company, 1915. Accessed August 13, 2014. http://www.gutenberg.org.

_____. "The Doctor's Dilemma." *Pygmalion and Three Other Plays*. Intro. and notes John Bertolini. New York: Barnes & Noble Classics, 2004.

_____. *Fanny's First Play*. Middlesex: The Echo Library, 2006.

_____. "Getting Married." *Getting Married/Press Cuttings*. Ed. Dan Laurence New York: Penguin, 1986.

_____. "Heartbreak House." 1919. *Pygmalion and Three Other Plays*. Ed. J. Bertolini. New York: Barnes & Noble Classics, 2004.

_____. "Ideals and Idealists." *The Quintessence of Ibsenism*. London, 1891. *Eight Modern Plays*. Ed. Anthony Caputi. New York: W.W. Norton, 1991.

_____. "John Bull's Other Island." *Modern Irish Drama*. Ed. John Harrington. New York: W.W. Norton, 1991.

_____. "Major Barbara." *Pygmalion and Three Other Plays*. Intro. and notes John Bertolini. New York: Barnes & Noble Classics, 2004.

_____. "Man and Superman." *George Shaw, Bernard's Plays*. Ed. Sandie Byrne. New York: W.W. Norton, 2002.

_____. *Misalliance*. Middlesex: The Echo Library, 2006.

_____. "Mrs. Warren's Profession." *Plays Unpleasant*. Ed. Dan Laurence. New York: Penguin, 1957.

_____. Preface to Lillah McCarthy. *Myself and My Friends: A Life on the Stage*. New York: Dodd, Mead, 1933.

_____. "Press Cuttings." *Getting Married and Press Cuttings*. New York: Penguin, 1957.

_____. *Pygmalion*. Ed. Nicholas Grene. New York: Penguin, 2003.

_____. "Review of The Notorious Mrs. Ebbsmith." *The Theatrical 'World' of 1895* (London, 1896) in Harold Fromm, *Bernard Shaw and the Theatre in the Nineties: A Study of Shaw's Dramatic Criticism*. Lawrence: University of Kansas Press, 1967.

_____. *The Road to Equality: Ten Unpublished Lectures and Essays 1884–1918*. Ed. Louis Crompton. Boston: Beacon Press, 1971.

_____. *Saint Joan*. New York: Penguin, 1951.

Shelangoskie, Susan. "Spiritualism and the Representation of Female Authority in Shaw's *Getting Married*." *UPSTAGE: A Journal of Turn-of-the-Century Theatre* 2 (Summer 2011). http://www.oscholars.com/Upstage/issue2/susan.htm.

Showalter, Elaine. *A Jury of Her Peers: American Women Writers from Anne Bradstreet to Annie Proulx*. New York: Knopf, 2009.

Siklos, Stephen. "Biographies: Phillipa Garrett Fawcett, 1868–1948." http://www.newn.cam.ac.uk/about-newnham/college-history/biographies/content/philippa-fawcett. 2004.

Smith, Ethyl, music; lyrics by Cicely Hamilton. 1911. http://www.thesuffragettes.org/resources/anthems/.

"Society in Tableaux Aid Suffrage Cause." *New York Times* January 16, 1911. Online.

Souvenir Programme for Ellen Terry Jubilee, June 12, 1906. Drury Lane Theatre. *www.ForgottenBooks.org*.

Sowerby, Githa. *Rutherford and Son: A Play in Three Acts*. London: Sidgwick & Jackson, 1912). Accessed through Internet Archive.

Spender, Dale, and Carol Hayman, eds. *How the Vote Was Won and Other Suffragette Plays*. London: Methuen, 1985.

Stafford, Tony. *Shaw's Settings: Gardens and Libraries*. Gainesville: University Press of Florida, 2013.

Staller, David. "The Importance of Being Shaw." Pearl Theatre Company/Gingold Theatrical Group Program, 2013.

Stanton, Elizabeth Cady. "Letter 118- to John Hooker, 2/22/1870." *The Selected Papers of Elizabeth Cady Stanton and Susan B. Anthony, Vol. 2: Against An Aristocracy of Sex, 1866–1873*. Ed. Ann D. Gordon. New Brunswick: Rutgers University Press, 2000.

Stier, Theodore. "Barker and Shaw at the Court Theatre: A View from the Pit." *The Shaw Review* 10, no. 1 (January 1967): 18–33.

Stowell, Sheila. *A Stage of Their Own: Feminist Playwrights of the Suffrage Era*. Ann Arbor: University of Michigan Press, 1992.
"Swan Lake." http://www.balletmet.org/Notes/SwanHist.html.
Templeton, Joan. "*The Doll House* Backlash: Criticism, Feminism and Ibsen." *PMLA* 104, no. 1 (1989): 28–40.
Ibsen's Women. Cambridge: Cambridge University Press, 2001.
_____. "Of This Time: Of This Place: Mrs. Alving's Ghosts and the Shape of the Tragedy." *PMLA* 101, no. 1 (January 1986). Jstor.
Terry, Ellen. *Four Lectures on Shakespeare*. Ed. and intro. Christopher St. John. New York: Benjamin Blom, 1932.
Tickner, Lisa. *The Spectacle of Women*. Chicago: University of Chicago Press, 1988.
Trask, Willard. *Joan of Arc: In Her Own Words*. New York: Books & Co., 1996.
Turco, Alfred, Jr. *Shaw's Moral Vision: The Self and Salvation*. Ithaca: Cornell University Press, 1976.
Turner, Mary. "The Woman with the Pack." *Votes for Women*. May 31, 1912.
"Unladylike Behaviour." *The Guardian*. http://www.theguardian.com/education/2007/nov/13/research.higher education.
Vaughan, Gertrude. "The Woman with the Pack." *Women's Suffrage Literature: Vol. III—Suffrage Drama*. Ed. Katharine Cockin et al. London: Routledge, 2007, 459–552.
Vicinus, Martha, ed. *The Widening Sphere: Changing Roles of Victorian Women*. Bloomington: Indiana University Press, 1977.
Walkowitz, Judith. *City of Dreadful Delight, Narratives of Sexual Danger in Victorian London*. Chicago: University of Chicago Press and London: Virago Press, London, 1992.
_____. "The 'Vision of Salome': Cosmopolitanism and Erotic Dancing in Central London, 1908–1918." *The American Historical Review* 108, no. 2 (April 2003).
"Warm Welcome for Miss Ellen Terry: Actresses Discusses Shakespeare's Heroines and Interprets Passages from the Poet." *New York Times* November 4, 1910. nyt.com. Accessed July 12, 2012.

Weintraub, Rodelle, ed. *Fabian Feminist: Shaw, Bernard and Woman*. University Park: Pennsylvania State University Press, 1977.
Weintraub, Stanley. *Journey to Heartbreak: The Crucible Years of Shaw, Bernard 1914–18*. New York: Weybright and Talley, 1971.
_____. *St. Joan Fifty Years After: 1923/24–1973/74*. Baton Rouge: Louisiana State University Press, 1973.
Welch, Catherine. "George Shaw, Bernard on *Getting Married*." *New York Times* May 24, 1908. nyt.com.
Welch, David. "Patriotism for Patriotism and Nationalism." British Library. World War I exhibit. http://www.bl.uk/world-war-one/articles/patriotism-and-nationalist.
Wells, H.G. "The Fourth of August—Europe at War." *The Project Gutenberg E-Book of Modern History, The European War, Vol. 1*. New York: New York Times Company, 1915. Accessed August 13, 2014. http://www.gutenberg.org.
West, Rebecca. *The Return of the Soldier*. Intro. Ann V. Norton. New York: Barnes & Noble, 2006 (1918).
Wilde, Oscar. *The Plays of Oscar Wilde*. New York: Modern Library, n.d.
Willard, Charity Cannon. *Christine de Pizan: Her Life and Works—A Biography*. New York: Persea, 1984.
Wollstonecraft, Mary. "Vindication of the Rights of Woman." *The Feminist Papers: From Adams to de Beauvoir*. Ed. Alice Rossi. New York: Columbia University Press, 1978.
Woodfield, James. *English Theatre in Transition: 1881–1914*. Lanham, MD: Rowman & Littlefield, 1984.
Woolf, Virginia. *A Room of One's Own*. New York: Harvest/Harbrace, 1989.
_____. *Moments of Being*. Ed. Jeanne Schulkind. New York: Harcourt/Harvest, 1985.
Woollcott, Alexander. "The Play: The New Shaw Play." *New York Times* November 11, 1920. Online. Accessed 9 July 2011.
_____. "Second Thoughts on First Nights: There Are War Plays and War Plays." *New York Times* December 14, 1919. Online. Accessed July 9, 2011.

Index

*= Member of the Actresses Franchise League/worked with Shaw

Achurch, Janet 12, 36, 54, 74, 218
Adler, Doris, on Cleopatra 75, 222
Aldrich, Mildred, on American Ibsen productions, 1890s 35–36, 219
anti-suffrage (Antis) 130, 140–146, 148, 151, 158, 196
Archer, William 36, 47–48, 54, 61
Ashwell, Lena*: as beginning actress 51, 73–74, 82, 115; in Edy Craig tableaux 123; Kingsway Theatre manager/performer 129, 132, 135–136, 155–156, 181–183; war work and leadership 199; 220, 226, 228–229
Asquith, Prime Minister Herbert Henry 127, 199
Auerbach, Nina: *Ellen Terry: Player in Her Time* 1–3, 9, 32, 212, 217, 224, 230; *Private Theatricals* 19, 33, 217–218
Austen, Jane: *Persuasion* 24–25, 160, 218, 221

Baker, Elizabeth: *Chains* 15, 168, 227, 231
Bancroft, Marie/Prince of Wales Theatre 7–8, 46
Barker, Harley Granville 5, 55, 82, 197, 223, 228, 231; as director 3–5, 14, 55, 82–83, 85, 95–96, 98, 109, 183, 197; *Madras House* 174, 176–177, 183, 228; *Voysey Inheritance* 96, 98–99, 183,

223; *see also* Vedrenne-Barker seasons at the Royal Court Theatre, 1904–1907
Barlow, Judith 205, 228, 230
Barrie, J.M.: Ashwell in *The Twelve Pound Look* 82–83; *The Old Lady Shows Her Medals* 200–201, 229
Bernhardt, Sarah 9–11, 36, 61, 75–77, 194, 203, 217
Bertolini, John 65, 105, 220–221, 223, 224, 230
Besant, Annie 120–121, 179, 228
Blatch, Harriot, and open-air meetings and suffrage in New York 5, 122–123
Brooks, Peter 9, 217; *see also* melodrama
Brownstein, Rachel 9–10; *Tragic Muse* 25–26, 218
Bush-Bailey, Gilli: *Plays and Performance Texts by Women: 1880–1930* 221–222
Byrne, Paula: *Jane Austen and the Theatre* 24, 218, 223
Byrne, Sandie (ed.): *George Bernard Shaw's Plays* ("Man and Superman") 223

Cameron, Rebecca 124, 128, 225; *see also* pageants
Campbell, Mrs. Patrick (Stella)* 4, 15, 57–60, 82, 93–94, 110, 134, 189–190, 197

Index

Carlson, Susan 115, 127, 224
censorship 79, 81, 222–223, 228
Chapin, Alice*: *At the Gates* 15, 140, 142–144, 226
Chaudhuri, Una: *Staging Place* 56, 220
Chekhov, Anton: *The Cherry Orchard* 100, 210–211, 230, 232
Cima, Gay Gibson 14, 49, 218, 220
Cleopatra 8, 28, 52, 74–77, 123, 206, 222
Cobrin, Pamela: *From Winning the Vote to Directing on Broadway* 122, 172, 174, 217, 225, 228
Cockin, Katharine 123, 126, 222, 225, 227
Commedia (dell-arte) and modernism 203, 211–12
Conolly, Leonard: *The Shaw Festival: The First Fifty Years*; on *Mrs. Warren's Profession* (Shaw) 164, 221, 227
Contagious Diseases Act 69, 109, 120
cosmopolitanism 13, 222; *see also* Schwartz, Vanessa; Walkowitz, Judith
court masques/women's performance *see under* Sanders, Julie
Craig, Edith (Edy)* 8, 11, 32, 73–74, 82, 196, 123–124, 155, 165, 222, 225
Criterion Hotel, Piccadilly 5, 114, 158
Croft, Susan: *Votes for Women and Other Plays* 226–227
Crothers, Rachel: *A Man's World* 15, 169, 171, 172, 228

dePizan, Christine: *The Book of the City of Ladies* 219
DiCenzo, Maria: "Feminism, Theatre Criticism, and the Modern Drama" 128, 184, 224–225, 228
Diederot, Denis 19–20
Dietrich, Richard 71, 221
discussion plays 96, 228; *see also* New Drama (new drama)
Dumas, Alexandre, *fils*: *La Dame aux Camèlias* 10–11

Egerton, George (Mary Dunne) 56, 220
Elbert, Monika: "Striking a Pose" 28–29, 219
Elliot, Gertrude (Mrs. Forbes-Robertson)* 15, 52
Ellis, Sarah Stickney 116, 224
Eltis, Sos: "The Fallen Woman in Edwardian Drama" in Kerry Powell *Victorian and Edwardian Theatre* 68, 71

Fabian 6, 102, 152, 177, 196, 224, 226
Farfan, Penny: *Women, Modernism and Performance* 49, 220
Farr, Florence 82
Felix, Rachel *see* Brownstein, Rachel
Fiske, Minnie Maddern 159, 168
Flaneur 51, 55
Flaubert: *Madame Bovary* 48, 79
Forbes-Robertson, Beatrice* 15, 148
Forbes-Robertson, Johnston 52, 106
Freud, Sigmund 3, 10, 215
Friedl, Bettina: *On to Victory* 147–148, 150–151, 226–227
Fuller, Margaret: "The Great Lawsuit" in *Woman in the Nineteenth Century* 28, 30–31, 82, 116, 219, 224

Gahan, Peter: on *John Bull's Other Island* (Shaw, Bernard) 92, 223
Gainor, J. Ellen: on *Captain Brassbound's Conversion* (Shaw) 106–107, 224
Gale, Maggie: *Plays and Performance Texts by Women: 1880–1930* 221–222
Galsworthy, John 6, 14, 83–85, 158, 196, 222–223; *The Silver Box* 107–108
Gardner, Viv 8, 217
Gassner, John 211, 230
Gilman, Charlotte Perkins 60, 169, 221; *Something to Vote For* 150–152, 227
Gladstone, Home Sec. Herbert 113, 126, 165, 226
Glover, Evelyn*: *Miss Appleyard's Awakening* 144, 226
Godey's Lady's Book (ed. Josepha Hale) 28, 30–31, 219
Goethe, Wolgang von: *Elective Affinities* 19–20, 218
Goldman, Emma: *The Social Significance of Modern Drama* 34, 102, 183–185, 219, 223, 228–229
Grand, Sarah: "The New Woman" 12–13, 41, 62, 65, 114, 221
Great War *see* World War I
Green, Martin: *The Triumph of Pierrot* 203, 230
Gregory, Fiona: "Performing the Rest Cure" 58, 220
Grein, J.T. & the Independent Theatre 69, 81, 137, 158
Grene, Nicholas 188, 190, 229; *see also* Shaw, Bernard, *Pygmalion*

Hadfield, Dorothy 72–73, 220, 222
Hall, Edith 14, 198, 217–218, 229–230

Hamilton, Cicely* 15, 165; as actress in Shaw's *Fanny's First Play* 129, 153; *Diana of Dobson's* 135, 175; *How the Vote Was Won* 124–126, 138, 141, 147, 152, 155; *Just to Get Married/Marriage as a Trade* 165–168; *The Pageant of Great Women* 8, 124, 148, 226–227
Hamilton, Lady Emma 2
Harlequinade, commedia-dell-arte and modernism *see* Green, Martin; Swan, John
Harradan, Beatrice*: *Lady Geraldine's Speech* 142, 146, 226
Harrington, John 198, 223, 229
Hatcher, Jeffrey: *Compleat Female Stage Beauty* 21–22, 218
Hayman, Carol: *How the Vote Was Won and Other Suffragette Plays* 147, 226
Hirschfield, Claire 133–134, 225
Hofmannsthal, Hugo Von 93, 110
Holledge, Julie: *Innocent Flowers* 7, 46–47, 108, 114, 126, 217, 220, 224–225
Holroyd, Michael: *Bernard Shaw. Vol. II: The Pursuit of Power* 234; *A Strange Eventful History* 59, 106, 221, 224
Hull House 83–85, 222
Hyde Park (as suffrage march site) 114, 126, 153, 226

Ibsen, Henrik 7, 12, 34, 43, 53, 68, 187, 220; *A Doll House* 12, 36–37, 40, 42, 44–45, 47, 54, 60, 174, 185; *Ghosts* 37–39, 47–48, 81, 84, 219; *Hedda Gabler* 3, 46–48, 81, 220
Innes, Christopher 42–43, 45, 81, 100, 175–176, 182, 210, 220–223, 228, 230
Irving, Henry & Lyceum Theatre 11–12, 59, 105–106, 117, 221, 224

Jackson, Shannon *see* Hull House
Jennings, Gertrude*: *A Woman's Influence* 15, 145–148, 226
Joan of Arc: as historical icon/suffrage symbol 1–3, 5, 8, 28, 32, 123, 125, 127, 148, 154–155, 213, 217, 230; *see also* Shaw, Bernard, *St. Joan*
John, Angela: *Staging a Life* 47, 81, 220, 222
Jonson, Ben *see* Sanders, Julie

Kaplan, Joel: *Theatre and Fashion: Oscar Wilde to the Suffragettes* 135–136, 226
Kennedy, Dennis: *Granville Barker and the Dream of Theatre* 82–83, 95, 107, 111, 174, 222–224, 228
Kent, Susan Kingsley 120, 218, 225, 228
Kingston, Gertrude* 15, 166, 197–198
Kingsway Theatre 82, 129, 132, 135, 155, 181, 183; *see also* Ashwell, Lena
Kultermann, Udo 79, 222

Langtry, Lillie*: On Sarah Bernhardt in *Days I Knew* 10–11, 75, 123
Lea, Marion* 3, 47–48, 81
Leask, Margaret 135, 183, 199, 220, 222, 226, 228–229
Life Force 88, 181
The Little Theatre 166; as a model for Neighborhood Playhouse 198
Lowell, Amy: "Patterns" 201, 230
Lyttleton, Edith: *Warp & Woof* 82, 134–136, 226

MacCarthy, Desmond (critic of Vedrenne Barker/Royal Court seasons 1904–1907) 41–42, 80, 85, 88, 90, 92–93, 105–106, 109, 220, 222–224
Mansfield, Richard 82
Marshall, Gail: *Actresses on the Victorian Stage* 21, 219; *Shakespeare and Victorian Women* 218, 220
matinee 4, 8, 13, 38, 47, 56, 61, 82, 84, 94, 107, 133–134, 198, 220, 223
Matthison, Edythe Wynne* 93–95, 204, 223, 230
Mattingly, Carol 121, 225
Maxine Elliot's theatre, New York 148
McCarthy, Lillah* 4, 15, 86–87, 89, 95, 114–115, 127, 129, 152–153, 186, 197, 211–212
McCullough, Catherine: *Bridget's Sisters* 149–150, 226–227
McIsaac, Peter 20, 218
Meisel, Martin: *Realizations* 1–2, 27, 212, 217–218, 223
Melodrama 2, 7, 9–10, 12–13, 17, 19, 27–28, 35–36, 42–43, 45, 48–49, 61, 63, 67, 70, 73, 77, 83–85, 98, 104–105, 108, 111, 135, 140, 145, 168, 170, 172–173, 182, 198, 209, 214–215, 217
Meyer, Annie Nathan 37, 39, 219
Michaud, Stéphane 20, 218
Mill, John Stuart: *Subjection of Women* 29, 118, 120, 219
Millay, Edna St. Vincent: *Aria da Capo* 15, 204–206, 211–212, 230
Minto, Dorothy* 15, 123, 167
Morgan, Margery 98, 222–223, 229

Nevinson, Margaret Wynne*: *In the Workhouse* 150, 227
New Drama (new drama) 25, 69, 72, 79, 80–81, 85, 131, 133, 158
New Woman 7–8, 12–13, 24, 41, 56–57, 62, 65–66, 68–69, 87, 114, 118–119, 121, 123, 129, 135, 182, 204, 209, 217–219, 221
Newsome, Stella: *Women's Freedom League 1907–1957* 229–230; see also Women's Freedom League

O'Hara, Michael 186, 229
Olive, Edyth* 14–15
Owen, Wilfred 196, 201, 229

pageants 124, 128–129, 225; see also Cameron, Rebecca
Pankhurst, Christabel 103, 111
Pankhurst, Emmeline 5, 87
Pankhurst family 122, 138
parades 115, 122, 124, 155, 199, 217; see also Cameron, Rebecca
Parks, Edd Winfield: on Millay's *Aria da Capo* 205, 230
Pepys, Samuel: on Ned Kynaston and Mrs. Hughes 21, 218; see also Hatcher, Jeffrey
Peters, Margo: *Shaw and the Actresses* 36, 87–88, 219, 222–223
Peters, Sally: *A Feminist in Spite of Himself* (excerpt in Powell, Kerry, *Victorian and Edwardian Theatre*) 89, 223
Pinero, Arthur Wing 32, 57–58, 68–71, 74, 77, 81–82, 108, 196; *The Notorious Mrs. Ebbsmith* 58; *The Second Mrs. Tanqueray* 57–58, 82
Pioneer Players 11, 74, 82, 221
Powell, Kerry 43, 61, 66, 220–221

Queen Victoria 32, 116

Racine, Jean 10, 12
Raitt, Suzanne 200, 230
Restoration theatre 8, 21, 24, 63, 75, 111; see also Hatcher, Jeffrey
Robins, Elizabeth* 1, 3, 5, 12, 14, 36, 46–47, 49, 54–55, 61, 74, 81, 83, 107–108, 114, 121–122, 127–128, 132, 163, 171, 219–220, 222, 225, 228
Rousseau, Jean Jacques: *Emile* 118–119
Royal Court Theatre seasons (1904–1907) see under Vedrenne-Barker

St. John, Christopher 8, 15, 148, 165; *How the Vote Was* Won 138, 155–156; 218, 224, 226–227
Sanders, Juliet: "Caroline Salon Culture and Female Agency" 21, 218
Scaggs, Carmen T. 222
Schwartz: *Spectacular Realities* 53, 64, 220
Scott, Clement, on Ibsen's *A Doll's House* and *Ghosts* 36, 47, 60, 219–220
Shaw, Bernard: *Androcles and the Lion* 4, 186, 229; *Caesar and Cleopatra* 52, 74, 75, 77, 206, 222; *Candida* 40–42, 74, 82, 89–90, 123, 163, 204, 219, 220, 223; *Captain Brassbound's Conversion* 105–107, 197, 224; *The Doctor's Dilemma* 103–105, 224; *Fanny's First Play* 129, 143, 152–155, 174, 227; *Heartbreak House* 15, 204, 206–207, 210, 212, 214, 230; "Ideals and Idealists" from *The Quintessence of Ibsenism* 39, 40, 43 *John Bull's Other Island* 90–92, 223; *Major Barbara* 96–97, 101, 103, 107–108, 187–188, 208, 223–224; *Man and Superman* 87–89, 180–181, 223; *Misalliance* 174–175, 178–179, 182, 228; *Mrs. Warren's Profession* 68–70, 74, 84, 97, 122, 221–222; *Press Cuttings* 140–142, 226; *Pygmalion* 186–189, 191–192, 197, 223–224, 229–230; *St. Joan* 1, 3, 15, 212–215, 230; *You Never Can Tell* 65–67, 221
Shaw, Mary: in Ibsen's *Ghosts* 38, 84, 233, 219; in Robins's *Votes for Women* and as activist 171, 228
Sheldon, Edward: *Salvation Nell* 159, 168, 169, 227–228
Showalter, Elaine: *A Jury of Her Peers* 119, 225
Smyth, Ethel: "March of the Women" 128
Sowerby, Githa: *Rutherford & Son* 15, 174, 183–185, 228–229
Spender, Dale: *How the Vote Was Won and Other Suffragette Plays* 147, 226
Stafford, Tony: *Shaw's Settings* 88, 223
Stage Society 74, 81–82, 106
Stasis 13, 20–21, 23, 27, 31, 33, 53, 58, 61, 77, 79, 140, 178, 193
Stowell, Sheila: *A Stage of Their Own* 109, 132, 135–136, 141, 184–186, 224–225, 228–229; *Theatre and Fashion: Oscar Wilde to the Suffragettes* 135–136, 226; see also Kaplan, Joel
suffragettes 113, 115, 121–123, 126

Swan, John: *The Triumph of Pierrot* 203, 230

Tableau (freeze) 1–3, 17, 28–29, 42–43, 51, 73, 75, 104, 125–126, 154–155, 212, 215
Tableaux vivant(s) 1–3, 8–9, 19–20, 28–33, 75, 77, 109, 122–124, 126, 148, 217–219, 225–226
Templeton, Joan 37–39, 54, 219–220
Terry, Ellen* 1, 8, 11, 15, 22, 27, 32, 51, 57, 59, 73, 82, 94, 105–106, 117–118, 123, 125–127, 156, 197, 217–221, 224–225
Thorndike, Sybil* 15, 214
Tickner, Lisa: *The Spectacle of Women* 114, 124, 224
Trafalgar Square 5, 50, 55, 58, 109, 212–122, 171
Trudi Tate 200, 230
Turco, Alfred, Jr.: *Shaw's Moral Vision* 91, 223
Turner, Mary (on Gertrude Vaughan) 154–155, 227

Vaughan, Gertrude* 15; *The Woman with the Pack* 154–155, 229
Vedrenne-Barker seasons at the Royal Court Theatre, 1904–1907 4–5, 13–14, 42, 50, 55, 82–85, 90, 92, 95–96, 99, 112, 132, 158, 160, 163, 167, 180, 198, 220, 223, 228

Walkowitz, Judith: *City of Dreadful Delight* 55, 220; "The Vision of Salome" 77, 222
Weintraub, Stanley: *Journey to Heartbreak* 195, 201, 229; *St. Joan Fifty Years After* 230
Wells, H.G. 196, 229
West, Rebecca: *Return of the Soldier* 202, 230
Wilde, Oscar 12, 13, 220–222; *An Ideal Husband* 43–46; *The Importance of Being Earnest* 63–66; *Lady Windermere's Fan* 67–68, 73; *Salome* 77–79
Women Writers Suffrage League 114, 165
women's club movement, transatlantic 121
Women's Freedom League (off-shoot of WSPU) 74, 140, 142, 199, 229; see also Newsome, Stella
Women's Social and Political Union (WSPU) 5, 14, 50, 103, 109, 113, 122, 138, 143, 152, 154, 165, 180, 199, 224–225
Woolf, Virginia: on Ellen Terry in Shaw's *Capt. Brassbound's Conversion* 106; *Moments of Being* 15, 17; *A Room of One's Own* 116–118
Woollcott, Alexander 204, 206–207, 230
World War I 3, 14–15, 83, 158, 174, 193, 203, 205, 206, 211–212, 214, 218, 229

www.ingramcontent.com/pod-product-compliance
Lightning Source LLC
Chambersburg PA
CBHW051218300426
44116CB00006B/624